Egon Schiele
and His Contemporaries

Austrian Painting and Drawing from 1900 to 1930
from the Leopold Collection, Vienna

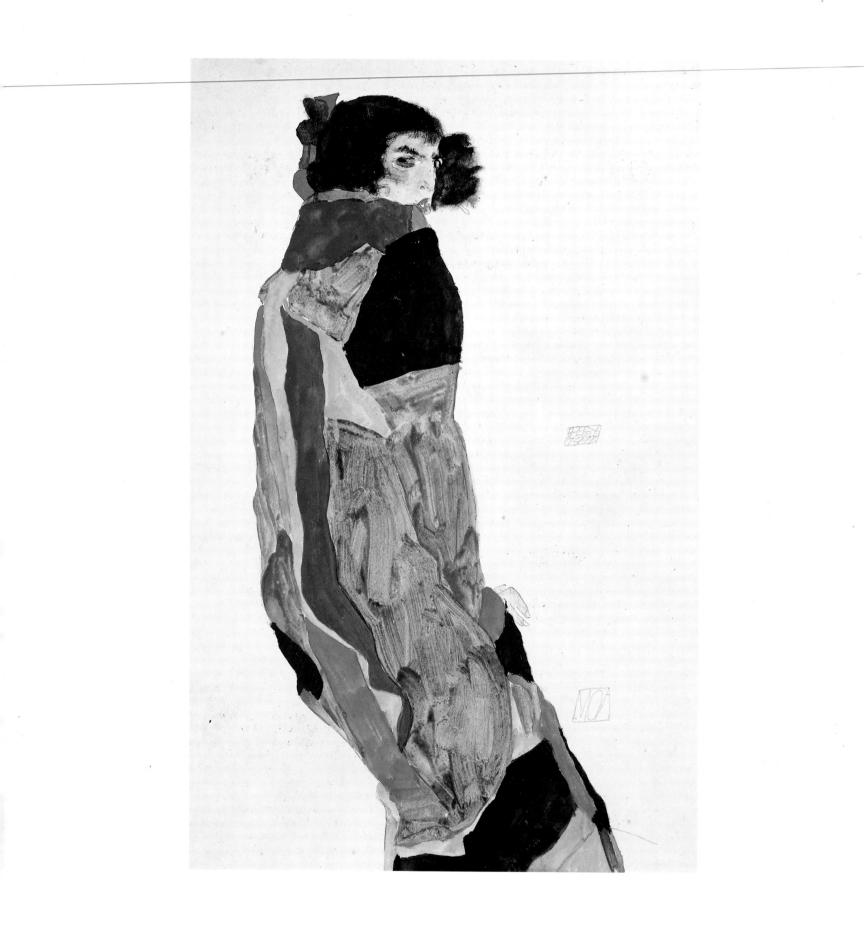

Egon Schiele and His Contemporaries

*Austrian Painting and Drawing from 1900 to 1930
from the Leopold Collection, Vienna*

Edited by
Klaus Albrecht Schröder and Harald Szeemann

With contributions by
Antonia Hoerschelmann, Rudolf Leopold, Klaus Albrecht Schröder,
Harald Szeemann and Patrick Werkner

Prestel

First published in German in conjunction with the exhibition 'Egon Schiele und seine Zeit:
Österreichische Malerei und Zeichnung von 1900 bis 1930 aus der Sammlung Leopold'
shown at the Kunsthaus Zurich (1988/89), the Kunstforum Länderbank Wien, Vienna (1989),
the Kunsthalle der Hypo-Kulturstiftung, Munich (1989/90)
and the Von-der-Heydt-Museum, Wuppertal (1990).

Cover illustration: Egon Schiele, *Self-Portrait with Winter Cherry*, 1912
Frontispiece: Egon Schiele, *Moa, the Dancer*, 1911

Translated from the German by David Britt (essays) and Ian Robson (biographies)

Prestel-Verlag, Mandlstrasse 26, D-8000 Munich 40, Federal Republic of Germany

Distributed in continental Europe and Japan by Prestel-Verlag,
Verlegerdienst München GmbH & Co KG,
Gutenbergstrasse 1, D-8031 Gilching, Federal Republic of Germany

Distributed in the USA and Canada by te Neues Publishing Company, 15 East 76th Street,
New York, NY 10021, USA

Distributed in the United Kingdom, Ireland and all other countries by Thames & Hudson Limited,
30–34 Bloomsbury Street, London WC1B 3QP, England

Designed by Norbert Dinkel, Munich
Offset lithography by Repro Karl Dörfel GmbH, Munich
Typeset, printed and bound by Passavia Druckerei GmbH, Passau
Printed in the Federal Republic of Germany

ISBN 3-7913-0921-8 (English edition)
ISBN 3-7913-0917-X (German edition)

Contents

Foreword

Given the extraordinary reputation of Gustav Klimt and Egon Schiele in the non-German speaking world today – one that surely rivals that of Van Gogh and the leading Impressionists – it is strange to reflect that outside central Europe relatively little notice was taken of these two great Viennese artists until the 1960s. Their compelling artistic achievements, at once decorative and of the greatest possible emotional intensity, coincided in Vienna at the turn of the century with an exceptional, highly innovative flowering of visual culture and of almost every other area of the arts and sciences. Architecture and the applied arts were of the greatest importance at this time, but in painting, Klimt and Schiele, together with Oskar Kokoschka, were the leading figures.

However, there were other, very fascinating painters who remain shadowy figures for most of us. Richard Gerstl, in particular, was an extraordinarily talented painter whose work seems to foreshadow both the concerns and the techniques of many of the Neo-Fauve painters of the 1980s, not only in Germany and Austria but also in the rest of Europe. His affair with the wife of the composer Arnold Schoenberg, to whom he had been giving instruction in painting, led to his suicide at the age of twenty-five. But by then he had produced a series of paintings – among them, the two self-portraits included here (Cat. 80, 87) – that embody as intensively as any works of art produced in the period the psychodrama that was the cultural life of Vienna as it approached the end of its history as an imperial capital. Even less familiar is the work of painters such as Herbert Boeckl, Albin Egger-Lienz, Anton Kolig, Koloman Moser (better known as a designer) and Max Oppenheimer, but they all represent a rich context in which to place the work of our heroes, Klimt, Kokoschka and Schiele, a context that, in breadth and complexity, can more than rival the painting being produced during this period in such central European cities as Dresden, Munich and Berlin.

To make a large public aware of the great achievements of artists, to recognize their quality and then to make effective propaganda on their behalf, is in itself a creative gesture, and collectors of imagination and sensibility, even of obsession, have more often than not been crucial in making real for us the art both of the distant past and of the present. One might reflect on the achievement of Charles I of England, who relentlessly scoured Italy for the chief works of Titian and Mantegna, or, in the nineteenth century, on that of the Brothers Goncourt and the Englishman Richard Wallace, whose passion for French art of the eighteenth century was the most important channel for transmitting the aesthetic ideals of that period to their own time and beyond. In more recent times, the persistence of George Costakis, the great collector of the Russian avant-garde, did much to preserve the creative work that flowered in the Soviet Union around 1917, work which was suppressed and all but eliminated by Stalin.

In the aftermath of the Second World War and the holocaust, the cultural world of turn-of-the-century Vienna was almost lost from view. For instance, even in the early 1960s performances of the symphonies of Mahler, not to mention of works of the second Viennese school (Schoenberg, Berg, Webern), were very rare events in the concert halls of Europe and America, and needed the strongest and most passionate advocacy. Now Mahler has all but overtaken Beethoven and Brahms in popularity and has become veritably *the* composer for our time. And in 1986 something quite extraordinary happened: the Centre Georges Pompidou contrived to remain open until two in the morning in order to accommodate the crowds that were flocking to see the exhibition 'L'Apocalypse joyeuse: Vienne 1880-1938'.

It is thus appropriate to pay homage to the most single-minded and, in the best sense, obsessive collector of Austrian painting of the early twentieth century, Prof. Dr Rudolf Leopold, who has done more than anyone to promote not only his heroes, Klimt and Schiele, but also their talented and still little-known contemporaries. To meet Rudolf Leopold in his house in a converted *Heurige*, one of those romantic wine hostelries situated on the outskirts of Vienna, is a unique experience. Collecting on this level is usually associated with considerable wealth and ostentation. The impression one receives of Prof. Leopold's lifestyle is quite the reverse. One senses the extraordinary sacrifices that he has made in order to bring the works together. One should add that no collection, public or private, remotely rivals this overview of the period and, in particular, of the painting of Schiele himself. Only the Albertina, thanks to the enthusiasm of a previous director and great art historian, Otto Benesch, whose father was personally acquainted with Schiele, possesses watercolours and drawings of equal quality. Prof. Leopold, a practising optician, has built up a collection based above all on love and enthusiasm, yet in spite of its

extraordinary richness and breadth, it is also extremely precise in conception. It is interesting that he himself has pointed out in his interview with Harald Szeemann that his collection of Schiele concentrates on the expressively painted works, rather than the more linear paintings, although he possesses examples of these too. However, the fact remains that, irrespective of whether individual works tend towards the expressive — for instance, in the grandiose masterpiece *The Hermits* of 1912 (Cat. 25), in which the two painters Klimt and Schiele, like Doppelgangers, become almost as one — or towards the linear — as in *Seated Male Nude* of 1910 (Cat. 6) — we find ourselves in the presence of an artist who, by the time he died in 1918 at the age of twenty-eight, had produced an astonishingly varied and rich oeuvre. As with all great artists, each individual work becomes an event in itself, creating its own cosmos and mood in contrast to the work that precedes it. Schiele's oeuvre adds up to a psychologically intense autobiographical experience and, when seen together, can only serve to extend our appreciation of his achievement. That is why his work especially benefits from being together in one place, and it is largely because of Prof. Leopold's persistence that it can now be viewed in this way, rather than being, as might easily have happened, dispersed arbitrarily among museums and private collections throughout the world. It is to be hoped that these works will be able to stay together on a permanent basis, preferably in the Austrian capital, whose intellectual and emotional spirit they represent so perfectly.

Norman Rosenthal

Interview with Rudolf Leopold

S: *People tend not to think of Austria as a country of collectors, in the way the USA, Belgium, West Germany and Switzerland are. Is this a false impression? After all, there is now a very lively art-gallery scene in Vienna.*

L: Your impression is right. Art collecting has never really got off the ground here because the Austrian state will not allow it to. There are many more obstacles to be overcome than there are in the USA, in Switzerland or in the Federal Republic of Germany. It all starts with the wealth tax. Before 1938 the state imposed no wealth tax on art collections, on the correct assumption that owning art was not like owning a going industrial concern and did not constantly produce profits. In the so-called Third Reich, art collections were made liable to wealth tax. When I talked to a member of the government some years ago, he confirmed to me that the Austrian state took over a number of tax laws from the Third Reich after 1945, on the assumption that this would maximize the tax yield. In this case the result has been the exact opposite. I could demonstrate this, but that would take us far beyond the framework of this conversation.

A further obstacle, both to art collecting and to the existence of an art trade extending beyond our own borders, is the high level of value-added tax and customs duty that our state charges on the importation of works of art. In the USA, for example, they are only too glad to see works by major artists coming into the country, and they admit them free of duty. In West Germany, they do charge VAT on imported works of art, but at a much lower percentage rate than here. This means that Austrian collectors and dealers labour under a crucial handicap compared with those abroad when it comes to buying works of art elsewhere and bringing them into the country.

S: *If Austria is not a country of art collectors, perhaps this also stems partly from the absence of a developed institutional sector: the non-commercial exhibitions and museums whose task it is — year in, year out — to maintain a public awareness of art?*

L: That is also true, I'm afraid. Our exhibition scene at the moment cannot remotely be compared with what it was at the beginning of the century, in the period before the First World War. Then there were numerous important shows, especially at the Vienna Secession, and there was the 'Internationale Kunst-

Rudolf Leopold
in the summer of 1988

schau' [International Art Show] organized in 1908, and again in 1909, by the group that centred on Gustav Klimt.

In the decades since the Second World War, many important international touring exhibitions have failed to reach Austria, either because our state has considered the cost too high or because no suitable exhibition space has been available. There are now plans to build one on the Messepalast site in the next few years.

All we have had so far are a few interesting major exhibitions at the Künstlerhaus, a centrally located but far from beautiful building.

S: *What was the decisive stimulus that started you off as a collector?*

L: Here I must go back a bit further. During the Third Reich I went to Gymnasium [grammar school] which was then renamed the Oberschule [secondary school]. The teachers gave absolutely no indication of what visual art meant, or what its history might be. The 'state art' of the Nazi period — which was a mere simulacrum of art — bored me to tears. Nor was my imagination fired by the stuff that hung on the walls of prosperous bourgeois houses — mainly what is called 'salon painting'. As far as I knew, this was what 'fine art' was. I decided — and I said so at the time — that I never wanted pictures like that on *my* walls.

Additionally, my father, who was a well-known agronomist, was interested in economics and agriculture to the exclusion of

virtually everything else, and the only museum he took me to was the Natural History Museum. I had inherited artistic talent from my mother – and my teachers, both at primary level and at the so-called Oberschule, were impressed by my gift for understanding colour relationships and proportion – but all that remained latent.

Then, a couple of years after the war ended, I took myself to the Kunsthistorisches Museum in Vienna. I was especially impressed by the paintings of Brueghel, Rembrandt and Veláz-quez, and I decided on the spot that I would be a collector of real works of art. Since paintings by those three artists were rather beyond my means, I set my sights on the nineteenth-century Austrian painters; I had seen their works in the Öster-reichische Galerie, and I was able to compare them with what I saw in nature.

S: *Famous collectors have usually had close relationships with their artists. The central groups of works in your collection are by Schiele, Gerstl and Klimt, none of whom you knew personally. Have you ever missed this kind of contact?*

L: Yes, I have regretted its absence very much. I would very much have liked to talk to the three artists you mention, about their paintings, about their initial ideas and how they worked on them. Their work has touched me much more deeply than that of most living artists. It seems to me that Gerstl is the only *Neue Wilde* [Neo-Fauve] who shows true genius.

S: *Which are the artists in your collection with whom you have had contacts, whom you have visited, or whose advice you have sought? Kokoschka, for instance: what was your experience of him?*

L: I have visited many artists, often and with great pleasure. On such occasions, I have mostly concentrated on looking at their paintings and discussing them. Their opinions on other artists, especially living ones, do not interest me particularly. Artists tend to be biased, not to say jealous, when it comes to their artistic colleagues – even if they refuse to admit it. And even when it comes to assessing the works of dead artists, they tend not to treat them fairly unless their own work lies in the same direction. So, with Josef Dobrowsky, for instance, a good-natured man, I used to enjoy discussing Brueghel and Cézanne, but never Schiele, who was quite alien to him. And I got on excellently with Herbert Boeckl, but only after he had accepted my suggestion that we keep off the topic of Schiele.

Now: you ask whose advice I have sought – in other words, which artists I consulted when I was considering an addition to my collection. That is something I have never done. For one thing, I have never wanted to do so, because of the bias I have just mentioned. For another thing, I have never needed to do so – unlike most collectors, even those who have been awarded the epithet of 'great'. I have always made my own decisions, relying entirely on my own talent, which I have developed less through reading than through constant looking and comparing. This is not arrogance on my part. I recognized the value of Schiele's works, which in the Third Reich were all banned, and

I did so not just ahead of almost all the collectors but ahead of most museum and gallery directors too. This is how I have been able to build up, since 1950, the most comprehensive collection of this artist's work that exists anywhere. There are many other artists, too, whose importance is increasingly coming to be recognized, and whom I assessed correctly long before the majority of collectors or gallery directors.

As for my experiences with Oskar Kokoschka: after his retrospective at the Künstlerhaus in Vienna in 1958, I had a conversation with him that lasted twenty minutes or so. That was in the Anton Romako room of the Österreichische Galerie, where tables had been laid for the reception after the private view. I knew that as a young man Kokoschka had been to Dr Oskar Reichel's house, where he had seen Reichel's big Romako collection and had been deeply impressed by the works of that great and, alas, still internationally underrated artist. There is much that is central to Kokoschka's early work, whether the portraits or the flayed sheep with its sensitively rendered tex-tures, that is inexplicable without the influence of Romako (Figs. 1, 2). So I asked OK how he liked the Romakos.

The answer came straight back: 'Very much. You are too young to know that in my young days there was a very rich doctor in Vienna whose name was Dr Reichel. He had so much money that he didn't know what to do with it. I advised him to collect Romakos, and so he did. I have always had a high opinion of Romako, and I have secured international recognition for him – and for Maulpertsch too.'

The truth of the matter is that the Viennese collector in question, Dr Reichel, had bought most of his Romakos by 1903, and that Kokoschka did not visit his house until 1909/10. It is also the case that Romako, as I have said, has yet to receive international recognition; on the other hand, the greatness of Franz Anton Maulpertsch was recognized by German art histori-ans as early as the turn of the century.

In the evolution of modern European art, every single year of the first two decades of the century was a significant one. OK knew that perfectly well, and so did Ernst Ludwig Kirchner. That is why both antedated a number of their important early works, often by several years. But whereas Kirchner often painted the false dates straight onto the canvas, Kokoschka was much more cunning: he simply dropped hints to everyone on the art scene who mattered to him. As a specific instance: I asked OK when he painted his still-life with the flayed sheep. He answered that he could not remember exactly, it must have been 1907 or perhaps 1906. According to the latest research, the painting was not done until the early part of 1910. That is what I thought all along, although it was not the 'official' view. I find the painting as enthralling as I ever did, despite the (now official) redating. I really don't think that great artists like OK or Kirchner had any need to falsify the dating of their early works.

OK always took an interest in the whereabouts of his most important works. And so he found out that *Landscape in the Dolomites (with the Cima Tre Croc) (Dolomitenlandschaft [mit der Cima Tre Croci]*; Cat. 117) had come into the possession of a

Fig. 1 Anton Romaka, *Isabella Reisser*, 1885, detail; oil on canvas

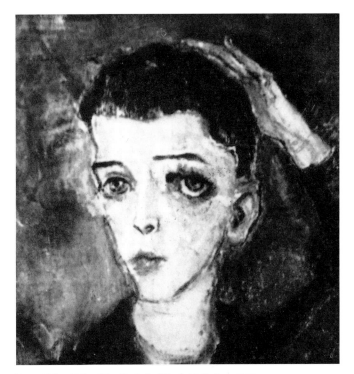

Fig. 2 Oskar Kokoschka, *Portrait of Dr Reichel's Son*, 1910; oil on canvas

person who had spent his life collecting Schiele. This was myself. At the same time his old friend Willi Hahn told him that this same collector had already bought other works by him, and that he was a truly unconventional person with whom he, OK, would get on famously. Willi Hahn told me that OK said at once: 'Let him come and see me. I invite him.' Unfortunately, this meeting at Villeneuve never took place.

S: *Schiele is the central figure as far as you are concerned. How did you come to know of him? How did this marriage of minds and eyes take place? How was your Schiele collection built up?*

L: Schiele certainly is the central figure in my collection. I have already told you about my visit to the Kunsthistorisches Museum in Vienna in 1948, and what it meant to me. Until 1950 I concentrated on Old Masters. The twentieth-century section of the Österreichische Galerie had not opened – and it did not open, if I remember rightly, until 1955 – so I had no way of seeing any Schiele, or Klimt or Gerstl. Then, at a book auction in 1950, a copy of Nirenstein's extremely rare catalogue raisonné of Schiele came up: it is rare because very few copies were printed. I bought it. What fascinated me about the book was not the text but Schiele's paintings, in good collotype reproductions by Max Jaffé. I found myself looking at compositions that bore comparison with the best of the Old Masters, and yet the content was entirely contemporary. It did not take me long to decide that this was the artist I must collect. I soon found out that it was no easy matter. Many of his important works had been taken abroad by émigrés. As for the process by which I built up what is now the largest collection of Schiele's work: it would take hours to tell you.

S: *And what about Klimt?*

L: Very soon after I started to collect Schiele, I started to collect Klimt drawings too. I was not in a position to buy paintings until later.

S: *And Gerstl?*

L: There I had a stroke of good fortune. In 1953 or 1954 I was telephoned by a man called Alois Gerstl, who introduced himself as the painter's brother. He asked me to give an opinion on the authenticity of a Schiele painting he had. In the few years I had been collecting Schiele, I had acquired something of a reputation as an expert. The putative Schiele painting was not at all easy to judge. I soon worked out, however, that it had been begun by Schiele and 'finished' by someone else. What interested me much more were the works by Gerstl that his brother showed me on the same occasion. It was the very first time I had set eyes on any of this artist's work!

In spite of the size of my Schiele collection, no one of consequence has ever been able to accuse me of one-sidedness or bias. Even though the Gerstl pictures were painted in a style – I would call it 'painterly painting' – which was totally new to me, I was instantly spellbound. The longer I looked, the more fascinated I became. I have always collected whatever fascinates me – unless it is beyond my means, as Van Gogh is, for instance. Paintings by Gerstl have always been very hard to find because he produced so little, and there were none on the art market in those days. His brother had very few left, and initially he was reluctant to sell.

Not long afterwards, I paid him a second visit and took another look at the pictures. On the portrait of Alois Gerstl in

uniform, the bare canvas border did not extend all round the edge; instead, on the left, there was a strip of painting that continued onto the side of the stretcher and was nailed down there. I asked Gerstl about this, and he made some evasive answer to the effect that it was due to carelessness; rather than add a strip, he said, this part of the painting had been sacrificed. I made it clear that I found this hard to believe, and that I thought the painting must once have been much larger.

'If you think that', said Gerstl, 'then tell me how wide you think the missing piece might be.' I showed him with my hands, about 60 centimetres.

He gave me a sly look and said: 'If you're psychic, maybe you can tell me what the colours were.'

'I would suppose that the dominant colour must have been a light, broken green.'

There was a long silence. Alois Gerstl just stood there open-mouthed. Then he said: 'Everything you say is right. I would never have thought that anyone could have guessed it. None of the many people I have shown the painting to – collectors and art historians – has ever noticed it. Not even the man from the Österreichische Galerie who is writing a book about my brother. I have never told anyone the truth until this moment. Now I'll tell you, because you worked it out for yourself.

'In the early 1903s I let a man called Nirenstein – he later changed his name to Kallir – persuade me to cut the painting in two. Nirenstein was an art historian, and he was well known as an art dealer in Vienna in those days. He owned the Neue Galerie before he emigrated to America. He told me then that he thought it would be better to separate the figure of myself, on the right-hand side, from the left-hand half with the desk and the chair. He said that ever since Van Gogh a chair had been a perfectly acceptable subject for a painting, and if we cut the painting in two that would give us an extra painting by my brother! But to make both parts self-sufficient, he thought it necessary to cut both pieces down slightly, taking a bigger strip from one and a smaller strip from the other.

'I thought, this man is an art historian, and he must know more about art than I do. So I agreed to all he suggested. The painting was cut in two, and the two strips were thrown away. It was not until later that I started to have second thoughts. I was ashamed of having given in. And that is why I have never told anybody.'

I was horrified by Gerstl's story, and I told him so. For one thing, I said, no one had the right to cut up paintings after the artist's death – when he could have no say in the matter – just to suit themselves, and then cut strips off and throw them away! And furthermore, I told him, Kallir's historical analogy with Van Gogh was total nonsense. Van Gogh's chair is treated as if it were a living thing; Gerstl's chair and desk were there simply as vehicles for colour and light, and both their colour and chiaroscuro depended on the presence of the figure beside them. That was how I had been able to tell him approximately what the missing piece of the painting must have looked like. No one else could have done it; many artists have confirmed that I have a painter's eye.

S: *Your collection presents an almost complete picture of Austrian art, including the applied arts, from 1880 to the 1940s. Was this panoramic view intended from the start? Or did you not aim for completeness until later? If so, how did this come about?*

L: It was certainly not planned as such from the start. It gradually evolved that way through the artists who fascinated me. And then, for each artist, I did make an effort to have each important phase of his work adequately represented in my collection. But I have never aimed at completeness in the stamp-collecting sense.

S: *Your collection tends to pursue parallels: your Black African sculpture, for instance, complements the works of classic Modernism since Picasso. But the collection does not extend to the present day. Oswald Oberhuber is the only contemporary artist in your collection. Why this artist in particular?*

L: It is simply not true that Oberhuber is the only living artist in my collection. I have some early paintings and sculptures by him, but I also have works by many other contemporary artists: Arnulf Rainer, for instance.

But let me go back to parallels and Black sculpture. I was collecting works from Black Africa and the Sepik River area of New Guinea before I ever knew that Picasso and other French artists, along with the German Expressionists, had taken an interest in them. Schiele owned some art of this kind too. Between the works of primitive peoples and those of the Expressionists there is a fundamental affinity, and I sensed this. So I have bought many fine works by these nameless artists. They are quite equal to the best products of European art.

The fact that these sculptures by primitive peoples form a 'complement', as you put it, to classic Modernism, although not to contemporary art, has no relevance to my collection. The overwhelming mass of what is being produced in the Western world in this 'present day' of yours has nothing to do with art in any real sense at all. It is speculatively made and shrewdly managed. The only art that has ever lasted is the art that springs from true inspiration.

S: *Do you have a card-index or a notebook, or have you got your collection in your head?*

L: Most of it I have in my head. I have only made lists for those artists whose works are always being requested for exhibitions.

S: *Can you give an exact, or at least approximate, tally of your holdings? Artists' names? Paintings? Works on paper? Wiener Werkstätte, Africa, New Guinea, other categories?*

L: I could give you an answer, but I beg you not to insist on it. It really would take too long.

S: *In your farmhouse at Grinzing you keep the majority of your pictures in stacks – although Schiele and Klimt are hung on the walls. Is there any order? What about conservation and restoration, climatic influences? Aren't you afraid that serious damage is inevitable?*

L: Let me answer your last question right away. Precisely the opposite is the case. Our sixteenth-century vinegrower's house at Grinzing has such thick walls that there are no wide variations of temperature or humidity. The only place where there might be a danger is in the centrally heated rooms, and there I have had an automatic system installed to control temperature and humidity. You say that only Klimt and Schiele are hung on the walls; you are overlooking the many other artists whose paintings are also hung, including Gerstl, Kolig, Boeckl, Faistauer and Kolo Moser. It is true that a large number of paintings are stacked. But they are arranged in a very precise order.

As for your question about conservation: the majority of my paintings, as all the specialists have told me, are in a better state of preservation than is usually the case in museums.

S: *As a picture restorer, you are something of a nature-healer, aren't you? Would you let us into some of your secret remedies?*

L: My practice as a restorer has nothing to do with nature-healing. I have had the opportunity of watching many restorers at work, and of helping them, and that is how I have learned the trade. I started restoring a few years after I embarked on my collection. And that was because most restorers – I would rather not discuss my fellow art historians in this context – do not have the same feeling for colour that I have. Their retouching, for example, often simply fails to match.

If you are asking for recipes, all I would like to say is that I have developed a method of my own for creating exactly matching textures to fill gaps, which are then covered by resinous varnishes.

S: *You do, however, send out many pictures to restorers. Has this always been successful, or are you still looking for the ideal restorer?*

L: Pictures in my collection are restored only when it is necessary. Often just a minor operation can be vital for the survival of the picture.

There are 'technical' restorers, and there are 'artistic' restorers. I have met a great many restorers in my career as a collector, but never one who had attained the highest standard in both types of restoration. For this reason, in my experience, there is no such person as the ideal restorer. For the technical side I have found one whom I believe to be the best in Austria. And as I am virtually a qualified restorer myself, what is called the 'artistic' side of the restoration work is mostly done by me. I only regret that my many activities leave me so little time to do it. Restoration is something I enjoy enormously.

S: *When standing in front of pictures and discussing them, you always stress their painterly qualities, less often the content. I studied under Hans Hahnloser, who came from the Vienna School of Julius von Schlosser, Alois Riegl and Fritz Novotny, and he insisted on the same approach, a descriptive rather than interpretative way of seeing. Is this something you have developed for yourself, or do you see yourself as standing in a tradition, let us say the tradition of Novotny and John Rewald?*

L: It depends on the person with whom I am discussing pictures. Artists may be biased – as I said earlier – but I still prefer discussing painting with them. They are the quickest to grasp the pictorial qualities, without many words being necessary. On the other hand, in conversations with art historians and art critics I do place a special emphasis on painterly values, because I am afraid I have found that they often fail to appreciate these values properly and try to fill the gap with what you call 'interpretative seeing'. But if you read my Schiele book, for instance, you will see that I myself do quite a bit of interpreting, wherever I consider it necessary. Although I did study with Novotny, I do not see myself as belonging to that tradition. You are asking about something I have developed for myself.

I embarked on interpretation very early on, when I started to collect Schiele. You know, no doubt, that the art critic Arthur Roessler knew Schiele well and owned some of his paintings and drawings. I visited Roessler for the first time in 1950. He had an early work by Schiele that he wanted to sell, and while I was there he showed me his other Schiele pictures. The old gentleman's manner made it fairly plain that he thought it well-nigh presumptuous for a young man, as I was at the time, to want to buy a painting by Schiele at all. In his view, at twenty-five I was too young for any such thing. He pointed to one of his Schiele paintings and said to me, in a severe, schoolmasterly tone: 'What have you to say about this sunset?'

I hesitated for a moment; I realized that a great deal depended on my answer to that question. Thirty-eight years have passed, but I can very clearly remember what I said: 'You call the painting just a "sunset", but that reveals nothing of whether the mood is cheerful or melancholy. Looking at this painting one ought to say, with all due solemnity: "The sun is sinking." The foreground is cold and dark already, and every leaf is stiff with cold. Looking into such a deeply melancholy sky, I feel like asking whether this departing sun will ever rise again.'

That broke the ice, and Roessler was very kind to me after that. He even let himself be persuaded to sell me, in place of the early work, the watercolour *The Dead Town (Die tote Stadt)* of 1910. It was the first work by Schiele that I ever owned.

It was not until seven years later that I bought from Roessler the painting of the sinking sun. When I got it home, unpacked it and looked on the back, I saw that Schiele himself had written on the stretcher, in his tall Gothic handwriting, *Sinking Sun (Versinkende Sonne;* Cat. 32).

S: *The work of the latest generation of artists in Austria deserves to be taken very seriously: Siegfried Anzinger, Herbert Brandt, Sepp Danner, Franz West, Otto Zitko. We foreigners tend to see them as 'different', because their artistic antecedents lie in Austria: in Gerstl and in Schoenberg. How does it come about that, instead of collecting young artists at affordable prices, you are running up debts to buy more Schieles?*

L: I have already told you that I do collect young artists. I only wish I found them as fascinating as I do certain works by Schiele. If that were so, I should not be bleeding myself white to buy him.

S: *Rather belatedly, people abroad are paying attention to the highly individual painting and performance art of* Wiener Aktionismus, *and this is now regarded as a powerful contribution in its own right to post-war European art. Why are there no works by Günther Brus, Otto Mühl or Hermann Nitsch in your collection? And why none by Rainer?*

L: I have already said that I do have works by Arnulf Rainer in my collection. Only the early works, however. In spite of all the skilful propaganda to the contrary, it will eventually be recognized that it is only the early works that have any importance. The praise accorded his *Death Masks (Totenmasken)* makes no sense. What is interesting about them has nothing to do with Rainer. Rigor mortis often gives faces an expressive look, and in the right lighting this effect can be intensified. That is just what Rainer's photographer has managed to do. And what Rainer has added does nothing, in most cases, to intensify the expressive quality of the mask. On the contrary, it weakens it.

S: *You have in your collection practically all the works that reveal Schiele as an expressive painter. Have you left it to others to collect the ones in which drawing predominates?*

L: It is true that almost all the important expressive paintings by Schiele have found their way into my collection. Fortunately, the earlier directors of the Österreichische Galerie failed to recognize their importance, and so what they collected was only what most Schiele collectors between the wars were trying to buy: his late, mostly rather mannered, paintings. However, it is certainly not true that I have left the less painterly works for others to collect. Where they are great works of art – like the *Seated Male Nude (Sitzender männlicher Akt*; Cat. 6) of 1910, in which drawing is certainly dominant – I have bought them for my collection, just as I have bought many drawings.

S: *I have the impression that, all the way from looking at pictures to conserving them, you are an obsessive collector. Do you feel isolated in your obsession? Or are you now not without honour, as a prophet in your own land?*

L: I would consider the word 'passion' very much more appropriate, as far as I am concerned. There is certainly nothing 'obsessive' about the very careful way in which I approach paintings.

As for your question about my being honoured as a prophet in my own land: yes, I am honoured, but not nearly so much as I am envied. Most of our politicians simply pay lip-service to culture: as far as they are concerned, it is only good for prestige or for publicity. Art in Austria needs a Mitterand.

Harald Szeemann

Art in a City of 'Total Art'

It is often surprising how long it takes for a particular epoch of intense cultural activity to be rediscovered and to enrich the general cultural understanding. The title of this book names the protagonist but not the place: it was turn-of-the-century Vienna. With the collapse of the Habsburg Empire, and the fairly inglorious history of Austria up to the treaty which re-established its autonomous statehood after the Second World War, this fantastic blossoming of art – a cultural nexus just as intense and vital as the one that manifested itself in Paris in the 1900s – was forgotten for a time, in Austria itself as well as elsewhere. This is no longer the case.

In 1983 an exhibition was shown in Zurich, Düsseldorf, Vienna and Berlin under the title of 'Der Hang zum Gesamtkunstwerk' (The Tendency Towards the Total Work of Art). The catalogue – if not the exhibition – suggested that the city of Vienna was a total work of art in itself, an artistic synthesis: *Gesamtkunstwerk Wien*.

In a catalogue article with this title, Werner Hofmann describes how the endeavour to bind all the arts together in a synthesis proceeded concurrently with the radical process whereby those same arts achieved autonomy and self-definition. Hans Makart and his festive procession of 1879, Gustav Klimt's ceiling painting for the Burgtheater in 1888, his designs for the ceiling paintings in the hall of the new university building, his *Beethoven Frieze* (*Beethovenfries*) of 1902, and all the work of the Wiener Werkstätte (Vienna Workshop), stood for synthesis (the *Gesamtkunstwerk*) and for splendour (*der schöne Schein*). The adversaries of this same synthesis – people like Adolf Loos, Karl Kraus, Oskar Kokoschka and Arnold Schoenberg – stood, equally uncompromisingly, for catharsis and rethinking, for 'Truth' and 'death-dealing Eros'. Hofmann finds a visual expression of both opposing principles in Klimt's *The Embrace* (*Die Umarmung*); they culminate in a literary vision of the end of the world as *Gesamtkunstwerk*, as created by Karl Kraus in his drama *Die letzten Tage der Menschheit* (The Last Days of Mankind).

In another text in the same catalogue, Jean Clair evokes one admirer of the Viennese Ringstrasse, with its medley of historicist architectural styles, who set up a *Gesamtkunstwerk* of sorts for himself, in the shape of a totalitarian state: that devotee of Richard Wagner and his *Ring*, Adolf Hitler.

Vienna as *Gesamtkunstwerk* has been brought to life in a number of grandiose exhibitions with a bias towards cultural history: in Vienna in 1985 there was 'Traum und Wirklichkeit: Wien 1870-1930' (Dream and Reality: Vienna 1870-1930); in Paris in 1986 there was 'L'Apocalypse joyeuse: Vienne 1870-1938' (The Joyous Apocalypse: Vienna 1870-1938); in New York in 1987 there was 'Vienna 1900'. These exhibitions gave magnificent visual expression to many of the components and parameters of that Viennese synthesis: Makart's procession; the early work of Klimt; the 1873 World's Fair; the triumph of operetta (Johann Strauss); the architecture of Otto Wagner; Gustav Mahler as conductor and as composer; the development of the Social Democratic labour movement under Victor Adler; Ernst Mach and his 'emotional ego'; Sigmund Freud's *The Interpretation of Dreams* of 1900; Otto Weininger's *Geschlecht und Charakter* (Sex and Character); Hugo von Hofmannsthal, Arnold Schoenberg, Peter Altenberg, the Wiener Werkstätte, Josef Hoffmann, Kolo Moser, Adolf Loos, the Secession, Gustav Klimt, Oskar Kokoschka, Egon Schiele, Robert Musil, Karl Kraus, Ludwig von Wittgenstein, 'Red Vienna', Max Reinhardt, the new opera, film.

This magnificent cultural background, and the nature of the city, whose growth into a metropolis in the second half of the nineteenth century had been accompanied by vast changes in its urban structure and by the increasing display of material and cultural power, has inevitably meant that one of the contrasting artistic strains – that which aspired towards the autonomy of the arts – has tended to be eclipsed. This strain represents the rejection of 'splendour' in favour of 'truth': the representation of the truths of life, not of aestheticism. Its consequence was a shift in Austrian art towards 'painterly' form. This transmutation of existential and artistic tensions into the fundamentals of pictorial thinking and action, within the complex setting of a multinational empire on the point of collapse, forms the subject of the present book.

The artistic flowering outlined above coincided with the last years of the Austro-Hungarian monarchy, a period that has been described as a cultural revolution, but also as a 'joyous apocalypse' (Hermann Broch) and as a 'trial run for the end of the world' (Karl Kraus). Those who lived their active and creative lives within this vast field of nervous tension included not only those named above but also the representatives of Austrian Symbolism, Pointillism and Expressionism: Leopold Blauensteiner, Herbert Boeckl, Hans Böhler, Arnold Clementschitsch, Josef

Dobrowsky, Albin Egger-Lienz, Anton Faistauer, Gerhart Frankl, Richard Gerstl, Albert Paris Gütersloh, Anton Kolig, Carl Moll, Alfons Walde, Franz Wiegele and the others whose works are shown here.

This array of names makes it all the more surprising that the critical response to Austrian art did not really begin until the 1950s; with architecture and the applied arts it started even later. One exception was Oskar Kokoschka, whose work with *Der Sturm* in Berlin, and whose emigration and exile, caused him to be regarded from an early stage as an international rather than an Austrian artist. He is represented here by two major works that have seldom been on public view: *Landscape in the Dolomites (with the Cima Tre Croci) (Dolomitenlandschaft [mit der Cima Tre Croci];* Cat. 117) of 1913 and the disturbing *Self-Portrait, Hand Touching Face (Selbstbildnis, die Hand ans Gesicht gelegt;* Cat. 120) of 1918.

The focal point of the works selected for exhibition here is, however, the work of an artist whose genius reached its full flowering in a career cut short at the age of twenty-eight: Egon Schiele. His burning, total subjectivity marks the cleanest break of all with the aestheticism of the past. It is the source of an art of expression specific to Vienna and clearly distinct from the Expressionist tendencies of the same period in Germany *(Die Brücke),* in France (the Fauves) and in Switzerland (Cuno Amiet). Its source lay in the demand 'to be oneself, unconditionally and with total immediacy'. The present selection of fifty-two paintings and works on paper is a retrospective *in nuce:* it covers an evolution that spanned thirteen years. It shows the artist already absorbed with self-portraiture at the age of sixteen; breaking free from the aesthetic of the Secessionists, and of Gustav Klimt above all; and turning to a quest for expressive pictorial truth in the representation of human beings, nature and urban landscapes.

These images bear the imprint of Klimt's sensitive and sensuous line, of Ferdinand Hodler's Symbolism, of George Minne's elongated figures, of Henri de Toulouse-Lautrec's repertoire of themes; but all these are consumed in the blaze of Schiele's magnificent evocation of a bodily awareness haunted by Eros, sex and death, and yet lucidly structured and formed. This is done through an uncompromising use of line and colour which, as it were, captures the instant of greatest tension, urgency, tragedy, beauty and ugliness. The tension does not simply turn inward and smoulder: it always projects itself provocatively – even exhibitionistically – forward, enlisting the viewer's participation as a witness to the artist's self-distortion, to his vision, and to the expressive force of the body as gesture and/or metaphor.

By comparison with Schiele, the groups of works by other turn-of-the-century Viennese artists are relatively modest in numerical terms, as if preparing the way for his genius or providing it with an escort. Klimt is represented here by three paintings. Significantly, these are not his well-known, over-sophisticated syntheses of bodies and ornamental forms but more painterly works: the *Still Pond in Schloss Kammer Grounds (Stiller Weiher im Schlosspark von Kammer, c.* 1899; Cat. 99), a landscape which belongs in the context of Impressionism and Giovanni Segantini's Divisionism; a climactic achievement, *The Large Poplar (Die grosse Pappel,* 1903; Cat. 101); and the Symbolist *Death and Life (Tod und Leben,* before 1911, reworked in 1915; Cat. 109).

The works of Richard Gerstl, who tragically committed suicide in 1908 at the age of twenty-five, will come as a surprise. His contribution to early Expressionism in Austria is still relatively little known. The confessional nature of his painting, his intense concentration on a sitter or a landscape that is seen – in contrast to Schiele – within a spatial context, shows a violent reaction against Symbolism and Pointillism and the adoption of a light-filled, colourful style of brushwork reflecting a vehement, painterly form of psychic automatism.

One more work that deserves particular mention is the disturbing *Finale* (1918; Cat. 70) by Albin Egger-Lienz. This apocalyptic vision was painted at the end of the First World War, in the year in which both Klimt and Schiele died.

These are the high-points of the selection – from which the work of Alfred Kubin has been excluded on grounds of style as well as of content. It is a selection that concentrates on the essentials of painting and drawing. It bears the mark of a collector whose realization of the individuality and strength of Austrian art dates back to the 1940s, and who has made it his consistent endeavour to collect that art: Rudolf Leopold, an ophthalmologist by profession, a man obsessed, an obsessional collector. Switzerland owes him its first survey of Schiele's art, through an exhibition which reached the Kunsthalle, Berne, in 1957 by way of the Stedelijk Museum in Amsterdam; the art world in general owes him the first comprehensive, indispensable monograph and catalogue raisonné devoted to Schiele's work (1972). Our wish for him is that his own life's work may one day become the Leopold Museum of Austrian Art.

Klaus Albrecht Schröder

Not Blind to the World

Notes on Gustav Klimt and Egon Schiele

Boundaries

Anyone setting out to construct a strictly chronological genealogy of Modernism in Vienna would very soon lose his historical bearings. In Western Europe Modernism extended over several decades and fitted perfectly into the accepted pattern of artistic evolution; but in turn-of-the-century Vienna it compressed itself into a brief moment of time, crystallizing most distinctly in 1908. This was the year of an artistic apotheosis (that of Gustav Klimt and his circle of 'Stylists', consecrated by Austria's greatest ever 'Kunstschau' [art show]); of a swansong (the historical costume procession around the Ringstrasse to mark the Emperor's diamond jubilee); of a scandal (Oskar Kokoschka's exhibition debut); and of a decisive break with the past (Egon Schiele's departure from the Academy). If we also recall that 1908 was the year in which Richard Gerstl, the most radical painter of the 1900s, committed suicide, it becomes apparent that it was a historical turning-point, marked by a cluster of symbolic encounters between past, present and future.

The Secessionists wanted to do away with the boundaries between art and life, but they simultaneously erected a new barrier of their own: with the best of intentions, they managed to confuse one part of life with the whole. This was the misconception that Adolf Loos and Karl Kraus demolished, systematically and with relish. The Wiener Werkstätte (Vienna Workshop), and the Secession itself, were reliant on a clearly defined segment of society. Equally, all their products and artifacts were aesthetic exercises; according to Werner Hofmann, they possessed 'a mediating and embellishing function'[1] but had no function at all in relation to life as a whole, or to everyday reality. Hofmann takes it upon himself to cast the same accusation at Klimt, thereby adopting materialistic ideology as a yardstick of artistic sincerity. Klimt's 'aesthetic exercises', and those of Josef Hoffmann, are of the second degree: they operate on the level of culture.

Even so, this does not invalidate Hofmann's remark that the art of Klimt, and that of all the 'Stylists', is that of a sharply defined and well-demarcated class: the bourgeoisie. It is undeniably true that the devorative procedures of Viennese *Jugendstil* were inseparable from the social evolution of the metropolitan bourgeoisie in the Austro-Hungarian monarchy: when that class became obsolete, so did they. By emancipating themselves from

social realities, Klimt's rarefied early landscapes (Cat. 99, 101) make their own statement about the unedifying nature of those same realities. These are works with their own clearly defined place in history – and criticisms of them for being ahistorical, or for being 'art for art's sake', miss the point.

Austrian art of the first half of this century clung so determinedly to objective reality that it was very soon accused of being retrograde. Western European Modernism in general, which saw itself as a process by which art advanced towards autonomy, defined this autonomy, one-dimensionally, as liberation from the remnants of material reality. However, it takes a considerable effort to define Anton Faistauer's still-lifes as 'illustrations' on the theme of coffee-cups and fruit (Cat. 75); and the painting of Hans Böhler (Cat. 62-64) or of Anton Kolig (Cat. 123, 124, 128) can no more be understood from the point of view of realism than Gerhart Frankl's views of Döbling are to be classified as topographical documents.

The idea of aesthetic autonomy, deduced from the emancipation of the formal language from the objects it represents, lies behind even the most precise of Alfons Walde's views of Kitzbühel. The same goes for *Alpine Pastures in the Ötz Valley* (*Almlandschaft im Ötztal*; Cat. 69) by Albin Egger-Lienz, an artist who has been unjustly dismissed as a 'peasant painter'. Egger-Lienz's allegory *The Spring* (*Die Quelle*; Cat. 72) is an image of a boy drinking; but it is also painting – closer to the Fauves, whom Egger-Lienz mocked, than to Franz von Defregger, whom he admired. Austrian art belongs within the international Modern Movement; but this does not mean that it would be right to dismiss its representational subjects as scattered remnants of literalism, alien to the true content of the art itself.

The specific path pursued by Austrian Modernism – the art of the 'Stylists', led by Klimt, and their rebellious successors, the Expressionists – is bound to elude anyone who perceives it in purely aesthetic terms, in the absence of content. In these works, what would once have been called, reassuringly, 'the motif' is certainly not the be-all and end-all; but it is far from irrelevant.

Faistauer, Böhler, Frankl, all – to adopt an aphorism of Schoenberg's – set out to paint a picture, not the object shown in that picture. The dialectic between the picture as such and its subject became the central theme of the Austrian response to Cézanne. Colour textures and the organization of the relation-

ship between colour, painting and picture plane amount to *peinture pure*, and belie the idea that the painter's intention was purely mimetic. Quite often — as with Egger-Lienz and Faistauer — the pronouncements of the conservatives, the bitterest opponents of 'art for art's sake', are the biggest obstacles to the understanding of their own art.

Dialogue

> Portraiture, like biography, has an interest all its own. An important individual, one whom we cannot imagine in isolation from his surroundings, comes forward alone and stands before us as if before a mirror; we are expected to give him our close attention; we are to concentrate on him, just as he concentrates on himself, standing appreciatively in front of the mirror … the accomplished courtier stands before us as if he were paying court to us; we do not think of the high society he has trained himself to please.[2]

The ideal of a dialogue between sitter and viewer, of which Goethe speaks here in *Wilhelm Meister* — what turn does it take in the work of Schiele (Fig. 1)? What kind of world is it that confronts Schiele's truculent, reticent, forbidding, withdrawn, resigned, aggressive, doubting, despairing gaze? Who is it who faces that eloquent eye?

It would be an over-simplification to say that the Expressionist self-portraits of Schiele, Kokoschka (Cat. 120) and Gerstl (Cat. 87) uncompromisingly speak to us of the person portrayed. There is a second layer of meaning, which is captured in the look in the subject's eyes. There is more to a self-portrait than the manner in which the artist takes himself as a theme: what the artist's eye sees is not only himself but the other, the viewer. The dialogue which springs from the way he looks at himself and at us is something more than an inner monologue.

The look that meets the viewer's eye is always something more than the mere artistic motif of the sitter's eye, which is its source. Its interest, above all in the self-portrait, has always resided in its capacity to convey the soul: what the age of Sigmund Freud called the psyche.[3] Lodovico Dolce, in his *Dialogo della pittura*, published in 1557, lays particular stress on the strong psychological element involved: 'But it is the eyes above all that are known as the windows of the soul, and in them the painter can accordingly express every passion: mirth, pain, anger, fear, hope and yearning.'[4]

Schiele's self-portraits, whether grimacing or resigned, all of course communicate a psychic content (Cat. 10). But they additionally mark a turning-point in the history of the relationship between the self and the viewer. In a portrait, the look in the sitter's eyes establishes an almost conspiratorial relationship between the world inside the picture and the viewer outside it; but if that look is a grimace, it completely disrupts the utopian feeling of achieved communication that goes with eye-contact. The viewer is repelled, and the implication of closeness is negated. The attraction implicit in the way the viewer's eye is caught, and the grimace, which is a mime of rejection, are mutually dependent. The often described phenomenon of denial of communication — as demonstrated by those numerous models

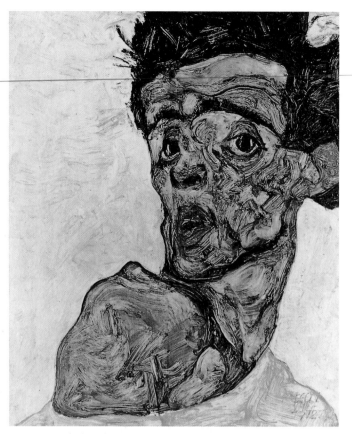

Fig. 1 Egon Schiele, *Self-Portrait with Raised Shoulder*, 1912; oil on canvas. Leopold Collection, Vienna

who turn away from the viewer, thus refusing access to the private world behind the physical façade — is carried one stage further in these works, which seek contact with the viewer, only to deny it.

This not only applies to a particular group of works by Schiele but typifies the self-depictions of a whole age. Even the function of the direct stare in Gerstl's early *Self-Portrait, Semi-nude, against Blue Background* (*Selbstdarstellung als Halbakt vor blauem Hintergrund*; Cat. 80) turns out to be more complicated than the straightforward encounter between figure and viewer which the work ostensibly presents. All that unites in formal terms divides in psychological terms. Gerstl's direct gaze, into the mirror and out at the viewer, promises communication and concord; the rhetoric of the austerely frontal pose — an expression of awesome remoteness — negates this intimacy entirely. The gaze is enveloped in an unreal aura that completely subverts our everyday experience of the semantics of eye-contact. Purely contemplative, the image of the painter annuls the dialogue implicit in the way he looks the viewer straight in the eye.

The Hagiography of the *Artiste Maudit*

Schiele adopts the genre of the self-portrait, but he mostly dispenses with the commonest form of self-portraiture, the full-length type in which the artist is seen standing in front of his canvas or seated in a landscape, alone in his studio or accom-

panied by a model. No one modelled for Schiele as often as he did himself. One wonders what it was about looking in a mirror that preoccupied him.

A major source of information on the place of the individual in the society of his time lies in the self-depictions that are found in its art and literature. The form of self-depiction that prevails in a society is governed more by the relationship between the individual and that society than by any factor intrinsic to the development of the art-form concerned.[5] In Modernism – which we can date from the rise of bourgeois society – techniques of self-observation and self-control are constantly developing. The relationship between a growing intensity of social control and a progressive refinement of techniques of self-revelation – between the socializing process and the observation of the self – supplies the historical context in which artistic forms of self-examination emerge and proliferate.

Indispensable to any consideration of the self-portrait from the point of view of the sociology of art is the work of George Herbert Mead on the genesis of the social self. He was the first to give a compelling account of the process of the emergence of the self, and the link between this and the individual's ability to see himself through the eyes of others, the members of the society that surrounds him.[6]

The question, once again, is this: what and whom does Schiele see in the mirror? Certainly not just his own body. Clearly, he is looking for poses, and for habitual distortions; he is alienating himself from himself. There is a world of difference between Schiele looking at his own body, seeking a direct experience of his own identity, and Schiele imaginatively taking on the viewpoint of other people, experiencing his own ego as that of someone else.

In 1912 Schiele painted *Hermits* (*Eremiten*; Cat. 25), in which he depicts himself together with Klimt. Rudolf Leopold suggests that he is paraphrasing Klimt's cloak as a black monastic habit. The implied relationship with Klimt is one of extreme tension: Schiele is here working in a manner diametrically opposed to Klimt's. So there is something surprising about the psychic unanimity between the two figures, who combine to form a single wall of grief. In a letter to the collector Carl Reininghaus, Schiele defended the unconventional, unstructured, and anatomically puzzling stance of the two figures:

> You are quite right, I admit, at first sight. There is no telling, initially, how the two of them are standing …. The indeterminate quality of the figures, who are visualized as hunched and bent …. the bodies of men weary of living – suicides – but men of feeling. See the two figures as something like a dust-cloud, resembling this earth, trying to constitute itself and yet powerless to avoid collapse. In a painting that is not intended to have this particular significance, one naturally expects the attitudes of the figures to be stressed; but that is not what is meant here.[7]

Rudolf Leopold has pointed to a difference between the attitudes of the two hermits that is important in the context of Schiele's artistic opposition to Klimt: both have 'the bodies of … suicides', and both bear the indelible scars of life; but one of them is still inwardly fighting against death. Although Schiele's cheeks have

fallen in, and his furrowed brow is crowned with withered thistles, his 'eyes wide open in pain' and his 'full, sensual lips' convey a life which the other hermit lacks. Klimt has his 'eyelids closed, and a garland of autumn fruits on his brow – as if he had already garnered his harvest'.[8]

The repertoire of masks that Schiele dons, as he successively assumes the mantle of a 'hermit' and a 'prophet', points to a metaphorical dialogue with himself: this precludes any simplistic interpretation of his self-portraits as mere products of his life, and suggests that a more plausible interpretation would be one based on social expectations and role-playing. Even within the genre of portraiture – restricted here to the special case of the self-portrait – there is no point in any blanket reference to 'art as expression', without asking what it is that is expressed.

Furthermore – to remain with 'art as expression' for a moment – parallel to the question of what is communicated there is the question of what possibilities of communication are available: the modes and limits of the expressible and the communicable. What forms of representation, what role-models, were available to the early twentieth-century artist? To what extent does the institutional context known as Art govern what may be felt, shown or confessed? 'It makes a difference whether life is shown from a religious, a legal, a medical and therapeutic, a vocational, a private, a scientific or an aesthetic point of view.'[9]

The tradition of self-portraiture presented Gerstl, Schiele and Kokoschka with a set of reflections on the self against which they could react, but which they could not simply bypass and ignore. Schiele was certainly well aware of Klimt's aversion to self-portraiture. Not only are there no self-portraits by Klimt, he even went to the trouble of providing a written explanation – the man who used words so sparingly, and who loathed pronouncing on artistic questions as much as he loathed writing letters. The reason, according to him, was his lack of narcissism:

> No self-portraits by me exist. I am not interested in myself as the 'subject of a picture'; what interests me is other people, females in particular, and, above all, other phenomena. I am convinced that as a person I am not particularly interesting. I am nothing special to look at …. The world will have to do without my artistic or literary self-portrait. Which is not a matter for regret. Anyone who wants to know about me – as an artist, which is the only interesting aspect – will have to take a close look at my pictures and try to work out from them what I am and what I want.[10]

In the era of the photograph, Klimt was in a position to dispense with any painted rendering of his appearance for posterity's benefit. The generation that followed him – the Schieles, Gerstls, Kokoschkas – were no more interested in the naive form of the self-portrait than he was. However, they had no intention of abandoning the form of self-depiction that had been known since Romanticism as *problematische Selbstdeutung*: the enigmatic or challenging interpretation of the self (Fig. 2).

Werner Hofmann has summed up the new expressive vocabulary available to the Viennese Modernists – from Gerstl by way of Kokoschka and Schiele to Herbert Boeckl – in one vivid phrase: 'fleshly awareness'.[11] This is an image of the determination 'to break out of the gilded cage of ornamental

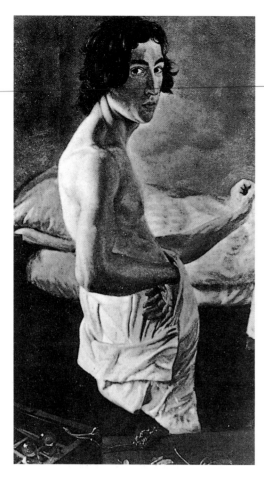

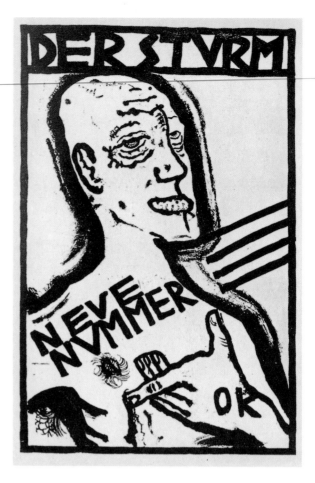

euphemism into the wilderness of unchecked desires ... to be aware of the flesh, instead of smoothing it out into ornament or mortifying it in a spirit of asceticism – this, in 1908, was the new radicalism, still unlabelled, but destined to be known a little later as "Expressionism". This craving for sensory awareness represents a licence for the artist to wound, to unmask, to commit acts of violence and to destroy.'[12]

It remains to be asked to what extent the language of signs invented by Gerstl, Kokoschka (Fig. 3) and Schiele is in practice laden with that intensity of sensory experience which conveys the physical in all its immediacy. The fixation on the body, the flesh, as a choreographic vehicle for the unmediated communication of a psychic state, tends to distract attention from the implicit cultural context of the gestural code used, and this comes to be seen as the natural psychophysical reflex transformed into an image. Types evolved within Christian iconography are converted into modern symptoms of suffering. The symbolism of the suffering of Christ and his saints migrates from its religious context into the stigmatized bodies of the Expressionists, where it takes root as a mark of socially conditioned martyrdom.

The rhetoric of the afflicted flesh is an artistic construct: it derives from Western iconographic tradition, not from unmediated experience. The marks of suffering inflicted by the world, for all their apparent immediacy, are the images and the gestures of a fossilized metaphorical martyrology which began in the Renaissance and was radicalized in Romanticism. The 'self-por-

Fig. 2 Victor Emil Janssen, *Self-Portrait at the Easel, c.* 1829; oil on canvas. Kunsthalle, Hamburg

Fig. 3 Oskar Kokoschka, Poster for *Der Sturm,* 1910

Fig. 4 Egon Schiele, *Self-Portrait as Sebastian;* poster drawn for his exhibition at the Galerie Arnot, 1915

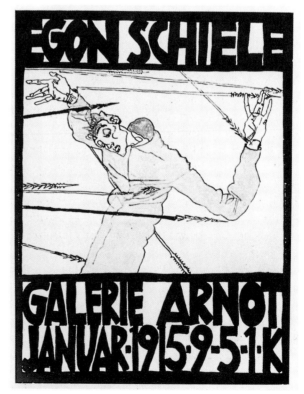

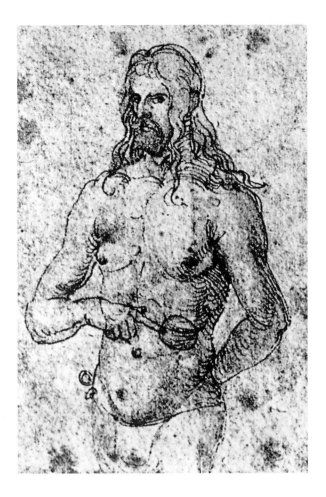

◁ Fig. 5
Albrecht Dürer,
*Self-Portrait as Man
of Sorrows*, 1522;
pen and ink.
Formerly Kunsthalle,
Bremen

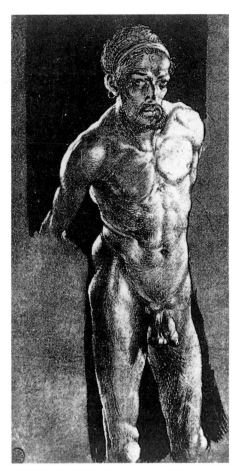

Fig. 6
Albrecht Dürer,
Nude Self-Portrait,
c. 1506. Weimar

trait as Man of Sorrows' – Gerstl's *Self-Portrait, Semi-nude, against Blue Background* (Cat. 80), Kokoschka's *Pietà* on the poster for his play *Mörder, Hoffnung der Frauen* (Murderer, Hope of Women), or Schiele's self-dramatization as St Sebastian (Fig. 4) or as Prophet – derived from a cult of the artist which found its way into the world of images along with the Latin formula *artifex divinus*.[13]

The earliest of these sacral self-portraits, the Christ-like images of Albrecht Dürer, had lost none of their power over the artistic imagination when they were taken up by early Austrian Expressionism. In a number of his self-portraits Dürer identified himself with Christ (Fig. 5). The best known, which is in the Alte Pinakothek in Munich, gave Gerstl the frontal pose, rare in self-portraits; another, a drawing dating from about 1506, now in Weimar (Fig. 6), was the source from which he took the idea of his later nude self-portrait. Dürer shows himself in a pose that holds overtones of a Flagellation, thus anticipating a self-image of the artist that was to become current in Romanticism.

By way of the Pre-Raphaelites and the Symbolists, the Christomorphic image of the artist came down to the Aesthetic Movement; and in the decades that led up to 1910, the Romantic casting of the artist as a priest, and of art as religion, became a reality. Philippe Junod has traced the socio-economic developments within advanced bourgeois society which led the artist to dream of a new and idealized position within society: 'Equally vulnerable to the laws of the market economy and to the whims

of his new bourgeois clientele, he is torn between compromise and defiance, between the taste of the philistines, on whom he depends, and the bohemian ideal which demands such immense sacrifices on his part In this atmosphere of contradictions, caught between Romantic idealism on the one hand and great material insecurity on the other ... the artist once more seeks identification with Christ.'[14]

The corollary – the association of artistic creation with notions of salvation – was in the air in Secessionist Vienna. Peter Altenberg spoke of the central room at the 1908 'Kunstschau', which was set aside for Klimt, as a 'Klimt Church of Modern Art'.[15] The Secession building itself was erected as a sanctuary against commercialism in art. Schiele encapsulated the whole idea in an aphorism: 'My paintings must be placed in temple-like buildings.'[16]

The sacralization of art extended to the artists themselves. The iconography of the artist's hypertrophied ego, as manifested in the Christ-like self-portrait and in the whole theme of the artist as martyr and victim of society – Max Oppenheimer's *Ecce Homo* self-portrait (Fig. 7) is another example – was reinforced by the reappearance of the halo in portraiture. The aura, a secularized form of nimbus, was used by Gerstl, Kokoschka, Schiele, Oppenheimer and Koloman Moser in commissioned portraits and figure paintings as well as in self-portraits.

The nimbus, the traditional emblem of sanctity and dignity, reflects the idea that the body generates spiritual emanations (Fig. 8). The formulaic significance of the halo can mostly be

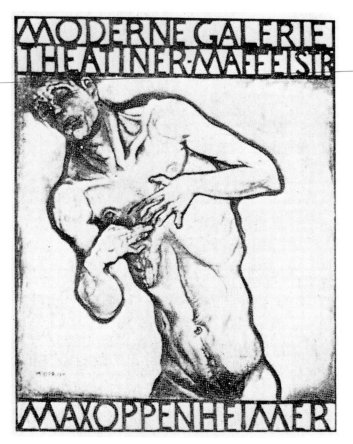

Fig. 7 Max Oppenheimer, Poster for exhibition at the Moderne Galerie,
Munich, 1911

associated with the adoption of religious imagery – in the
context of the sacralization of the artist and his work – but it
also has a historical background. The nineteenth century was
always discovering new emanations, currents and forms of radia-
tion which revealed that objects have properties that transcend
their obvious material presence.[17] The discovery of electricity
and radioactivity, with their revelation of the permeability of
solid bodies, was deeply unsettling to traditional habits of per-
ception.

The terminology of Freud's depth psychology, with its
'drives' (or 'impulses') and its 'energies' of the libido, has its
origins in physics. The same pattern of imagery was adopted
in turn by Erik Tesar when he described Kokoschka's paintings
at the 1909 'Kunstschau' (Fig. 9): in them, he wrote, 'the super-
conscious … makes headway in powerful currents'.[18] Contem-
porary critics and admirers often said of Kokoschka that he must
be using X-rays; and this same idea was one of the major
arguments put forward on behalf of Expressionist portraiture,
with its absence of 'likeness'.[19] Finally, we have Karl Kraus's
word for it that 'in distorting, the truth of genius transcends
anatomy … where art is concerned, the real is merely an optical
illusion'.[20]

The theme of visionary premonitions – like that of the self-
portrait as Christ – is a recurrent one in nineteenth-century art.
The Romantic artist appears as a 'seer', endowed with second
sight. This symbolic figure, in turn, is presented in the traditional
iconographical guise of the prophet. From Jean-François Millet's

self-portrait as Moses with the Tablets of the Law, by way of
Antoine Bourdelle's 1909/10 portraits of Rodin, the line extends
to Schiele, who presented himself as a prophet and seer in 1911.

Schiele, who was not a great reader, may well have derived
this imagery from Arthur Rimbaud, whose works he had in his
small personal library: 'I say that one must become the seer,
must make oneself into the seer.'[21] In this one sentence, Rimbaud
puts on record both the modern artist's self-image and his sense
of mission.[22] There is nothing heroic about these new images
of prophets. Significantly, the triumphant Christ, in whose guise
Dürer had depicted himself in 1500, had been replaced by the
Man of Sorrows.

The increasingly difficult relationship between artist and
public crystallized in a whole new iconography of the artist as
a social outcast: the child, the fool and the savage personify the
artistic virtues of naivety, freedom and genuineness. Kokosch-
ka's self-dramatizations as an outsider, a shaven-headed convict,
a savage, a Maori, are evocations of these very virtues. Paul
Westheim, who in 1917 wrote the first biography of Kokoschka,
confirmed his status as a 'man possessed' – which is also how
Schiele saw himself in one of his self-portraits.

Fig. 8 Koloman Moser, *Self-Portrait, c.* 1916; oil on canvas. Österreichische
Galerie, Vienna

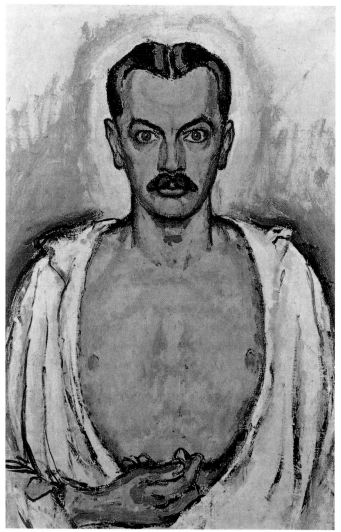

Richard Muther, who reviewed the 1908 'Kunstschau' for *Die Zeit*, gave some space to Kokoschka,[23] whose tapestry designs he described in terms which stress the ideas of naivety and primitivism: 'The *enfant terrible* in all this is Kokoschka … his tapestry designs are horrific: fairground stuff, raw Red Indian art, Museum of Ethnography, Gauguin run mad …. Even so … this *enfant terrible* really is a child, and definitely not a poseur.'[24]

The prototype of all these versions of the artistic persona was the French concept of the 'artist accurst' – the *artiste maudit*, as exemplified by Baudelaire, Rimbaud and Verlaine – which in turn is inseparably coupled with the loneliness that Eugène Delacroix said was the characteristic of every genius.[25]

From Dürer to Kokoschka, from the artist as demiurge to the *artiste maudit* plagued by existential doubt, there runs a tradition in which Christological and martyrological imagery is enlisted in the service of the artist's own self-image. Within this tradition, Schiele's assumption of the guises of 'monk', 'hermit', 'prophet', 'seer', 'preacher', 'proclaimer', forms part of a tendency – Symbolism – which the mainstream of Modernism in Western Europe had already abandoned as over-literary. In 1904 the Vienna Secession's enthusiasm for the Swiss painter Ferdinand Hodler had propelled him to international fame; the fact that this happened in Vienna is no more a coincidence than is Schiele's reverence for Klimt, from whom he departed in formal terms, but whose Symbolism he had made his own.[26]

The concept of the 'misunderstood artist', the 'persecuted prophet', brings with it that of loneliness as a perversion of inwardness. It springs from the conversion of artistic liberation into isolation. This problem, of which Goethe and Schiller were the first to become aware, became a desperate one for the generation of the Romantics. In their works, loneliness manifests itself as a grand artistic gesture; this was a world in which the bourgeoisie had emerged from feudal society with great economic power but had remained politically impotent.[27]

At the turn of the century, Georg Simmel analysed the conflict between the individual and society in his book *Philosophie des Geldes* (Philosophy of Money): 'The individual craves to be a self-contained whole, a finished form with a centre of his own, from which all the elements of his being and his actions derive a single, coherent meaning. But if the supra-individual whole is to be fully rounded … it cannot permit its individual members to be rounded entities in this way. The wholeness of the whole remains in eternal conflict with the wholeness of the individual.'[28] The individual's existence in the world is defined by his isolation; the loss of undistorted communication with the world carries the threat of the trauma of total solitude.

The writings of Hugo von Hofmannsthal cast light on the political background which lay behind the cultivation, in turn-of-the-century Vienna, of solitude as an artistic metaphor for powerlessness.[29] Arthur Roessler, collector and critic of the *Arbeiter-Zeitung*, wrote of his friend Schiele's 'fear of loneliness, which sometimes rose to the pitch of terror. The feeling of loneliness, a loneliness that froze him to the core, remained with him from childhood on, in spite of his family, in spite of brief intervals of cheerfulness in the company of his friends.'[30]

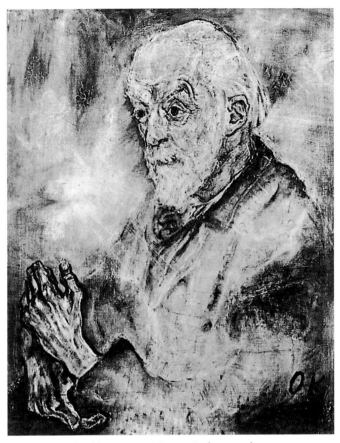

Fig. 9 Oskar Kokoschka, *Portrait of Auguste Forel*, 1910; oil on canvas. Städtische Kunsthalle, Mannheim

Transfiguration of the Ordinary – A World Grown Cold

The same factors that led to the Christ-like self-portrait – a genre which found its masterpiece at the turn of the century in Gerstl's *Self-Portrait, Semi-nude, against Blue Background* (Cat. 80) – led to an exclusively subjective conception of mood (*Stimmung*) which took the place of all communion between subject and object, between the individual and society, or between the artist and his world. This shift in the function of art, which underlies all the work of Klimt and Carl Moll, lived on in the art of Schiele, Kokoschka and – long unrecognized – Gerstl: artists who have been unjustly accused of solipsism.

At the turn of the century, artists and art itself – like the individual citizen – found themselves on the defensive. The work of art in itself, despite all the utopian hopes of a union between art and life that were nurtured by the Secession and the Wiener Werkstätte, could supply only an illusion of a reconciliation which was doomed to fail. What politics and economics had failed to supply could not be achieved through art.

As might be expected, the spontaneous aesthetic experience found its place in landscape and still-life painting: nature is the traditional setting for an intensive preoccupation with the self. The early landscapes of Moll – *Heiligenstadt Park in Winter* (*Heiligenstädter-Park im Winter*; Cat. 129) – and of Klimt – *Still Pond in Schloss Kammer Grounds* (*Stiller Weiher im Schlosspark von*

Kammer; Cat. 99) and *The Large Poplar* (*Die grosse Pappel*; Cat. 101) — bear witness to the incompatibility of the cult of neurosis and the distractions of everyday life, and to the artistic resolution of this frustration through images of inner peace and contemplation. They seek to convey material and immaterial constituents, the light and atmosphere which suggest ethereal stillness.

The pictorial space is framed in a way derived from the landscapes of Fernand Khnopff (Fig. 10) and from Japanese woodcuts. Why should Belgian Symbolism and Japanism fall on such fertile ground at just this time? Klimt's early landscapes, like Schiele's nude drawings, are unthinkable without these extraneous influences: the accelerated perspective; the displacement of the horizon upwards, or even out of the picture altogether; the way tree trunks intersect the upper edge. What matters is the effect created by these compositional structures: that of concentration on a single segment of landscape as an object of meditation in itself. This is in keeping with the tendency of Viennese *Jugendstil* to adopt the static pictorial format *par excellence*, the square. 'The impression of perspectival recession disappears, so that no mechanical, Euclidian habits of visualizing space may disturb our contemplation.'[31]

This static, meditative form tends to be combined with motifs of gently vibrating restlessness, full of inner life and lacking in stability: water, ponds, landscapes under snow, transitory atmospheric phenomena like the gathering storm in *The Large Poplar*. In 1905 Hofmannsthal stressed the connection between the unfathomable nature of social reality, in the real world, and the artistic predilection for weightlessness: 'The essence of our age is ambiguity and indeterminacy. It can find no rest except on shifting ground, and is quite aware that the ground is shifting, where other generations believed in permanence.'[32]

What is implied, but not expressed, in Hofmannsthal's words — the fascination with a suspended state of atmospheric refraction of nature, and with its internalization — had been defined as early as 1886 by Max Haushofer, in an essay on the 'mood landscape' (*Stimmungslandschaft*) which had a considerable influence on Austrian Impressionism: 'The masterpieces of mood-creation in the art of landscape painting teach us that there exist certain moods common to nature and man The component parts of a landscape can be the vehicles of this mood.'[33]

The vibrant unity of man and nature, together with the growing impossibility of unmediated participation in nature — or in society — was generally felt, in the *fin de siècle* world, as a loss which the individual might endeavour to make good through aesthetic experience.[34] The practice of concentrating on a tiny section of a landscape made Moll — who was a pupil of Emil Jacob Schindler, the great master of the Austrian school of Impressionism, based on *Stimmung* — and after him Wilhelm Bernatzik, Gustav Klimt and others, highly appreciative of the 'intimate landscapes' of the Barbizon School.[35]

The centring of the artist's psyche in a subjective perceptual experience, which was the basis of *Stimmung*, was incompatible with the manifold sensory distractions of metropolitan life.

Klimt's concentration on a restricted visual field in his woodland paintings may be interpreted as a response to the alienated form of seeing inherent in urban life. But nature offered itself to Klimt, the townsman, only at a price; that of an alienation process. He wrote in one of his letters that he had painted some of his landscapes with the aid of a telescope, and that in other cases he had defined the content of his composition by using a so-called viewfinder, 'a (square) hole cut in the lid of a cardboard box'.[36] The reifying perception of the town-dweller, well suited to gaining one's bearings in the overwhelming maze of visual impressions that is a big city, does not desert the artist when he goes out to the Salzkammergut countryside to pay tribute to the longed-for immediacy of perception.

The blurring, and the Divisionist break-up, of Klimt's motifs often takes the smaller objects to the limits of recognizability. This was the phenomenon that the public in Vienna still found shocking when the paintings of the Impressionists were belatedly exhibited there.

This shock of non-recognition was never present in the landscapes of the 'Stylists'. The Impressionist homogenization of phenomena of motion, and the atmospheric dissolution of separate objects, had been tamed by the Viennese variant of Giovanni Segantini's Divisionism into a purely painterly phenomenon. It was not until Expressionism, with its disintegration of form, that the image was once more subverted by departure from the literal reproduction of the object. Impressionism, with its painterly dissolution of reality, was a reaction to the unmanageable profusion and rapidity of visual stimuli in the modern city. Klimt's landscapes are not reactions to these perceptual shocks of modern life but artistic reworkings of a mode of seeing that Impressionism and Neo-Impressionism had already altered.

Around the turn of the century, Viennese art tended towards the Divisionism of Georges Seurat, Paul Signac and, above all, Segantini, but without their scientific urge to give pictorial embodiment to Neo-Impressionist colour theory. What attracted Klimt and the painters of his circle — especially Leopold Blauensteiner (Cat. 54-56) — to Divisionism was the carpet-like effect of the brushstrokes: the atomization of the material, its decomposition into the tiniest dabs of colour, which permitted a new integration of formerly discrete phenomena, in accordance with the formula enunciated by Siegfried as he forges his new sword: 'I've filed to chaff the sharp splendour; in the crucible I'm cooking the splinters.'

The separate objects dissolve and become — as with Moll (Cat. 131) — the bearers of evanescent tricks of light. As separate components of the image, they are united by the impulse to create a mood. And this mood (*Stimmung*) comprehends everything. Techniques of this sort remain totally peripheral to the alienation process that is going on in the real world. They are in no position to arrest the collapse of perceptual organization, or to re-synthesize a world of experience which has been shattered by an over-particularized perception. The homogeneity of the carpet pattern masks the heterogeneity of life in appearance only.

Fig. 10
Fernand Khnopff,
At Fosset: Still Waters,
1894; pastel.
Whitford and Hughes Collection,
London

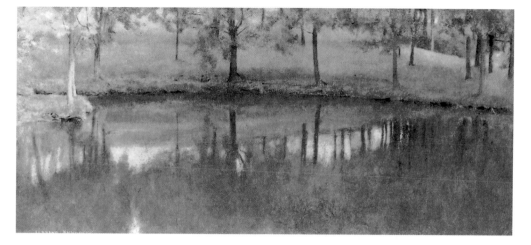

Sensations progressively usurp the place of the subjective presence, which becomes increasingly elusive as a result of that generalized identity crisis of the turn-of-the-century ego which furnishes the literary theme of Hofmannsthal's famous 'Lord Chandos's Letter'. As early as 1885, Ernst Mach had proclaimed the dissolution of the ego into the sum of its reactions to perceptual stimuli, with fatal consequences for the subjective sense of identity: 'What is primary is not the ego but the elements (emotions) ... the elements form the ego ... the ego is not an unalterable, defined, clearly delimited unity.'[37]

Klimt's *Still Pond in Schloss Kammer Grounds* (Cat. 99) can be taken as a model of the fragmentation of the visual world. The tree at the top is a fragment; the reflected tree is so big as to fill nearly half the picture, but it too is a fragment. What nevertheless unifies the image is its *Stimmung*, a much-abused pictorial concept which Vassily Kandinsky attempted to rescue by redefining it as *Klang* (sound), which he characterized as 'psychic states disguised in the forms of nature'.[38]

Johannes Dobai describes Klimt's landscapes as 'biomorphic'; this would make Schiele's images of nature 'anthropomorphic'. The nature that makes its appearance in Schiele's paintings is inherently closer to figure painting than the visible fragments of landscape might lead one to suppose at first sight. In a letter, Schiele himself expressed his comparative lack of interest in nature:

> I think – I know – that drawing from nature is meaningless as far as I am concerned, because I am better at painting pictures from memory, visions of landscape. What I am mostly looking at now is the physical movement of mountains, water, trees and flowers. Everywhere one is reminded of similar movements in the human body, of similar stirrings of joy and suffering in plants One thing that goes straight to one's heart, one's deepest being, is seeing an autumnal tree in summer. It is this melancholy that I would like to paint.[39]

Rudolf Leopold has detected this phenomenon of anthropomorphism in Schiele's *Small Tree in Late Autumn* (*Kleiner Baum im Spätherbst*, 1911; Cat. 23). On the one hand, the harsh angle at which the tree leans and the absence of a number of branches seem to be the result of weather damage; on the other, the tree bears distinctly human features: 'The end of the trunk thickens towards the top; it looks like a head, from which the thin branches stretch up on either side like arms, in wild gesticulation. The main bough below, stretching to the right, corresponds to one leg, and the limewashed white trunk to the other.'[40] Its anthropomorphic features make the tree 'a parable of human destiny ... fundamentally ... the picture is a dramatic allegory of human isolation and helplessness in the face of hostile powers: it is a latter-day Dance of Death'.[41]

The parabolic nature of many of Schiele's works shows him to be heir to the Symbolist tradition, which saw objects as the signs of what could not be expressed: the gulf between appearance and reality is as wide in his work as in that of any artist who ever mistrusted the superficial. This extends even to downright reversals of optical phenomena, reversals of which one is scarcely aware, because they are not instantly signalled by distortions of form.

One of Schiele's most successful landscapes, *Sinking Sun* (*Versinkende Sonne*, 1913; Cat. 32), exemplifies this process. From an elevated viewpoint, we seem at first to be witnessing a simple sunset of the kind that art tends often to regard as an uplifting spectacle. First a hilly foreground terrain shrouded in deep, slumberous green, then the sea, and then two islands — this is the repertoire of landscape features. Schiele spans the whole with a pair of differing trees, which reach above the horizon into the sky.

The sunset, or *tramonto*, has been a symbol of transience at least since fifteenth-century Venice: it marks a transition from Here to the Beyond, from Life to Death, and its message of the vanity of human life is sweetened by an accompanying promise of transcendental bliss. There is none of this in Schiele's painting. Ever since Friedrich Nietzsche proclaimed the death of God, the symbolism of the setting sun has either degenerated into the melodramatic finale of one of nature's spectacles or else resolved itself into a metaphor of a world that is growing cold. When looked at carefully, the distribution of colour in *Sinking Sun* becomes a visually disorientating experience, which has no counterpart in our experience of sunsets. As Leopold has pointed out, the islands are seen from their shadow side, and so they ought to look black. The sea, the islands and the sky, all differently lit, are correlated by the bright carmine pink of the sun; and this serves to point the contrast between the one-third of

Fig. 11 Camille Pissarro, *Morning Sunlight on the Boulevard des Italiens in Paris*, 1897; oil on canvas. National Gallery, Washington D.C.

the painting that is alive and the cold, dead, sombre hills of the gently rising foreground. Schiele ignores verisimilitude and entrusts the symbolism of the work to its colours: his pictorial thinking is largely dominated by the thermodynamic colour symbolism of heat and cold.[42]

Schiele's *Sinking Sun* goes beyond the bounds of landscape painting: it stands not for nature but — according to Schiele's own testimony — for his own psychic state. What happens when the sun has set and taken with it the last vestiges of warmth and light? Schiele's masterpiece contains no promise of its return, whether eschatological or — as in the case of every sunset so far — natural. It would also be possible to read the painting as the symbol of a yearning to transcend earthly life and the limitations of time: a yearning that has failed to encounter eternity. This vision of a nature without hope is the antithesis of the transfiguration of the ordinary which we see in the landscapes of Klimt.

Urban Tales

Schiele's fixation with the subject-matter of Symbolism is apparent not only in his landscapes and figure paintings but also in his views of villages and towns. Krumau (Český Krumlov), his mother's home town, becomes a metaphor of a dying or a dead world. None of his views of its architecture has anything of the emotional charge that the term 'home town' might suggest. The indices of such an emotional content — a certain orientation, a sense of self-identification, signs of positive feeling — are absent in every case.

With one late exception, the houses of Schiele's Krumau are empty of people. Seen from above, they are an embodiment of the human presence, but even the traces of that presence, such as clothes lines (Cat. 41) or open shutters, do not connote the inhabitants, who are absent. These views embody a human

presence only in the highly significant sense that Schiele projects his own states of mind onto them as he does onto nature.

Krumau, as Schiele shows it, is a doom-laden place. *Dead Town III (Tote Stadt III, 1911; Cat. 21)* feeds on the imagery of the dead city as formulated, most relevantly, in Georges Rodenbach's novel *Bruges-la-Morte* (1892), which gave Bruges a place alongside the other famous dead cities of *fin de siècle* mythology: Venice, Ravenna, Pisa, Toledo. This legend always incorporates an analogy between the psychic state of the protagonist and the soul of the town. What Schiele painted in *Dead Town* was the town as its own tomb, like the Bruges that Rodenbach describes: 'Bruges the Dead was buried in the tomb of its own stone quays, and the veins of its canals had grown rigid; the great pulse of the sea had ebbed away.'[43] Rodenbach's work was known in Vienna, as was Khnopff's painting *The Deserted City*. Once more, the content of Schiele's work is derived from a movement to which, in terms of artistic form, he was implacably opposed.

The bird's-eye view — for which Schiele himself gave the rather lame explanation that he found it formally interesting — creates a panoramic vista at the expense of any direct involvement (Fig. 11). This is not the viewpoint of Robert Musil, who roves the streets as the Impressionists had done before him, to sense the vibrant life that is there. Albert Paris Gütersloh was aware of the implications of such a perspective when he wrote of Schiele in 1911: 'A town that is seen foreshortened, from above, he calls the dead town. Because every town becomes so when it is seen in this way. The hidden meaning of the bird's-eye view emerges unconsciously. The title is an inspiration quite equal to the painting it denotes.'[44]

The town, for Schiele, is a field of association for his own emotions; predictably, none of his townscapes gives anything like an exact rendering of the place concerned. Schiele is no Merian, and the comparative illustrations in Rudolf Leopold's catalogue raisonné go to show how little Schiele cares for topographical accuracy. Nor does he select his views of Krumau with the eye of a tourist, strolling round to surrender himself to whatever charms the town may have to offer. On the contrary: he examines each and every building for its symbolic content. The chord struck within him seeks an external sounding-board. Many of the houses pull faces that are as human as the attitude of the tree in *Small Tree in Late Autumn* (Cat. 23). They negate the specific identity of the town, and render it nameless. When Schiele endows the town with mythical status, there is no hint of an intimate relationship between the artist and his dwelling-place.

It is interesting to note that Schiele, who produced some of the most important townscapes in twentieth-century art, avoided taking the big city as a subject. He took his cue not from Vienna, where he spent most of his time, but from Krumau and from Stein an der Donau — old town centres, not modern ones. We should not, therefore, expect to find an indictment of the injustices and miseries of city life, as we know it from the writings of Eugène Sue, Charles Dickens and Victor Hugo; Schiele does not depict social degradation, crime, industrializa-

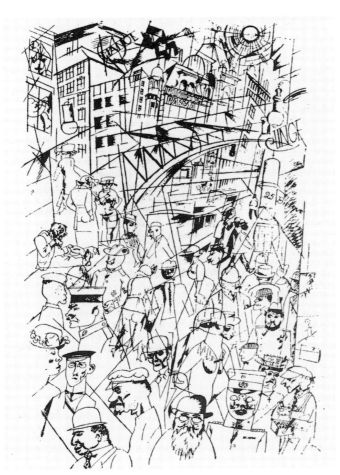

Fig. 12 George Grosz, *Friedrichstrasse*, 1918; pen and ink

Fig. 13 Alexander Georgevich Yakimchenko, *The Street*, from the cycle
The City, 1921; linocut

tion, slums, the brutal face of capitalism in its early phase and at its peak. This is what sets him apart from George Grosz (Fig. 12), from Otto Dix, and also from Egon Erwin Kisch's descriptions and photographs of the Vienna slums, which aroused a great deal of attention when they appeared in 1908.

When Kokoschka paints bird's-eye views of interchangeable cities – London, Prague, Lyon, Linz or Venice – what interests him is primarily the cosmic level: the city as a container for a self-generated dynamic which is the essential characteristic of urban life. Schiele's townscapes, by contrast, are intensely anti-urban. They have a sense of a milieu – it is easy to imagine a particular milieu as existing within the individualized houses of Krumau – and yet they contain no people, who after all are the indispensable prerequisite of any milieu. Time comes to a grinding halt in Schiele's towns, even in those cases in which the title itself does not contain the idea of death. And so, although his views of Krumau lack any sign of the social motion and flux that is inherent in any town, every one of these paintings presents us with the equation 'Krumau = World'. For Schiele's celebrated saying that 'all is living dead' is implicit in his interpretation of the buildings of Krumau: these are the still-born fossils of an urban community that has had past origins but never a present existence.

The statement that Schiele's imagination was stirred by the 'old town' calls in fact for some qualification. The 'old town' in

this context is not merely the opposite of a modern business or residential quarter (Fig. 13); it stands for a past that never existed. Hence the absence of any sense of unfolding in Schiele's towns, which, in spite of the bird's-eye view, never permit any insight into their inner life. The eye encounters nothing but façades and roofs: surfaces, in other words. The house that grimaces is a masked house. And the mask, for the *fin de siècle* consciousness, is the only outer surface to afford a view of the depths – in accordance with Nietzsche's aphorism that all that is deep loves the mask.

The Beauty of Ugliness

The beautiful and its negation, the ugly, elude objective definition. The statement that any motif – the uncouth peasant, excrement, sexual organs, decomposing corpses – is ugly 'in itself' lacks the very self-evidence to which it lays claim. It is undeniable that ugliness, disgust and obscenity have a quantitative basis, but even a comparison between female figures in exactly the same erotic attitudes in drawings by Klimt and by Schiele shows how Klimt used formal techniques to cushion the impact of what he was presenting, while the colour accents in Schiele's work call attention to the very taboo that he is breaking.

Sieben Billionen Jahre vor meiner Geburt
war ich eine Schwertlilie.

Unter meinen schimmernden Wurzeln
drehte sich ein andrer Stern.

Auf seinem dunklen Wasser
schwamm
meine blaue Riesenblüte.

Fig. 14 Koloman Moser, Illustration for a poem by Arno Holz
in *Ver Sacrum*

There is no way of systematically defining the artistic productions that have from time to time been excluded from the canon of beauty or else marginalized. An aesthetic of the unaesthetic obviously presupposes a process comprising 'the establishment of a canon, the breaching of that canon and a new licence'. The emancipation of the 'no longer fine arts' in modern times is impossible to grasp except in relative terms. Karl Rosenkranz, a pupil of Hegel, noted in his book *Ästhetik des Hässlichen* (Aesthetics of the Ugly): 'The beautiful, like Good, is absolute; and the ugly, like Evil, is relative.'[45]

The boundary markers between *Jugendstil* and Expressionism have their foundation in the words 'beautiful' and 'ugly':

> All liberators have had recourse to ugliness as a sure remedy against the curse of commonplace beauty and regulation prettiness. From Böcklin and Klinger to Toorop and Klimt, there is a passionate impulse to adjust and to redefine the words 'beautiful' and 'ugly'
> We have always believed that ugliness, like all the other disagreeable things in life, finds redemption through humour But now it can be seen that there is another all-purpose redemptive force. And that is style. For two whole generations nature in its entirety has been posing for the artist. Now nature is tired. A general need for style is spreading through the world. It is time to infuse spirit into all this matter.[46]

All the residues of Symbolism and aestheticism that are to be found in Schiele's work pale into insignificance beside his demolition of a concept which for Klimt and his circle was absolutely central: that of beauty. When the form blatantly pursues ugliness, the category of moral goodness, which is inseparable from that of beauty, is simultaneously eliminated.

As late as 1899, Hermann Bahr – who was later to be a promoter of Expressionism, as he had been of Naturalism – was still pronouncing that beauty was truth and truth beauty: 'Beauty and art [are] not an ornament ... but ... the only true form of life itself.'[47] Bahr still believed that man could cling to beauty as a safeguard against slipping into the clutches of evil. The pointed emphasis on ugliness in the work of Kokoschka and Schiele, their rejection of the harmony intrinsic to all Wiener Werkstätte design (Fig. 14), was a violation of the basic Wiener Werkstätte ideal of self-identity.

All Schiele's self-portraits are the signs of a fragmented personality; his double self-portraits (Cat. 16) are the signs of a split personality. His constant assumption of various roles, his borrowing of masks – whether 'monk' or 'St Sebastian' – exacerbates the difficulty of locating his centre, the unchanging core of his nature. Who and what is Egon Schiele? An ascetic or an onanist? The quiet individual described by his contemporaries, or one who screams and arches his back in anguish? Each self-portrait by Schiele takes a different aspect of his ego as its subject: each one throws away the unity of beauty and character which was the ideology of the self-contained individual at peace with himself and with the world. It is pointless to search for the authentic Schiele. Exterior and interior, surface and depths, are no longer quantities that relate to each other. All this is a contributing factor in the call for portraiture to abandon likeness. Robert Musil found a way to harmonize appearance and reality: '"I am just an accident," smirked Necessity. "I look basically no different from the face of a patient with lupus, to the unprejudiced eye," admitted Beauty.'[48]

In expanding the range of emotional expression into regions of instinctual and emotional life that were previously forbidden territory, Schiele included even the disillusion that follows the masturbator's hollow enjoyment.[49] His drastic expressions of emotion reveal him as anything but a free or liberated individual. The figure becomes the victim of a new set of constraints, which are created by the composition. Based on a principle of linear bracing of parallel body outlines, this in itself becomes a symbol of earthly bondage: broken flesh, broken soul. Self-expression here is a long way from self-liberation.

The resolution of the age-old conflict between physical gratification, bodily self-expression and spiritual or moral elevation had proved beyond the capacity of a generation that was the first to dedicate its creative efforts to the liberation of the human body. This is what exposed Schiele and Kokoschka, in particular, to the allegations of mental abnormality hurled at them by the bourgeois press. Adalbert Franz Seligmann, the influential art critic of the *Neue Freie Presse*, warned his readers against visiting the Kokoschka room at the 1908 'Kunstschau': 'Persons of taste are liable to suffer a nervous shock.'[50]

What Seligmann – and with him all those who clung to the bourgeois ideal of art – could not achieve was aesthetic detachment. For him the definitive criterion of art was 'the beautiful, understood as the sensory presence (imitation) of a world which appears fundamentally sound and whole';[51] and this at a time when Alfred Kubin,[52] Arnold Schoenberg,[53] Oskar

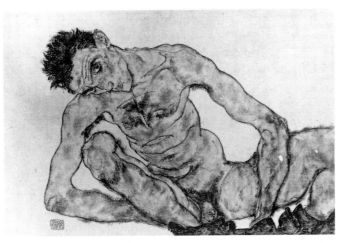

Fig. 15 Egon Schiele, *Self-Portrait as Nude, Squatting*, 1916; pencil, watercolour and gouache

Kokoschka and Egon Schiele had long since abandoned any such criterion. In 1917 Schiele wrote to his brother-in-law, Anton Peschka, in connection with his plans for a *Kunsthalle*, defining the function that art had for him: 'Since the bloody horror of the World War came upon us, there must be many who have come to realize that art is something more than an adjunct to bourgeois luxury.'[54]

The adverse criticism and sheer loathing which greeted Schiele's paintings were reactions to their content as well as their form. Arthur Roessler described both, without mincing his words, in a sympathetic exhibition review (written in 1912):

> Some of the portraits painted by Schiele had led to the realization that he has the ability to turn people inside out, and people were appalled by the thought of seeing what had been so sedulously concealed, a mass of sewage and maggots, devoured by decay ... the features of those possessed, whose souls fester and whom unspeakable torments have frozen into a lifeless mask He has seen and painted the gem-cold eyes in human faces that shimmer with the pallid hues of putrefaction, and the death beneath the skin.[55]

Even without the sorry episode in which Schiele was briefly imprisoned for his erotic drawings, it would be evident that he nowhere violates the classical canons of art so uncompromisingly as he does in his drawings of the nude. He had, as his prison diary reveals, absolutely no comprehension of the moralistic outrage expressed by the court at his nude drawings – although the diary also makes it clear that the breach of the taboo must have been a conscious action on his part: 'These adults, have they forgotten how corrupted they themselves were, i.e. attracted and excited by sex, when they were children?'[56]

The directness of the depictions (Fig. 15) leaves no room for evasion, especially as Schiele excludes the possibility of sexual caricature, which had traditionally been used to show the unacceptable on the pretext of ridiculing it. 'By preference', wrote one critic, 'Schiele paints and draws the uttermost depths of vice and degradation; he shows woman as a herd animal, a creature of instinct, devoid of all the restraints of morality and shame.'[57] This sort of comment confirms that the problem, for Schiele's

contemporaries, consisted in their own inability to distance themselves from the object represented: they took the fictional artifact for reality.

This was as much because of the object shown as of the way it was shown: the vulva as much as the style. Leopold says on one occasion that in many of his female nudes Schiele presents the genital area like a bullseye or like the Sacred Heart of Jesus (Cat. 20).[58] And indeed, Schiele counters repression with ostentation: what others prefer to forget, he forcefully brings to light. Leopold's pithy formula, which situates sex somewhere between lethal aggression and religious ecstasy, makes it vividly clear how hard it was for a conservative Catholic society to disengage the spiritual from the physical, so long as the satisfaction of physical desires was ideologically supposed to be incompatible with the development of spiritual and moral faculties. The danger that the psyche might be sullied by physiology was an ever-present one for art – unless some form of aesthetic stylization could be introduced to transpose sexuality into an erotic mood: a form of *Stimmung*, in fact. By his very nature, Schiele never did this; nor did Kokoschka, although Klimt certainly did.

In Klimt's work eroticism is omnipresent: in landscape and in portraiture, as well as in depictions of sexual subjects. The scenes of nature, the lakes and marshes, in Klimt's early work, including *The Large Poplar II* (Cat. 101), are described by Werner Hofmann as 'metaphors of the aristocratic isolation of the male'.[59] Life, nature and woman tend to flow into each other. It is true that for a short time Klimt, too, became the target of accusations of obscenity, over his *Nuda Veritas* and the nude figures in *Philosophie* and *Medizin*;[60] but then, in 1901, the authorities were even confiscating postcards of works by Rubens and Titian for impermissible displays of nudity. The fact is that the attacks on Klimt, which were indeed prompted by the sexual content of his work, were mild in comparison with the verbal assaults on Schiele and the legal consequences he had to suffer.

So effectively is sex tamed in Klimt's stylized versions of the female form that Karl Kraus even recommended *Nuda Veritas* as eminently well suited to the expulsion of 'carnal thoughts'.[61] What makes the flesh so remote, in Klimt's drawings of the nude, is his ornamentalization of the body: 'It is ornament that really creates the erotic aura, which engulfs the women so completely that it is no longer possible to tell whether they relate to the linear flow as objects – captives, in other words – or as subjects in their own right, the generators of this swirling labyrinth.'[62] Ludwig Hevesi, the chronicler of the Secession and friend of Klimt, particularly admired 'the Klimt curves: those parabolic and hyperbolic lines of his, which in nature are only partly visible'.[63]

If ornament was the formal medium of eroticism, its basis was *Stimmung*. Mood, the paradigm of possible fields of association, creates the field in which erotic communication can take place. There is no Klimt drawing that is not steeped in an implied erotic atmosphere; and this is something that is not to be found in Schiele's drawings at all.

The obsessive emphasis on sexuality as an artistic theme —
from the simple nude, by way of various forms of fetishization
of the body, to the depiction of coitus and onanism (Cat. 47,
110) — in the work of Klimt, Schiele, Auguste Rodin and Edvard
Munch (to name only four highly controversial artists of the
period) has a social basis. Eroticism as an artistic subject was
related to the 'sexual question', which sprang from the political
demands of women for equality in sex, marriage, work and
society as a whole. A wealth of scientific and pseudo-scientific
literature — all of it written by men — investigated the sexual
determinants of character, of the psyche, of intellectual capa-
cities, of moral qualities, and wrestled with the recurrent problem
of defining what is sexually sick, perverse and criminal and what
is normal and healthy.[64]

Even taking into account the fact that Schiele's drawings
and watercolours were primarily intended for sale to private
collectors, and not to go on public show,[65] one is still surprised
that they so completely ignore that threshold of embarrassment
in sexual matters which was so firmly implanted in turn-of-the-
century Viennese consciousness.

Although Schiele leaves caricature far behind him, it is to
caricature that he owes the loosening of the bonds that fettered
the artistic expression of sexuality. The disestablishment of
beauty, and the freedom to employ ugliness in all its conceivable
manifestations, were legacies of the licence won by caricature.
The knack of reducing a figure to a few strokes stems from
caricature, as does the adoption of themes from the marginal
areas of social life; even the acceptability of proletarian models
goes back to caricature and its marginal artistic status. This
relationship was noticed as early as 1901 by Eduard Fuchs:
'That the whole of art is today under the influence of caricature
is an indisputable fact.'[66]

The aesthetic alliance between thresholds of embarrassment
and categorical norms on the one hand, and a prevailing canon
of beauty on the other, was responsible for the simultaneous
allegations of perversion and caricature that were levelled
against Schiele in the press. Once more, it was the *Neue Freie
Presse*, in the person of its artistic pundit, Seligmann, which
accused Schiele of 'the production of atrociously mannered,
perverse caricatures and ... the depiction of hideous halluci-
nations'.[67]

The Greedy Eye

It has become customary to concentrate attention on the
relationship between the artist and society: there is some justifi-
cation for this, in the case of erotic art at least, because here the
real context of the work is the implied friction with the society
outside the studio, not the atmosphere inside it. However, any
exclusive concern with this social dimension tends to detract
from the initial, the primal relationship in the genesis of any
erotic drawing: that between the artist and the model. It is
important to avoid the trap of concluding that this relationship
is an entirely individual, private matter, on the grounds that,
say, Schiele, Kokoschka, Klimt, Anton Kolig and Franz Wiegele

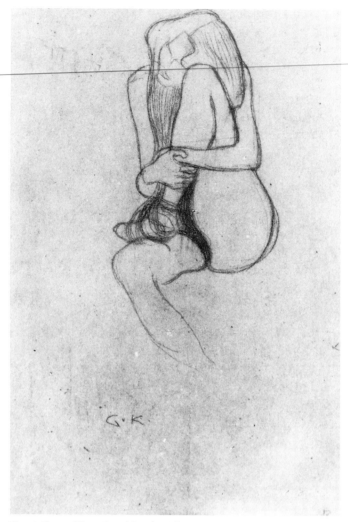

Fig. 16 Gustav Klimt, *Seated Female Nude, Facing Left,* 1902; black chalk.
Private collection

had such diverse relationships with their models that generalization is an impossibility. Nothing of the sort: the enforced passivity of the model is in itself a reflection of the male/female dichotomy, because it is a subject/object relationship founded on dominance.

Gottfried Fliedl has drawn attention to the marked passivity of the poses of Klimt's female models, his predilection for states of sleep or drowsiness, and the way in which his concentration on outline at the expense of internal modelling facilitates, indeed makes possible, the intended perception of women as nudes, or in other words, as objects. The artist's subjective isolation of parts of the body – as in the 'phallic inflation' of the thighs – shows how little justification there is for citing Klimt's erotic drawings (Fig. 16) as evidence of the emancipation of female sexuality.[68]

Schiele's models, unlike those of Klimt, are shown in a wide variety of poses and from all possible angles, in a way that suggests a certain freedom of action on their part; nevertheless, the range of poses is limited by the practicability of the motif for drawing purposes. The recurrence of a number of stereotyped attitudes – the raised leg, the view beneath the skirt, the bent back – points to the limits he imposed on his models' self-determination. This is so in spite of Schiele's legendary gift for capturing a pose and sequences of movements without *pentimenti* and with an unerring sense of spatial relationships. In Klimt's drawings, by contrast, the dynamic of shifting viewpoints is hardly present at all: it is only in his late work that there are attempts to capture nudes in motion.

Schiele makes virtually no distinction between nude drawings of himself – although these give him complete freedom of self-expression – and drawings of models: the theme in both cases is the pose itself, frozen into a facial expression, an attitude and bizarre gesture, which symbolizes the paralysis of communication. The two women in *Pair of Women Squatting* (*Hockendes Frauenpaar*; Cat. 52) – a late, unfinished work – are defined by a force outside themselves; they are trapped within oval forms that define the unvisualizable space in which both women exist in such a way as to make the composition an image of defenceless captivity.

The nude male figure has always been a very different matter. Committed by pictorial tradition to an entirely different code, in the work of Anton Kolig it assumes familiar attitudes of virile display, casual and self-assured. The difference between male and female role-awareness is evident in Kolig's *Seated Nude Youth* (*Sitzender Jünglingsakt*; Cat. 126). There he sits before us, immersed in himself, in an expansive attitude, legs apart, yet without brashness. Klimt's female nudes are marked by 'rather a narrow scale of psychological differentiation';[69] Kolig, by contrast, gives his male nude the privilege of being himself.

Once we have recognized that Klimt and Schiele endowed the eye of the artist with unlimited authority – rather at the expense of the object seen – we should consider a further motivation behind the endless variations of liberated seeing. Ever since the dialogues of Plato, the eye has been allotted a higher status than the other senses, as the sense capable of perceiving the essence of things. This distinction is something that the eye has constantly had to justify by its good conduct in resisting the blandishments of the body. The disappearance of the Aristotelian conception of the 'eye of the soul' has given the eye a newly enhanced status: that of supposed scientific incorruptibility. But what has always been despised about the eye is its capacity for voracious greed. A whole metaphorical tradition of ocular aggression is encapsulated in Ovid's oft-repeated phrase about 'deflowering with the eye alone'.[70]

In 1894 Norbert Grabowsky included sexuality in his theory that sensual gratification is an impediment to the gaining of insight: 'Everyone with a proper understanding of his own interests should practise continence. In an obscure and mysterious way, whoever gives himself over to Woman more less [*sic*] loses the capacity to think metaphysically and to become aware of his higher self. Sensual gratification of any kind is the foe of understanding.'[71]

Schiele's eye gives the lie to this kind of moral demarcation. His restless visual sense cannot be equated with the Mannerist ideal of an image 'equally beautiful from all sides' – because the object he is exploring from every angle is a deliberate mockery of currently fashionable ideas of beauty – but it remains true that, in his work, visual sensual gratification emancipates itself to become an indulgence of the eyes far removed from any kind of cheap hedonism. Broken body and broken soul, perhaps; but they are seen: the veil has been rent, the eyes are not blind to the world.

Notes

1 Werner Hofmann, in Werner Hofmann, ed., *Experiment Weltuntergang: Wien um 1900*, exhibition catalogue, Munich, 1981, pp. 6-7.

2 Johann Wolfgang von Goethe, *Wilhelm Meisters Wanderjahre*, Book 1, Chapter 7, Cotta-Jubliäumsausgabe, Stuttgart, n.d., vol. 19, p. 88.

3 It was Ludwig Curtius who traced back to the early Hellenistic period the discovery of the potential dialogue implicit in the sitter's gaze. The earliest instance of this effect identified by Curtius was in the painting of *Alexander's Victory* by Philoxenos, c. 300 BC, a lost work known through a celebrated mosaic copy in Naples.

4 Quoted by Alfred Neumayer, *Der Blick aus dem Bilde*, Berlin, 1964, p. 53.

5 Whether presented by the individual himself, as in an autobiography or diary, or created by society, as in the self-incriminating statements made before the Spanish Inquisition or the Moscow show trials, all formalized accounts of the self and all techniques of self-observation are mediated to us through society. The distinction between voluntary and involuntary confessions, however crucial to the individuals concerned, tends to be obscured by the passing of time.

6 Goerge Herbert Mead, *Mind, Self, and Society from the Standpoint of a Social Behaviorist*, Chicago, 1967.

7 Rudolf Leopold, *Egon Schiele: Gemälde, Aquarelle, Zeichnungen*, Salzburg, 1972, p. 212.

8 Ibid.

9 Alois Hahn and Volker Kopp, eds, *Selbstthematisierung und Selbstzeugnis: Bekenntnis und Geständnis*, Frankfurt, 1987, p. 17.

10 Gustav Klimt, 'Was ich bin und was ich will: Zu einem nicht existierenden Selbstporträt', in Otto Breicha, ed., *Gustav Klimt. Die goldene Pforte. Werk – Wesen – Wirkung. Bilder und Schriften zum Leben und Werk*, Salzburg, 1978, p. 33.

11 Werner Hofmann, 'Das Fleisch erkennen', in Alfred Pfabigan, ed., *Ornament und Askese im Zeitgeist des Wien der Jahrhundertwende*, Vienna, 1985, p. 120 ff.

12 Ibid., p. 123.

13 See Erwin Panofsky, *Idea: Ein Beitrag zur Begriffsgeschichte der älteren Kunsttheorie*, Leipzig and Berlin, 1924; Ernst Kris und Otto Kurz, *Die Legende vom Künstler: Ein geschichtlicher Versuch*, Frankfurt, 1980. On the *furor divinus*, see Kurt Badt, 'Der Gott und der Künstler', in *Kunsthistorische Versuche*, Cologne, 1968, p. 85 ff. On the concept of genius, see E. Zilsel, *Die Entstehung des Geniebegriffs: Ein Beitrag zur Ideengeschichte der Antike und des Frühkapitalismus*, Tübingen, 1926.

The idea of the divinity of the artist, which was expressed in the phrase 'divine frenzy' (*furor divinus*) and later 'Apollonian madness', before being finally secularized as 'creative genius', played an important historical role in the fifteenth and sixteenth

centuries in establishing the dignity of art and thus helping to advance the cause of aesthetic autonomy.

14 Philippe Junod, 'Das (Selbst)porträt des Künstlers als Christus', in Erika Billeter, ed., *Das Selbstporträt im Zeitalter der Photographie: Maler und Photographen im Dialog mit sich selbst*, exhibition catalogue, Lausanne, 1985, p. 64. In the same vein, Cézanne observed that art was 'a priestly office, which demands pure individuals totally dedicated to it'.

15 Peter Altenberg, 'Kunstschau 1908 in Wien', *Wiener Allgemeine Zeitung*, 9 June 1908.

16 This aphorism, and others, are found in a letter from Schiele to his uncle, Leopold Czihaczek, dated 1 September 1911. Christian M. Nebehay, *Egon Schiele: Leben und Werk*, Salzburg, 1980, p. 96.

17 The whole complex of radiations and currents, and their influence on art, is the subject of a forthcoming book by Christoph Asendorf.

18 Quoted by Heinz Spielmann, 'Kokoschkas Kindheit und früheste Gemälde', in *Oskar-Kokoschka-Symposion der Hochschule für angewandte Kunst in Wien*, Salzburg and Vienna, 1986, p. 37.

19 In the 'Manifest der Futuristen', published in the Expressionist periodical *Der Sturm*, edited by Herwarth Walden, there is the following declaration: 'A portrait must not look like its sitter.' *Der Sturm*, vol. 3, no. 103, March 1912, p. 822.

20 Karl Kraus, *Die Fackel*, no. 374, 1913, p. 32. In the naive mystical language current at that time, the transparency and mutability of the model are a factor of the 'second sight and visions' (*Gesichte und Visionen*) that distinguish the true artist.

21 Quoted by Franz Erpel, *Max Beckmann: Die Selbstbildnisse*, Berlin, 1985, p. 19.

22 Nietzsche's Zarathustra was the ultimate literary expression of this particular role-model: '... and I would not know how to live, were I not to be a seer of what must come. A seer, a perfecter, a creator, a future in myself and a bridge to the future.' Quoted by Erpel (see note 21), p. 19.

23 The frequency with which the press mentioned, and took issue with, Kokoschka appears surprising if one bears in mind the fact that the 'Kunstschau' was the largest art exhibition ever held in Vienna: over 1,000 works by 179 artists in 54 rooms. The newspaper critics, overwhelmed by the sheer volume of the task, mostly gave little space to reviewing the works on show; and yet Kokoschka's name constantly recurs. The legend of Kokoschka as an unappreciated and despised artist was launched, at least in part, by the artist himself. It finds expression in his self-dramatizations as the Man of Sorrows, as a bearer of the Stigmata, and – also in 1909 – as 'one who runs amok'. Werner J. Schweiger made a historical reconstruction of the critical response to Kokoschka's early work, and this enabled him to correct the image of the artist as a social outcast. Werner J. Schweiger, 'Zwischen Anerkennung und Verteufelung', in *Oskar-Kokoschka-Symposion* (see note 18), p. 114 ff.

24 Richard Muther, 'Die Kunstschau', *Die Zeit* (Vienna), vol. 7, no 2049, 6 June 1908, pp. 1-2.

25 G. Pelles, *The Passionate Men: A Study of Romantic and Neoclassic Painters in France and England in the Early XIXth Century*. New York, 1957. See also Junod (see note 14), p. 70.

26 See Peter Gorsen, 'Jugendstil und Symbolismus in Wien um 1900', in *Wien um 1900: Kunst und Kultur*, Vienna, 1985, p. 17 ff.

27 Wolf Lepenies has described the cult of solitude in the eighteenth and early nineteenth centuries as a kind of inner exile, in which the individual could indulge a penchant for melancholy or else seek imaginative compensation for his lack of achievement in real life. Wolf Lepenies, *Melancholie und Gesellschaft*, Frankfurt, 1972, pp. 76-101.

28 Quoted by Hartmut Scheible, *Literarischer Jugendstil in Wien*, Munich and Zurich, 1984, p. 11.

29 The social upheavals of the late nineteenth-century *Gründerzeit*, a period of rapid industrialization, posed a threat to the social class which was the natural habitat of art, music and literature. The liberal bourgeoisie found itself under simultaneous attack from the workers, organized by the Social Democrats, and the lower middle classes, represented by the Christian Social Party.

A poem by Hofmannsthal, 'Wien 1. Mai 1890, Prater gegen fünf Uhr nachmittags' (Vienna, 1 May 1890, Prater Park about Five o'Clock in the Afternoon), well evokes this whole political context of escapism, aestheticism and the cult of solitude: 'The mob howls in the streets; dearest, let it rage. Its love and its hatred are paltry and vile. In the little time they leave us, let us pledge ourselves to finer things. If a chill of fear grips you, wash it away with hot wine! Leave the mob in the streets: slogans, uproar, lies, deceit, all wither and fade away. Beautiful truth alone lives.' Quoted by Scheible (see note 28).

30 Quoted by Nebehay (see note 16), p. 19.

31 Johannes Dobai, *Gustav Klimt: Die Landschaften*, Salzburg, 1981, p. 17.

32 Quoted by Astrid Gmeiner, 'Carl Moll: Mittler zwischen Tradition und Moderne', in *Carl Moll: Seine Freunde, Sein Leben, Sein Werk*, Salzburg, 1985, p. 54.

33 Max Haushofer, 'Die Stimmungslandschaft', *Die Kunst für alle*, vol. 1, no. 15, 1886, p. 199. Some two decades later, Bruno Wille carried the idea further, pinpointing the connection between industrialization, progress and the loss of inner harmony: 'Modern civilization has achieved magnificent developments in machinery, natural science, soldiering, communications, practical education and travel. What we lack is inwardness, subjective culture ... inner harmony.' Bruno Wille, *Das lebendige All*, 1905, quoted by Ursula Peters, 'Künstlerischer Wille als fotografisches Programm der Jahrhundertwende', *Fotogeschichte*, vol. 6, no. 19, 1986, p. 10.

34 The early references to this in the German literature of late Classicism and of Romanticism have been mentioned above. Schiller, in Letter 6 of *Über die ästhetische Erziehung des Menschen*, explicitly addresses the topic of the alienation of culture from nature: 'The wound that afflicts modern humanity is a wound that civilization itself has inflicted. When greater experience and greater precision of thought came to require a sharper division between the various branches of knowledge, and when the growing complexity

of the mechanism of the state imposed a greater fixity of distinction among its orders and among its trades, an inner bond was broken within human nature, and its harmonious forces were rent by conflict.' Friedrich von Schiller, *Werke*, Hamburg, n.d., vol. 9, pp. 187-8.

35 The Barbizon group was represented in the big exhibition of French Impressionism that Moll organized at the Secession in 1903, as were the classical precursors of the school, Tintoretto, Rubens, Velázquez, Goya and Delacroix. Moll also demonstrated how the Impressionist tradition was continued and developed by Cézanne, Seurat, Van Gogh, Gauguin, Toulouse-Lautrec, Vuillard, Bonnard, Rysselberghe, Liebermann and Slevogt.

36 The complete text of the letter is printed in Christian M. Nebehay, 'Gustav Klimt schreibt an eine Liebe', *Mitteilungen der Österreichischen Galerie*, Vienna, 1978/79, pp. 108-9.

It has hitherto escaped the notice of Klimt scholars that the painter derived his method of artificially restricting the visual field from Alfred Lichtwark's manual for the amateur photographer. Lichtwark advised amateurs – the practitioners of Pictorialism – to internalize a mode of seeing based on segmentation. This was basically a form of reified consciousness which could be used to visualize a small segment of nature as an aid to taking better pictures: 'The amateur can make this task easier for himself by carrying in his pocket, on his excursions, a piece of dark cardboard with a rectangular opening in the middle, and trying out any motif that strikes him by viewing it through this opening.' Alfred Lichtwark, *Die Bedeutung der Amateurfotografie*, Halle an der Saale, 1894, p. 34. Lichtwark, director of the Kunsthalle in Hamburg since 1886, met Klimt in 1900, if not before. In that year, during the sixth Secession exhibition, a dinner was held at Moll's house in honour of Lichtwark and of the orientalist and collector Adolf Fischer.

37 Ernst Mach, *Antimetaphysische Vorbemerkungen*, Vienna, 1885, p. 18. See Christoph Asendorf, *Batterien der Lebenskraft: Zur Geschichte der Dinge und ihrer Wahrnehmung im 19. Jahrhundert*, Berlin, 1984, pp. 52-70.

38 Vassily Kandinsky, *Über das Geistige in der Kunst*, Munich, 1910 (published 1911); English translation in Vassily Kandinsky, *Complete Writings on Art*, ed. Kenneth C. Lindsay and Peter Vergo, London, 1982.

39 Letter to Franz Hauer, 13 August 1913. Nebehay (see note 16), p. 128.

40 Leopold (see note 7), p. 208.

41 Ibid.

42 In the painting *Mother with Two Children* (*Mutter mit zwei Kindern*, 1915; Cat. 48) the contrast between life and death emerges less from the skull-like face of the mother than from the chilly olive-yellow of her garment and the blue-grey of the skin tone. These colours of death and decay contrast with the warm orange of the background and the colourful clothing of the child on the right – who, however, is a cretin incapable of independent life. Schiele entrusts his existential message of the relationship between the living and the dead to the iconographical type of the *Pietà* and – as so often – to the symbolism of cold and warm hues. See Leopold (see note 7), p. 392.

43 Quoted by Hans Hinterhäuser, 'Die todessüchtige Seele', in the programme booklet for the 1987 production of Erich Wolfgang Korngold's opera *Die tote Stadt* at the Vienna State Opera.

44 Albert Paris Gütersloh, *Egon Schiele*, exhibition catalogue, Galerie Miethke, Vienna, 1911.

45 Karl Rosenkranz, *Ästhetik des Hässlichen*, Königsberg, 1853, reprint, n.d., p. 8. For the 'no longer fine [or beautiful] arts' (*die nicht mehr schönen Künste*), see Odo Marquard, 'Zur Bedeutung der Theorie des Unbewussten für eine Theorie der nicht mehr schönen Künste', in *Die nicht mehr schönen Künste: Poetik und Hermeneutik*, Munich, 1968.

46 Ludwig Hevesi, *Das verruchte Ornament*, 1903. Quoted in *Gustav Klimt. Die goldene Pforte* (see note 10), p. 117.

47 A year earlier, in 1898, Bahr had designed his ideal home. This was a house full of beautiful things – such as a chair, wallpaper and a lamp – in which he could be self-identical; 'In such a house I would see my own soul everywhere, as in a mirror. That would be my house.' Hermann Bahr, *Secession*, Vienna, 1900, p. 37.

48 Robert Musil, *Der Mann ohne Eigenschaften*, in *Gesammelte Werke*, ed. Adolf Frisé, Reinbek, 1978, vol. 1, p. 128.

49 The self-portrait with the totally disillusioned, vacant look in its eyes is in the Graphische Sammlung Albertina, Vienna.

50 Adalbert Franz Seligmann, 'Die Kunstschau 1908', *Neue Freie Presse*, no. 15,727, 2 June 1908, p. 14. Quoted by Werner J. Schweiger, *Der junge Kokoschka*, Vienna, 1983, p. 68.

51 Marquard (see note 45), vol. 3, p. 375.

52 'Yes, our age is forced to distil its beauty out of terror!' Alfred Kubin, letter to Reinhard Piper, July 1923. Quoted by Erpel (see note 21).

53 'Art is the desperate cry [*der Notschrei*] of those who in their own persons experience the fate of humanity.' Arnold Schoenberg, *Frühe Aphorismen*, 1909. Quoted by Hilde Zaloscer, *Der Schrei: Signum einer Epoche – Das expressionistische Jahrhundert*, Vienna, 1985, p. 11. This formula of Schoenberg's ultimately derives from Hegel's notion of art as the awareness of exigencies (*Nöte*).

54 The words quoted here were intended to form part of a public appeal, which remained unpublished; Schiele sent the text to Peschka in his letter of 2 March 1917. Nebehay (see note 16), p. 181.

55 Arthur Roessler, 14 May 1912. Nebehay (see note 16), p. 117. The idea that a smell of decomposition emanated from the paintings of Kokoschka and Schiele became a commonplace of art criticism. In the *Neues Wiener Tageblatt* of 11 November 1912, Friedrich Stern wrote of Schiele: 'He has a self-portrait here, also, which is hard to identify as such solely because of the advanced state of decomposition in which he has felt impelled to portray his own youthful features. This is sad.' Quoted by Nebehay (see note 16), p. 118.

56 Quoted by Jean-Michel Palmier, 'Träume um Egon Schiele', in Wolfgang Pircher, ed., *Debut eines Jahrhunderts: Essays zur Wiener Moderne*, Vienna, 1985, p. 141. The fact that the prison diary in question is a fake, written not by Schiele but by Roessler – as Rudolf Leopold has proved (see biography, p. 282) – may safely be ignored in this particular context, because Roessler's words do seem to convey Schiele's own thoughts and views. Leopold (see note 7), p. 666.

57 Arnim Friedemann, exhibition review, *Wiener Abendpost*, 21 March 1918.

58 The impossibility of maintaining any aesthetic detachment in a sexual context, and the incompatibility of this context with art as such, was first asserted by Jean Paul: 'There are two emotions which admit of no pure, free artistic enjoyment, because they force their way out of the painting and into the beholder's mind, where they twist contemplation into suffering. These emotions are those of disgust and sensual love.' Jean Paul, *Vorschule der Ästhetik*, vol. 3, section 2.

59 Werner Hofmann, 'Gustav Klimt und die Wiener Jahrhundertwende', in *Gustav Klimt. Die goldene Pforte* (see note 10), p. 36.

60 The moralistic outcry against these nude figures, which were considered to be inappropriate for their intended setting, a university building, spurred even Karl Kraus – who was definitely no admirer of Klimt – into taking up arms, if not on Klimt's behalf, at least against Klimt's adversaries: 'It is possible to have great reservations about the philosophical pretensions of Klimt's Faculty paintings; but it really will not do, in the last resort, to abuse this extraordinarily able man because his female figures are not "chubby" enough, or because they fail to match up to some "cuddlesome" ideal of prettiness.' Karl Kraus, *Die Fackel*, no. 155, 24 February 1904, p. 8.

61 Karl Kraus, *Die Fackel*, no. 74, April 1901, p. 27.

62 Nike Wagner, *Geist und Geschlecht: Karl Kraus und die Erotik der Wiener Moderne*, Frankfurt, 1982, p. 48.

63 Ludwig Hevesi, 'Weiteres zur Klimt-Ausstellung', in *Acht Jahre Secession*, Vienna, 1906, p. 449.

64 The most famous book on the subject was undoubtedly Otto Weininger's magnum opus, *Geschlecht und Charakter*, Vienna, 1903, which appeared in twenty-five editions over a period of twenty years. Other works that played a significant part in the debate on the 'sexual question' in Austria, and in Vienna in particular, are succinctly analysed by Wagner (see note 62), pp. 67-131.

65 Schiele's drawings and watercolours were his main, if not only, source of income. He was never able to make a living by selling his paintings, unlike Klimt, even though the latter's output as a painter was very much smaller. One price comparison will make this abundantly clear. Both artists painted portraits of Friederike Beer-Monti; Schiele was paid 600 crowns, Klimt 20,000.

66 Quoted by Peter Gorsen, *Sexualästhetik: Zur bürgerlichen Rezeption von Obszönität und Pornographie*, Reinbek, 1972, pp. 11-12. 'The crude and ugly aspect of sexuality, its animal character, the near-absurdity of its mechanics, emerge in caricature, liberated from the pursuit of some classical ideal of beauty, freed from the base prettification of ugliness.'

67 Adalbert Franz Seligmann, *Neue Freie Presse*, 11 January 1914, quoted by Leopold (see note 7), p. 668.

68 Gottfried Fliedl, 'Das Weib macht keine Kunst, aber die Künstler: Zur Klimt-Rezeption', in *Der Garten der Lüste: Zur Deutung des Erotischen und Sexuellen bei Künstlern und ihren Interpreten*, Cologne, 1985, pp. 92-93. Nor is Klimt's statement (ibid.) that a model's 'backside [is] more beautiful and more intelligent … than many other people's faces' exactly a document of feminism in action.

69 Fliedl (see note 68), p. 93.

70 *Impregnare eam ipsis oculis.* Quoted by Gert Mattenklott, 'Das gefrässige Auge', in D. Kamper and C. Wulf, eds, *Die Wiederkehr des Körpers*, Frankfurt, 1981, p. 237.

71 Norbert Grabowsky, *Die geschlechtliche Enthaltsamkeit als sittliche Forderung*, 1894. Quoted by Oskar Panizza, 'Die sexuelle Belastung der Psyche als Quelle künstlerischer Inspiration', *Wiener Rundschau*, no. 1, 15 February 1897, p. 350.

Patrick Werkner

Body Language, Form and Idea
in Austrian Expressionist Painting

Figure, nude or portrait as the representation of a psychic state: this was a nineteenth-century idea which came to Egon Schiele from the late Symbolist painting of the *fin de siècle.* It was an idea that he dramatized to the utmost. The way had already been paved in Viennese *Jugendstil,* and in the painting of Gustav Klimt in particular, but the radical shift to a true 'art of expression' took place only in the generation of Kokoschka and Schiele.

Schiele's self-portraiture, in particular − a theme he pursues with almost manic obsessiveness − is the reflection of a process which exhausts all the possibilities of bodily expression, every area of apparent ugliness and morbidity, and subjects the organism to a succession of near-terminal ordeals. Schiele was fascinated by the complex of relationships between inner experience and its external manifestation. The depiction of the body encompassed, for him, the whole range of the formal possibilities that were suggested by his experience of himself and his fellow creatures. 'I always think that the greatest painters have painted figures,' Schiele wrote in 1911.[1] The figure, for him, is the vehicle of expression. The outline of a nude delineates the drama of human life; the surface of a naked body in a watercolour becomes a psychic landscape.

Schiele's Self-Portraits

Schiele confessed that he had 'the craving to experience everything'.[2] His self-portraits are a visual record of that experience. In them there is no basic distinction between the image of his head and that of a semi-nude or nude figure. The grimace, the scream, the contorted face, are the exact counterparts of the crouching, tense, springing pose, and of the body seen in the form of a cross, a phallus or a geometrical figure. There are traces of a wide variety of influences in this: the gaunt, huddled youths of George Minne, the figures of Ferdinand Hodler, with their heavily symbolic eurhythmics − both artists had an honoured place in the exhibitions of the Vienna Secession − and Oskar Kokoschka's graphic linear images of adolescents.

The pictorial structure, throughout Schiele's work, tends to be a matter of drawing. His watercolours and oil paintings are markedly less painterly in conception than are those of Kokoschka, let alone Richard Gerstl. Within the Leopold Collection, this contrast emerges clearly from a comparison of two

major works of early Austrian Expressionism: Gerstl's *Nude Self-Portrait* (*Selbstakt,* 1908; Cat. 87) and Schiele's *Seated Male Nude* (*Sitzender männlicher Akt,* 1910; Cat. 6).

Gerstl, in his self-portraits, records his own nakedness and then imparts an emotional content to it in the process of painting − a process in which the surrounding space plays a decisive part. With Schiele, on the other hand, the figure always draws its life from its own gesture, its own outline, and the configurations that emerge within that outline. The texture of the painting within the figure is the servant of this process; and the space in which the figure moves is there to allow it to emerge in all the vividness of its contours. The relief of the figures shows the imprint of the space; their surface reflects a modelling imposed by the intrusive influence of that space. Gerstl links person and space through a painterly technique derived from Impressionism; Schiele replaces this with an emphasis on line and plane − and thus a sharper distancing of the human being from the world around him. Schiele's early figures − and trees and flowers − accordingly seem isolated and exposed.

Schiele opened up additional expressive possibilities through the freedom of his use of colour; and this applies to his nudes in particular. On a figure's back, for instance, red, green, blue and yellow tones flow into each other or are set down abruptly side by side. A head is coloured red and lilac, as if ready to burst, or frozen in a corpse-like pallor. Knees and ankles assert a life of their own in harsh blue; genitals, nipples and lips are emphasized in crimson; the solar plexus becomes a yellow-green globe. The same profusion of colours may be applied to a single hand or face. This expressive exaggeration of colour has its formal counterpart in the stretching or cramping of a body, or of one part of a body, and in the paroxysms that shake a whole figure or express themselves through a look.

It is in his self-portraits that Schiele carried all this to its extreme. Here, self-caricature alternates with self-contortion, tragic gesture with narcissistic pose. The self-portraits − especially those of 1910 and 1911 (Cat. 7, 19) − constantly force the body to an extreme, as if Schiele were consuming himself in flames.

The personal reminiscences of Schiele which were written − long afterwards − by friends such as Arthur Roessler and Heinrich Benesch describe him, by contrast, as a shy and introverted individual. There was something about him that made

one think of a 'messenger from some unknown, far-off place',[3] and he was a striking person to meet, as the portrait photographs of him also make clear. At the same time, he was 'calm and cheerful' and practised 'the art of life in the fullest sense of the word'.[4] Albert Paris Gütersloh called him 'one of the few good, generous human beings'.[5] He is described as never once having been 'angry, or even annoyed',[6] and as always calm, never vehement or passionate:[7] a striking set of descriptions, if we look at them in conjunction with Schiele's early self-portraits.

His was clearly a contradictory personality, as is further shown by comparing characterizations of this sort – 'a little diffident and a little confident'[8] – with his own words. In 1913, in a letter to his mother, with whom his relationship always remained tense, he wrote: 'In me, through my autonomous will, all fine and noble effects are combined … I shall be the fruit whose decomposition will produce eternal living creatures; so how great must be your joy that you brought me into the world?'[9]

The Body as a Vehicle of Expression

The figures in Schiele's early paintings live by gesture. There is barely one of them that is not characterized in this way. The whole body becomes a means of formal creation, both in its overall form and in detail. The face and hands, in particular, are elements in a stylized body language which involves a large number of recurrent formal devices.

This does not mean that it would be possible to extract a canon of symbols which could be used to interpret any given painting by Schiele. Unlike Alfred Kubin, for instance, whose work, with its manifold references to literature, philosophy and artistic Symbolism, lends itself to study in terms of these references, Schiele confronts us with a body of painting based on a highly private mythology, which draws on the resources of the unconscious. Similarly, those letters in which he himself provides explanations of his paintings or information on their content give little more than generalized points of reference, and reflect a highly emotive style of self-interpretation; whereas Kubin's stance seems very much more intellectual.

It was not only in pictorial art that the human body was coming into its own as a vehicle of expression. Its true medium was 'free expressive dance', the influence of which on Viennese art has already been described elsewhere.[10] Here it is sufficient to point to Schiele's enthusiasm for Ruth Saint-Denis, whose appearances in Vienna were described in such glowing terms by Ludwig Hevesi.[11] (Karl Kraus's counterblasts, in *Die Fackel*, were provoked not so much by the performer's 'graceful, serpentine skill' as by the 'nimble stylistic fingerwork' of the reviewers.[12])

There is just one, myth-laden account of a meeting between Schiele and Ruth Saint-Denis.[13] It appears that she became his ultimate criterion of physical suppleness: when Roessler showed Schiele his collection of Javanese shadow puppets, with which the artist then played for hours on end with astonishing skill,

Schiele's comment was that they were even better than Saint-Denis's dancing. The sharp, vivid outlines of the shadows on the wall fascinated him so much that Roessler let him choose one puppet as a gift. Schiele chose 'a grotesque figure of a demon with a weird profile'.[14]

One artist friend who shared Schiele's fascination with the expressive potential of the body was Erwin Osen, who took part in the 'Neukünstler' (New-Artists) exhibition in 1909. Nearly a decade older than Schiele, Osen was a former scene-painter who now did a mime act in cabaret with a female partner named Moa (Cat. 22). Like Schiele, he was interested in the body language of the sick; he did a number of drawings at the Steinhof mental hospital to illustrate a lecture on 'Pathological Expression in the Portrait'.[15] Mime van Osen, as he sometimes called himself, shared a studio with Schiele for a time. According to Roessler, Schiele was under the spell of Osen and of his companion, Moa, who was 'a willowy dancer with a bone-white face which froze into mask-like immobility beneath blue-black hair … with an unseeing look in the big, jet-black, melancholy eyes which glinted dully beneath the heavy, long-lashed eyelids, with their brown-blue shadow.'[16] Schiele repeatedly drew both Moa and Osen, the latter in a series of ecstatic mime attitudes. A number of Schiele's portrait and nude drawings of Osen bear close analogies to his self-portraits.

Experiencing Pain, Desolation and Death

After Schiele's art broke free of the aesthetic of the Vienna Secession, it developed into a constant confrontation with the basic issues of human existence, and specifically with the polarity of life and death. Until the very late works – in which life and death are seen as a whole, however melancholy that whole may be – the atmosphere is one of profound anxiety and distress. 'All is living dead' is the last line of one of his poems.[17]

As a child, Schiele lost his eldest sister; when he was fourteen, his father died after years of insanity. Adolf Schiele, stationmaster and 'senior official of the Imperial and Royal State Railways', seems to have succumbed to a progressive paralysis.[18] He is said to have received a succession of imaginary guests, whom he invited to stay for dinner, while his family was obliged to play along with the delusion.[19] Left unsupervised for a moment, he took all his stocks and shares, or so we are told, and burned them in the stove.[20]

The adolescent Schiele was undoubtedly troubled by his father's behaviour – all the more so because he was clearly very attached to him. As late as 1913, he wrote that he thought of his father with sorrow and visited the places that he associated with his memory.[21] In 1910 he told his sister of 'a fine spiritist incident: I was awake, but held captive by the spirit who had made himself known to me in my dream; for as long as he was speaking to me, I was rigid and speechless'. Anton Peschka adds: 'The night before, [Egon] said his Papa had been with him.'[22] Two years later, Schiele wrote of his painting *Hermits* (*Eremiten*; Cat. 25) that it was 'more a vision', the culmination

of his 'experiences in the years following the death of my father'.[23]

Schiele's experiences of death, sickness and pathological behaviour found their way into his painting from 1909 onwards. Roessler tells us that he spent months 'drawing and painting proletarian children. He was fascinated by the ravages of the sordid sufferings to which these innocents are exposed.'[24] Through his acquaintance with a gynaecologist, Erwin von Graff, he was able to do drawings in the women's hospital in Vienna. His depictions of pregnant and sick women and girls amount to a counter-manifesto to the refined female portraiture of the Secessionists.

In his portraits, in his self-portraits and in his ecstatic nudes Schiele is constantly searching for the hidden, daemonic, un-whole aspect; and there is no difference in principle between these and the 'pathological' subjects. All these images blur the distinction between sickness and health, between the normal and the abnormal; all spring from the sceptical vision that reveals the scars, the vulnerability, the shadow side, that lie concealed behind a sleek personal façade.

Schiele saw the abyss that lies beneath apparently innocuous appearances; he was aware of death in the midst of life. From 1909 onwards, he constantly reverted to the theme of motherhood; and in 1910 and 1911 he produced three paintings in which the beginning of life is brought into contact with death. The painting *Dead Mother I* (*Tote Mutter I*; Cat. 13) focuses on the head and hands of a newborn child, which seems still to nestle in its amniotic sac. What surrounds the face is dark, however, and covers the child's mother like a shroud, so that we see only her tilted head and one hand.

Dead Mother I may be seen as an expressive intensification of Klimt's *Mother with Children* (*Mutter mit Kindern*, 1909/10; Fig. 1), which was painted concurrently with the first version of *Death and Life* (*Tod und Leben*, finished in 1915; Cat. 109). Schiele's painting does more than document his closeness to Klimt, whom he had once taken as his model: it also shows how Klimt himself remained bound to the theme of the fragility of life from the time he gave it its first monumental expression in the university murals. It was Klimt, therefore, who supplied Austrian Expressionism with one of its leitmotifs.

Eros and Sexus

'The erotic work of art has a sanctity of its own!'[25] Schiele's pronouncement is at once a defence of his own work and a recognition of the existential profundity of Eros. His fascination with death constantly interacted with his urgent concern with sex; and his early Expressionist work can all be reduced to the field of tension between Eros and Thanatos. It was logical that his 'craving to experience everything', his irrepressible curiosity, should lead him into a taboo area.

Drawings and watercolours of the female nude are numerically the largest section of his output. The centrality of this topic in his work is matched by its analogous position in that

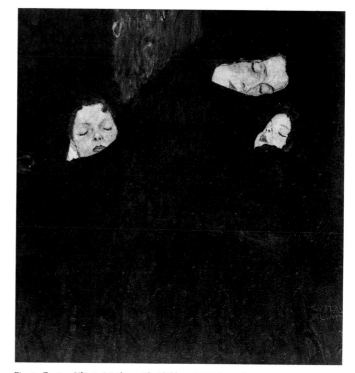

Fig. 1 Gustav Klimt, *Mother with Children*, 1909/10; oil on canvas. Private collection

of Klimt. The gaunt, bony, long-limbed girls in Schiele's nudes and semi-nudes, the contortions of their bodies and the often daemonic treatment of their images, form a marked contrast with the mostly soft, rapt, self-absorbed nudity that Klimt depicts. The uncompromising nature of Schiele's erotic images, and of his own life-style, led in 1912 to his spending twenty-four days in prison after a trial in which one of his erotic drawings was ceremonially burnt.

It is a striking fact that Schiele created a series of highly expressive portraits of men and comparatively few portraits of women. In view of the harshness of his style, however, it is hardly surprising that he received few commissions for female portraits. A portrait of a lady, in turn-of-the-century Vienna, was meant to show her as beautiful and elegant, and often it swamped her in a mass of ornament which converted her into a piece of stage decor. By contrast, all one could expect from Schiele was to be stripped of pretence and twisted out of shape.

The clear division between a man's world, which might be intellectual enough to tolerate experiments in expressivity, and a woman's world, whose function was to present an image of refined sensuality, reflects the prevailing tension between the sexes. The consequent atmosphere of compulsion and obsession strongly affected Schiele, and it was not until his later years that he found his way to a more relaxed treatment of erotic themes, as in *Reclining Woman* (*Liegende Frau*; Cat. 50) of 1917 or *Pair of Women Squatting* (*Hockendes Frauenpaar*; Cat. 52) of 1918.

His early confrontation with the themes of the nude and sexuality is worlds apart from the vital, primitive nakedness that appears, for instance, in the work of the members of the Dresden

group *Die Brücke*. The primal naturalness of all that is sexual, its closeness to the nature of existence itself, as embodied in the early works of Ernst Ludwig Kirchner or Erich Heckel, stands in total contrast to the sexual question as Schiele presents it. The sensual freedom that emanates from the paintings of the Fauves or the early German Expressionists is poles apart from the melancholy, even tragic, nature of Schiele's eroticism.

It is characteristic of him that he often uses props to heighten the erotic effect of what he shows. Stockings and underclothes, shoes and ribbons, are sexual fetishes often emphasized through colour. A lifted skirt, a hand-gesture, a look from beneath lowered eyelids, shows Woman as seductress, as an enticing, animal creature. There are, however, also sympathetic, compassionate images of his mostly youthful models, tender embraces and sensitive renderings of the individual figure. Schiele shows a preference for girls around the age of puberty; in his own adolescence, his sister Gertrud, four years younger than himself, had modelled for him, in some cases naked.

The predominant image in his early Expressionist figure work is that of the nude as an inscrutable, an ecstatic or a suffering being, very much as in his self-portraits, and with the same body language, gestures, and handling of form and colour. However, in contrast to his frequent nude self-portraits, Schiele seldom incorporated female nudes in his early oil paintings. For one thing, he had a ready market for drawings and watercolours of this subject; and for another, it was easier to capture in a drawing the fleeting, spontaneous quality of the pose, of a movement or a mood.

In his nudes of models and of himself, Schiele worked with a sureness of line which was capable of characterizing a figure in a single outline or a few strokes. When critical accounts of Schiele's style refer to an 'encounter with the rational', which is supposed to have led to the clear line in his later portrait and nude sketches, there is a tendency to overlook the fact that in his early Expressionist work, too, the line has an expressive autonomy of statement — a feature that springs ultimately from the linear and planar style of the Vienna Secession.

Transcendence and Realism

'I paint the light that comes out of all bodies', wrote Schiele in 1911.[26] This approach, firmly based in reality and equally firmly transcending that reality, encapsulates his programme as an artist. Schiele was too fascinated by the phenomenal forms of life to be satisfied with an abstract image; equally, he could never have allowed himself to be circumscribed by what was optically perceptible.

The aspiration to paint 'the light that comes out of all bodies' is based on a concept which goes back to Romanticism: that of all-pervading harmonies and an animate universe. This was an idea that fascinated a variety of artists around the turn of the century, and it achieved wide currency, especially in its various theosophical formulations. It is not possible to establish whether Schiele actually read the works of H.P. Blavatsky, Annie Besant

or Rudolf Steiner, but they were undoubtedly discussed in the circles in which he moved. In two letters — unfortunately impossible to verify by reference to original manuscripts — Schiele writes of 'astral light'.[27]

It seems highly speculative, however, to suppose that any specific image by Schiele was prompted by the idea of astral vibrations which extend and transcend the visible spectrum.[28] The same applies to attempts to detect the influence of Steiner in the 'haloes' and auras that appear round several of Schiele's heads. There are figures with 'haloes' in a number of Symbolist and *Jugendstil* paintings; and Impressionism and Post-Impressionism furnish examples of figures that expand and transcend their limits by similar means. This use of the aura was intensified in Expressionism as a way of expressing what happens within the psyche.

Like Kokoschka, Schiele painted visionary paintings, especially portraits. With Schiele, however, there is more of a hallucinatory element. Paintings such as *Poet* (*Lyriker*; Cat. 15) or *Self-Seer II* (*Selbstseher II*; Cat. 16), based on images of Schiele himself, belong to a series of works painted in 1910 and 1911 in which his troubled self-image, often nude or semi-nude, is brought into contact with an alter ego, thus doubling or multiplying the act of self-portraiture. The mostly closed or half-closed eyes, the smouldering, sightless eye-sockets, point to inner processes in the figures depicted. The titles alone of such paintings by Schiele as *Procession* (*Prozession*), *Madonna* and *Youth on his Knees before God the Father* (*Jüngling vor Gottvater kniend*) are sufficient indication of their visionary and in many cases metaphysical content. The same goes for the related self-portraits, and for the large painting *Hermits* (Cat. 25), one of Schiele's most important works. In one of his letters, Schiele wrote that this painting showed 'the bodies of men weary of living — suicides — but men of feeling'.[29] Here, too, Schiele has portrayed himself, as is proved by a self-portrait study for the painting (Cat. 24).[30]

In and around 1912 changes took place in Schiele's work which — without any abrupt transitions — point to the end of his early Expressionist phase. These changes can be traced most clearly in his self-portraits, which now take on a comparatively lyrical aspect. They are no longer so strongly marked by *angst*, ecstasy and visionary hallucinations as before. This tendency can be clearly detected, for instance, in *Self-Portrait with Winter Cherry* (*Selbstbildnis mit Lampionfrüchten*; Cat. 28) and in *Portrait of Wally* (*Bildnis Wally*; Cat. 29).

Schiele's visionary paintings now started to look more like paintings of ideas than explosions of raw emotion. The treatment of the nude, and of erotic subject-matter, became less daemonic. The theme of motherhood was taken up again, but no longer so exclusively dominated by the idea of death. *Mother with Two Children* (*Mutter mit zwei Kindern*; Cat. 48) combines echoes of Christian iconography — the *Pietà* and the Virgin and Child — into a tragic image of the family. In *Blind Mother* (*Blinde Mutter*; Cat. 39) of 1914, the theme becomes a pretext for a composition organized in a succession of planes and spatial elements. This painting reflects, much more clearly than the

earlier *Dead Mother I* (Cat. 13), the artist's encounter with the art of the rest of Europe; although Cubist tendencies found their way into his work only in a highly refracted form.

A similar new concern with spatial relationships appears in *Cardinal and Nun* (*Kardinal und Nonne*; Cat. 26) of 1912. The erotic subject of this work, to which Schiele gave the alternative title *Caress* (*Liebkosung*), is a paraphrase of Klimt's *The Kiss* (*Der Kuss*; Fig. 2). The presentation of sexual love as a problem – and even in Klimt's work an abyss opens next to the lovers – is emphasized by Schiele not only through the layout of the composition but through the clerical status of the persons portrayed.[31]

From 1912 onwards, Schiele's drawings place increasing emphasis on concrete reality; in portrait drawings, for example, there is a clearer concern with the external physiognomy of the sitters. All in all, these changes were the prelude to a line of development which led to the considerably more realistic manner of Schiele's last years. A characteristic document of this new style is one of his last paintings, *Pair of Women Squatting* of 1918 (Cat. 52).

Richard Gerstl: Antidote to Viennese Aestheticism

Richard Gerstl's painting stands in marked contrast to that of Schiele. Gerstl, who was seven years older, killed himself in 1908; his work came to public notice only in 1931, and he is unlikely to have come into contact with Schiele. Just before Schiele gained admission to the class of the history and portrait painter Christian Griepenkerl at the Academy in Vienna, Gerstl left it for the *Spezialschule* of a more open-minded academician, Heinrich Lefler. Unlike Schiele, Gerstl chose to dispense with rhetoric and symbolism, gesture and mysticism, and with a pictorial structure founded on line.

Gerstl was a painter through and through, and the Impressionist experience of light and colour had been the decisive influence on his art. In his early paintings he experimented with Pointillism, which was extremely influential in Vienna by way of the Divisionism of Giovanni Segantini. Gerstl practised the technique of optical colour mixing of pure hues, but abandoned the systematic application of Divisionist method in favour of a more animated handling. Alongside the dabs of colour, alongside a number of more two-dimensional paintings which recall Pierre Bonnard and Edouard Vuillard, there is also a marked tendency towards realism in Gerstl's work. A comparison between his two self-portraits in the Leopold Collection (Cat. 80, 87) typifies the contrasts within his oeuvre.

The major part of Gerstl's work was painted between 1904 and 1908; its avoidance of painterly refinement, and of the whole decorative 'design for living' that was so characteristic of Vienna in the 1900s, totally precluded any contemporary recognition. In Gerstl, the preciosity and playfulness that are so typical of Viennese *Jugendstil* disappear in favour of subjectivity of perception and suggestive use of background colour. His work differs from that of many Secessionist artists, and also

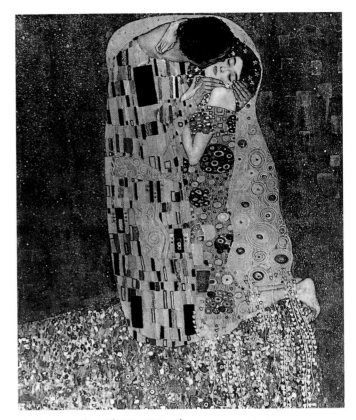

Fig. 2 Gustav Klimt, *The Kiss*, 1908; oil on canvas.
Österreichische Galerie, Vienna

from those who later became the Austrian Expressionists, insofar as it entirely dispenses with allegorical and literary references. His themes are the portrait, the nude, and the rural and urban landscape.

Gerstl intensified the Impressionist visual experience by adding an emotional charge to the painting of light. This developed, as his work proceeded, into a free, gestural handling that was increasingly remote from the object to be depicted. Within a few years he made a dramatic thrust forward to the very brink of autonomous painting. As a solitary who founded no school, he nevertheless anticipated much of the transposition of psychic agitation into painterly energy which was later to take place in Tachism, *Art Informel* and Abstract Expressionism.

The lack of recognition of Gerstl's work casts an interesting light on the specific character assumed by Modernism in the Vienna of the period. What was prized above all was a sumptuous mixture of Symbolism and *Jugendstil*. 'People are besotted with Khnopff and Segantini,' wrote Hermann Bahr as early as 1898.[32] The magazine of the Secession, *Ver Sacrum*, launched in the same year, devoted its December issue to Fernand Khnopff. Other artists who repeatedly figured in the Secession exhibitions were Auguste Rodin, Max Klinger and Arnold Böcklin. In the Symbolist content of their paintings these artists had much in common with Segantini, whose Symbolism, rooted in the natural world, created a deep impression.

The work of Edvard Munch, on the other hand, was initially greeted with indifference, and showings of the work of Van Gogh and Gauguin aroused more irritation than comprehension.

Even the great French Impressionist exhibition mounted by the Secession in 1903 met with no response either from public institutions or private collectors.

Not long afterwards, a large Ferdinand Hodler retrospective was a great success. His work was highly influential in Vienna, especially on Kolo Moser, many of whose paintings, both landscapes and figure compositions, look like paraphrases of Hodler – examples are *Venus in the Grotto* (*Venus in der Grotte*; Cat. 135) and *The Wayfarer* (*Der Wanderer*; Cat. 136). Moser called Hodler 'a magnificent individual at a primordial stage, yet highly sensitive – wild, a master of expressiveness in its every phase.'[33]

In the painting of the early phase of Viennese Modernism, the refined elegance of Viennese *Jugendstil* was combined with elements of rhetoric and allegory. This blend was modified by Klimt, discarded by Gerstl and adopted by Schiele, initially, in a style of intensified emotive expression. Schiele's persistence in employing symbolism, as well as his comparatively firm basis in the visible forms of reality, conflict with the classic Modernist position; and the same goes for the formal message of his works. Schiele's pictures are clearly distinct from those of the Fauves or the German Expressionists, which display a more abstract formal idiom and enshrine allusions both to primitive art and to a revolutionary way of life. In France and Germany, too, there was an elemental response to colour; in Austria, the influence of Secessionist and Wiener Werkstätte (Vienna Workshop) preciosity made such a response impossible.

It is in these respects, above all, that Gerstl stands revealed as the truly 'European' figure among Austrian artists. He dispenses entirely with unreality, the dream world, all that is mystical – although he has one thing in common with Schiele, the penchant for self-portraiture (which in Schiele's case often tends towards narcissism). A concern with the artist's own physical states – and with those of other people – is a prime characteristic of early Austrian Expressionism; and it has reappeared in a modified but equally pronounced form in the younger generation of Austrian artists since the 1950s. The problematic, often self-tormenting, approach to erotic themes in the work of Kokoschka and Schiele contrasts with the freer, more vital handling of sexuality in French and German art.

Varieties of Expressionism: The 'New-Artists'

In December 1909, at the Kunstsalon Gustav Pisko, near the Schwarzenbergplatz in Vienna, an exhibition opened under the title of 'Neukünstler' (New-Artists); it represented the work of a heterogeneous and short-lived artistic group. The impetus for this came from the legendary 'Kunstschau' (Art Show) exhibitions mounted by Klimt and his friends in the summers of 1908 and 1909, which had shown a cross-section of the Austrian and European avant-garde.

The 'Neukünstler' exhibition showed the work of a number of defectors from the Academy class of the reactionary Christian Griepenkerl, together with other young artists. Schiele was one of the ringleaders, if not *the* ringleader, in the exodus from the Academy, and it was probably he who gave the exhibition its title; at least, so his contemporaneous manifesto *Neukunst* would seem to imply. The artists who exhibited with him included – alongside a number of names quite forgotten today – Anton Faistauer, Franz Wiegele, Hans Böhler and Albert Paris Gütersloh, all of whom are represented in the Leopold Collection.

Of these, the most closely akin to Schiele at that time was his former classmate at the Academy, Anton Faistauer, whose poster for the exhibition looks like a paraphrase of Schiele's figure and gesture studies. Soon afterwards, however, Faistauer came under the spell of nineteenth-century French painting, in particular that of Courbet and Cézanne.

Where Hans Böhler is closest to Schiele is in his early drawings, with their erotic tone. His highly coloured paintings show a style which further develops the optical effects of Impressionism while absorbing a strong expressive element.

Franz Wiegele's connection with Expressionism was tenuous, and he soon turned to classical models. Together with Anton Kolig, who later became his brother-in-law, Wiegele was one of the central figures in the Nötsch Circle, which played an important part in the development of so-called Painterly Expressionism in Austria.

Kolig exhibited, along with Kokoschka, Wiegele, Faistauer, Gütersloh and Erwin Lang, at the *Hagenbund* (Hagen Group) exhibition in Vienna in February 1911. His painting is dominated by a gestural brushstroke, his drawing by the network of structural lines that compose his figures of nude youths.

Another member of the Schiele circle was Ludwig Heinrich Jungnickel, who had exhibited at the first 'Kunstschau' in 1908. He became known above all for his paintings of animals, and his Schiele-influenced nudes have tended to be overlooked as a result.

Of all Schiele's fellow exhibitors at the 'Neukünstler' show, the most vocal champion of early Austrian Expressionism was Albert Paris Gütersloh. In 1911 he published *Egon Schiele: Versuch einer Vorrede* (Egon Schiele: An Attempt at an Introduction), and in 1912 he raised the banner of *Neukunst* once more by mounting an exhibition under that title in Budapest, showing works by Kokoschka, Schiele, Faistauer, Kolig, Arnold Schoenberg, Robin Christian Andersen and himself. His catalogue introduction was reprinted in the local German-language daily, *Pester Lloyd*.[34] Gütersloh, who had begun his career as an actor and writer, wrote his first novel, *Die tanzende Törin* (The Dancing Fool), in 1909, and it was published in Berlin the following year. For the rest of his life he continued to cultivate both his talents, as a writer and as a visual artist.

The few drawings by Gütersloh that have survived from the period before 1912 show an individual manner of transforming the linear compositions of Viennese *Jugendstil* into more or less caricatural forms. He then began to fall in with the gestural language of Kokoschka and Schiele. In watercolours of fantasy scenes, religious themes or comic genre scenes, the expressive quality is powerfully stressed. The combination of Expressionist, Cubist and Veristic stylistic elements, which marks his work

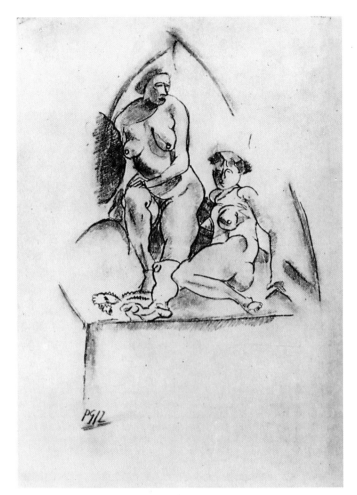

Fig. 3 Albert Paris Gütersloh, *Two Nudes*, 1912

The existence of a state of rivalry between the two artists is confirmed by Schiele's reaction to the preface written by Otto Benesch for the catalogue of his 1915 Galerie Arnot exhibition, in which Benesch linked his name with those of Klimt and Kokoschka. When Schiele complained, Benesch replied: 'Kokoschka is not so "bad" as to make it a sin to mention his name in association with yours.'[37] It is impossible to overlook Schiele's and Kokoschka's common roots in Viennese *Jugendstil*, and the initial closeness of style and content in their works. Kokoschka undoubtedly made the breakthrough into Expressionism before Schiele; however, the time-lag is considerably shorter than was long assumed.[38]

Unlike the founders of the Secession, the artists of the succeeding generation did not instantly form durable groupings or associations. These artists were far too individualistic – some even solipsistic – for anything of that kind.

Local Variants

Both Kokoschka and Schiele were represented in the private collection of the Viennese physician Dr Oskar Reichel, which went on show at the Galerie Miethke in 1913. This was a characteristic blend of Viennese Biedermeier, French Impressionism, Gauguin, Van Gogh, Toulouse-Lautrec and Munch, with works by Kokoschka, Oppenheimer, Schiele, Gütersloh and Faistauer. Reichel's collection also included a large body of work by Anton Romako, whom he rescued from oblivion; he ranks as the first great collector of Expressionist art in Austria.

Another collection in which Kokoschka appeared alongside Schiele was that of Franz Hauer,[39] which also contained works by Albin Egger-Lienz. This artist, who regarded Expressionism as a passing aberration, nevertheless produced some works that carry the characteristic Expressionist emotive charge. His monumental Symbolist studies of peasant subjects were joined, before the end of the decade, by paintings which depict the horror of his own wartime experiences in a decidedly Expressionist manner. Works such as *To the Nameless* (*Den Namenlosen*) or *Finale* (1918; Cat. 70) are among the few effective treatments of the horror of war in modern Austrian painting. Here, Egger-Lienz's stylized, rhythmic manner led him to images which go beyond mere allegory, although the subjectivity central to true Expressionism always remained alien to him.

Alfons Walde, like Egger-Lienz, came from Tyrol. He was decisively affected by the influences of Klimt and Schiele that he was exposed to in Vienna. These influences are visible above all in his early portraits of women (Cat. 140) and in his nudes, often imbued with worldly chic or sultry sensuality. Schiele's influence is visible, above all, in Walde's dense early views of the town of Kitzbühel. Walde also painted lively village scenes in intense colour, with a marked two-dimensional, ornamental quality. From the 1920s onwards, he concentrated on the Alpine landscapes, skiers and peasants which made him famous, and painted Kitzbühel, with its radiant blue sky, over and over again in countless variants.

after 1912 (Fig. 3), soon turned into a mélange of Biedermeier, bizarrerie and fantasy.

Max Oppenheimer, who signed himself MOPP, did not exhibit with the *Neukünstler* but was also a member of Schiele's wider circle. In 1910 he painted a powerful portrait of Schiele (Fig. 4) and was drawn by him in return. He is one of the few Austrian artists whose work around 1912 shows the dominant influence of Cubism, and even more of Futurism. The Futurists' technological enthusiasm, and their fascination with dynamic studies of motion, take a very 'Viennese' turn in his studies of the movements of orchestral and chamber musicians at work.

In 1909 Schiele was a newcomer to the Viennese artistic scene. Kokoschka had enjoyed the protection of Klimt for some time and had made a name for himself as an *enfant terrible* at the 1909 'Kunstschau', if not before. The circle around Adolf Loos and Karl Kraus also championed Kokoschka and reacted with hostility to any supposed 'imitators'. The early campaign against Oppenheimer, who had incorporated some stylistic features of Kokoschka's work in his own, is a clear illustration of this.[35] Kokoschka was at pains to distance himself from the work of Schiele, who was four years his junior,[36] and in 1918 he declined Schiele's invitation to exhibit jointly with him in a large exhibition at the Secession.

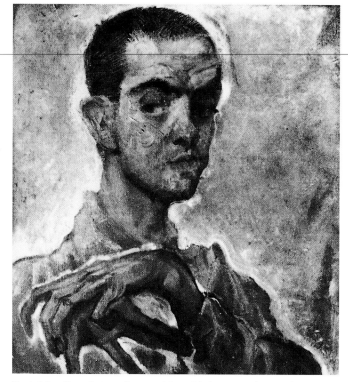

Fig. 4 Max Oppenheimer, *Portrait of Egon Schiele*, 1910; oil on canvas.
Historisches Museum der Stadt Wien, Vienna

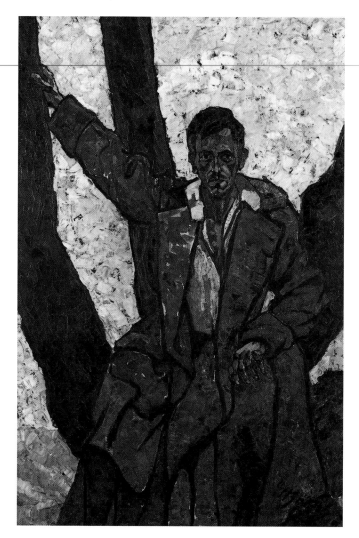

Fig. 5 Herbert Boeckl, *Portrait of Bruno Grimschitz*, 1915; oil on canvas.
Österreichische Galerie, Vienna

The 'Sacred Spring' of Austrian art, the innovations of the 1900s, were all phenomena which emerged from Vienna while it was still the metropolis of the Habsburg Empire. But in the years between the wars the art produced in the new, truncated republic was for the most part the work of a large number of artists from the provinces, who studied in Vienna, absorbed varying degrees of metropolitan influence and, in most cases, returned home to work. The massive eruptions of early Expressionism, its visions, chasms and passionate indictments, had given way to a more tranquil art which concerned itself primarily with considerations of form. The practitioners of what became known as Painterly Expressionism had a great deal in common with the German Impressionism of such artists as Max Slevogt, Max Liebermann and Lovis Corinth. The dynamism of the rendering of reality in these artists' works goes far beyond mere naturalism. The influence of Cézanne is present, but also that of local traditions, as well as the often-invoked Baroque heritage of Austrian painting.

This pattern is clearly marked in the work of a number of artists active in Carinthia: they included Kolig and Wiegele, and also Herbert Boeckl. This artist, four years younger than Schiele, showed Schiele's influence in his portrait of the art historian Bruno Grimschitz, painted in 1915 (Fig. 5). After 1918, with

Klimt and Schiele dead, and Kokoschka out of the country, Boeckl was probably the most gifted painter working in Austria. Initially, he used colour almost exclusively as a means of expression; he used it with a vigour whose elemental sensuality contrasts with the brooding *angst* of the early Kokoschka.

Boeckl is the most clearly defined exponent of Painterly Expressionism, as opposed to the psychological concerns of early Expressionism, which could have originated only in an urban atmosphere. Thus, death and destruction, which appear as the themes of some of his still-lifes, are marked less by horror than by a sense of acceptance of the inevitable. Four works in the Leopold Collection (Cat. 57-60) were painted before he travelled to Paris and to Italy and received a new impetus from Cézanne and from the colour of the Mediterranean landscape (Cat. 61). We can no longer speak of a 'contemporary' of Schiele's; but the latter's influence remained alive in the work of many Austrian artists well into the 1930s.

After 1945, Modernism began to revolve around abstraction, and Schiele, as a supposedly belated provincial offshoot of European Modernism, was credited with local importance at best. International recognition came only towards the end of the 1950s. This reflected a new attitude to the representation of the figure and the object in art, together with a renewed

appreciation of the importance of the symbol. The artistic practice of the 1980s – in which painting, and figuration in particular, are vital elements – goes to confirm the continuing relevance of Schiele's art, however different the premises on which it was originally produced. His paintings will meet with a powerful response at the international showings of the Leopold Collection – in which they appear for the first time within the context of a broad selection of the art of his contemporaries.

Notes

1 Letter to Leopold Czihaczek, 1 September 1911. Christian M. Nebehay, *Egon Schiele 1890-1918: Leben, Briefe, Gedichte*, Salzburg and Vienna, 1979, p. 182, no 251. What follows is discussed in a wider context in Patrick Werkner, *Physis und Psyche: Der österreichische Frühexpressionismus*, Vienna and Munich, 1986.

2 Letter to Leopold Czihaczek, 1 September 1911 (see note 1).

3 Arthur Roessler, *Erinnerungen an Egon Schiele*, Vienna, 1948, p. 5.

4 Heinrich Benesch, *Mein Weg mit Egon Schiele*, New York, 1965, p. 13.

5 Albert Paris Gütersloh, in 'Erinnerungsbuch an Egon Schiele', unpublished ms. album. Albertina, Vienna, Egon-Schiele-Archiv no. 508.

6 Benesch (see note 4), p. 13.

7 Roessler (see note 3), p. 6.

8 Benesch (see note 4), p. 11.

9 Letter of 31 March 1913. Nebehay (see note 1), p. 252, no. 453.

10 Patrick Werkner, 'Kokoschkas frühe Gebärdensprache und ihre Verwurzelung im Tanz', in *Oskar-Kokoschka-Symposion der Hochschule für angewandte Kunst in Wien*, Salzburg and Vienna, 1986, pp. 82-99.

11 Ludwig Hevesi, *Altkunst – Neukunst: Wien 1894-1908*, Vienna, 1909, pp. 282-4.

12 *Die Fackel*, no. 216, 9 January 1907, pp. 20-1.

13 Fritz Karpfen, 'Tanzende Sterne', undated clipping from *Die Weltpresse*. Albertina, Vienna, Egon-Schiele-Archiv, no. 863.

14 Roessler (see note 3), p. 36.

15 Apparently commissioned by the lecturer, a Dr Kornfeld. Letter from Erwin Osen to Schiele, 15 August 1913. Nebehay (see note 1), p. 270, no. 570.

16 Roessler (see note 3), p. 39.

17 Nebehay (see note 1), p. 143, no. 167.

18 Alessandra Comini, *Egon Schiele's Portraits*, Berkeley and Los Angeles, 1974, p. 9.

19 Ibid., p. 11.

20 Nebehay (see note 1), p. 15.

21 Nebehay (see note 1), p. 264, no. 544.

22 Nebehay (see note 1), pp. 134-5, no. 112.

23 Letter to Carl Reininghaus, after 27 February 1912. Rudolf Leopold, *Egon Schiele: Gemälde, Aquarelle, Zeichnungen*, Salzburg, 1972, p. 510.

24 Arthur Roessler, 'Egon Schiele', *Bildende Künstler*, no. 3, 1911, pp. 104-18; quotation p. 114.

25 Letter to Leopold Czihaczek, 1 September 1911 (see note 1).

26 Ibid.

27 Arthur Roessler, *Briefe und Prosa von Egon Schiele*, Vienna, 1921, p. 157.

28 Comini (see note 18), pp. 44-5.

29 Letter to Carl Reininghaus, after 27 February 1912 (see note 23).

30 Leopold (see note 23), p. 210.

31 Leopold (see note 23), p. 230.

32 Hermann Bahr, *Secession*, Vienna, 1900, p. 71.

33 Quoted in Hans Ankwicz-Kleehoven et al., *Hodler und Wien*, Neujahrsblatt der Zürcher Kunstgesellschaft, Zurich, 1950, p. 32.

34 Albert Paris Gütersloh, *Egon Schiele: Versuch einer Vorrede*, Vienna, 1911. Idem, 'Neukunst', in *Katalog A Neukunst Wien 1912*, exhibition catalogue, Budapest, 1912; published in German in *Pester Lloyd: Morgenblatt*, vol. 59, no. 3, 4 January 1912, pp. 1-3.

35 See Werner J. Schweiger, *Der junge Kokoschka*, Vienna, 1983, p. 202 ff.

36 Leopold (see note 23), p. 673.

37 Nebehay (see note 1), pp. 332-3, no. 738.

38 Werkner (see note 1), p. 104.

39 Schweiger (see note 35), p. 148 ff.

Rudolf Leopold

'Art Cannot Be Modern; Art Is Eternal'

An Introduction to the Work of Egon Schiele

In September 1911 Schiele wrote to Dr Oskar Reichel: 'I have the direct means in my possession to write down ... to explore, to invent, to discover, with the means from within myself, which already have the great power to ignite, to burn ... and to cast light into the darkest eternities of our little world Thus I bring forth ever more, never stopping, seemingly endless, from within myself I am so rich that I must give myself away.' At the beginning of the year, Schiele had sent to this Viennese collector a painting 'from the completely new series'; this series was *Deliriums (Delirien)* or *Prophets (Propheten)*, continued by the paintings *Poet (Lyriker; Cat. 15), Self-Seer II (Selbstseher II; Cat. 16), Wall and House against Hilly Terrain with Fence (Mauer und Haus vor hügeligem Gelände mit Zaun; Cat. 18)* and *Vision and Fate (Vision und Schicksal, L 170-75).** In a covering letter to Reichel, Schiele had written: 'In a while you will be completely convinced by it, as soon as you start to look not at it but into it. The picture is the one of which G. Klimt has said that he would be glad if he saw such visions. It is *certainly*, at the moment, the loftiest thing that has been painted in Vienna.'

These sound like big words for a man of twenty to use; but with hindsight it becomes apparent that Schiele was right. One need only make an exception for a very small number of works by Klimt, also painted at this time. In terms of artistic quality – including the capacity to break new ground – Schiele's only serious rivals among Viennese painters were Klimt and Kokoschka; and Kokoschka was living in Berlin at the time.

Both Kokoschka and Schiele recognized Klimt as the strongest and stylistically the most individual figure in modern Viennese painting. Not only his art, but also his artistic personality, played a vital part in their own attainment of artistic independence. Even so, it must not be overlooked that Klimt himself was later to be influenced by Schiele. The pose of Schiele's *Danae* of 1909 (L 130) probably inspired that of Klimt's *Leda*, painted in 1916/17 (D 202), even though the arm that clasps the right breast stems from the lower figure in one of Klimt's own water-serpent pictures (II-D 140), and even though Leda is shown more in profile.

What is more, Schiele's sensitive *Autumn Tree in a Gust of Wind (Herbstbaum in bewegter Luft,* 1912; Cat. 30) clearly had a formal influence on Klimt's *Apple Tree (Apfelbaum,* II-D 195). A conspicuous feature of *Apple Tree* is its low horizon, which runs slightly aslant, like the foreground line in the Schiele painting,

although it tilts the opposite way. There are also areas of brightness and hints of texturing in the sky. The monk-like bridegroom in Klimt's unfinished *The Bride (Die Braut,* D 222) of 1917/18 repeats, once again with a lateral inversion, the basic formal structure of the figure of the dying monk in Schiele's *Death-Throe (Agonie,* L 218) of 1912. One has only to look at the one raised and one lowered shoulder in connection with the angle of the head. Schiele always had a gift for making decisive pictorial use of such devices.

This digression, which presents a number of instances in which Klimt drew inspiration from Schiele, must not detract from the far greater influence exercised by Klimt over Schiele, who was a whole generation younger. In finding his way to a style of his own, Schiele was indebted not only to Klimt but to Kokoschka, who was four years older than himself. Both younger artists took the Klimt of the *Beethoven Frieze (Beethovenfries)* as their point of departure, supplemented in Kokoschka's case by the stimulus of Mycenaean art.

In this connection, it must be said that Schiele also exerted a reciprocal influence on Kokoschka, whose nude studies of *The Savoyard Boy (Der Savoyardenknabe;* Cat. 115) would not have been possible without the specific quality of line in Schiele's nudes of 1910. The twisting of the head, and the contrary movement of the eyes, as they appear in Kokoschka's lithograph *Self-Portrait with Crayon (Selbstbildnis mit Zeichenstift)* and in the closely associated oil painting *Self-Portrait with Paintbrush (Selbstbildnis mit Pinsel,* W 102), clearly derive from earlier works by Schiele, in particular his painting *Self-Portrait with Winter Cherry (Selbstbildnis mit Lampionfrüchten,* 1912; Cat. 28). On the whole, however, the reciprocal influences between the two leading Austrian Expressionists are neither frequent nor crucial.

Like every great artist, Schiele emerged from a specific tradition. At no time did he actually disown his origins in Viennese Secessionism in general, and Klimt in particular, in spite of all his *Neukunst* (New-Art) airs. What he did was to transform the stimuli he had received into a highly personal identity of his own. The influences that affected him in his earlier years are in any case insignificant by comparison with all that Schiele himself contributed to new art.

Like Klimt, he was born with the gift of creating compositions of an apparently effortless formal perfection. In contrast to Klimt's mainly decorative formulas, however, Schiele's works

* Numbers preceded by 'D', 'L' or 'W' refer to the catalogues raisonnés listed on page 273.

have a more structured look to them. There are other differences: where Klimt seeks to create tension by using contrast – as when he incorporates naturalistically painted elements in an abstract, ornamental mosaic of colour – Schiele achieves contrast through devices of design. In Klimt's figure compositions, a conceptual content is conveyed through sumptuous allegorical and symbolic forms which, from the point of view of content, are seldom convincing for us today.

The incompatibility of tragic depths with Klimt's 'bull-like' nature, his taste for sensual abundance, is proved by, among many other instances, his painting of 1909/10, *Mother with Children* (*Mutter mit Kindern*), also called *Emigrants* (*Auswanderer*, D 163; Fig. 1, page 37). The contrast with Schiele's *Dead Mother I* (*Tote Mutter I*; Cat. 13), painted at the end of 1910, speaks for itself. Schiele took as his point of departure the downcast face of the mother, its lower portion masked by shadow; but in Klimt's work what connection is there between the grief-stricken pose of the black-clad mother and the rude health of her complexion? Nor is there any sign that the children are helpless or in danger. With Schiele, by contrast, the tragedy of the theme is detectable in every detail of the image. The child is really helpless; the mother's features are careworn. The colours, too, symbolize the tragedy: Schiele has the expressive resources to translate an inner commitment to his subject into a real emotional darkness.

Art Nouveau in general – and this certainly applies to *Jugendstil* in its Viennese form – had a marked tendency towards aestheticism which was incompatible with any attempt to give a realistic rendering of the shadow side or the lower depths of human existence. As Expressionists, Schiele and Kokoschka brought tragedy and ugliness into their art, partly because of the sheer emotional impact that this generated. Moreover, they discovered ugliness as a dimension of formal creation and made it available to the artists who came after them. Their expressive forms have lost none of their fascination and their immediacy to this day. In fact, the work of the Expressionist avant-garde of the 1900s currently arouses so much interest and enthusiasm that it would seem to be entirely in tune with present-day taste.

Only a knowledge of Schiele's entire output, based on a critical stylistic analysis of every vital detail, makes it possible to define Schiele's position within the art of his own time. There are obvious differences between his work and other Expressionist endeavours, such as the painting of the *Brücke* group; however, the context in which his personality and achievement should be assessed is above all that of the Viennese painting of his period.

He differs, for instance, markedly from the young Kokoschka, whose improvisatory, far more painterly manner contrasts with Schiele's decidedly structural concerns. Kokoschka initially specialized in portraiture, while Schiele, alongside his figure compositions, painted a large number of expressive landscapes of equal artistic quality. Whereas Kokoschka went on to evolve a spectacular, almost Baroque painting style, Schiele was and remained a Gothic artist: a dreamer and a realist at the same time.

It would of course be wrong to overlook the common features that link the art of Schiele and Kokoschka and thus constitute the definition of Viennese Expressionism. During the crucial early period in their careers, both Schiele and Kokoschka cultivated unusual subject-matter and a painting of sombre, subtly nuanced tones that has little to do with the often deliberately barbaric wildness of German Expressionism. The Expressionism of these two Viennese painters (and of those who followed them) is more a vehicle for psychological penetration. Their portraits of the psyche, and their mood (*Stimmung*) landscapes, are the results of an empathetic and at the same time analytical encounter with the motif. Early German Expressionism, by contrast, sought excitement and vehemence through strongly overstated colours and crude contours. (The large areas of colour in *Brücke* painting of the first few years show the clear influence of French Fauvism.)

Unlike the *Brücke*, Kokoschka and Schiele took as their point of departure an existing artistic style, whose leading representatives were Gustav Klimt, Ferdinand Hodler and Edvard Munch. (Schiele's drawing was also influenced in many ways by Toulouse-Lautrec.) Their main indebtedness in formal terms was to Klimt and Hodler; in terms of content it was to Munch.

Schiele was certainly attracted by the way Munch found an original expression for profound vital forces – without resorting to obtrusive symbolism – and also by his concentration on the shadow side of life, with solitude, suffering, despair and death as his dominant themes. In their interpretation of these themes, however, the two artists are worlds apart. Eroticism, above all, is treated quite differently by Schiele, who was nearly three decades younger. In his work there is no trace of Munch's 'battle of the sexes', or of the menace of the 'demon woman'. This may partly be a matter of temperament; but it also reflects a very different cultural environment.

Schiele's Vienna was not the world of Ibsen or Strindberg, which dominated Munch's mental universe to the end of his life. Viennese decadence, around 1900, lived on its nerves; it was a complex of moods (*Stimmungen*) and was profoundly obsessed with Eros and Thanatos, love and death. This was the time, and the place, that produced Hugo von Hofmannsthal and Arthur Schnitzler, Otto Weininger and Sigmund Freud. The fashionable convolutions of Art Nouveau and Symbolism were by no means such a light-hearted, modish business in Vienna as they were elsewhere. For all the aestheticism and happy-go-lucky philosophy that are supposed to be the city's speciality, there was a search there for fundamentals, for relationships of principle, and for whatever might lie concealed behind the ornate façade, beneath the veneer of witty urbanity.

All the self-confident pomp of the later nineteenth century is overshadowed, in the art and literature of Vienna, by a sense of its impending end. This is so in the art of Anton Romako, for instance, who inspired the youthful Kokoschka. The idea of relapsing into a welter of tragicomic absurdity, a weird orgy of decadence and grotesquerie, is the theme of Alfred Kubin's 1907 novel *Die andere Seite* (The Other Side), and of Albert

Ehrenstein's story *Tubutsch*, which Kokoschka illustrated four years later. Life is seen as 'a mortal sickness'. The poet Georg Trakl was haunted all through his short life by the idea of revelation in disintegration and by a fascination with that which is doomed – a parallel with Schiele's art which deserves to be the subject of a special study.

The young Schiele soon came to reject all that was schematic, smooth or equivocal, and to stress expressiveness at all costs. His paintings breathe the torment of solitude, the terror of being haunted by one's own visions, the pain and despair of suffering, the grief of hopelessness. Schiele was nevertheless able to elevate his own subjectivity into something universally valid. Autumn becomes, for him, the symbol of the transience of human life and all things; and inanimate as well as animate nature is infused with a soul. In Schiele's figure compositions, as in his landscapes with trees or houses, and also (not least) in his views of towns, the phenomenal form of the motif is replaced by what is – especially from the point of view of his contemporaries – a highly unexpected, experiential form. Moods and feelings are fashioned into visionary images, full of all-embracing human significance, which have the power of speaking directly to the receptive viewer. Schiele has the gift of endowing even the most humdrum subject-matter with new content.

Expressionism, more than any other artistic movement in this century, took sides with humanity – and no artist more obsessively so than the young Schiele. He was filled with a sense of his human, as well as his artistic, mission. His life, full of suffering as it was, was that of a man elect, one who saw what others did not see, and who achieved what others could not achieve.

Schiele was an Expressionist, but it would be wrong to allow the confessional, animistic, ecstatic and visionary qualities of his works to obscure their extraordinary formal qualities. It would be equally wrong (although this too has been done in the past) to present Schiele's formal achievements as purely decorative ones. He certainly took *Jugendstil* as his point of departure, and *Jugendstil* was an art of surface effects; but he was soon able to harness those impulses to his own purposes. Even so, he did not desert his stylistic roots with the same carefree abandon as did some other artists who came to Expressionism by the same route. Schiele's historical significance lies in the way in which, in Vienna, *Jugendstil* passes into Expressionism without a break.

Otto Benesch – who had known Schiele's work since childhood through his father, Heinrich Benesch – called Schiele 'as a draughtsman, one of the greatest geniuses of all time'. He was quite right: the instrument which Schiele created for himself, and through which he gave the first proofs of his artistic individuality – and indeed mastery – was his personal line. He also raised emphasis and omission to the status of an art in itself. He succeeded, as few others have ever done, in conveying both formal relationships and emotional states through drawing alone – and often through outline alone. There is no question that, as a draughtsman, he occupies a unique position within Expressionism. No one else could shape a line with such virtuosity and such expressiveness: incisive or caressing; structural or frail; brittle, nervous, scratchy, tense; intermittent or vehemently expansive. So great was his range that he could have dispensed with colour altogether and still left us with virtually no sense of loss.

And yet Schiele was a painter, and a major colourist at that: it would be utterly unfair to his painting to treat it simply as a way of filling in areas predefined by drawing, or even as a vehicle of emotional values. It is true that these values are basic to his art; but colour also has a decisive structural function. In oil paintings and watercolours alike, the drawing usually represents the perceptual framework into which the colour is incorporated, often on entirely equal terms. Both elements together serve to express the manifold nature of human emotions and moods.

Between Schiele's first public exposure and his great success at the spring Secession exhibition in 1918 (six months before his death), only nine years elapsed; enough for him to prove himself to be a pioneer and a master of Expressionism, and not merely of its Viennese variant. However, it is impossible to do justice to Schiele's highly complex art if we look at its importance in the context of Expressionism and leave it at that. Earlier than any other leading Expressionist, Schiele turned away from the exclusive preoccupation with expressiveness and towards a new, more naturalistic way of painting, which is evidenced by his work from 1916 onwards.

This should not, of course, be regarded as belittling the importance of his Expressionist work. On the contrary, I am convinced that – if we leave aside the new orientation which appeared in his painting shortly before his death – Schiele did his most important and most characteristic work between 1910 and 1915. Even then, however, he never limited his options by restricting himself to a single line of development. It is the decisions and revisions in his career that make the evolution of this artist and his work such an enthralling process. His changes of course mark his art as a living and growing organism, which can never be restricted to any single predetermined path. What mattered to him was never the fact of belonging to any particular grouping: it was art itself. And this is why he wrote these words on one of his watercolours: 'Art cannot be modern; art is eternal.'

Titles in quotation marks are the artists' own.

Plates

Egon Schiele
1 *Self-Portrait with Palette,* 1905
Selbstbildnis mit Palette

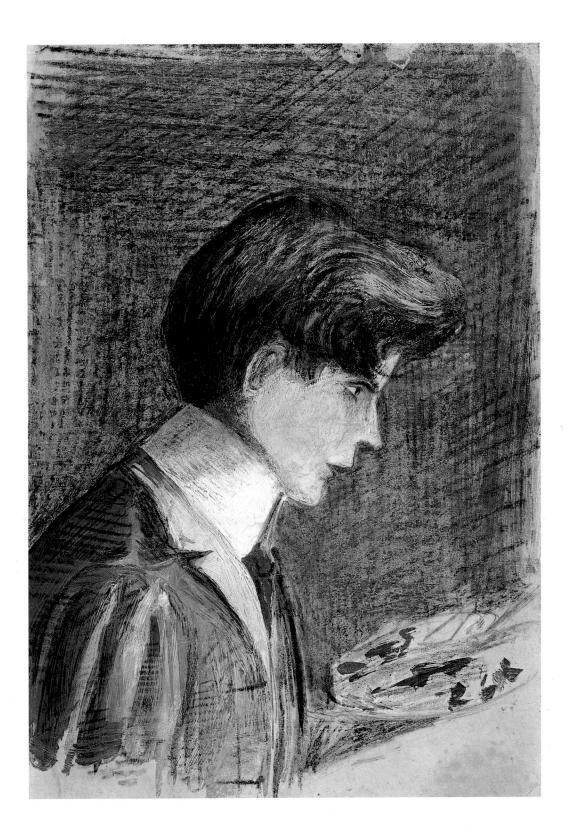

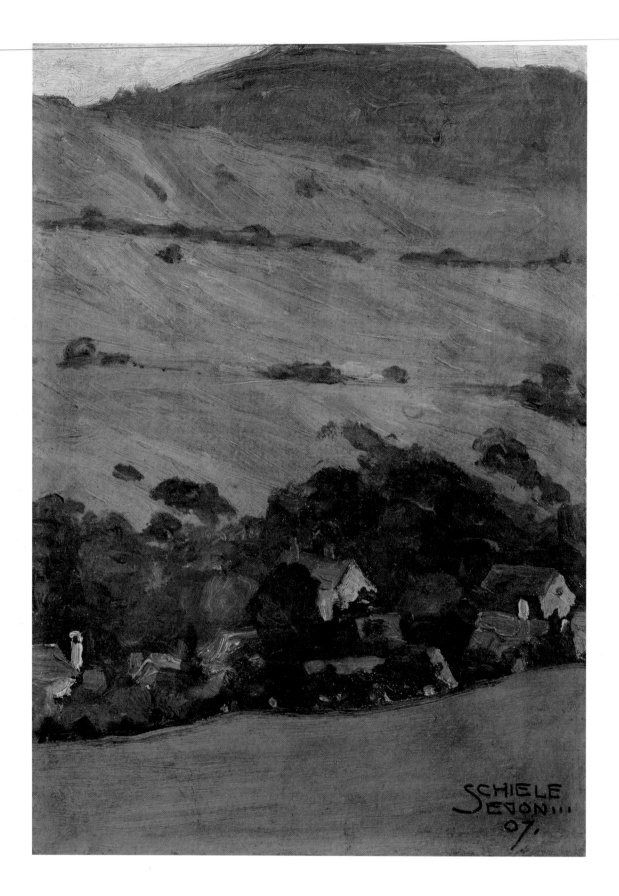

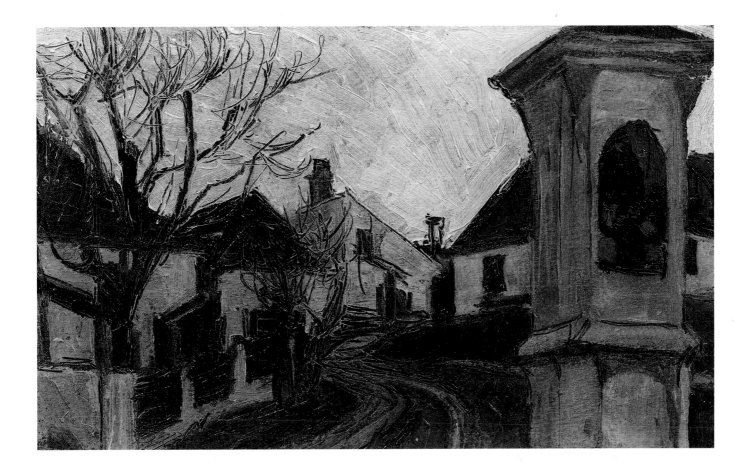

Egon Schiele
3 *Bare Trees, Houses and Wayside Shrine*, 1907
 Kahle Bäume, Häuser und Bildstock
 (Klosterneuburg)

Egon Schiele
2 *Houses against Hillside*, 1907
 Häuser vor Bergabhang

Egon Schiele
4 *Stylized Flowers against Decorative Background*, 1908
Stilisierte Blumen vor dekorativem Hintergrund

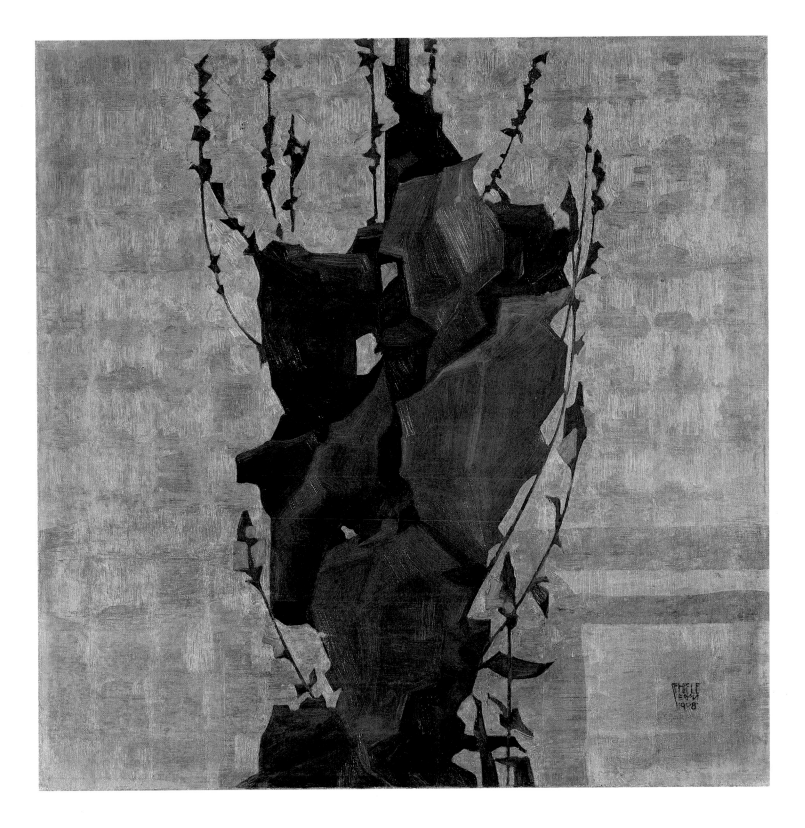

Egon Schiele
5 *Nude Self-Portrait, Kneeling,* 1910
Kniender Selbstakt

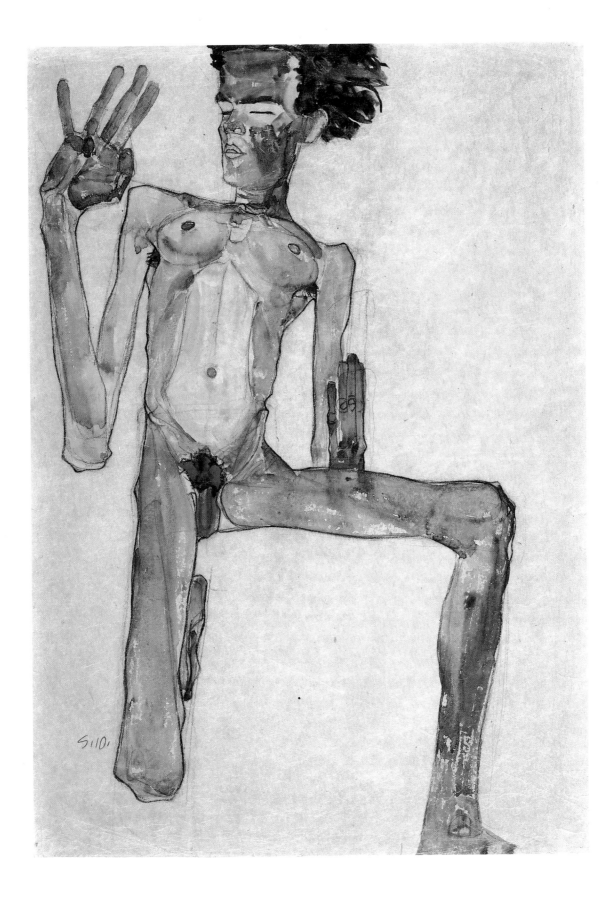

Egon Schiele
6 *Seated Male Nude*, 1910
 Sitzender männlicher Akt
 (Based on a self-portrait)

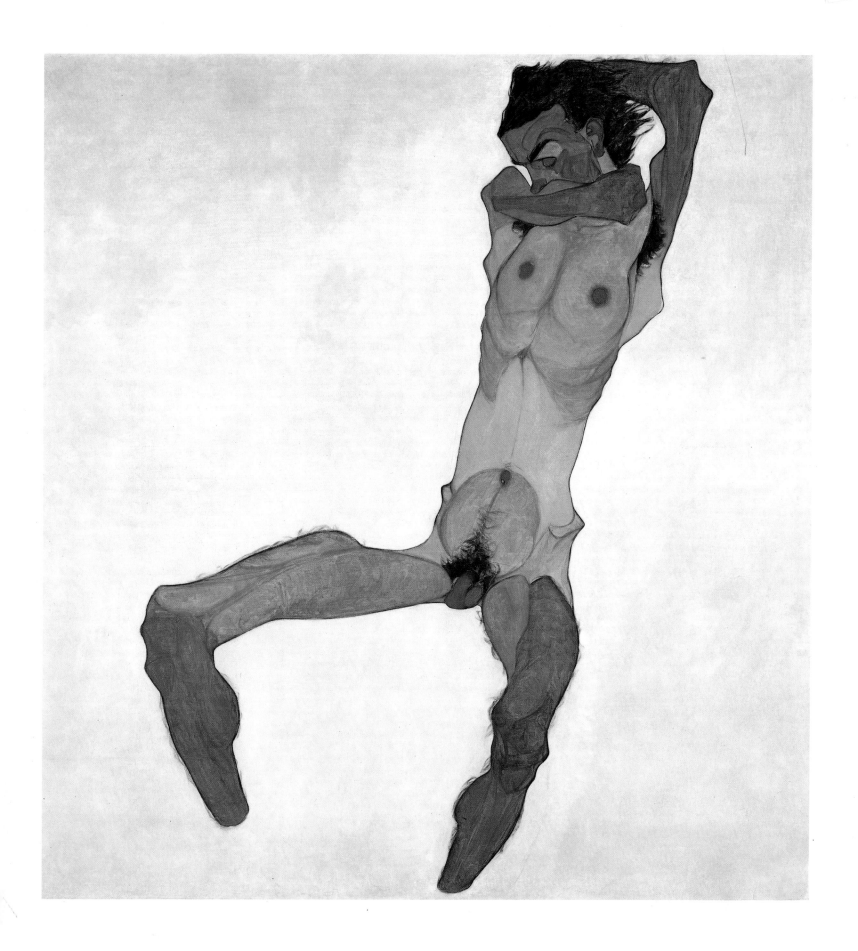

Egon Schiele
7 *Self-Portrait*, 1910
 Selbstbildnis

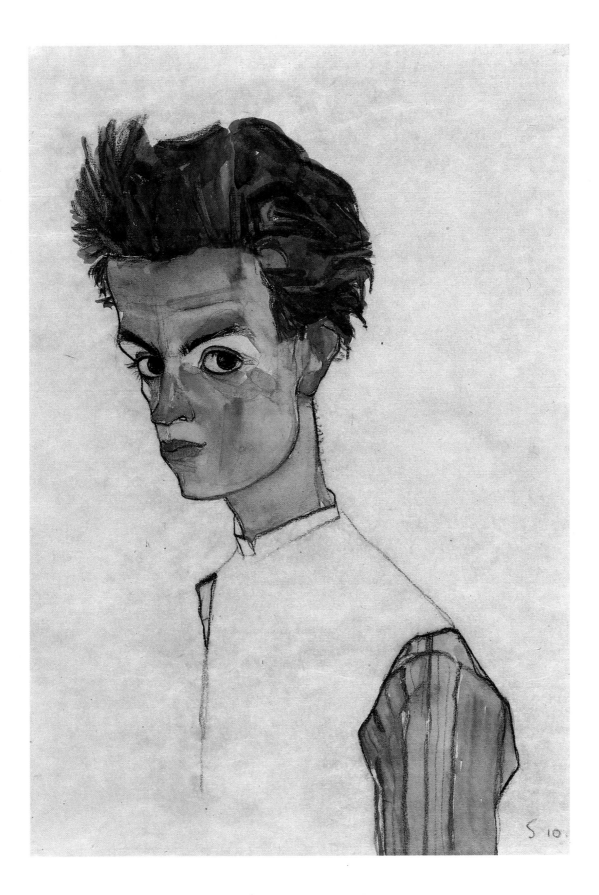

Egon Schiele
8 *Crouching Female Nude*, 1910
 Hockender weiblicher Akt

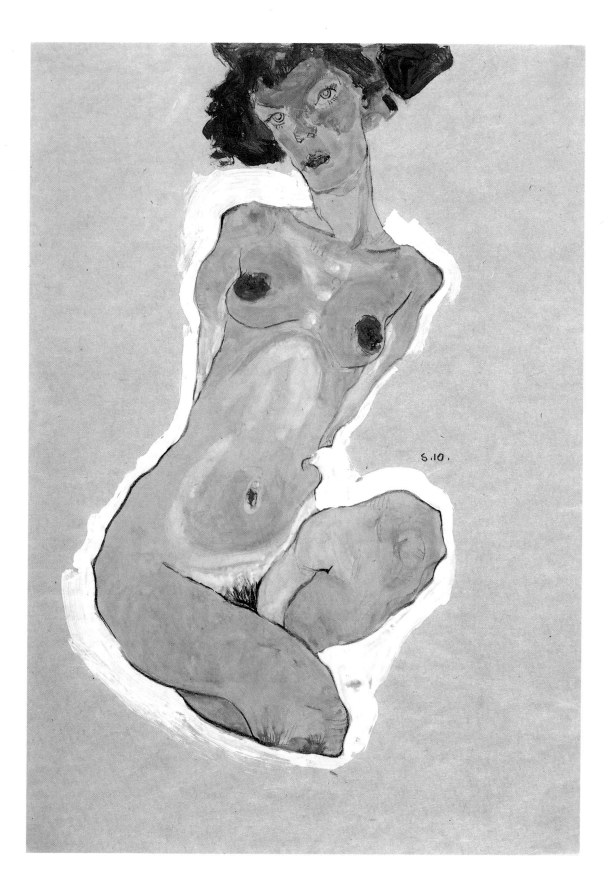

Egon Schiele
9 *Nude Self-Portrait*, 1910
Selbstakt

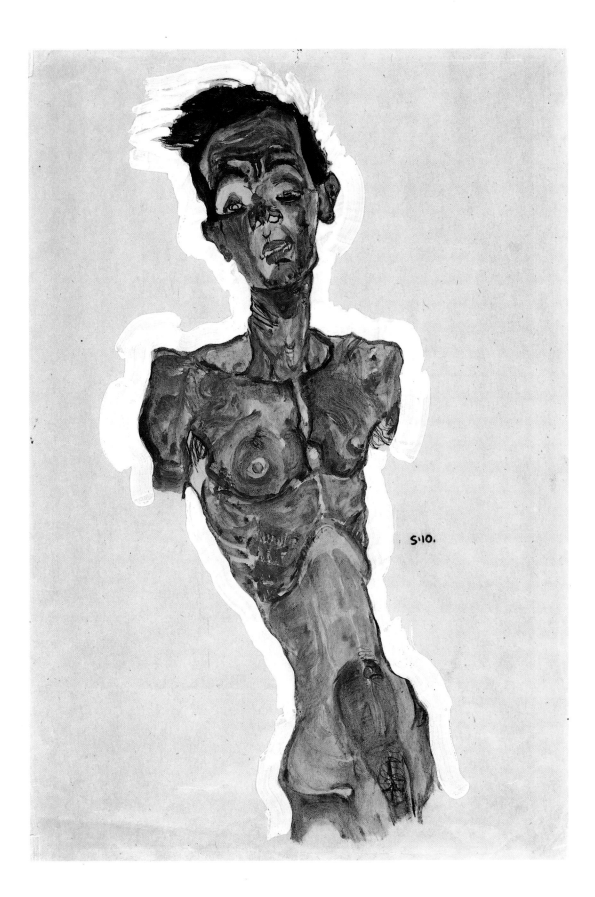

Egon Schiele
10 *Self-Portrait, Pulling a Face, 1910*
Selbstbildnis, eine Grimasse schneidend

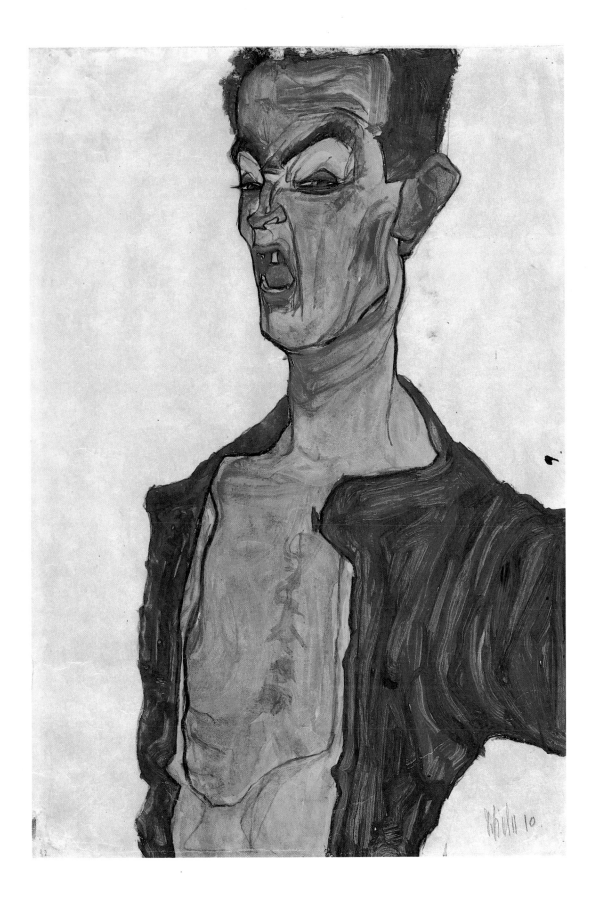

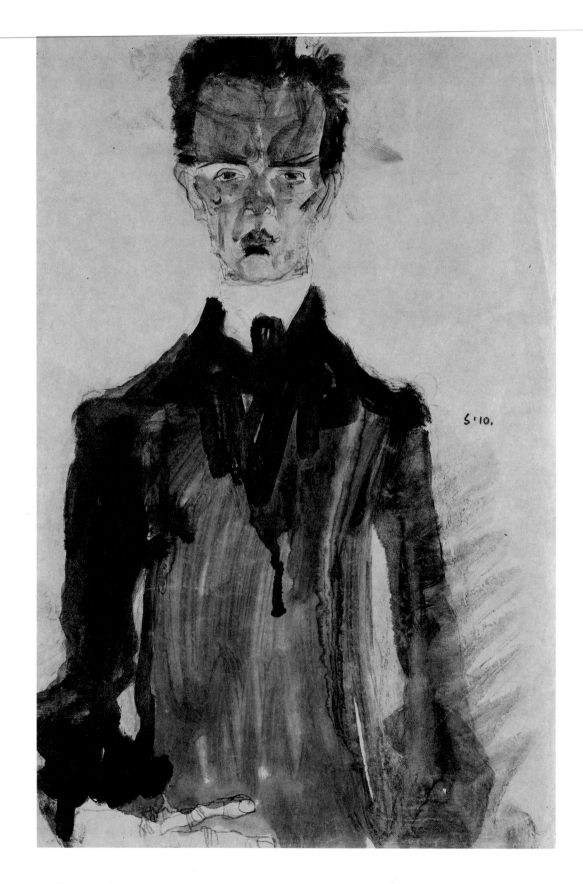

Egon Schiele
11 *Self-Portrait, Dressed in Black,* 1910
 Selbstbildnis in schwarzem Gewand

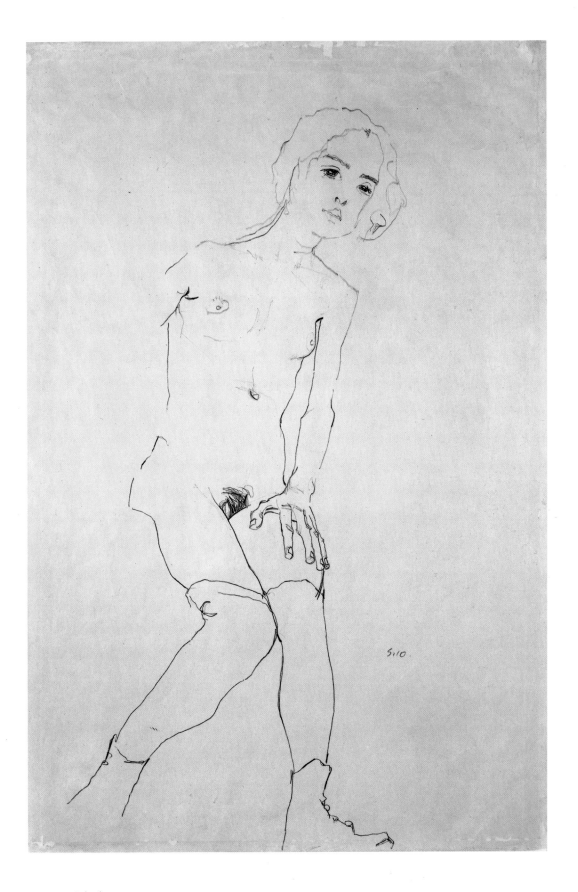

Egon Schiele
12 *Naked Girl with Stockings and Shoes, Seated*, 1910
 Sitzendes nacktes Mädchen mit Strümpfen und Schuhen

Egon Schiele
13 *'Dead Mother'* (I), 1910
'Tote Mutter' (I)

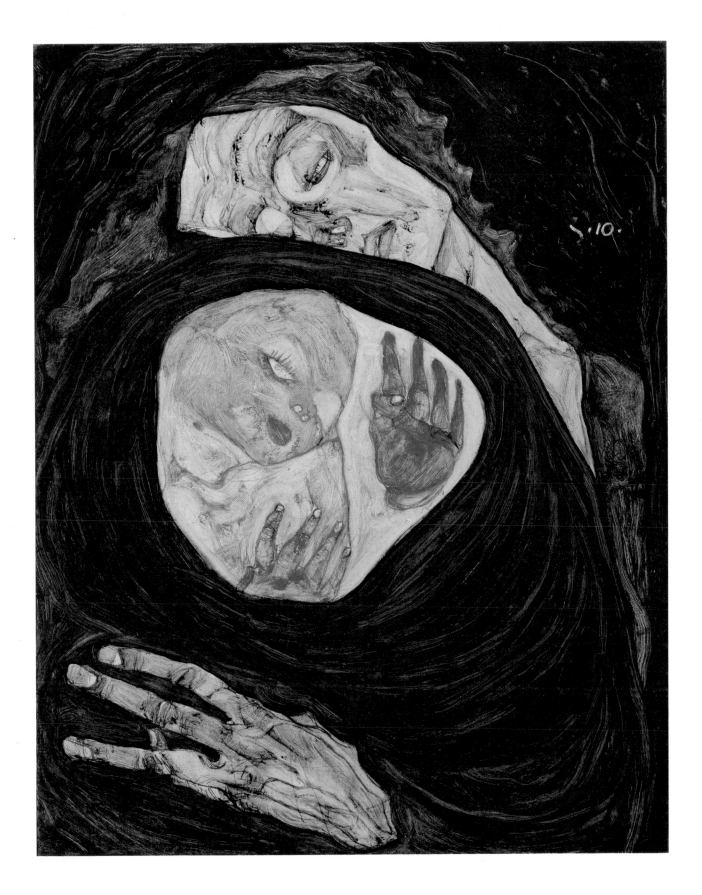

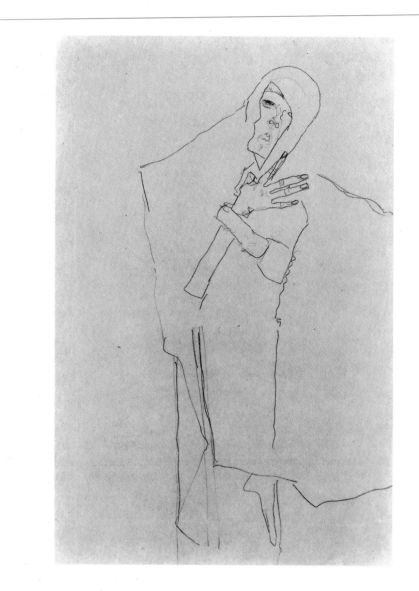

Egon Schiele
14 *Self-Portrait with Cape*, 1911
 Selbstdarstellung mit Umhang

Egon Schiele
15 *'Poet'*, also *'The Poet'*, 1911
 'Lyriker', also *'Der Lyriker'*

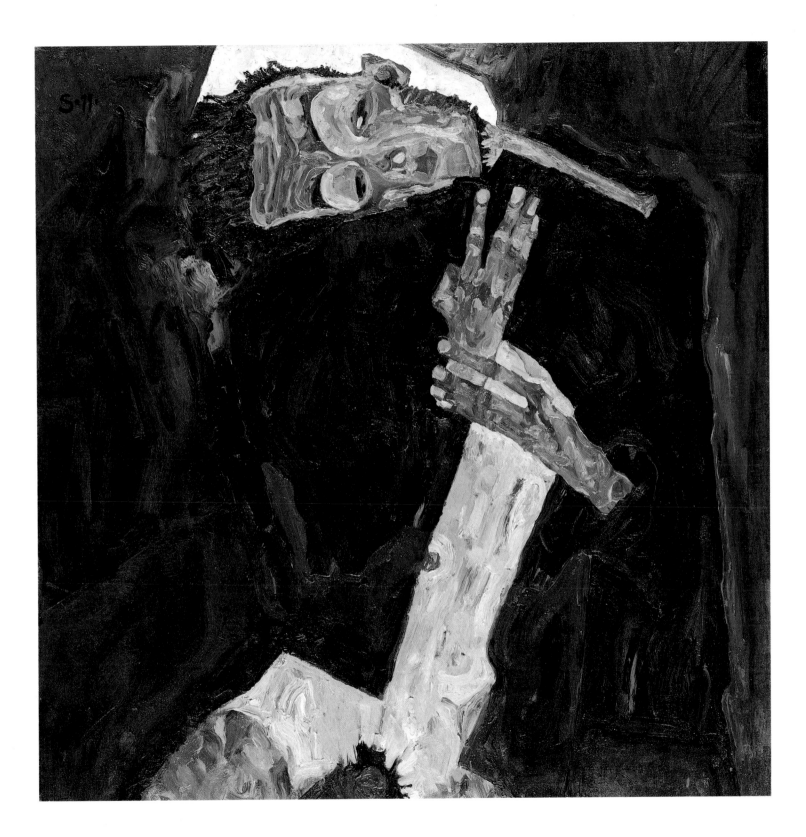

Egon Schiele

16 'Self-Seer' (II), also 'Death and Man', 1911
'Selbstseher' (II), also 'Tod und Mann'

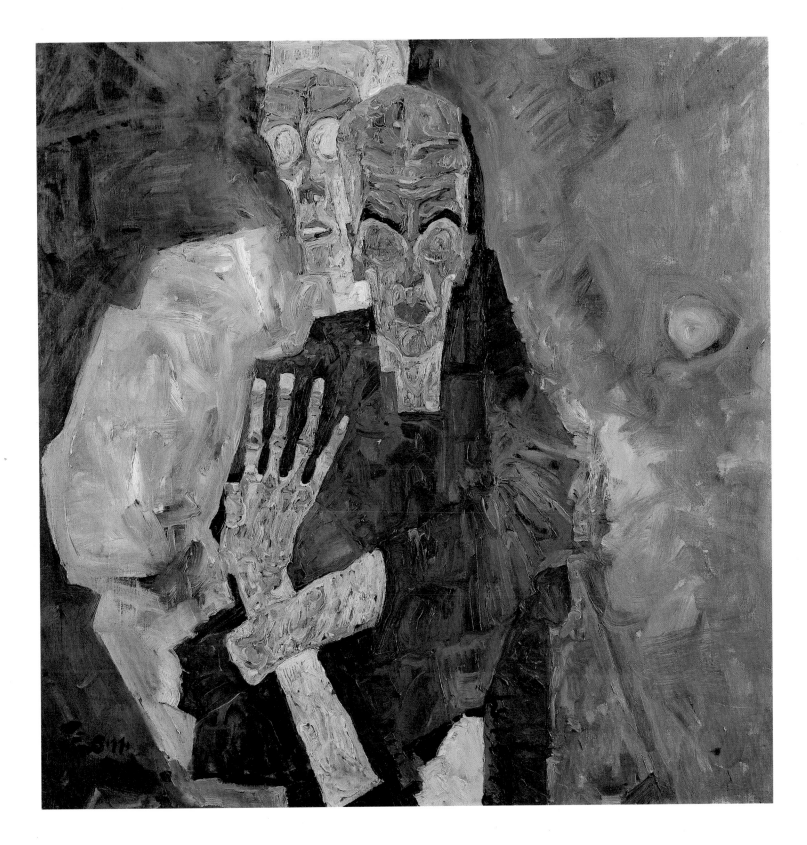

Egon Schiele
17 *Woman and Man*, 1911
Frau und Mann

Egon Schiele
18 *Wall and House against Hilly Terrain with Fence, 1911*
Mauer und Haus vor hügeligem Gelände mit Zaun

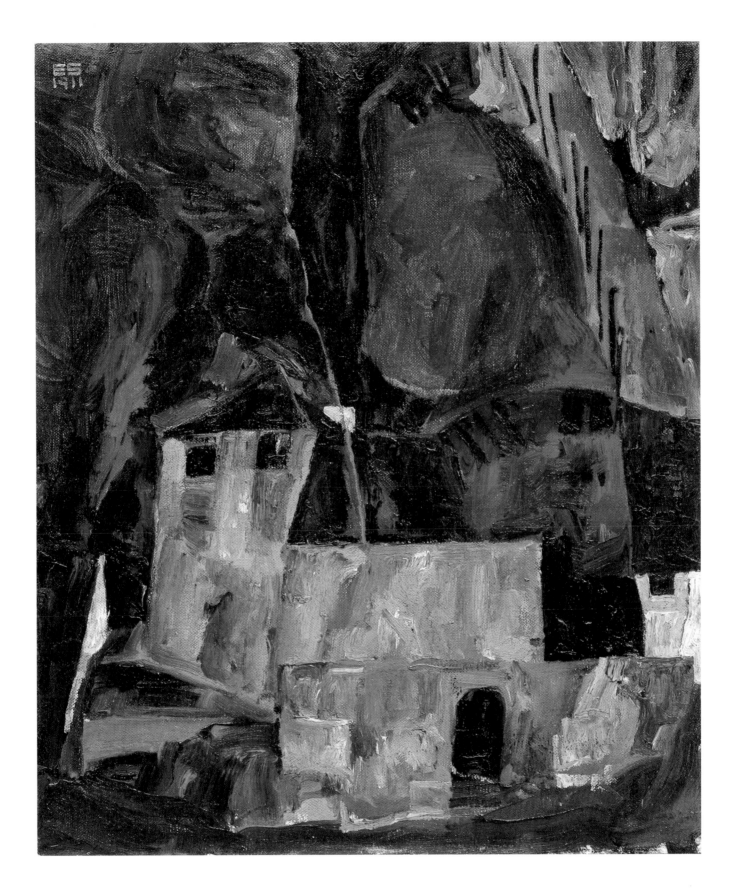

Egon Schiele
19 *Nude Self-Portrait,* 1911
Akt-Selbstbildnis

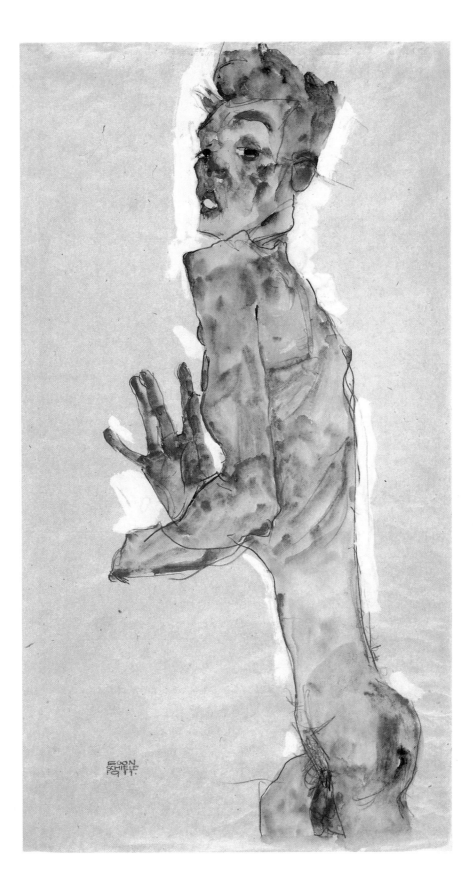

Egon Schiele
20 *Black-Haired Girl with Skirt Turned Up*, 1911
Schwarzhaariges Mädchen mit hochgeschlagenem Rock

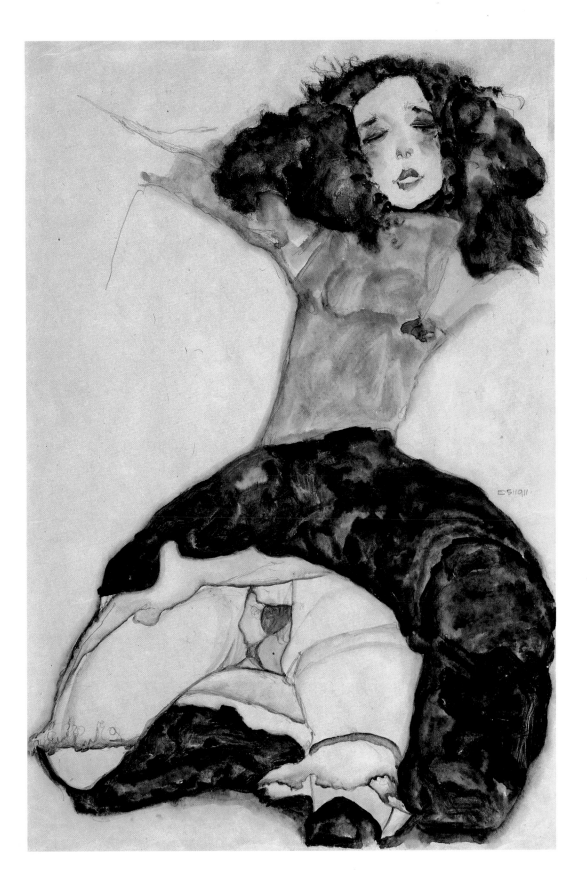

Egon Schiele
21 'Dead Town' (III), also 'Town on the Blue River' (III), 1911
'Tote Stadt' (III), also 'Stadt am blauen Fluß' (III)

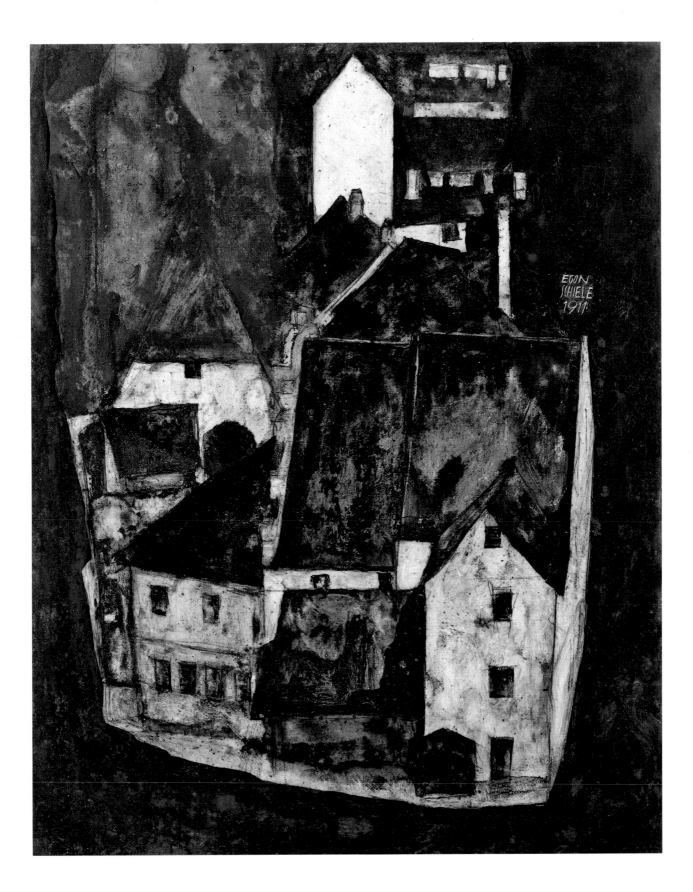

Egon Schiele
22 *Moa, the Dancer,* 1911
Moa, die Tänzerin
(Frontispiece)

Egon Schiele
23 *Small Tree in Late Autumn,* 1911
Kleiner Baum im Spätherbst

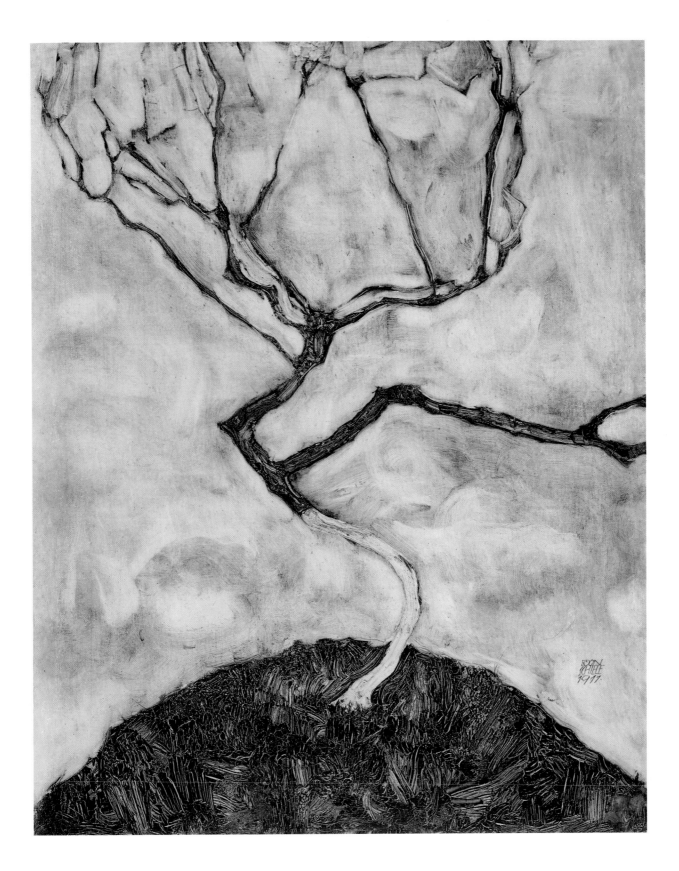

Egon Schiele
24 *Self-Portrait with Head Inclined*, 1912
Selbstbildnis mit gesenktem Kopf
(Study for *'Hermits'*)

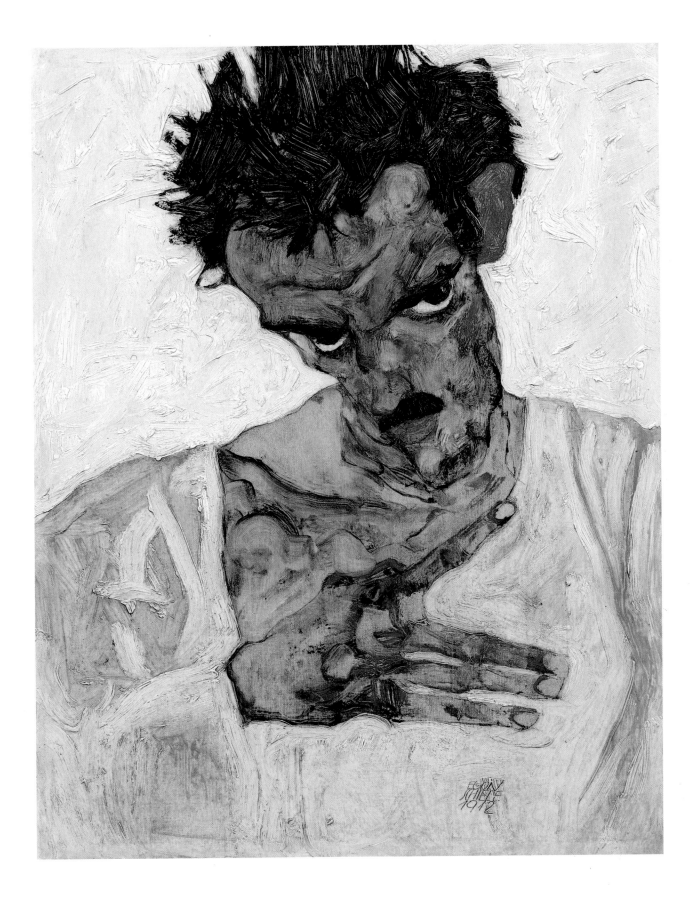

Egon Schiele
25 'Hermits', 1912
 'Eremiten'
 (Identifiable as Egon Schiele and Gustav Klimt)

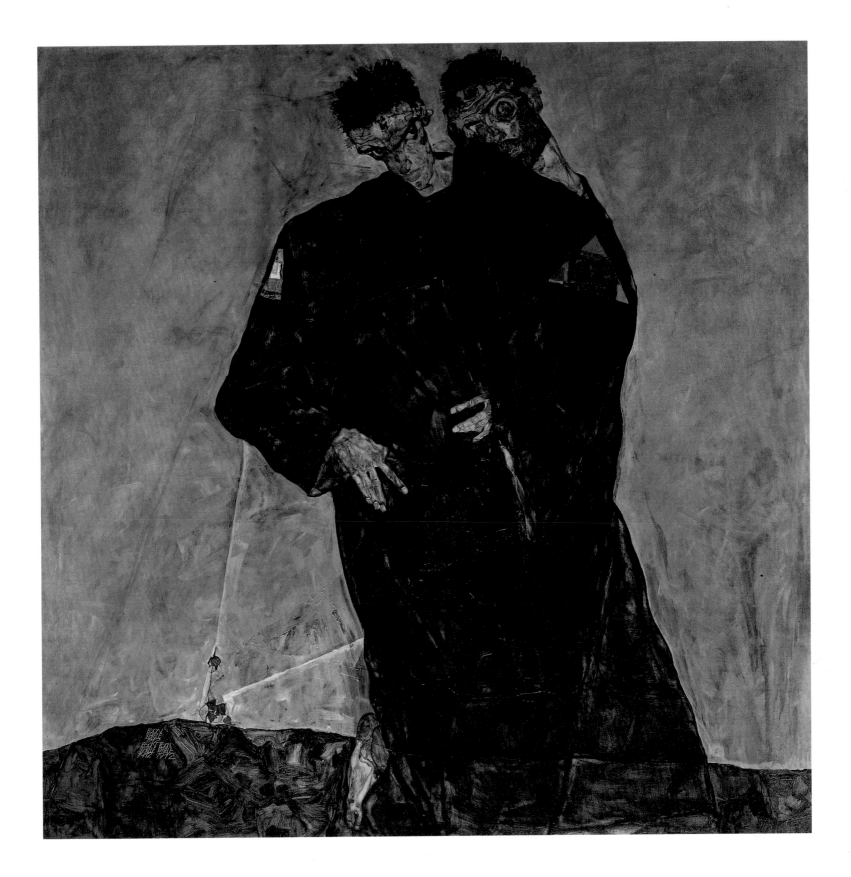

Egon Schiele
26 *Cardinal and Nun, 'Caress', 1912*
Kardinal und Nonne, 'Liebkosung'

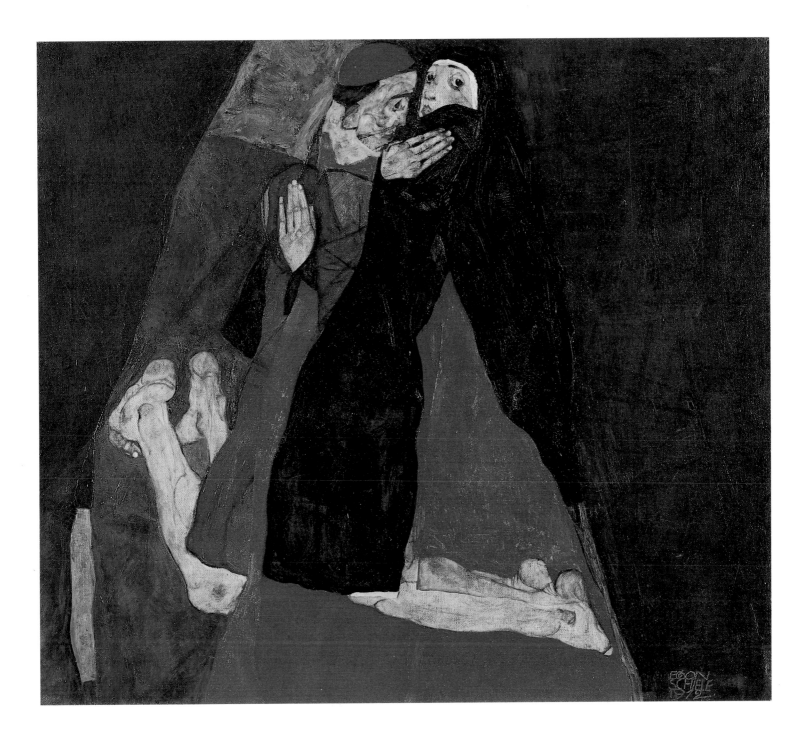

Egon Schiele
27 *Nude Bending Forwards*, 1912
Nach vorn gebeugter Akt

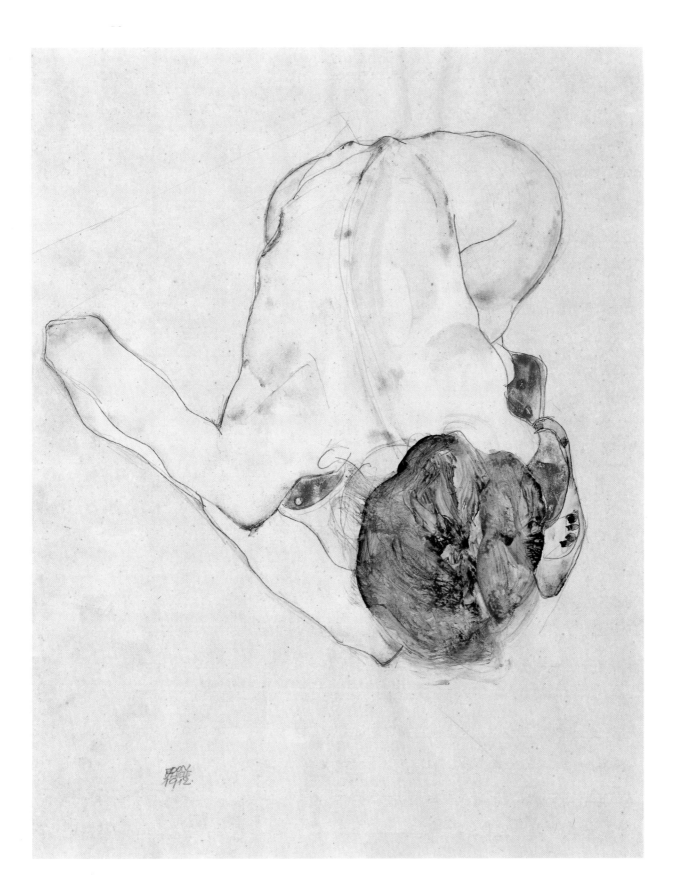

Egon Schiele
28 *Self-Portrait with Winter Cherry, 1912*
Selbstbildnis mit Lampionfrüchten

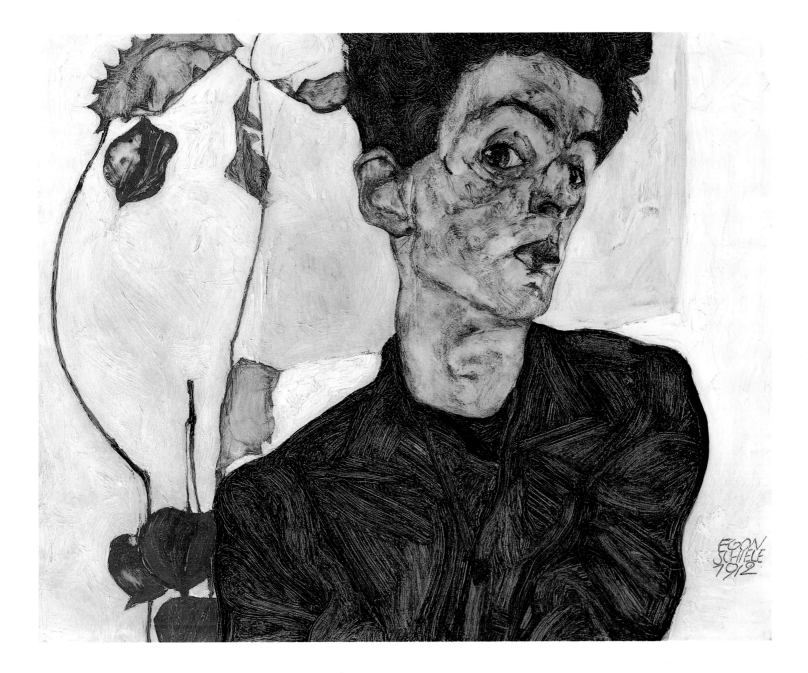

Egon Schiele
29 *Portrait of Wally,* 1912
Bildnis Wally

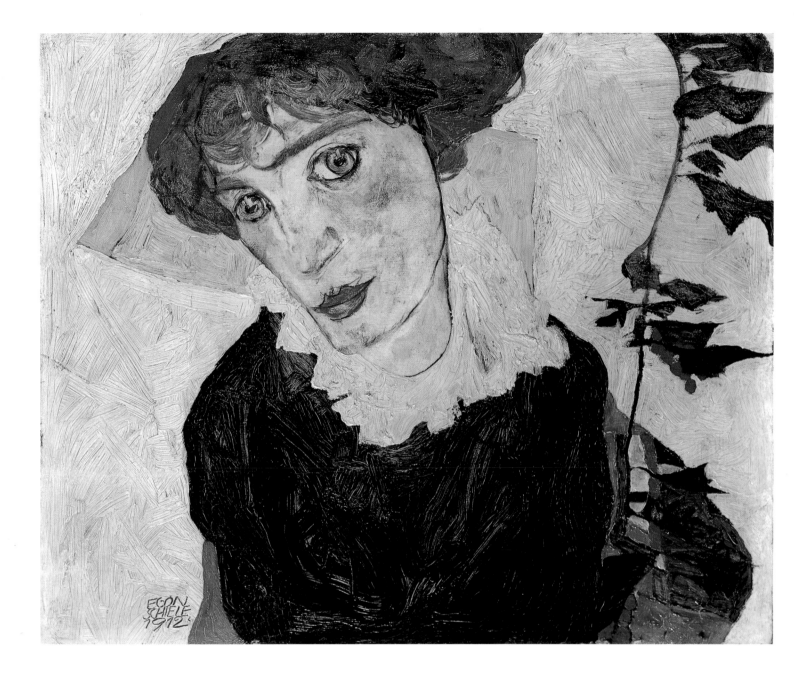

Egon Schiele
30 *Autumn Tree in a Gust of Wind,*
'Autumn Tree' (III), also *'Winter Tree'*, 1912
Herbstbaum in bewegter Luft,
'Herbstbaum' (III), also *'Winterbaum'*

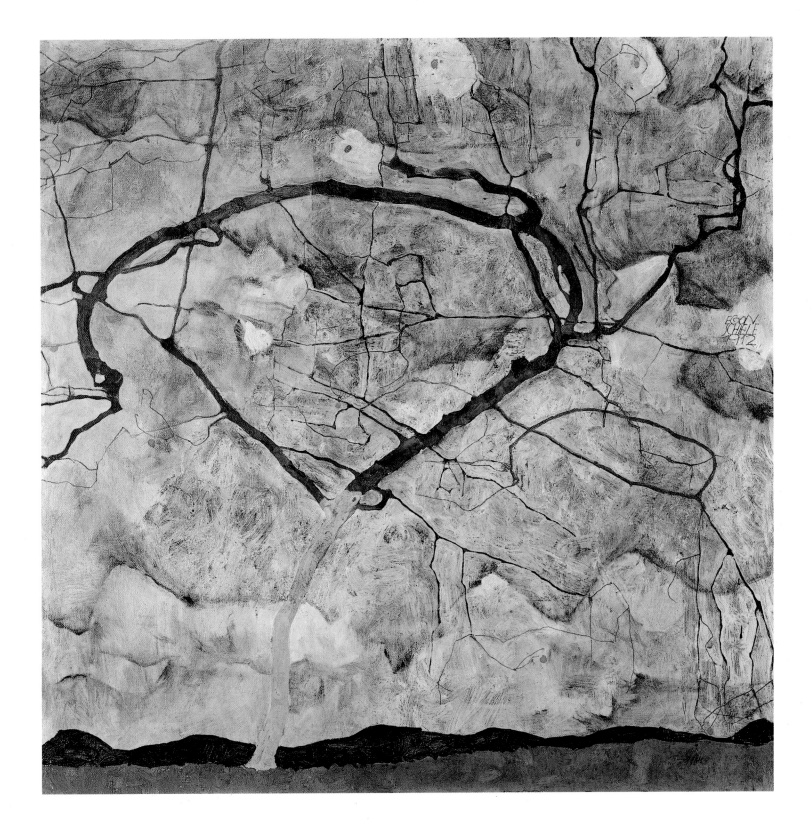

Egon Schiele
31 *'The Small Town'* (II), also *'Small Town'* (III), 1912/13
 'Die kleine Stadt' (II), also *'Kleine Stadt'* (III)

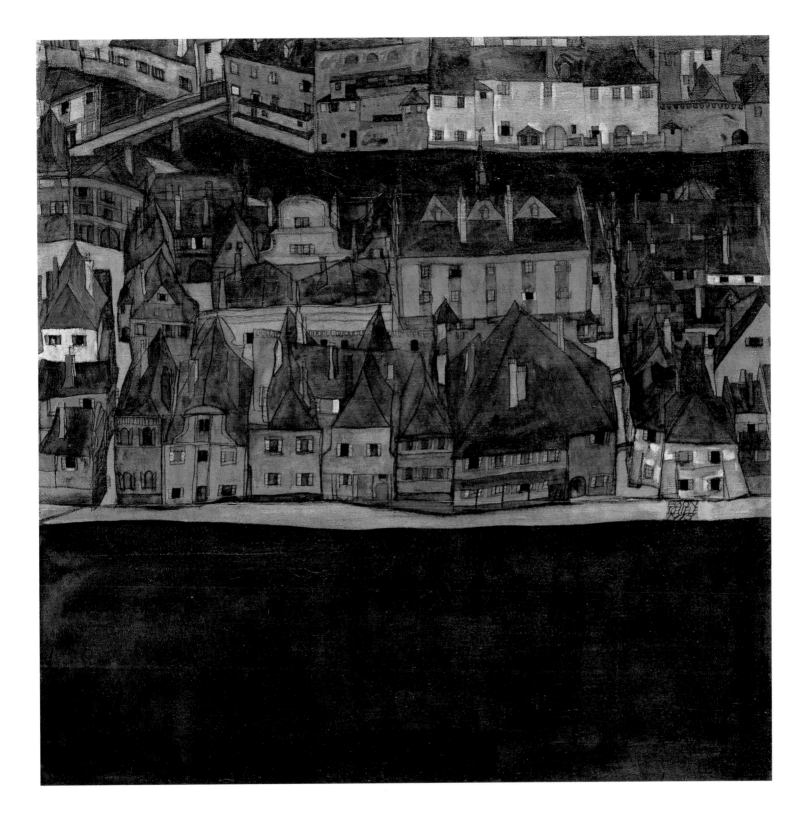

Egon Schiele
32 *'Sinking Sun'*, 1913
'Versinkende Sonne'

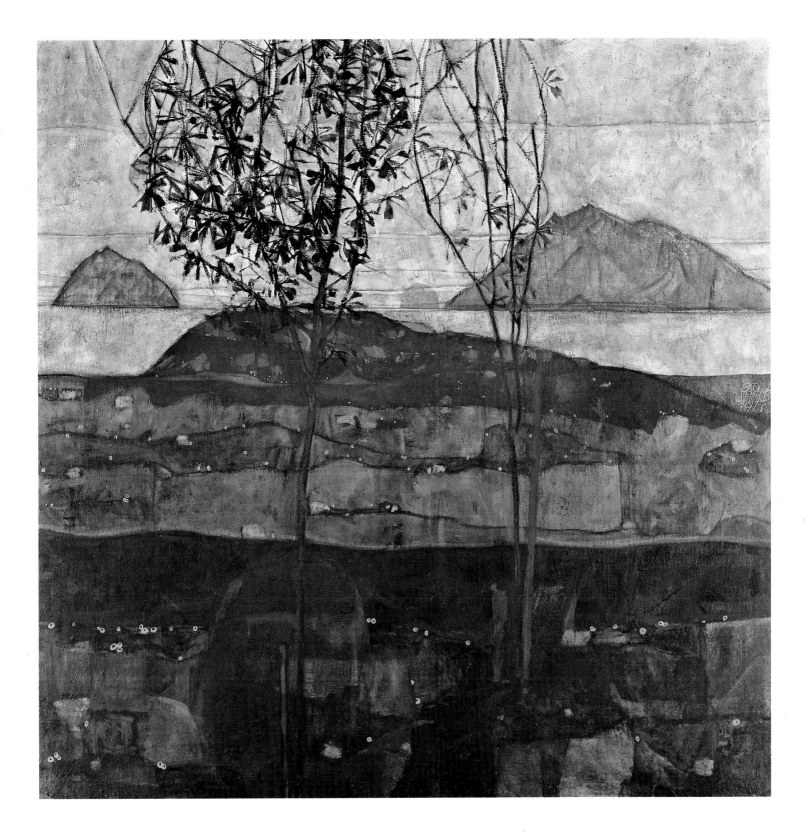

Egon Schiele
33 *Old Gable,* 1913
Alter Giebel

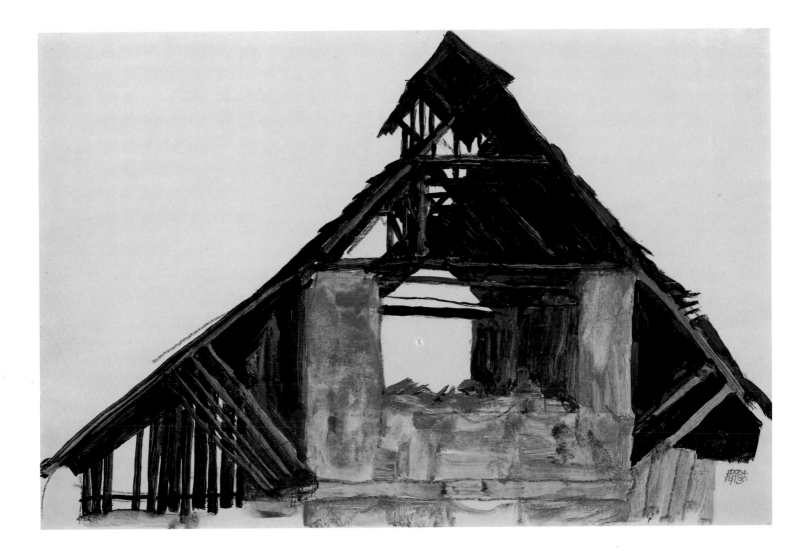

Egon Schiele
34 *Mother and Daughter*, 1913
Mutter und Tochter

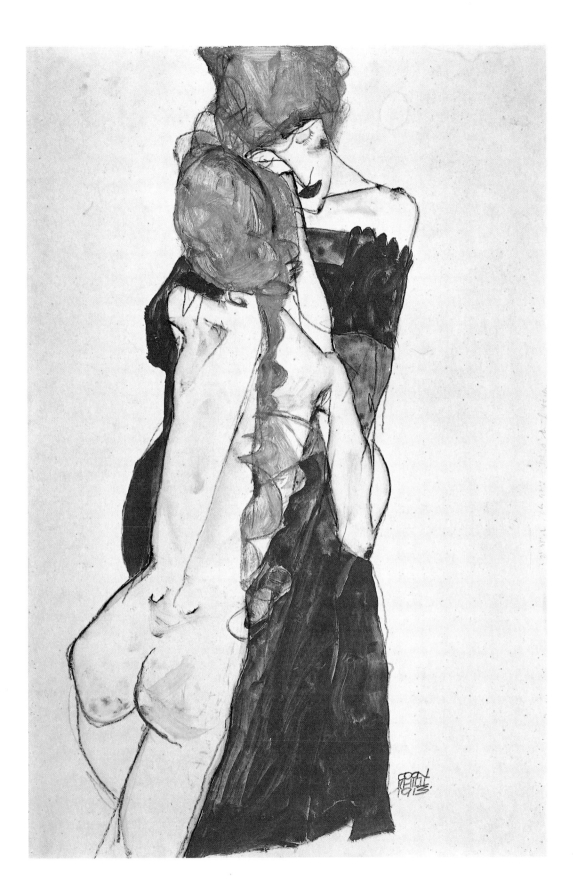

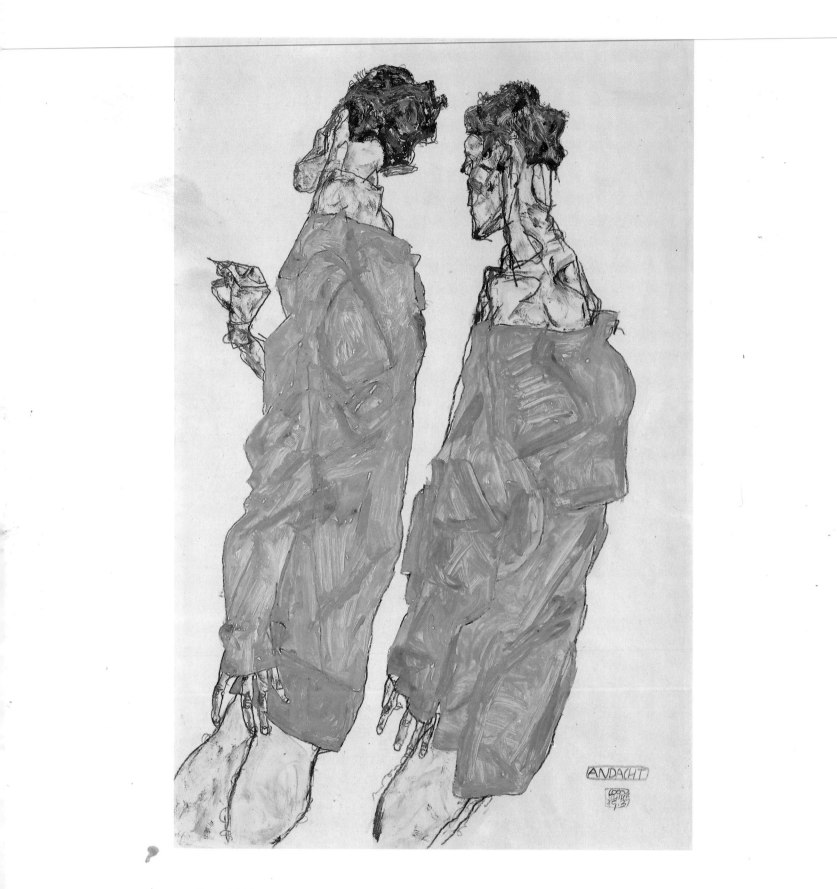

Egon Schiele
35 *'Rapt Attention'*, 1913
'Andacht'

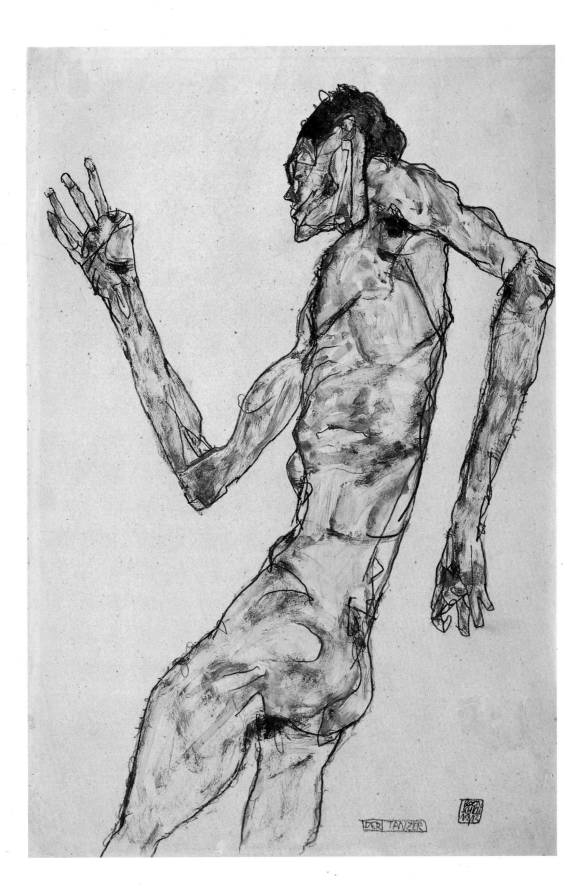

Egon Schiele
36 'The Dancer', 1913
'Der Tänzer'

Egon Schiele

37 *Krumau on the Moldau, 'The Small Town'* (III),
also *'Small Town'* (IV), *'Dead Town'* (VII), *'Town'* (I), 1913/14
Krumau an der Moldau, 'Die kleine Stadt' (III),
also *'Kleine Stadt'* (IV),
'Tote Stadt' (VII), *'Stadt'* (I)

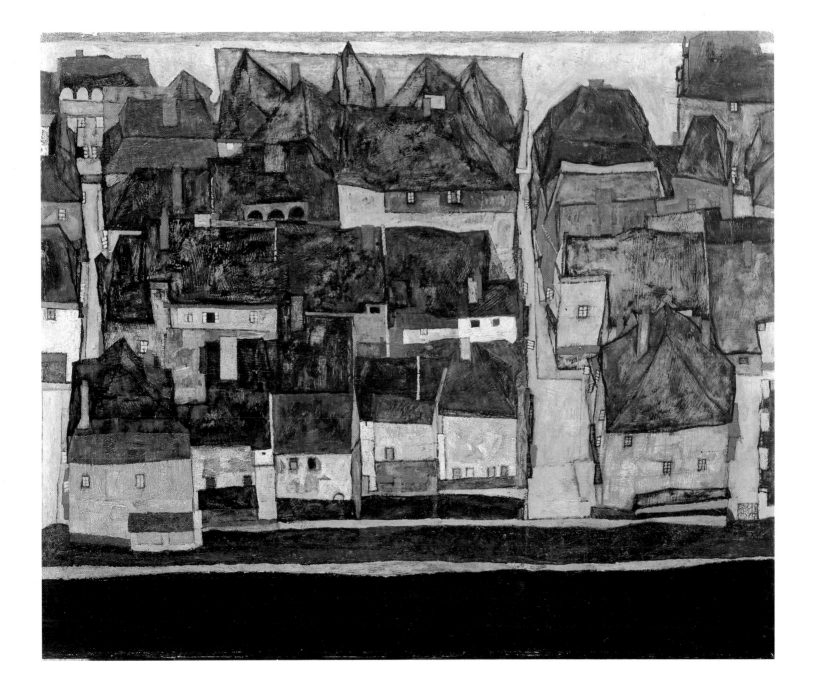

Egon Schiele
38 *Mother and Child*, 1914
Mutter und Kind

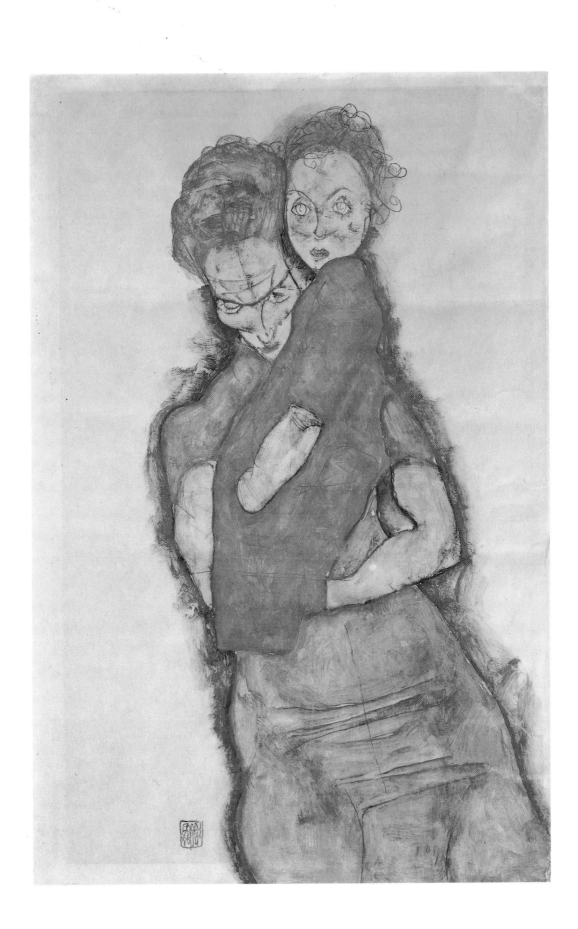

Egon Schiele
39 'Blind Mother', also 'The Mother' (I), 'Mother' (I), 1914
'Blinde Mutter', also 'Die Mutter' (I), 'Mutter' (I)

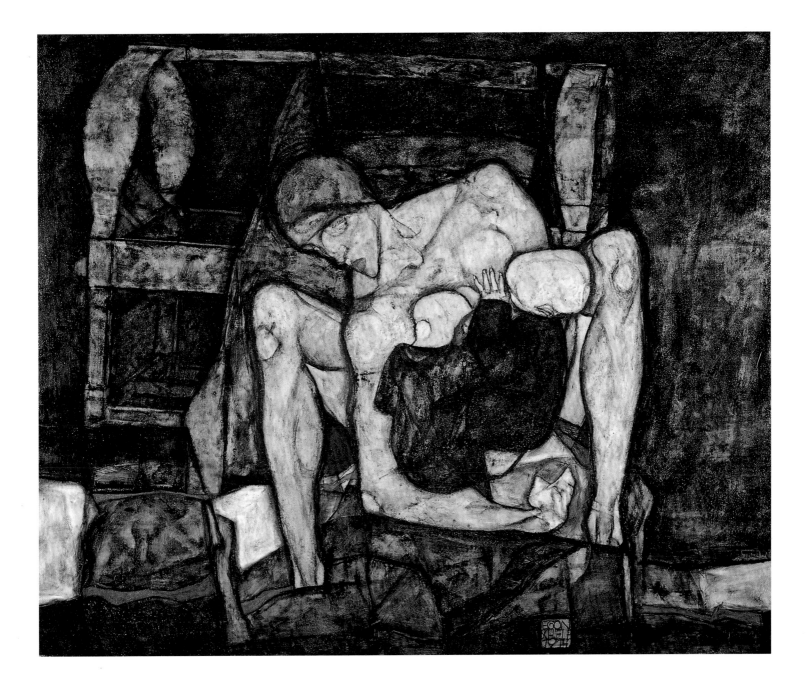

Egon Schiele
40 *Female Nude, Squatting*, 1914
Kauernder weiblicher Akt

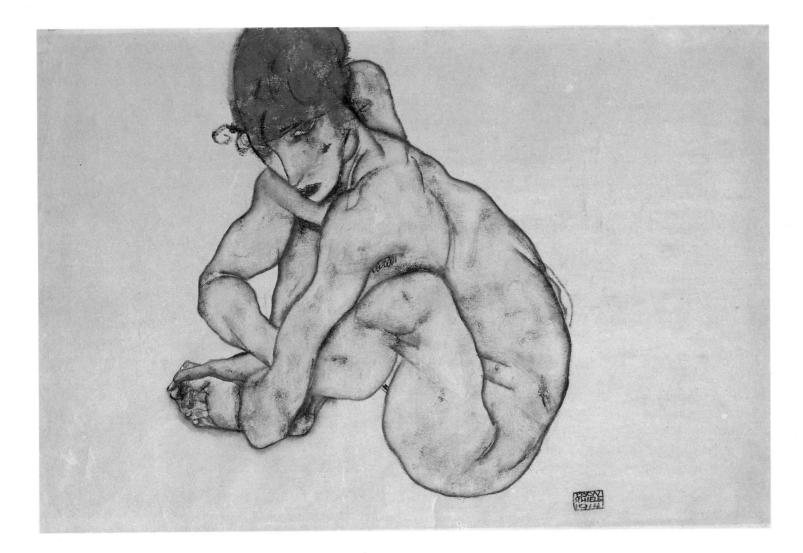

Egon Schiele

41 *Houses and Coloured Washing, 'Suburb'* (II),
also *'Two Blocks with Clothes Lines'*, 1914
Häuser und bunte Wäsche, 'Vorstadt' (II),
also *'Zwei Häuserblöcke mit Wäscheleinen'*

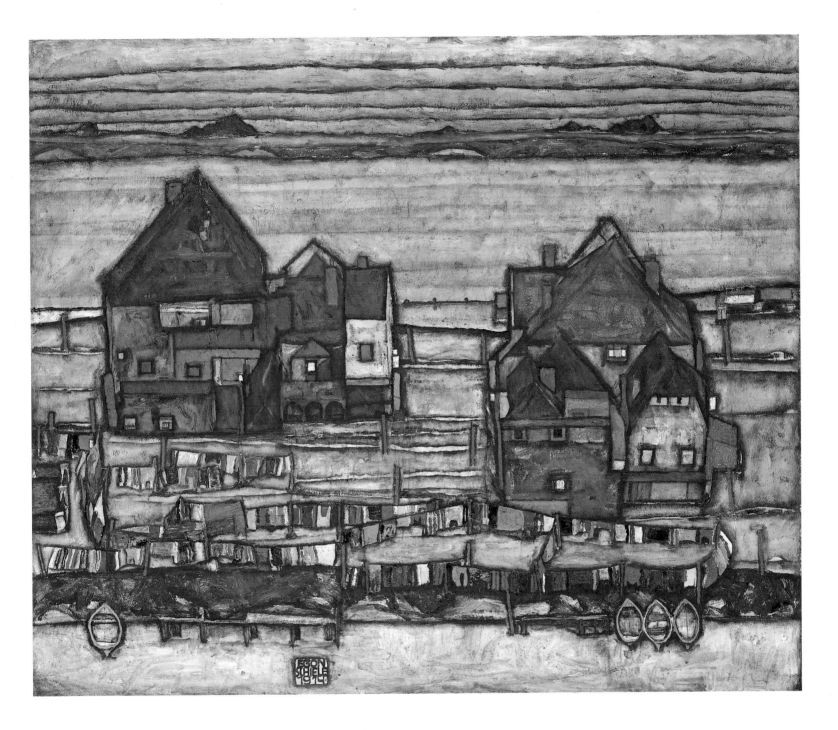

Egon Schiele
42 *Seated Woman with Blue Hairband*, 1914
Sitzende mit blauem Haarband

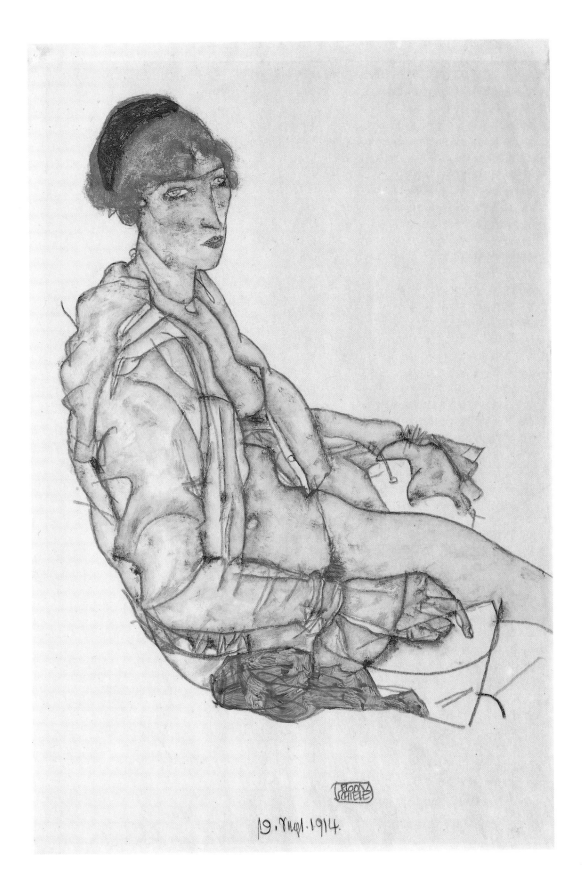

Egon Schiele
43 *Lovers,* 1914/15
Liebespaar

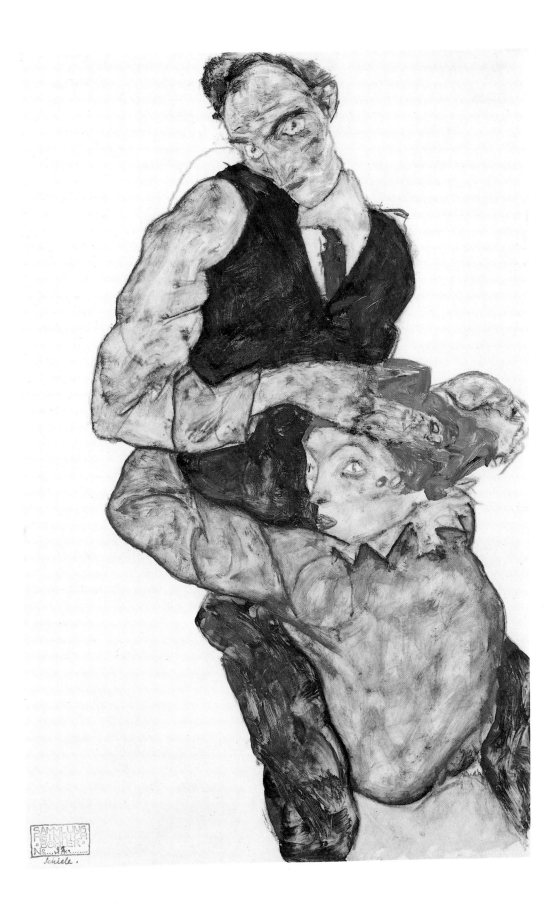

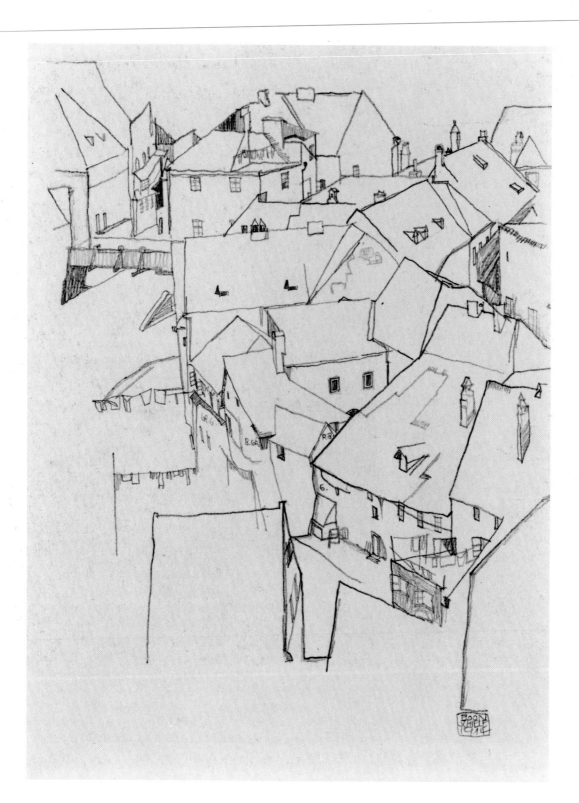

Egon Schiele
44 *Part of Krumau*, 1914
Krumauer Stadtviertel
(Sketch for *The Row of Houses*, L 258 and L 260)

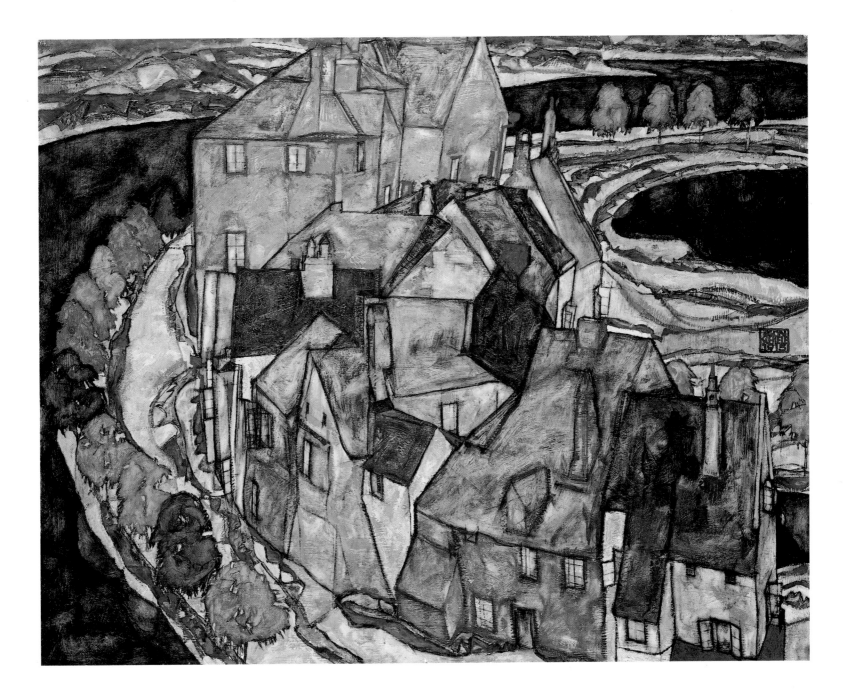

Egon Schiele
45 *The Row of Houses, 'Island Town', 1915*
Der Häuserbogen, 'Inselstadt'

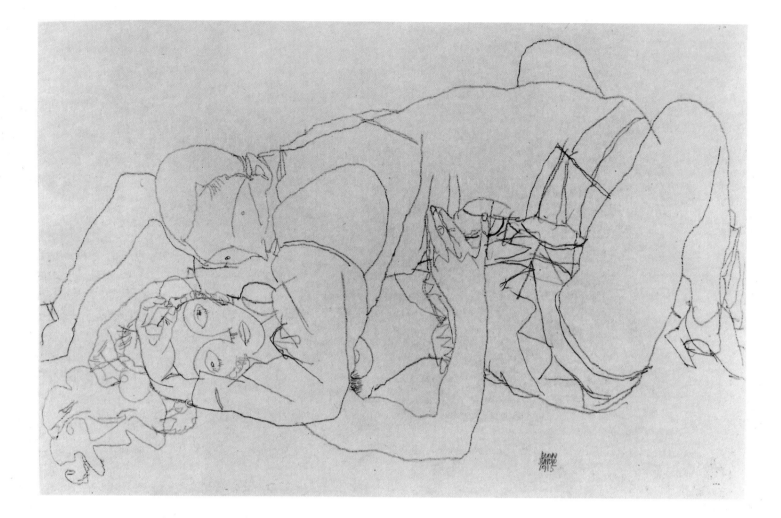

Egon Schiele
46 *Act of Love (Study)*, 1915
 Liebesakt (Studie)

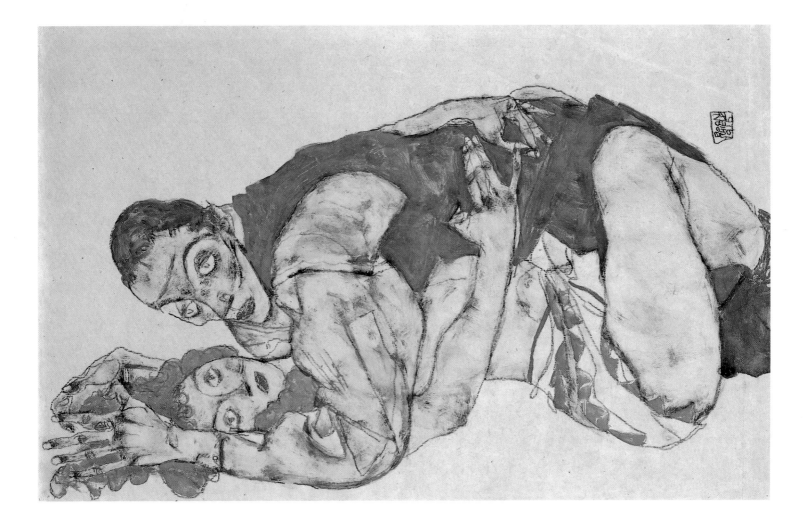

Egon Schiele

47 *Act of Love*, 1915
 Liebesakt

Egon Schiele
48 *Mother with Two Children, 'Mother'* (II), 1915
Mutter mit zwei Kindern, 'Mutter' (II)

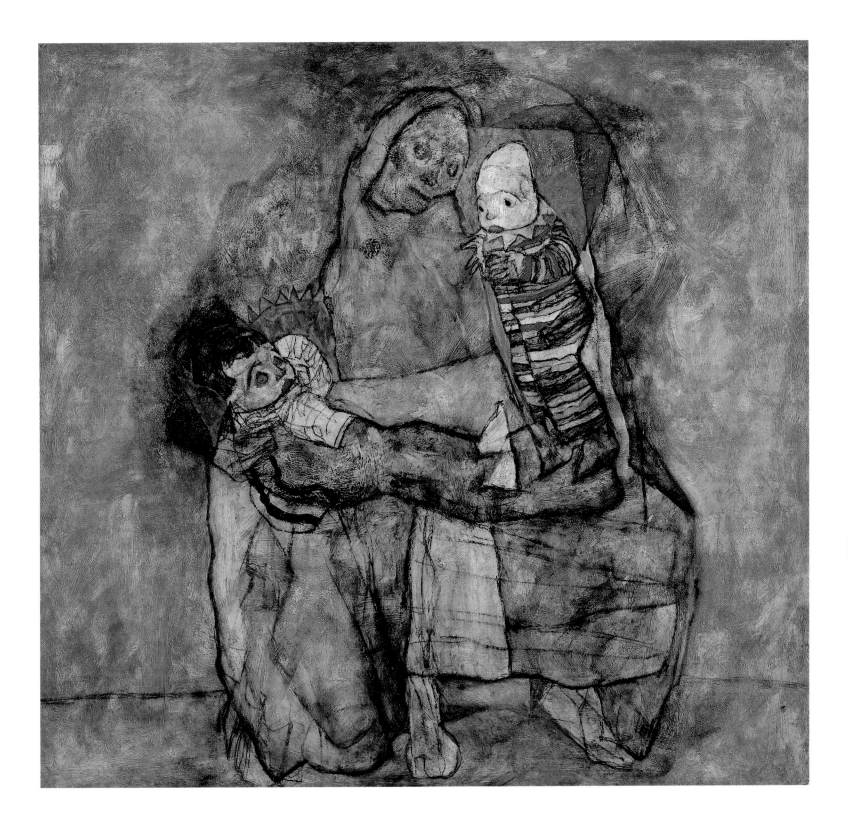

Egon Schiele
49 *One-Year Volunteer Lance-Corporal*, 1916
Einjährig freiwilliger Gefreiter

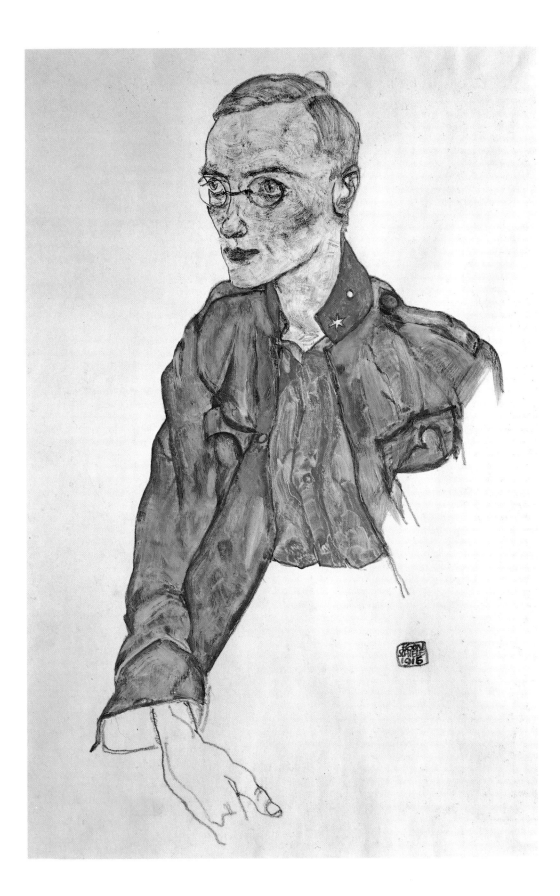

Egon Schiele
50 *'Reclining Woman'*, 1917
'Liegende Frau'

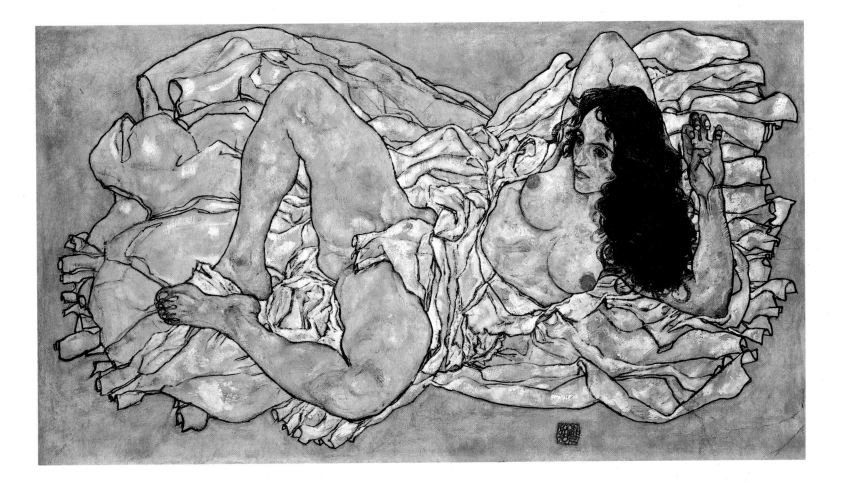

Egon Schiele
51 *Girl Kneeling, Resting on Both Elbows*, 1917
Kniendes Mädchen, auf beide Ellbogen gestützt

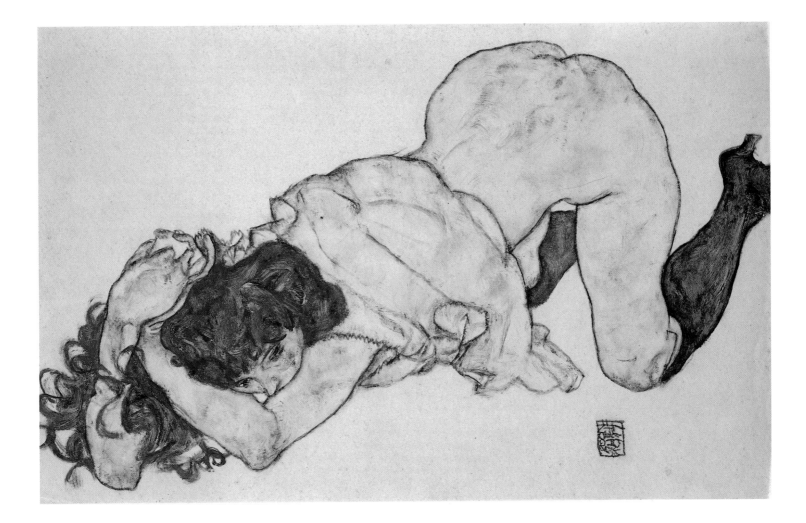

Egon Schiele
52 *Pair of Women Squatting, 'Crouching Pair',* 1918
Hockendes Frauenpaar, 'Kauerndes Paar'
(Unfinished)

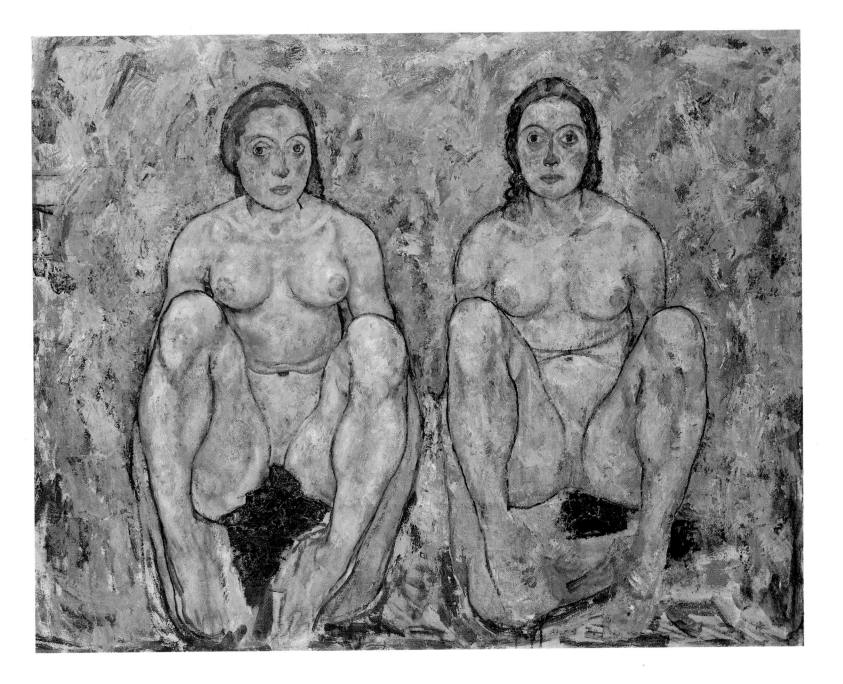

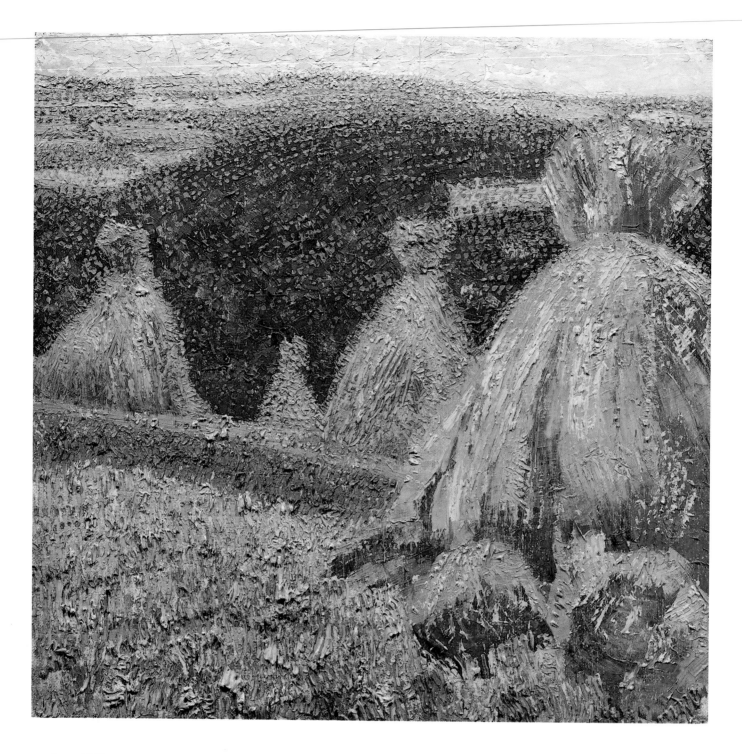

Leopold Blauensteiner
54 *Landscape with Sheaves of Corn,* 1902/3
Landschaft mit Ährengarben

Ferdinand Andri
53 *Mountain Landscape, c.* 1905
Gebirgslandschaft
(See p. 275)

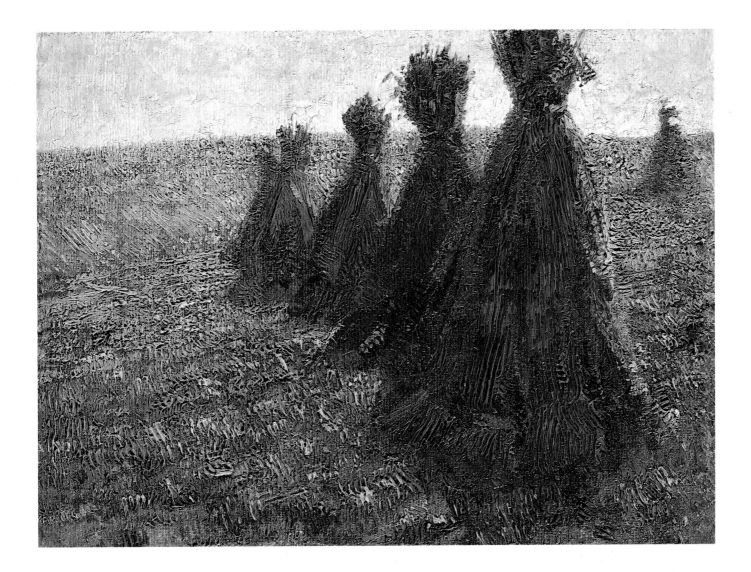

Leopold Blauensteiner
55 *Landscape with Sheaves of Corn,* 1902/3
Landschaft mit Ährengarben

Leopold Blauensteiner
56 *Landscape with Sheaves of Corn,* 1902/3
Landschaft mit Ährengarben
(See p. 276)

Herbert Boeckl
57 *Reclining Woman, 1919*
Liegende Frau

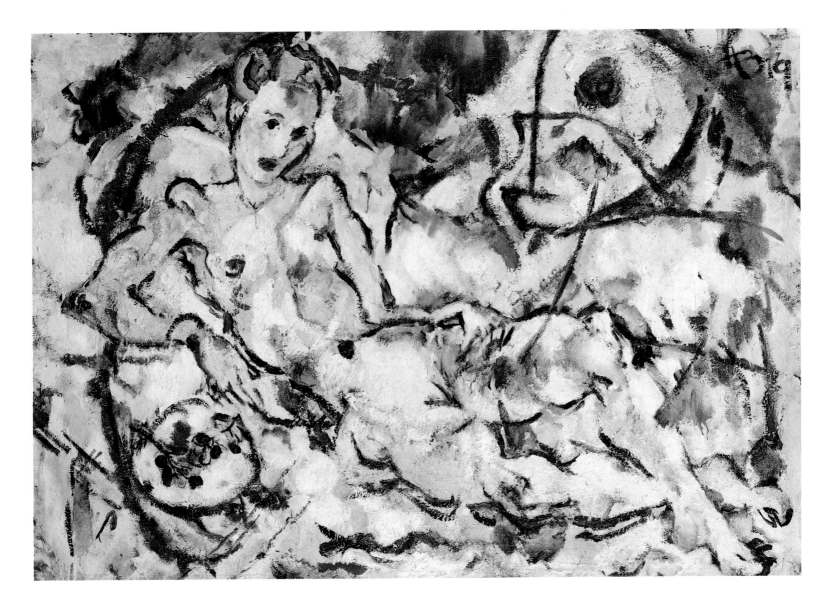

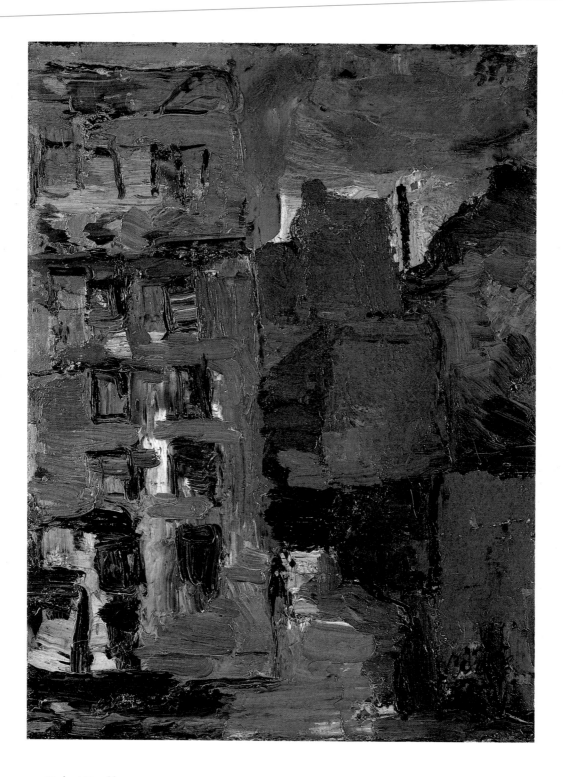

Herbert Boeckl
58 *Berlin Factory, 1921*
Berliner Fabrik

Herbert Boeckl
59 *Still-Life with Dead Pigeon, 1922*
 Stilleben mit toter Taube

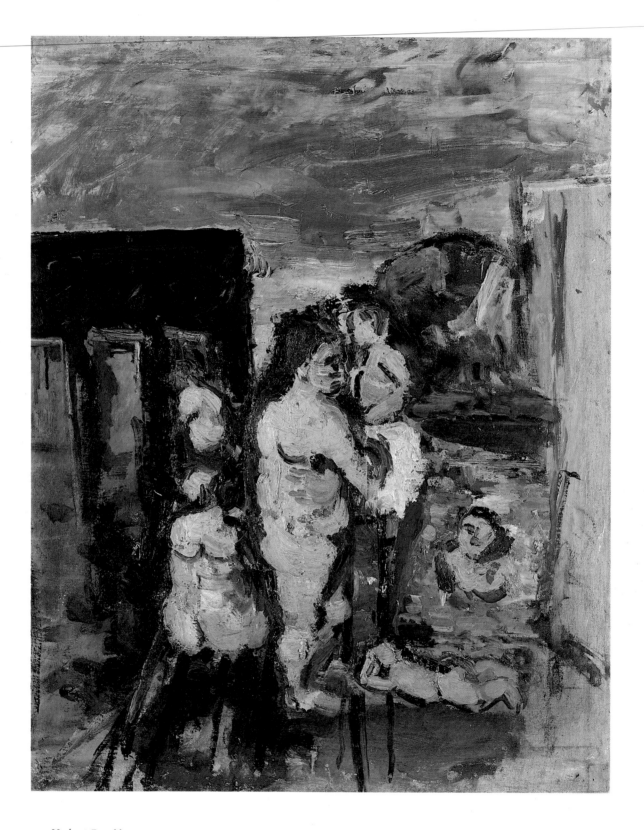

Herbert Boeckl
60 *Bathers at Klopein Lake, 1922*
 Badende am Klopeiner See

Herbert Boeckl
61 *Large Sicilian Landscape*, 1924
Grosse sizilianische Landschaft

Hans Böhler
62 *Negro Boy in Blue Jacket, c. 1925*
Negerjunge mit blauer Jacke

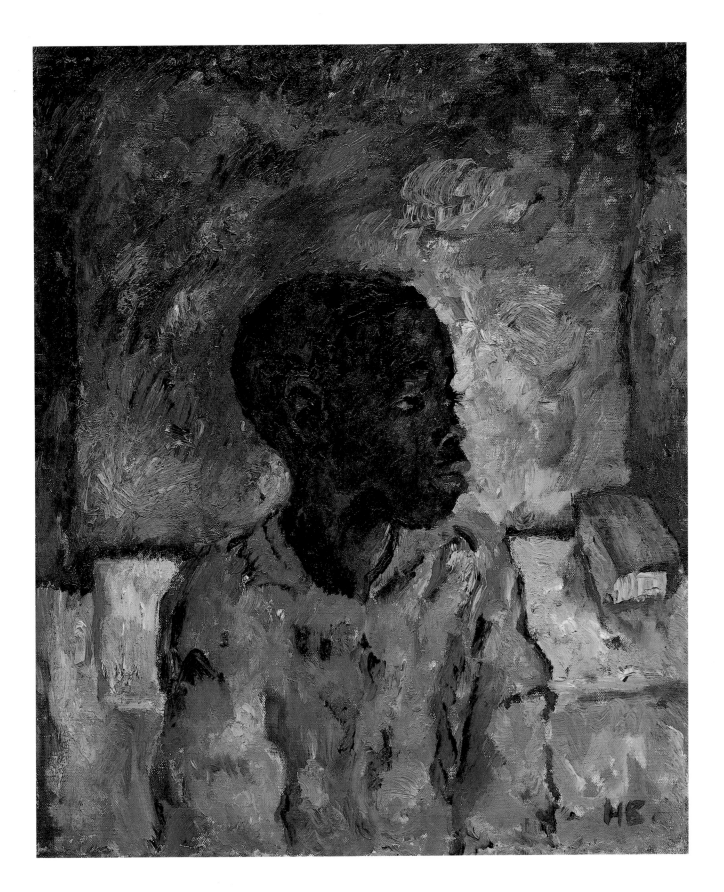

Hans Böhler
63 *Baden Landscape, 1925*
Badener Landschaft

Hans Böhler
64 *Seated Woman with Bunch of Flowers*, 1928
 Sitzende mit Blumenstrauss

Arnold Clementschitsch
65 *Street Scene*, 1920
Strassenszene

Josef Dobrowsky
66 *Children and Women in Landscape with Farmhouse, 1924*
Kinder und Frauen in Landschaft mit Bauernhaus

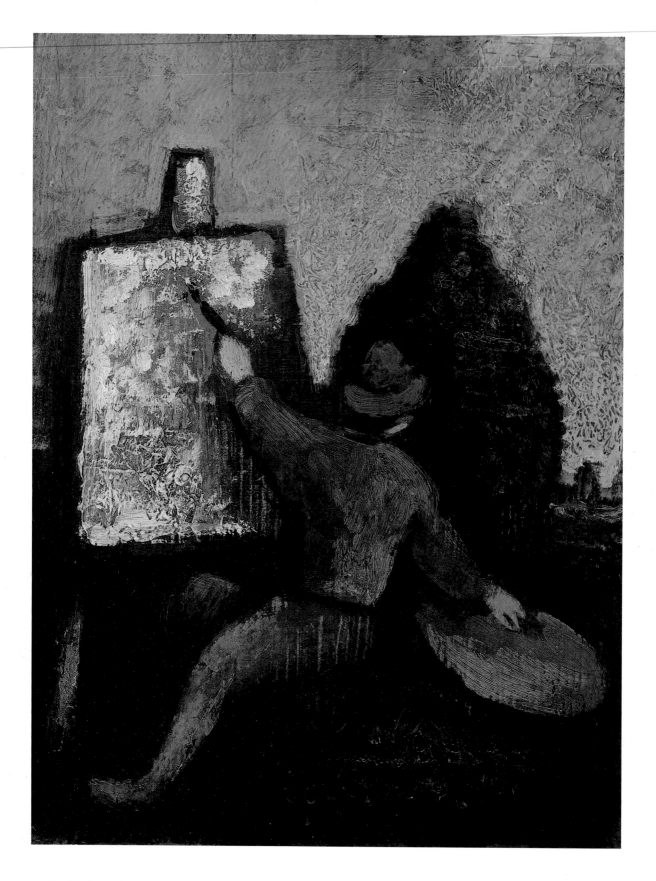

Josef Dobrowsky
67 *Painter at the Easel, c. 1925*
 Maler an der Staffelei

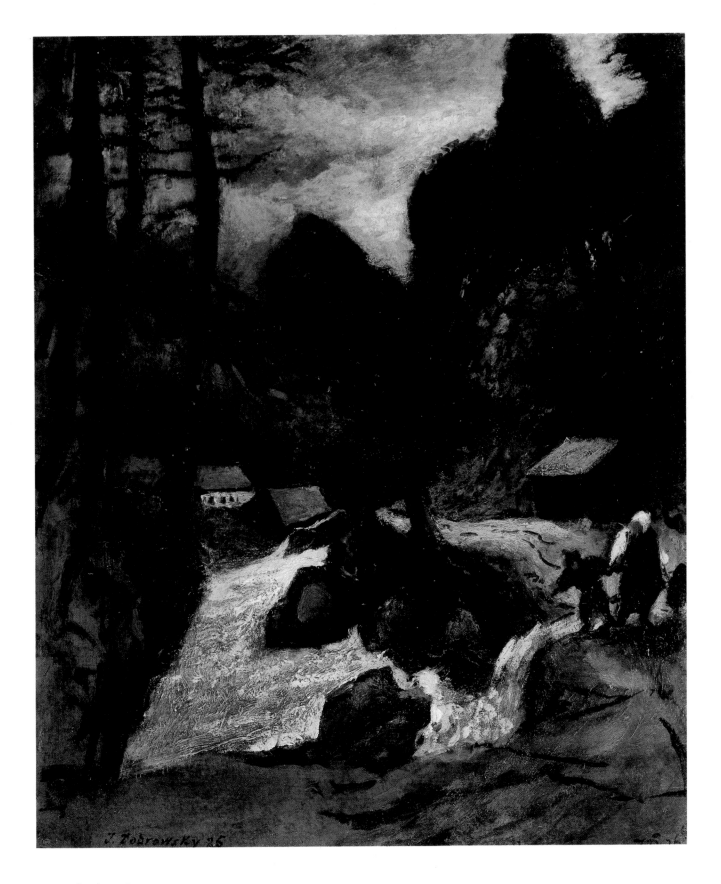

Josef Dobrowsky
68 *By the Torrent*, 1926
Am Wildbach

Albin Egger-Lienz
69 *Alpine Pastures in the Ötz Valley*, 1911
Almlandschaft im Ötztal

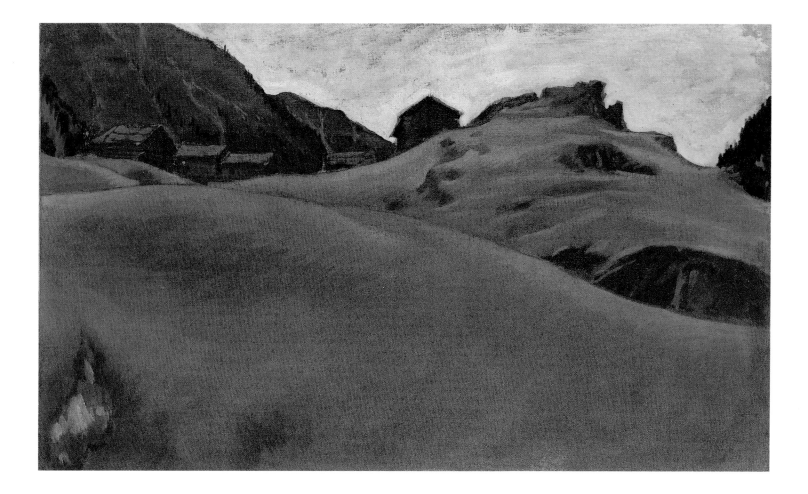

Albin Egger-Lienz
70 *'Finale'*, 1918

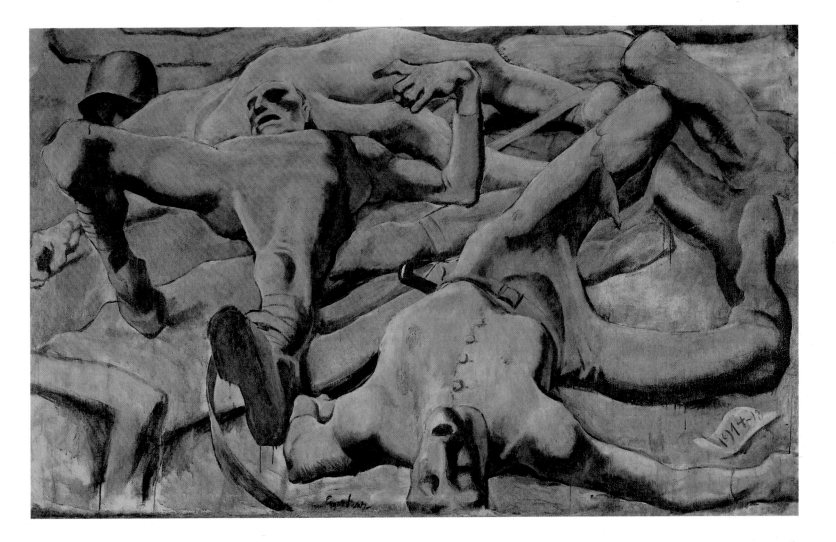

Albin Egger-Lienz
71 *'The Reapers'*, also *'The Mountain Reapers*
in Gathering Storm', c. 1922
'Die Schnitter', also *'Die Bergmäher bei aufsteigendem Gewitter'*

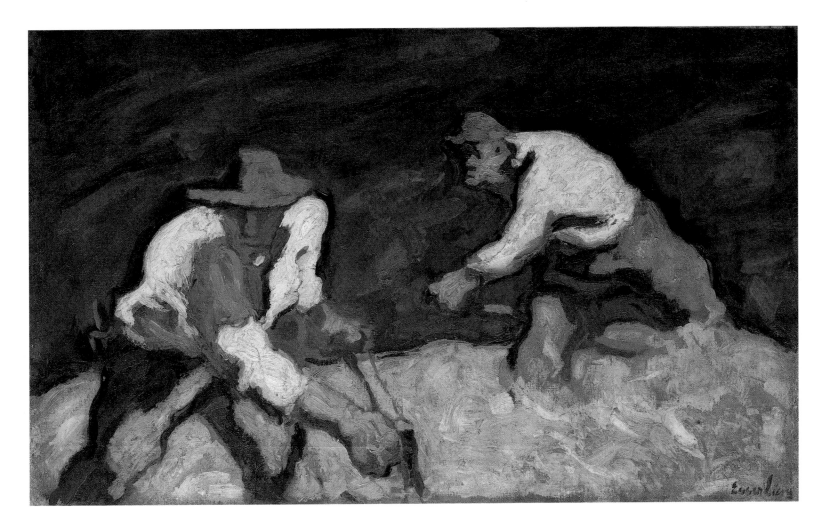

Albin Egger-Lienz
72 *'The Spring'*, 1923
'Die Quelle'

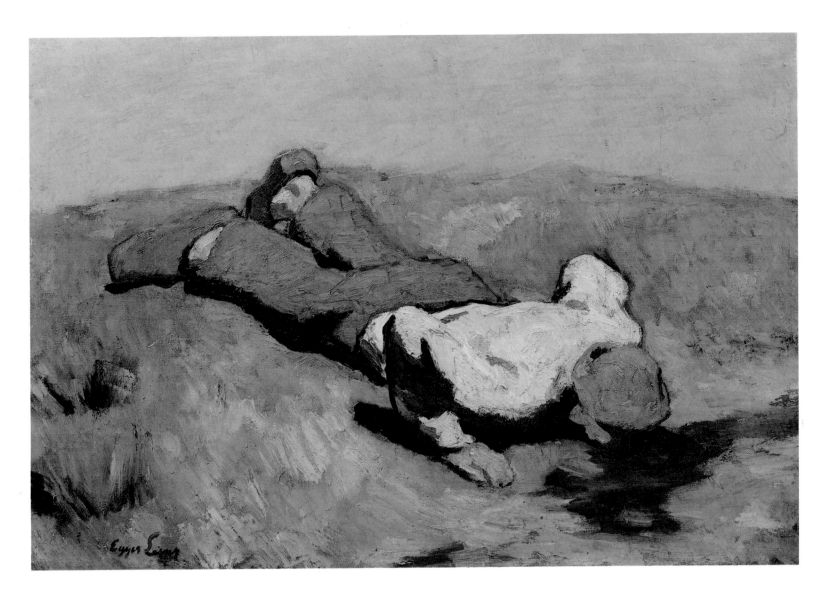

Anton Faistauer
73 *Old Mill near Maishofen*, 1911
Alte Mühle bei Maishofen

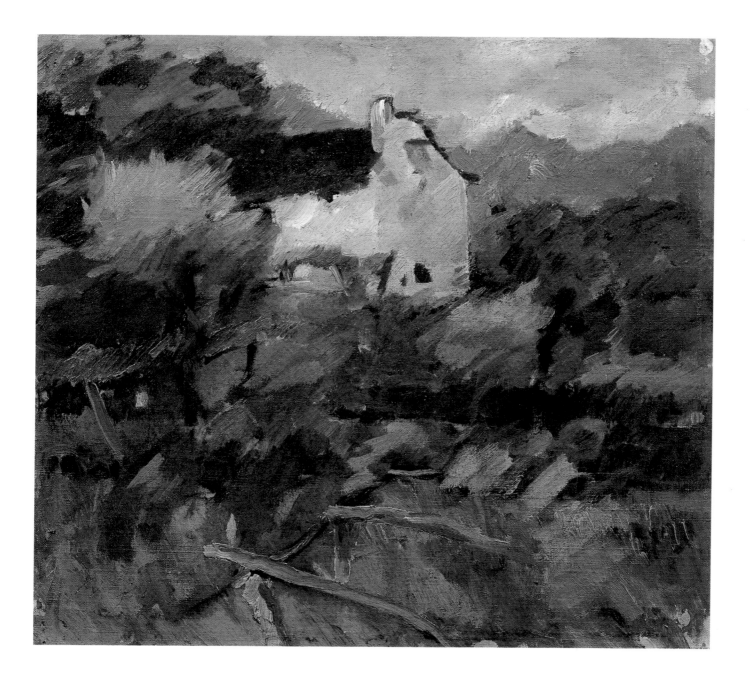

Anton Faistauer
74 *Larkspur Still-Life, c.* 1913
Rittersporn-Stilleben

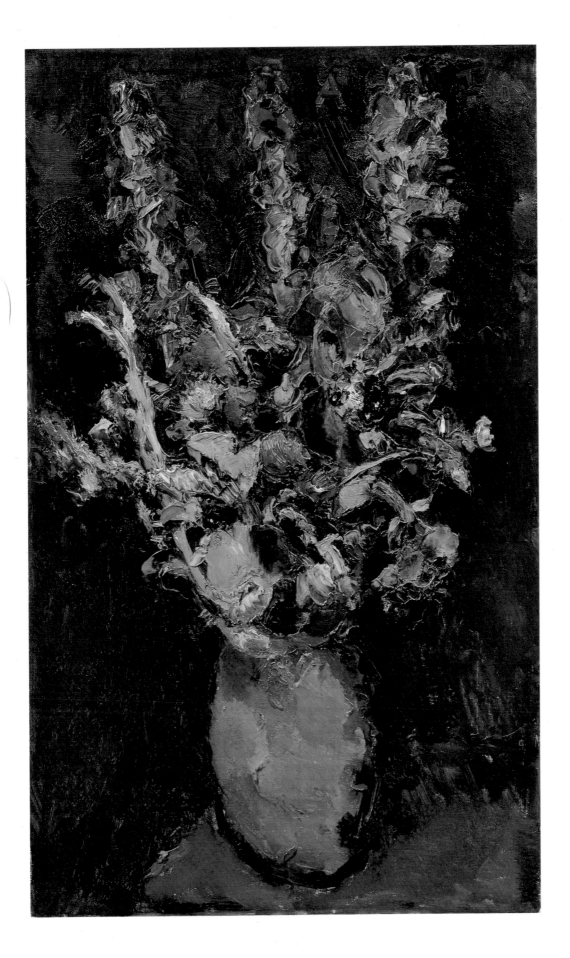

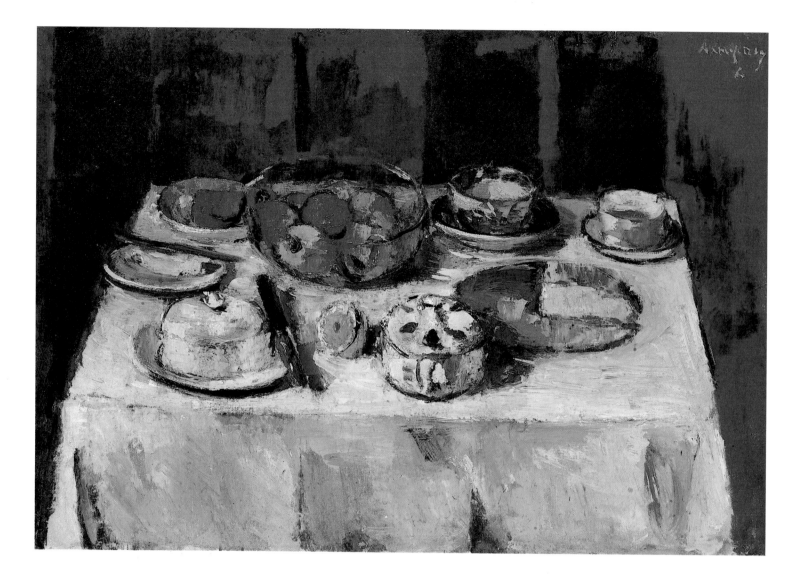

Anton Faistauer
75 *Still-Life (Set Table)*, 1916
Stilleben (Gedeckter Tisch)

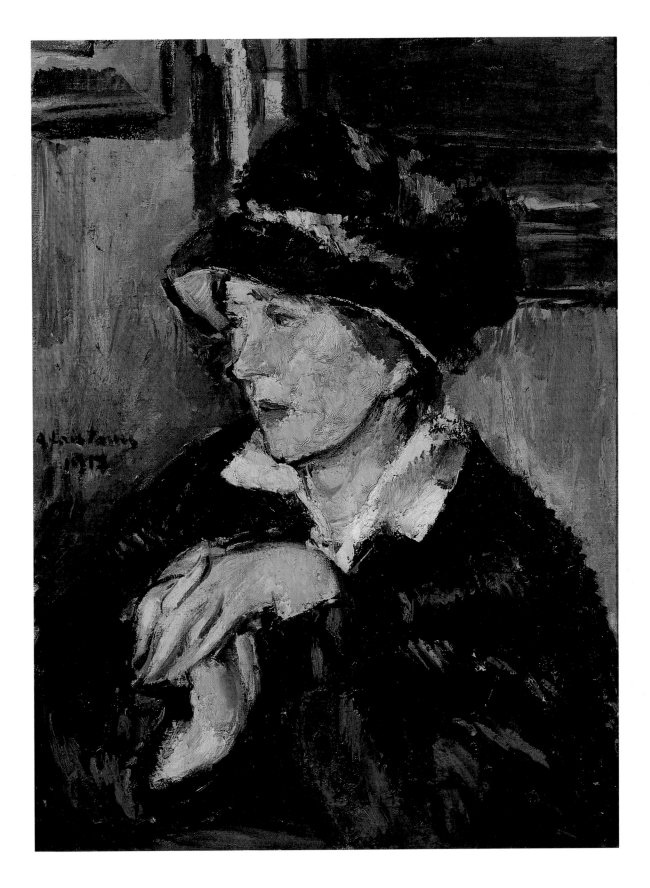

Anton Faistauer
76 *Lady with Dark Hat, 1917*
 Dame mit dunklem Hut

Gerhart Frankl
77 *Roofs with Chimneys, in the Background Mountains, c.* 1924
Dächer mit Rauchfängen, im Hintergrund Berge

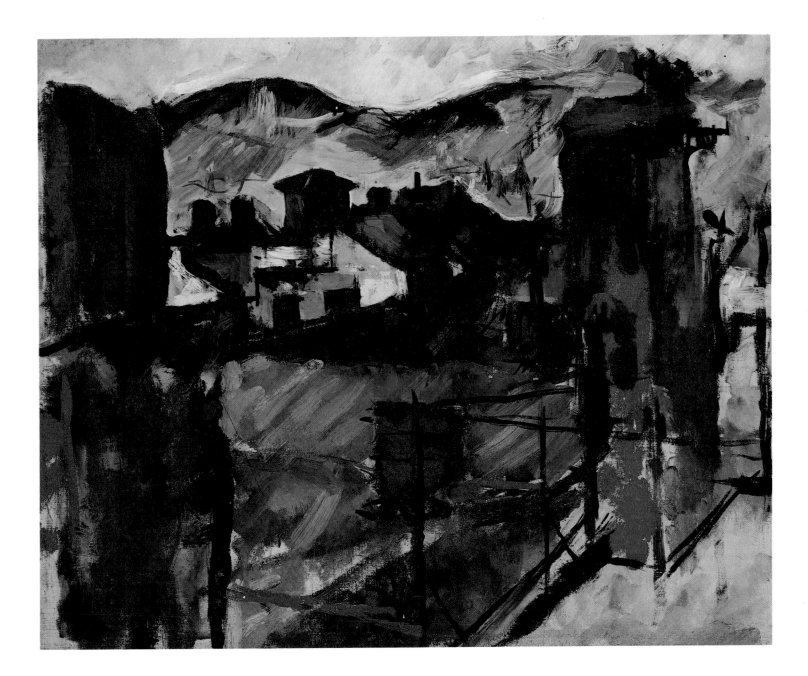

Gerhart Frankl
78 *Still-Life with Lobster*, 1928
Stilleben mit Hummer

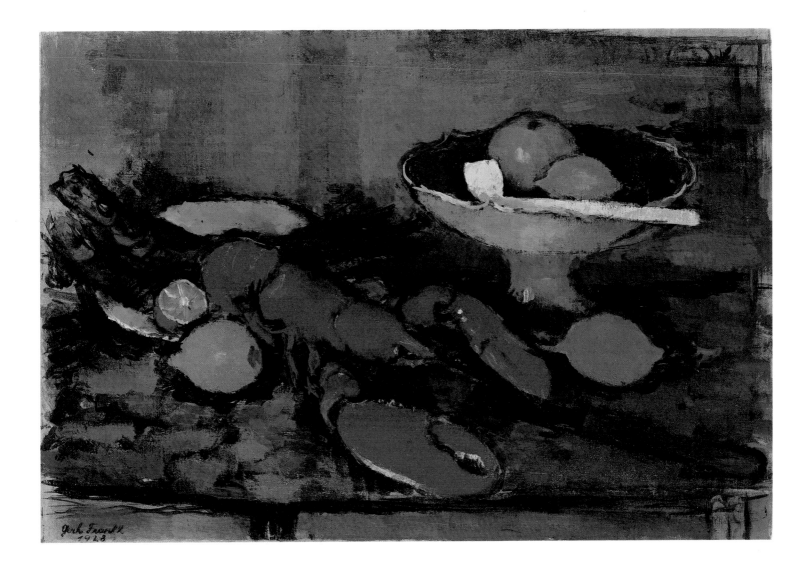

Gerhart Frankl
79 *Rheims Cathedral, 1929*
Die Kathedrale von Reims

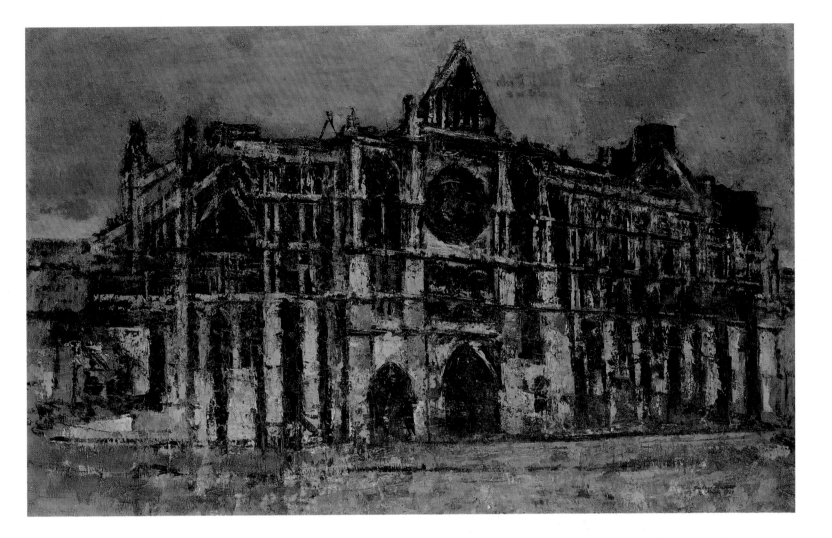

Richard Gerstl
80 *Self-Portrait, Semi-nude, against Blue Background*, 1901
Selbstdarstellung als Halbakt vor blauem Hintergrund

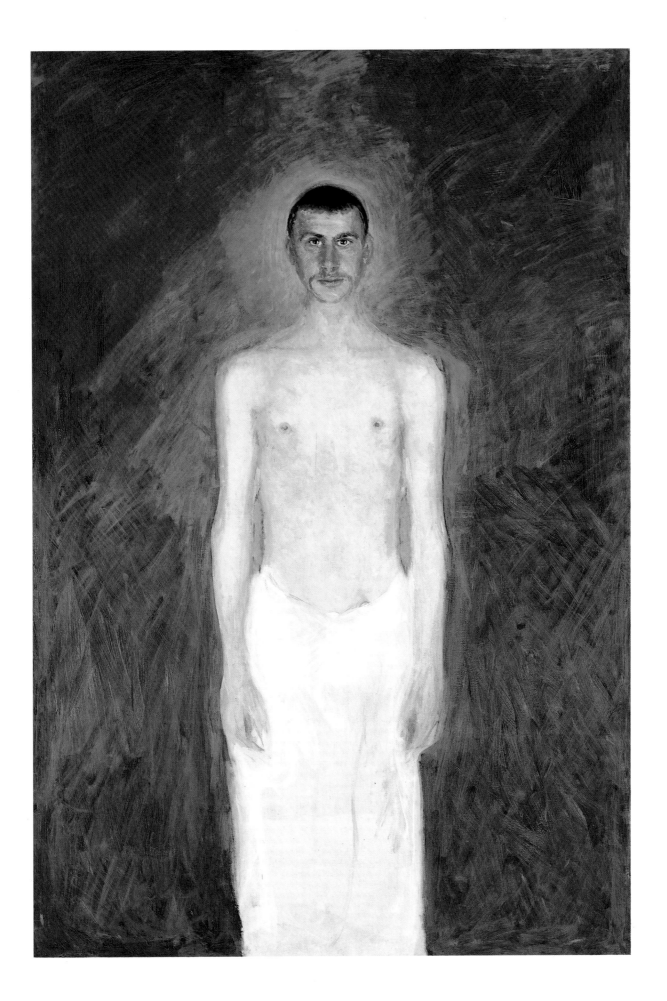

Richard Gerstl
81 *View of the Park, c. 1908*
Blick in den Park

Richard Gerstl
82 *Meadow with Houses in the Background, c.* 1908
Wiese mit Häusern im Hintergrund

Richard Gerstl
83 *By the Danube Canal, c.* 1908
Am Donaukanal

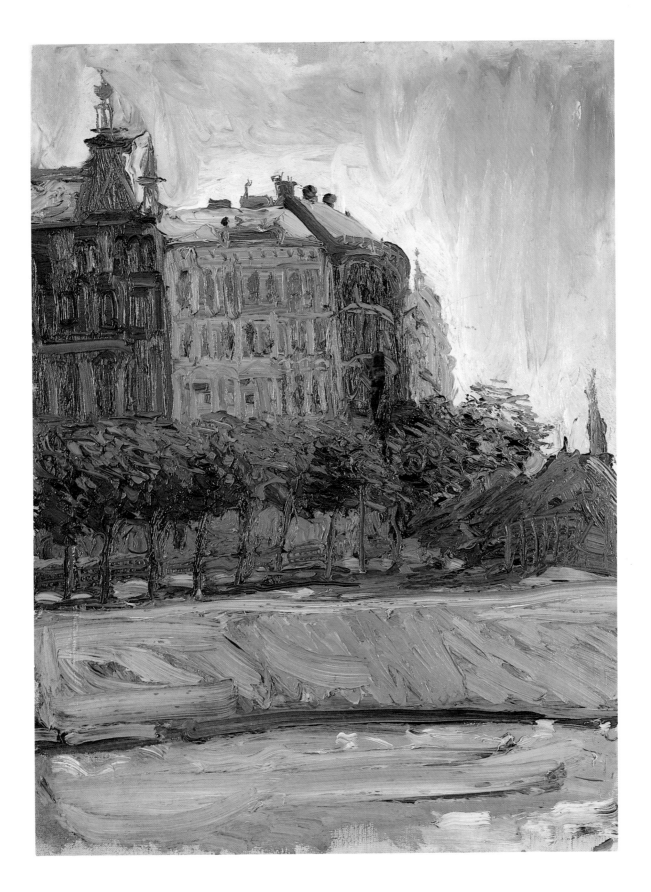

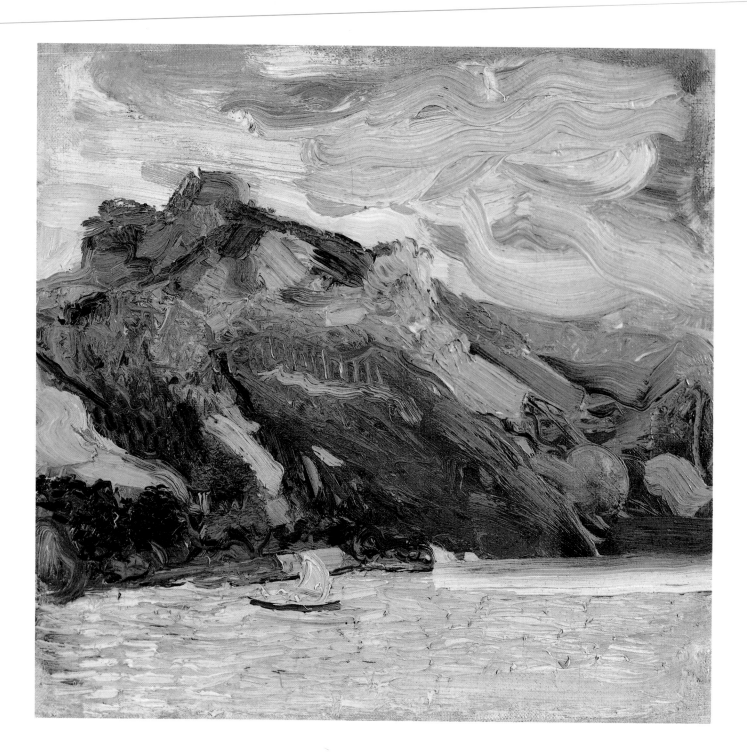

Richard Gerstl
84 *Lake Traun with the 'Schlafende Griechin', 1908*
 Traunsee mit 'Schlafender Griechin'
 (The mountain is so named owing to its resemblance to a sleeping Greek woman)

Richard Gerstl
85 *Lakeshore Road near Gmunden, in the Background the 'Schlafende Griechin'*, 1908
 Uferstrasse bei Gmunden, im Hintergrund die 'Schlafende Griechin'

Richard Gerstl
86 *Sunlit Meadow with Fruit-Trees,* 1908
Sonnige Wiese mit Obstbäumen

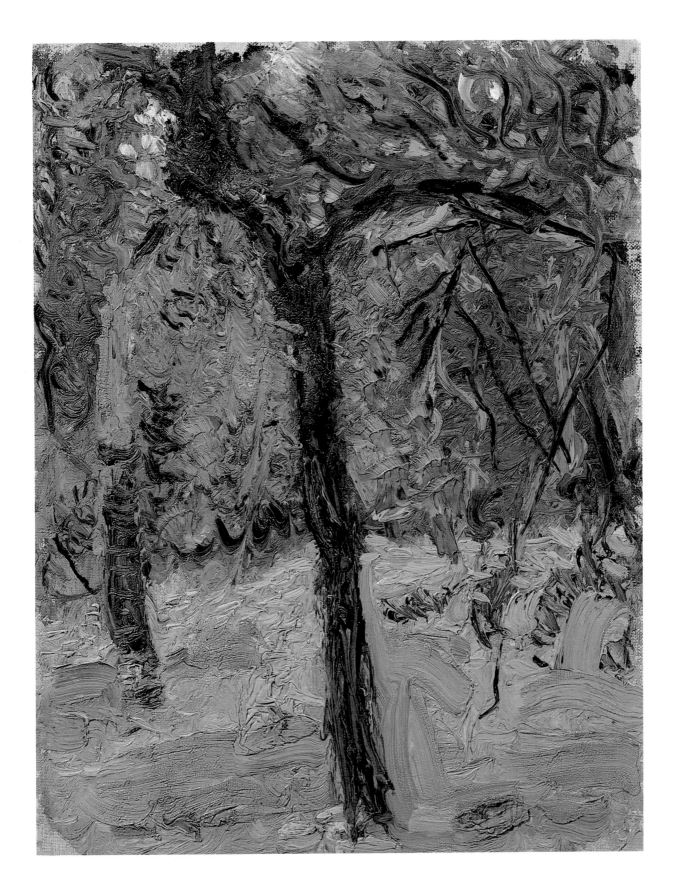

Richard Gerstl
87 *Nude Self-Portrait, 1908*
Selbstakt

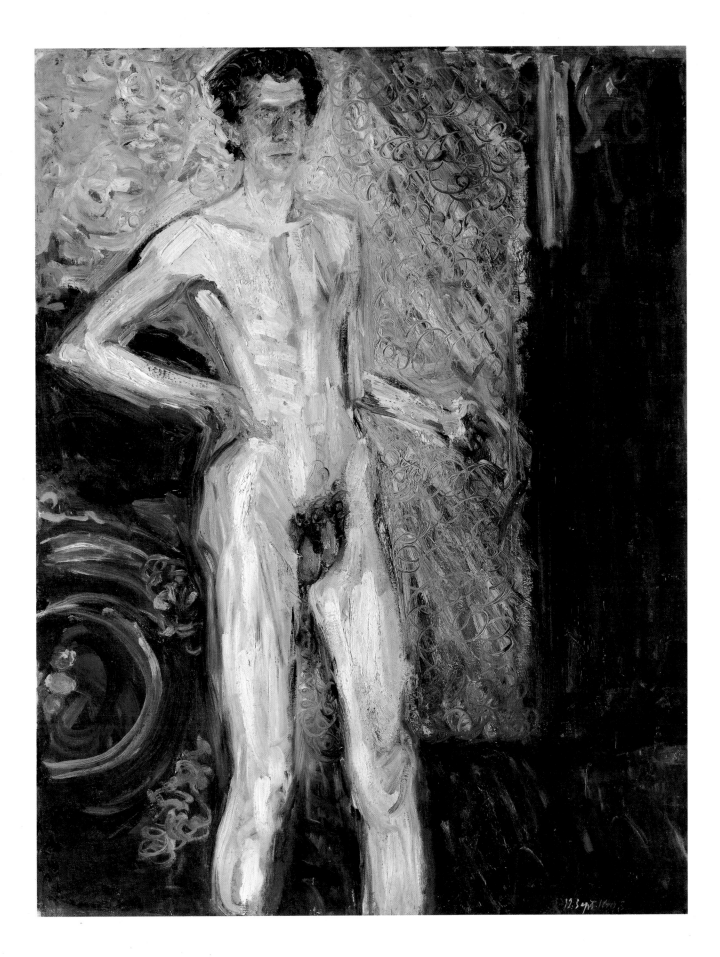

Albert Paris Gütersloh
88 *Still-Life with Armchair*, 1912
Stilleben mit Sessel

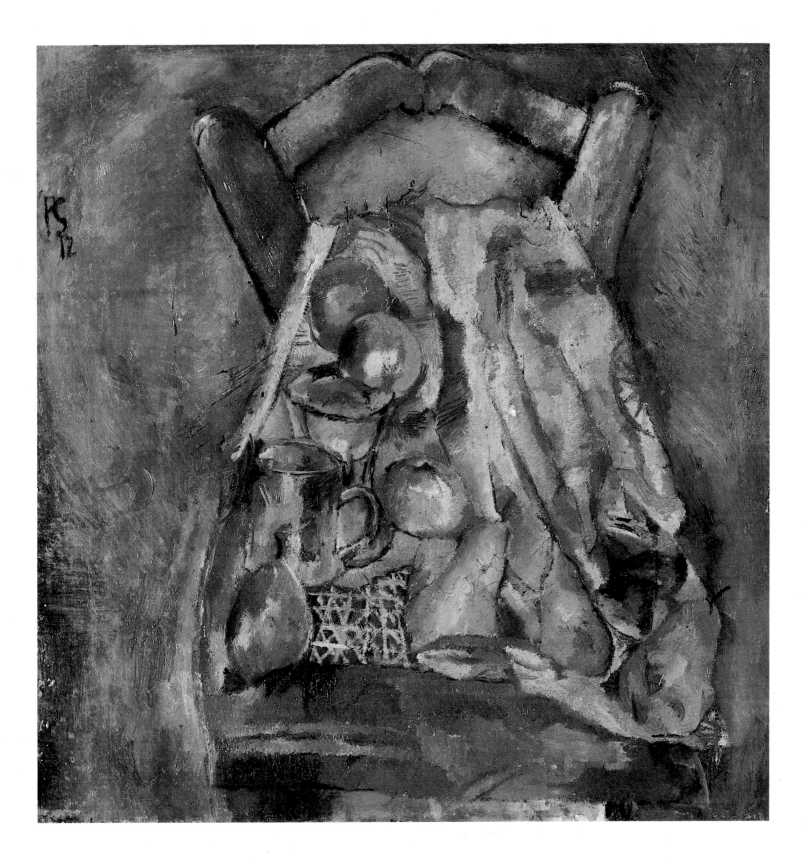

Albert Paris Gütersloh
89 *Woman and Child,* 1913
Frau mit Kind

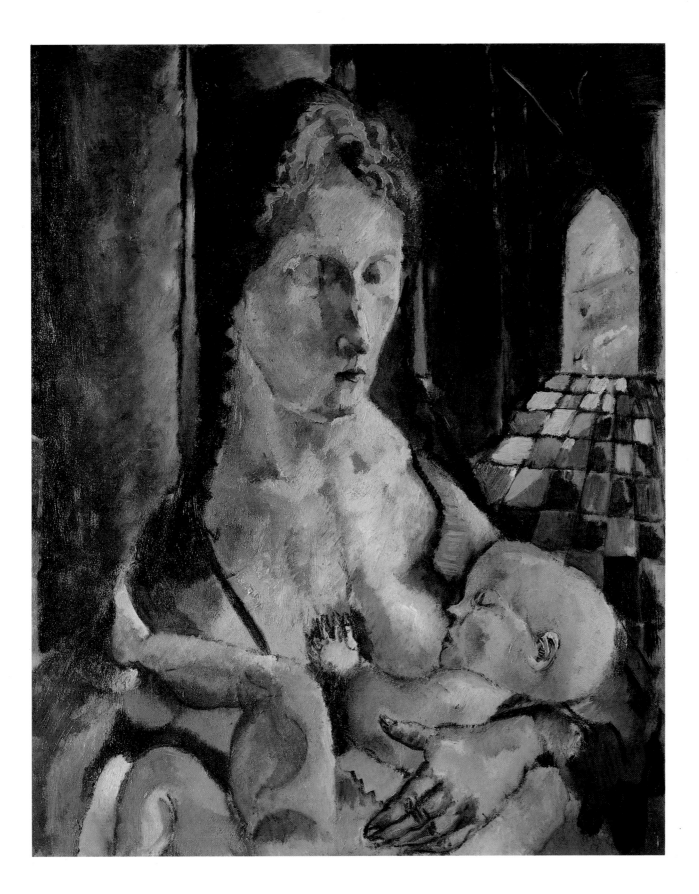

Albert Paris Gütersloh
90 *Portrait of a Woman*, 1914
Frauenbildnis

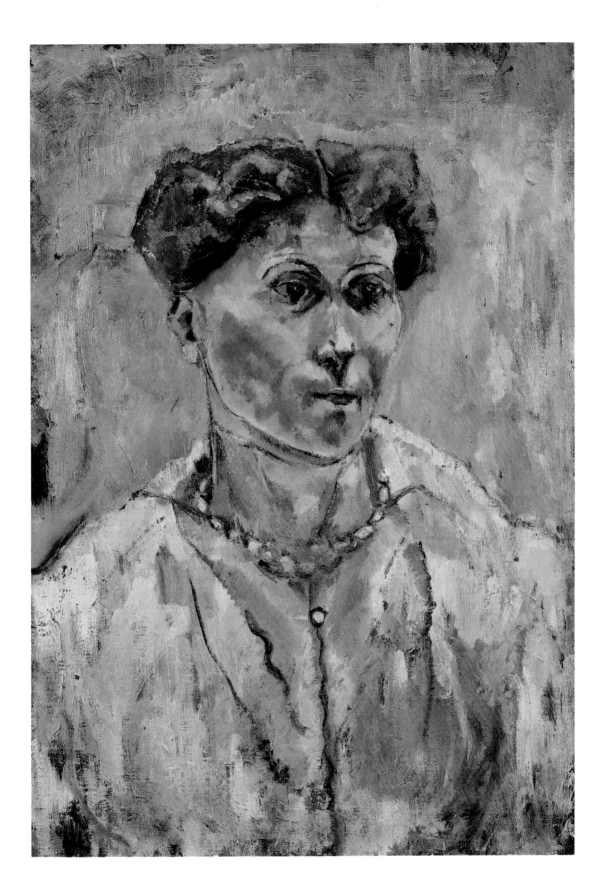

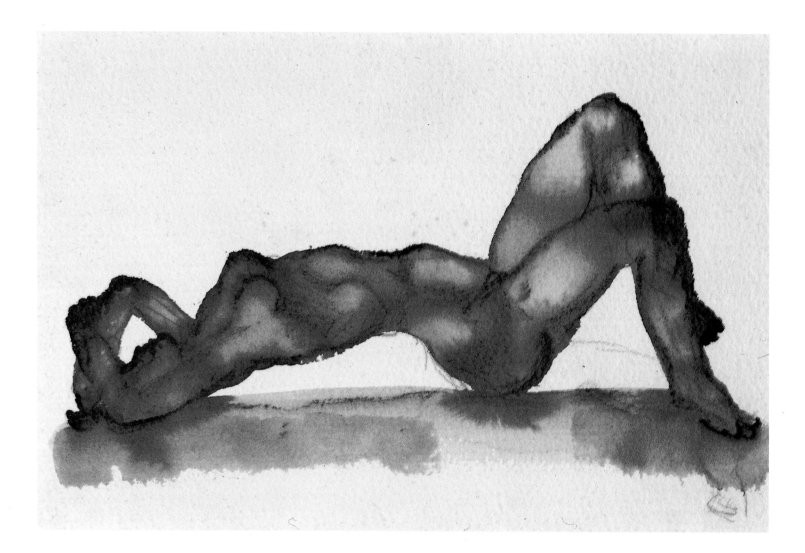

Anton Hanak
91 *Reclining Female Nude with Legs Drawn Up, c.* 1915
Liegender Frauenakt mit aufgestützten Beinen

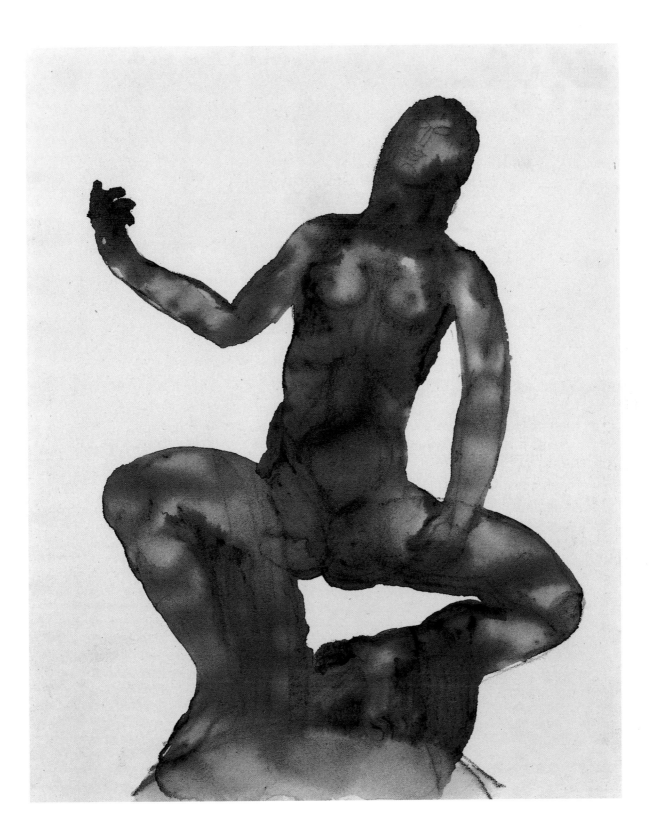

Anton Hanak
92 *Crouching Female Nude, c. 1915*
 Hockender Frauenakt

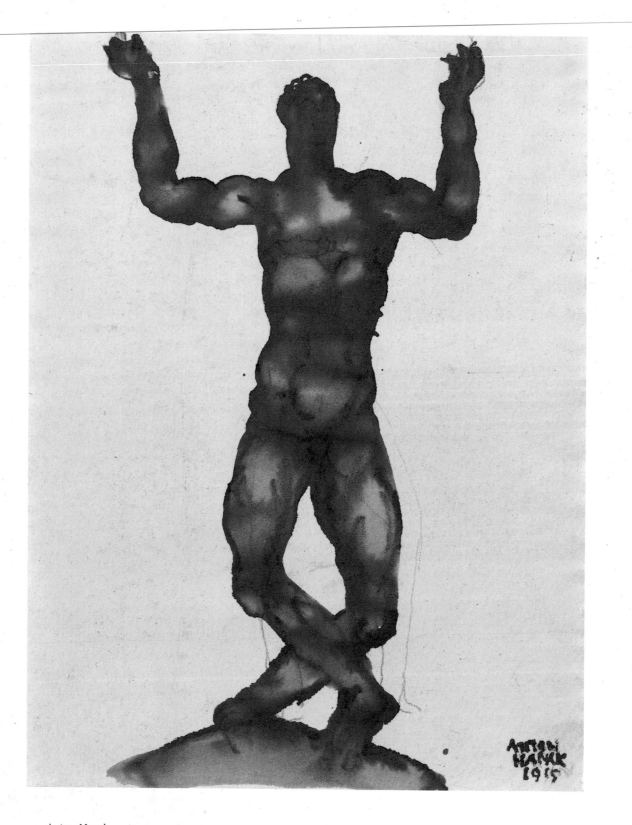

Anton Hanak

93 *Male Nude with Raised Arms*, 1915
Männerakt mit erhobenen Armen
(First idea for *'Man on Fire'*)

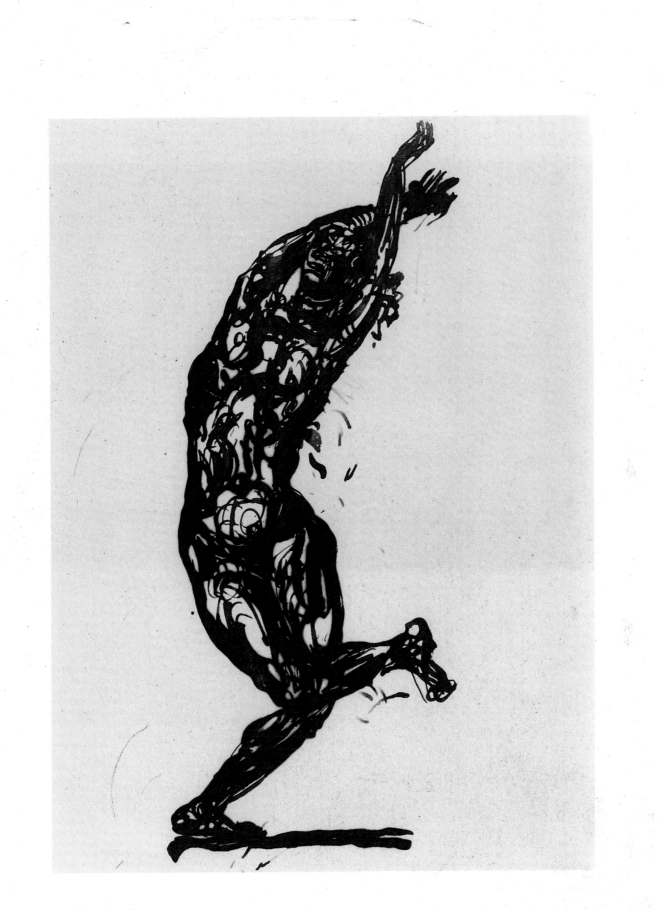

Anton Hanak
94 *Figure in Ecstatic Motion, c. 1921*
Figur in ekstatischer Bewegung

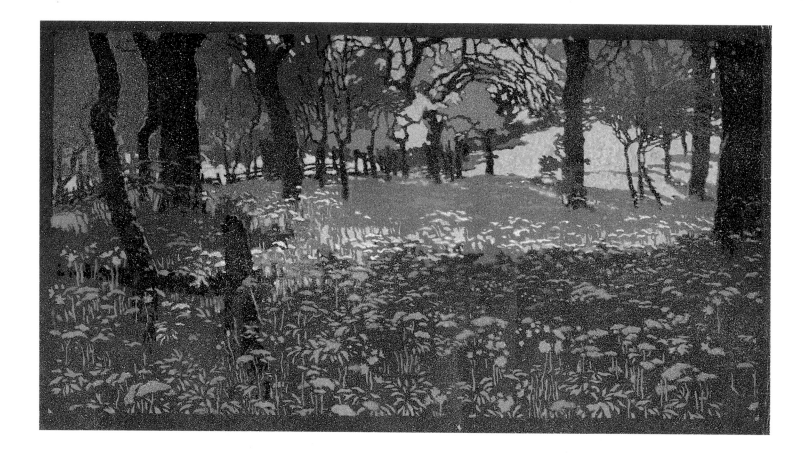

Ludwig Heinrich Jungnickel
96 *Meadow with Trees*, 1905/6
 Wiese mit Bäumen

Ludwig Heinrich Jungnickel
95 *Girl in Front of a Farmhouse, c.* 1903
 Mädchen vor einem Bauernhof
 (See p. 277)

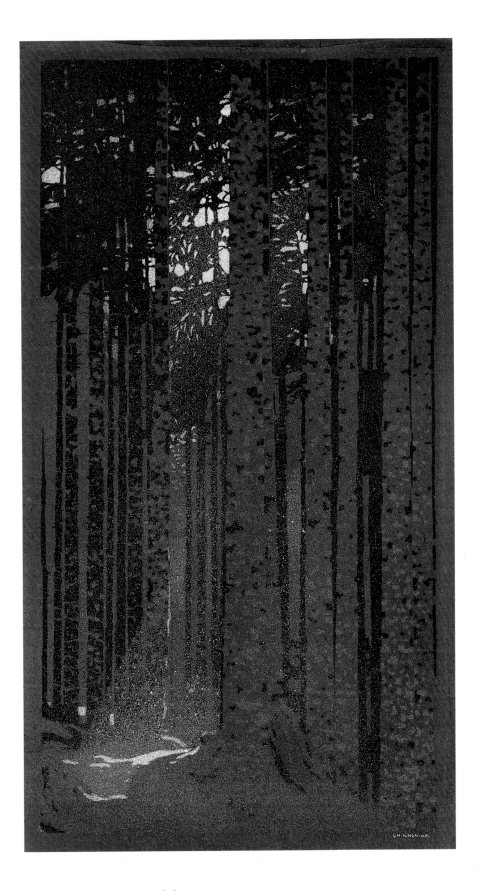

Ludwig Heinrich Jungnickel
97 *Sun in the Forest, 1905/6*
 Sonne im Wald

Gustav Klimt
98 *Girl with Hat and Cape in Profile*, 1897/98
Mädchen mit Hut und Cape im Profil

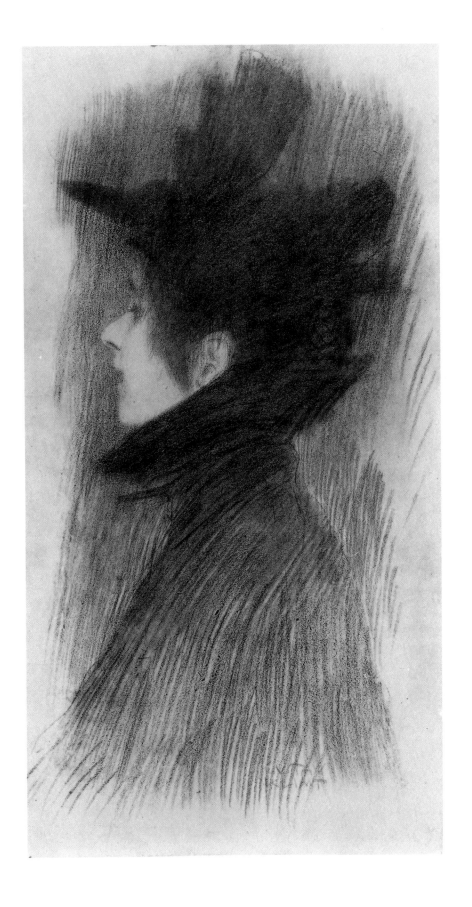

Gustav Klimt
99 *Still Pond in Schloss Kammer Grounds, c. 1899*
Stiller Weiher im Schlosspark von Kammer

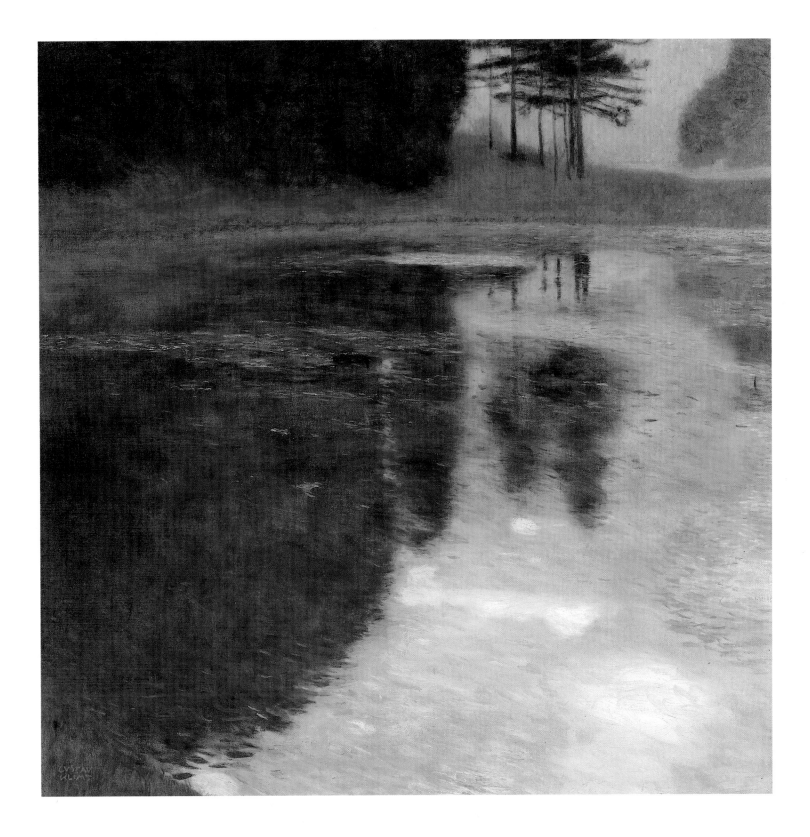

Gustav Klimt
100 *The Embrace*, 1902
Die Umarmung
(Study for the composition *'This Our Kiss for
All the World'* in the *Beethoven Frieze*)

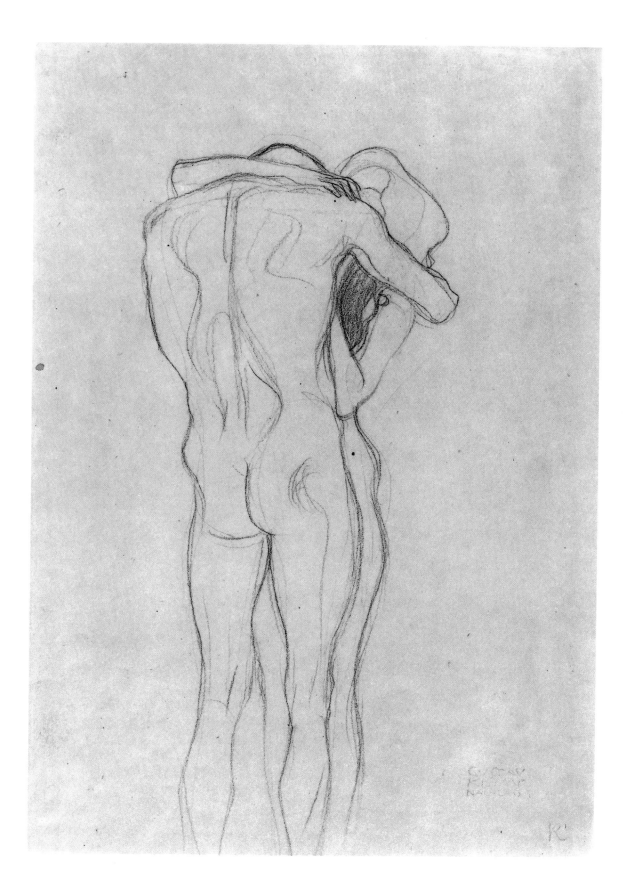

Gustav Klimt
101 *The Large Poplar* (II), also *'Gathering Storm'*, 1903
Die grosse Pappel (II), also *'Aufsteigendes Gewitter'*

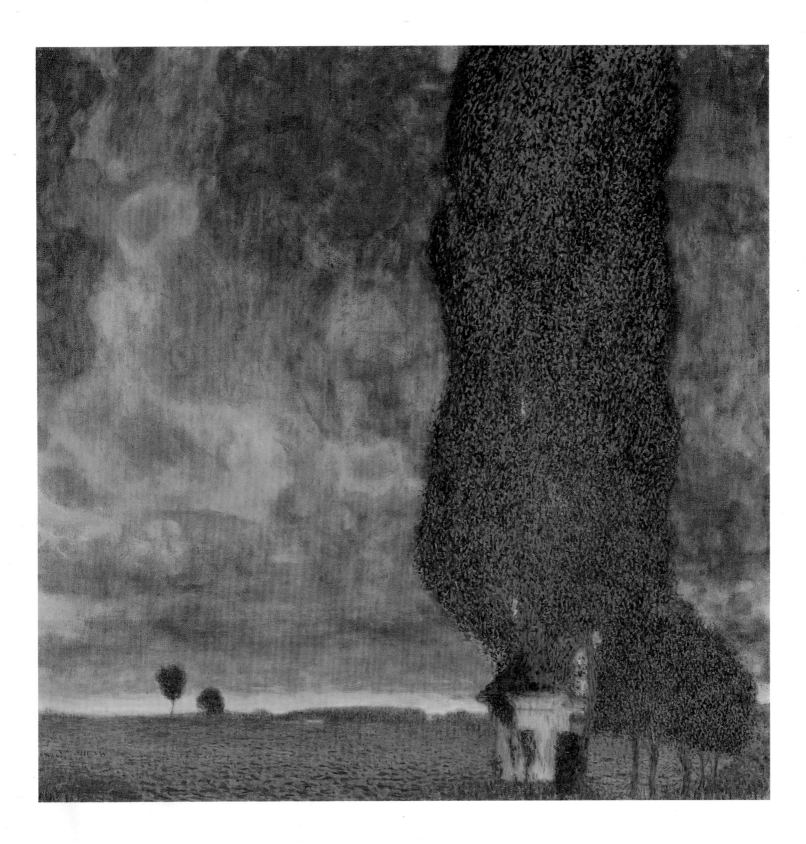

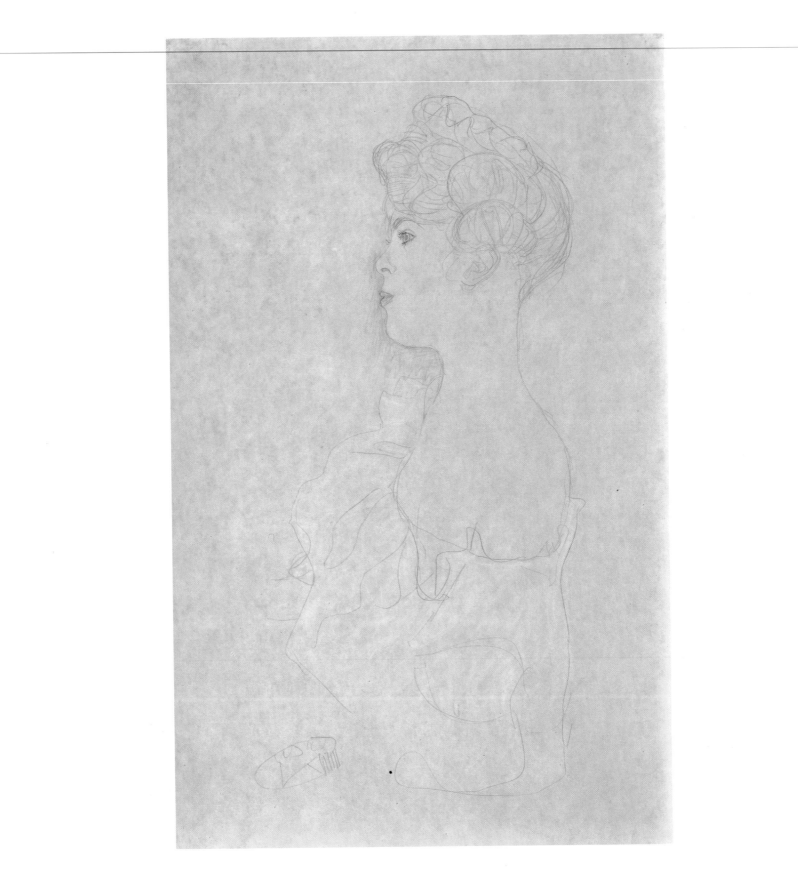

Gustav Klimt
102 *Portrait of a Girl*, 1904/5
 Mädchenbildnis

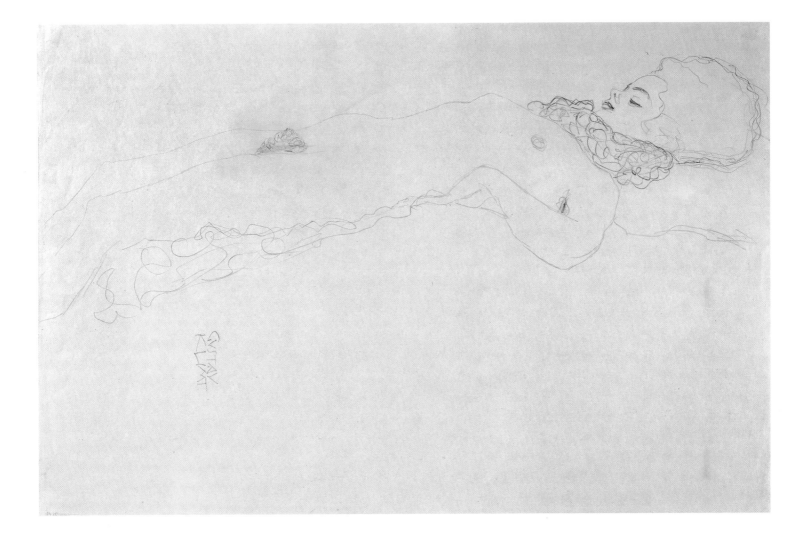

Gustav Klimt
103 *Reclining Female Nude, Head on the Right, with Ruff, 1905/6*
 Liegender Frauenakt nach rechts mit Halskrause

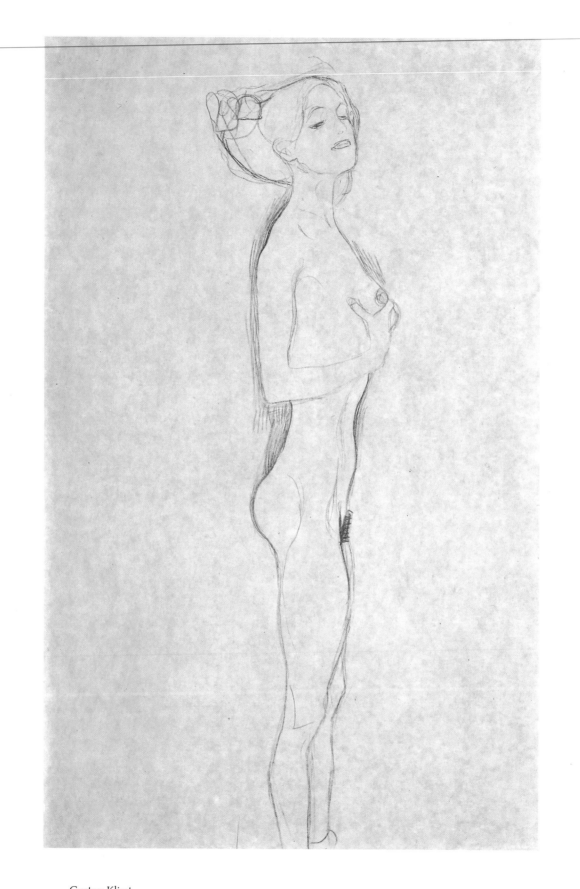

Gustav Klimt
104 *Naked Girl Standing, Right Hand on Breast, 1906/7*
 Stehendes nacktes Mädchen, die rechte Hand an der Brust

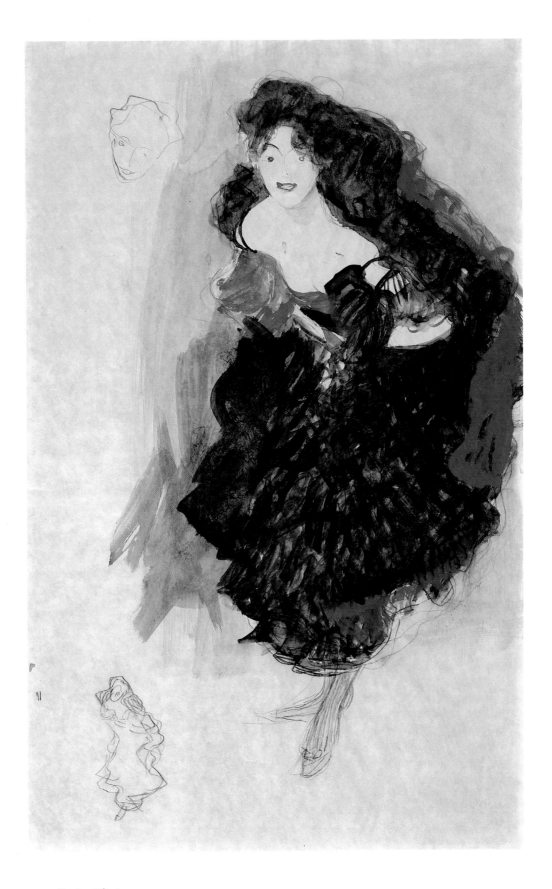

Gustav Klimt
105 *Dancer, c.* 1908
 Tänzerin

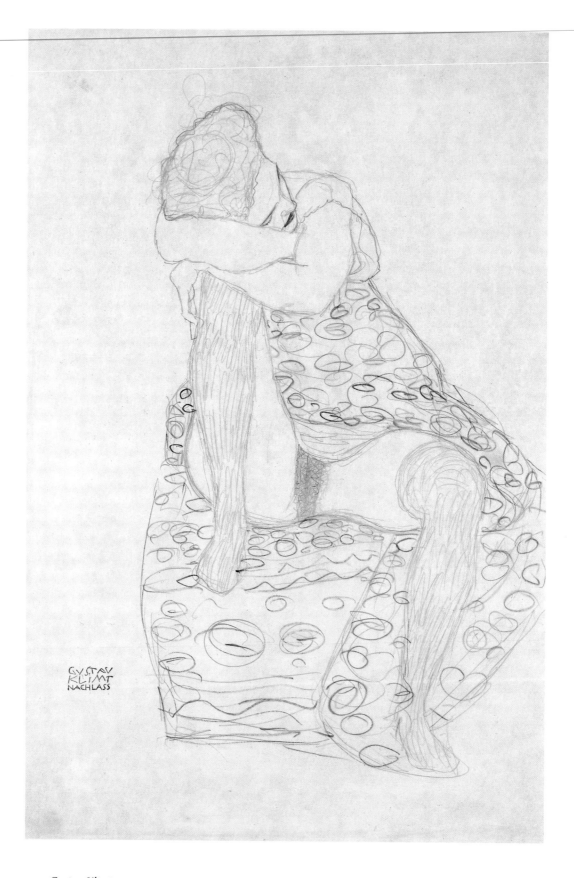

Gustav Klimt

106 *Seated Semi-Nude, Leaning on Right Knee,* 1909/10
Sitzender Halbakt, sich auf dem rechten Knie aufstützend

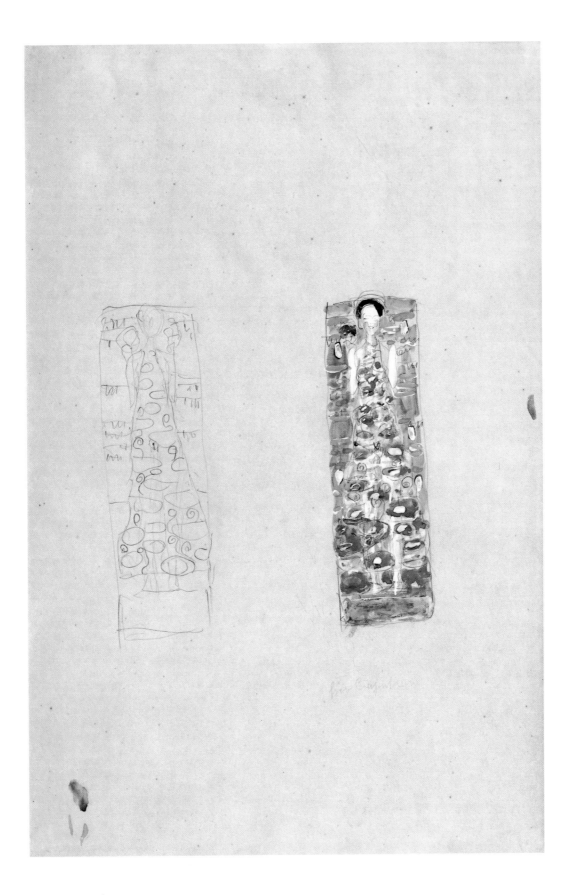

Gustav Klimt
107 *Two Studies for a Nike, 1911*
Zwei Entwürfe einer Nike (For '*Otto Wagner Testimonial*')

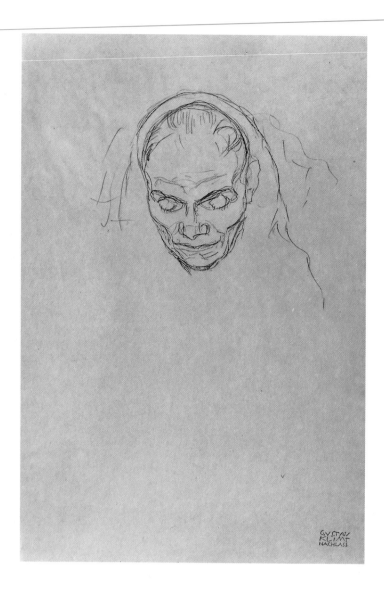

Gustav Klimt
108 *Head of an Old Woman*, 1908-11
Kopf einer alten Frau
(Study for the Mother in *'Death and Life'*)

Gustav Klimt
109 *Death and Life*, before 1911, reworked 1915
Tod und Leben

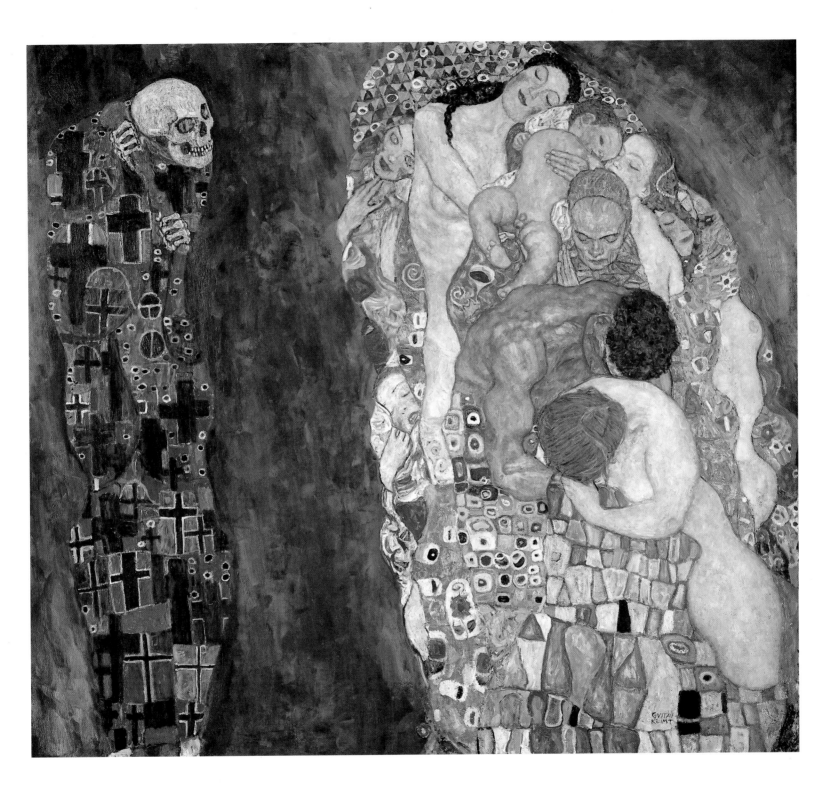

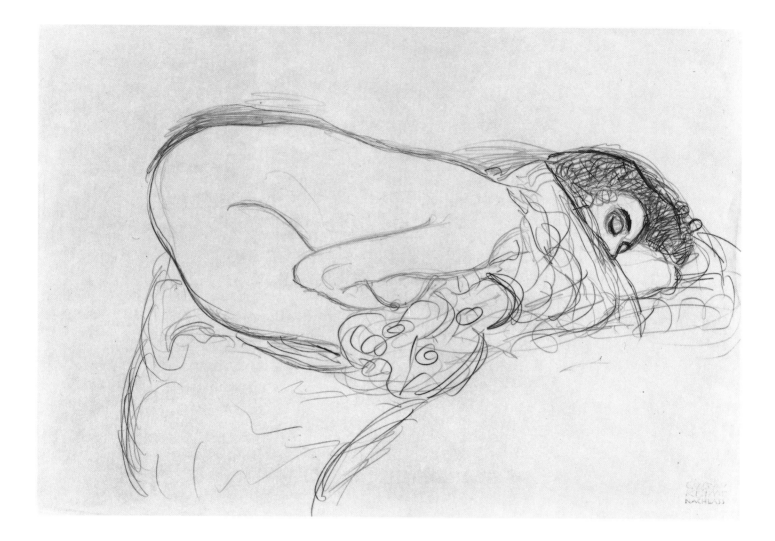

Gustav Klimt

111 *Kneeling Semi-Nude with Eyes Closed, Bending Forwards, 1913/14*
Kauernder Halbakt mit geschlossenen Augen, nach vorn gebeugt
(The pose closely anticipates that in *'Leda'*)

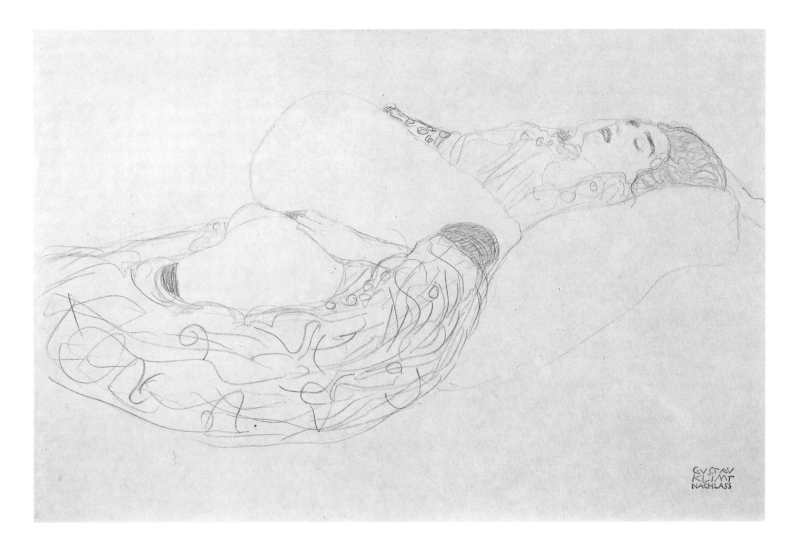

Gustav Klimt
110 *Reclining Semi-Nude, Head on the Right, with Eyes Closed (Masturbating)*, 1912/13
Liegender Halbakt nach rechts mit geschlossenen Augen (masturbierend)

Gustav Klimt
112 *Woman Dancing in Wrap, 1917/18*
 Tanzende mit Umhang

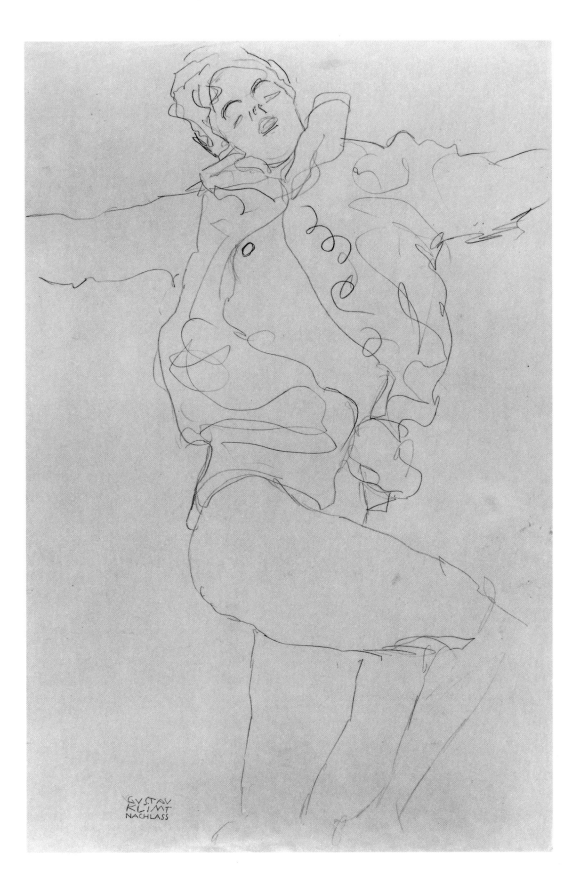

Gustav Klimt
113 *Semi-Nude with Eyes Closed*, 1917/18
Halbakt mit geschlossenen Augen

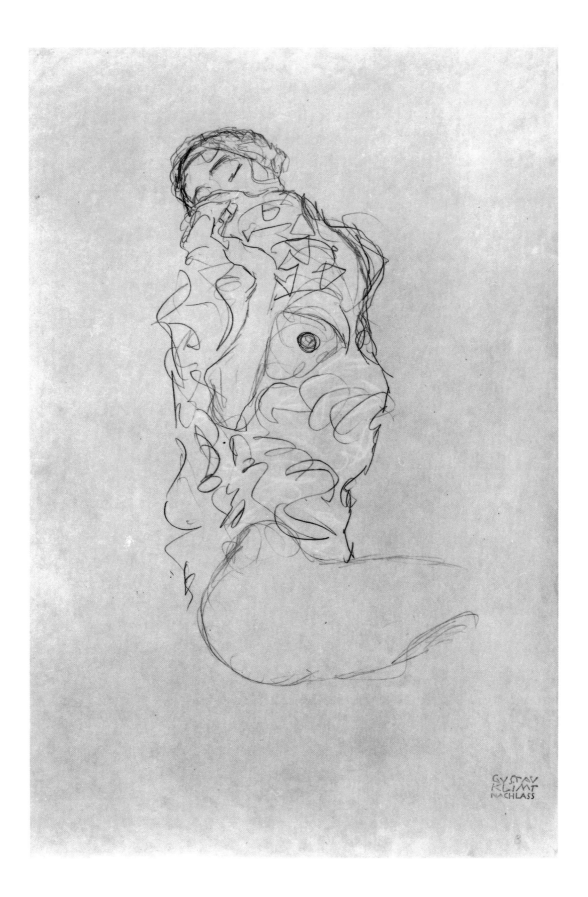

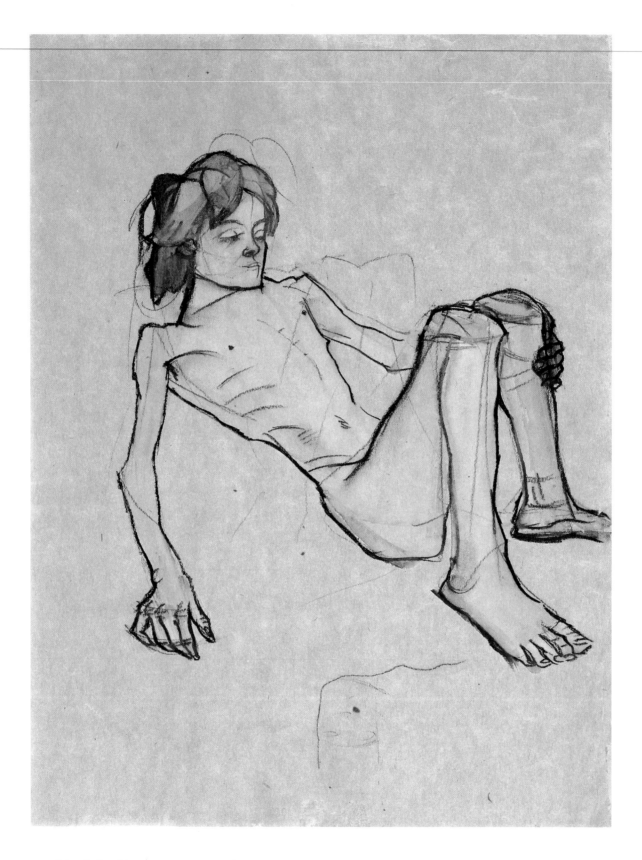

Oskar Kokoschka
115 *The Savoyard Boy*, 1912
Der Savoyardenknabe

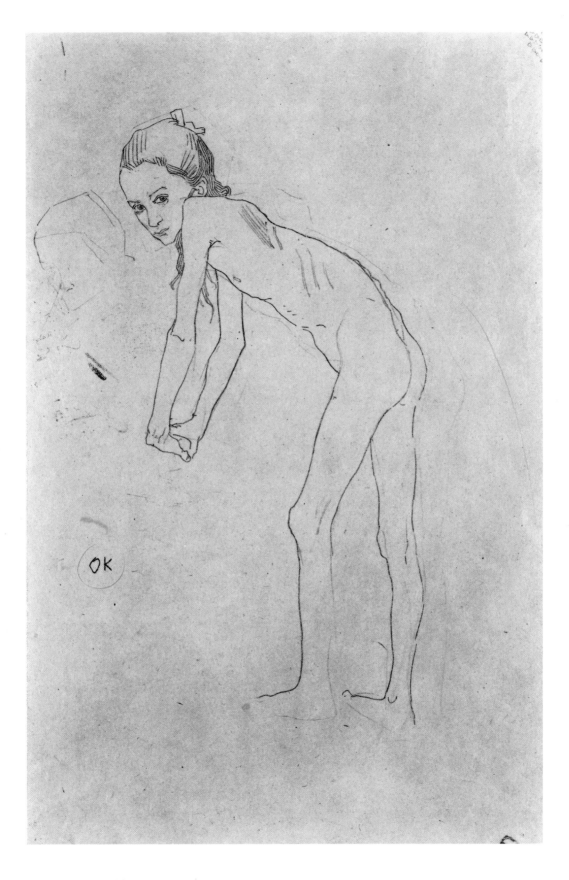

Oskar Kokoschka
114 *Girl Leaning, 1908/9*
Mädchen, sich aufstützend

Oskar Kokoschka
116 *Self-Portrait with Lover (Alma Mahler)*, 1913
Selbstbildnis mit Geliebter (Alma Mahler)

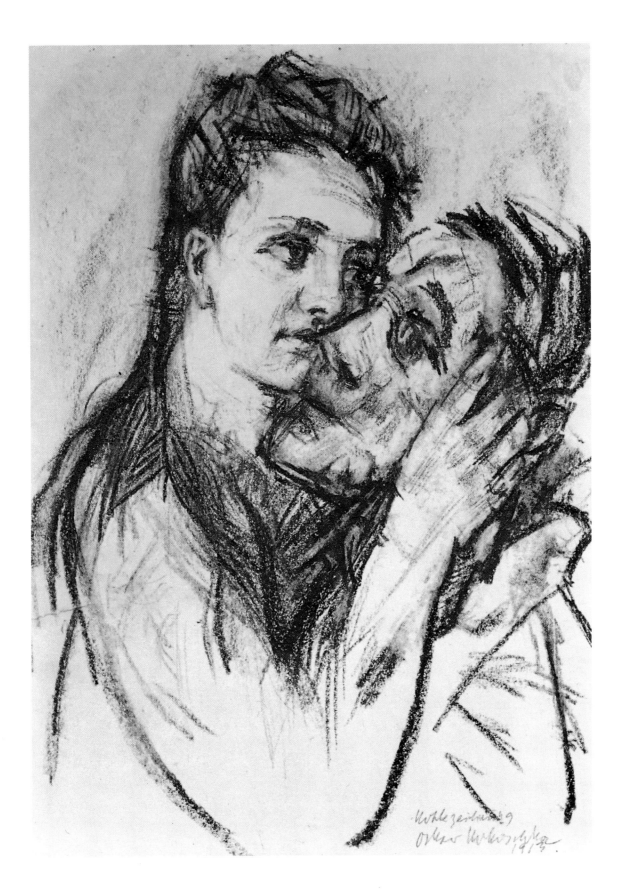

Oskar Kokoschka
117 *Landscape in the Dolomites (with the Cima Tre Croci)*, 1913
Dolomitenlandschaft (mit der Cima Tre Croci)

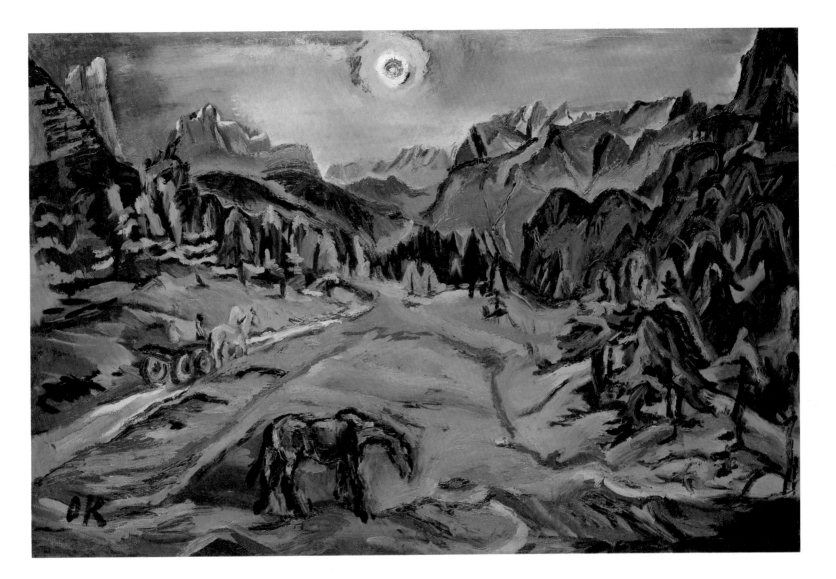

Oskar Kokoschka
118 *The Couple by Candlelight,* 1913
Das Paar im Kerzenlicht
(Oskar Kokoschka and Alma Mahler)

Oskar Kokoschka
119 *Parting of the Ways, 1913*
 Am Scheidewege

Oskar Kokoschka
120 *Self-Portrait, Hand Touching Face, 1918/19*
Selbstbildnis, die Hand ans Gesicht gelegt

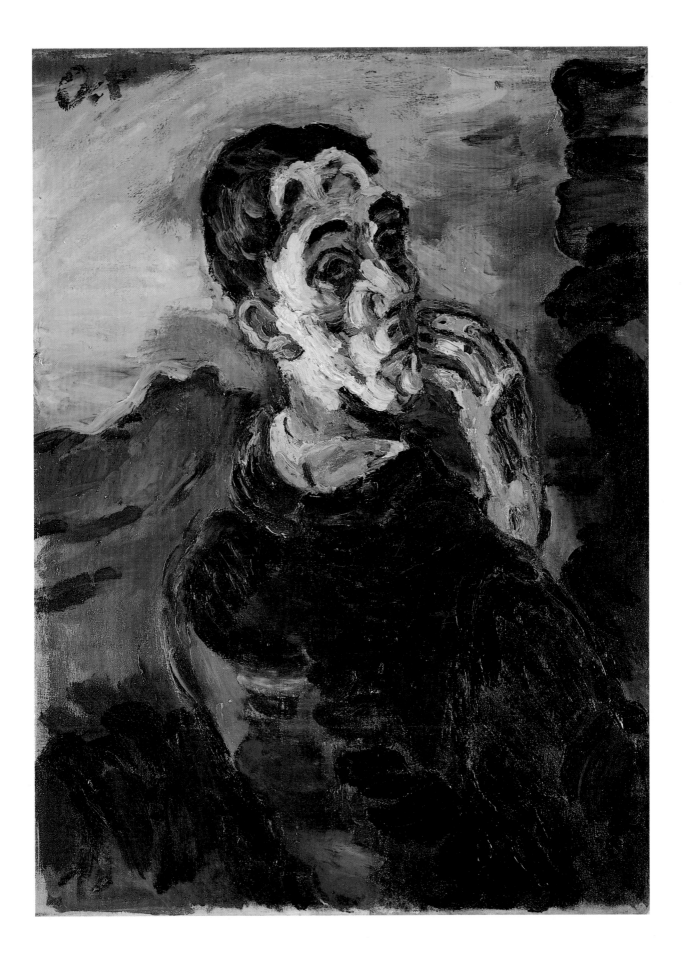

Oskar Kokoschka
121 *Seated Girl, with Hands in Lap, 1921*
Sitzendes Mädchen, die Hände in den Schoss gelegt

Anton Kolig
122 *Seated Nude,* 1912
Kauernder Akt

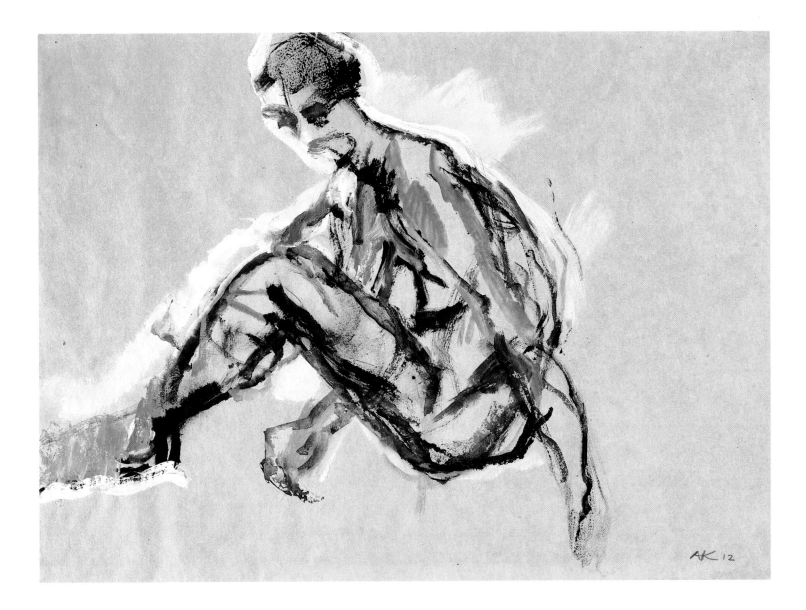

Anton Kolig
123 *Still-Life with Apples and Grapes*, 1912
Stilleben mit Äpfeln und Weintrauben

Anton Kolig
124 *Captain Boleslavski,* 1916
 Hauptmann Boleslavski

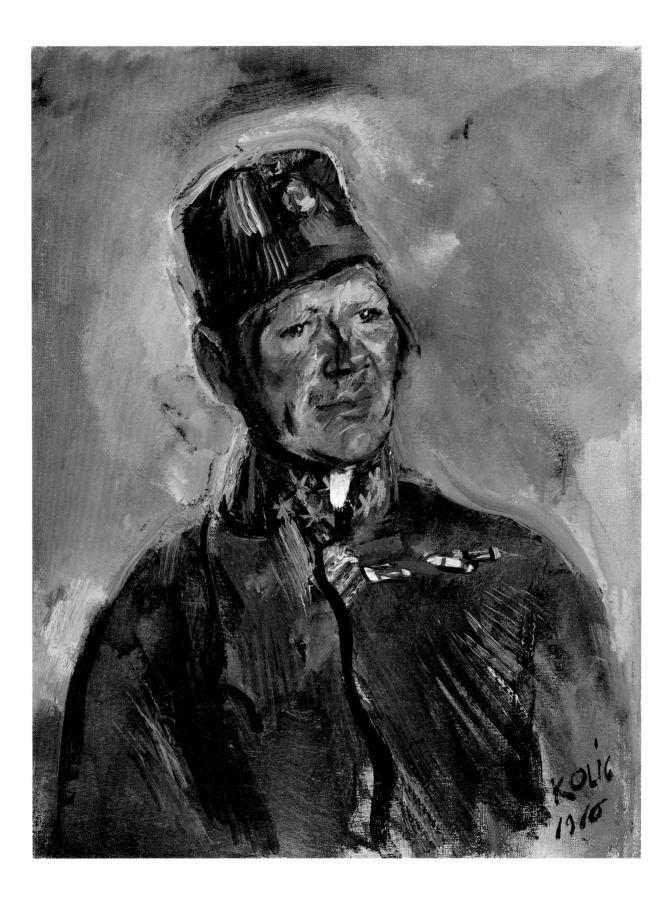

Anton Kolig
125 *Nude Youths, Reclining and Leaning, c. 1916*
Liegender und sich aufstützender Jünglingsakt

Anton Kolig
126 *Seated Nude Youth, 1919*
Sitzender Jünglingsakt

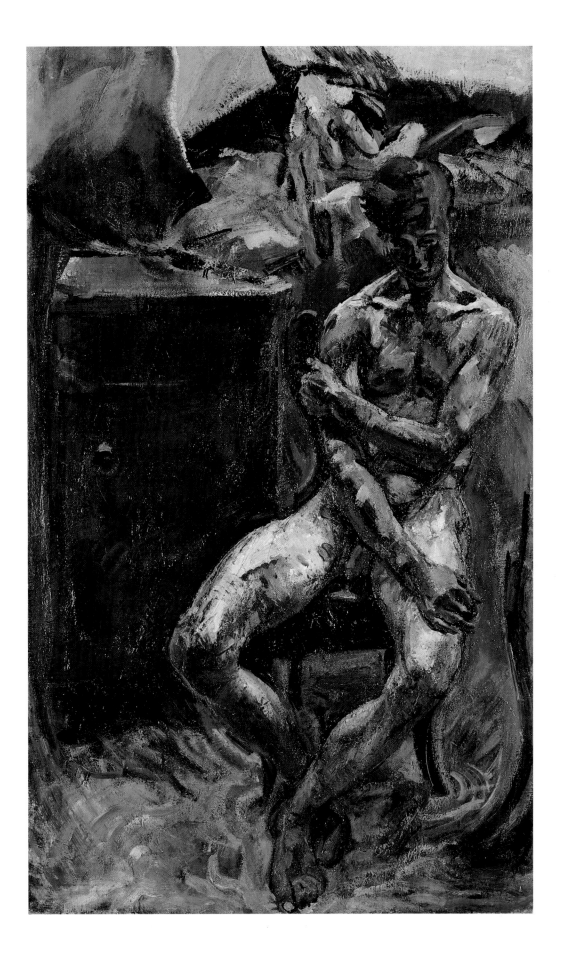

Anton Kolig
127 *Standing Male Nude*, 1924
Stehender Männerakt

Anton Kolig
128 *Self-Portrait in Blue Jacket*, 1926
Selbstbildnis mit blauer Jacke

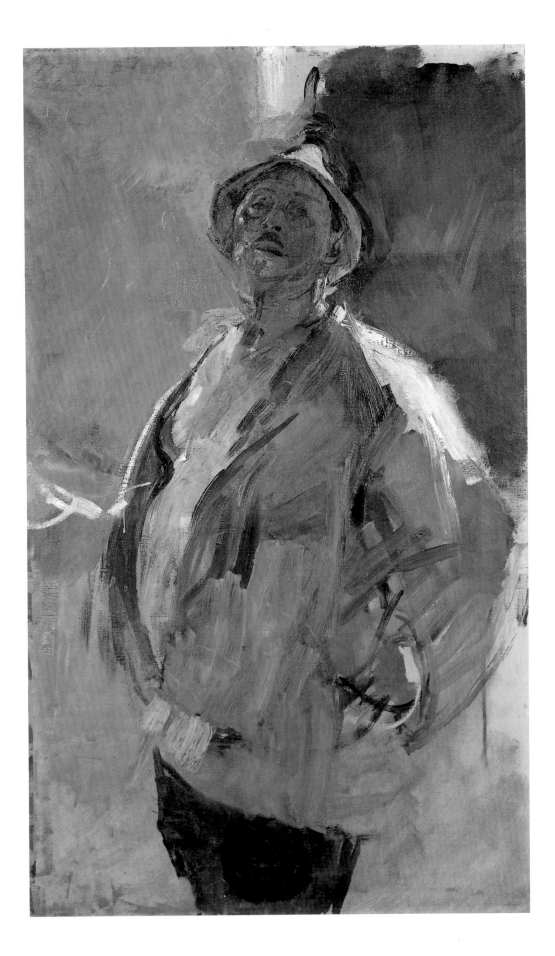

Carl Moll
129 *Heiligenstadt Park in Winter,* 1904
Heiligenstädter-Park im Winter

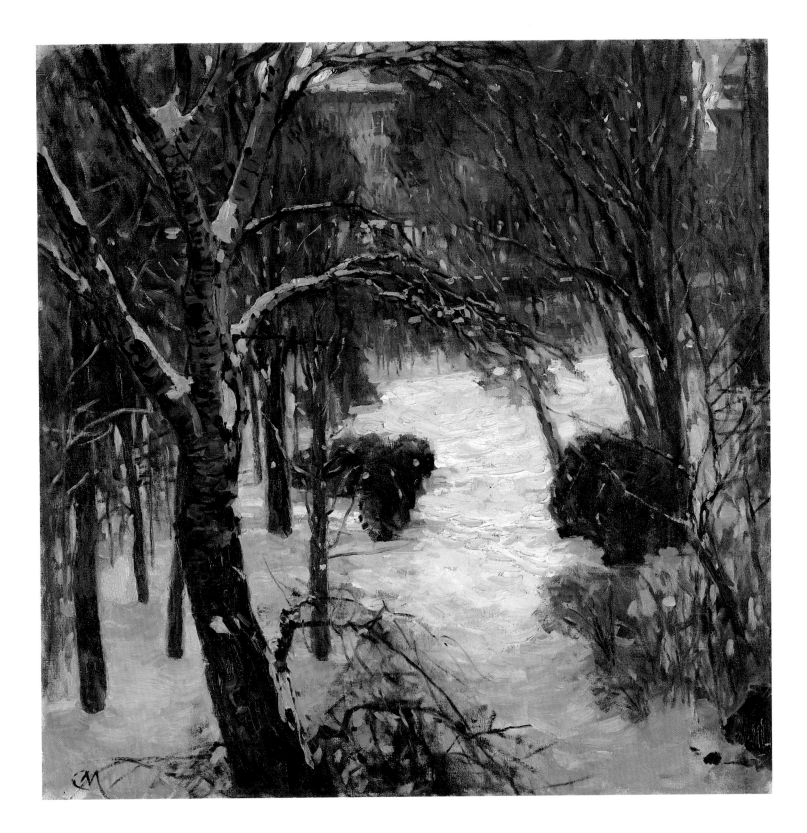

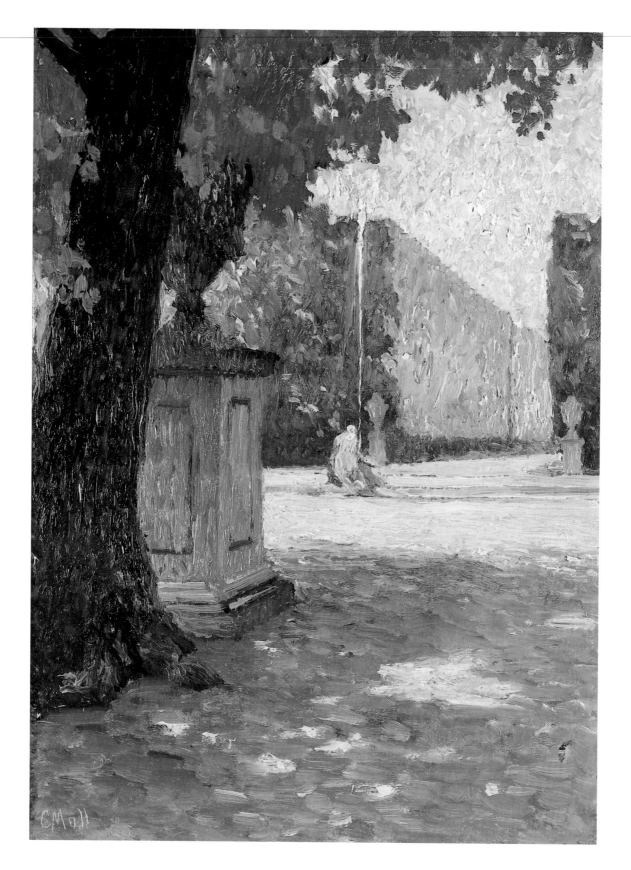

Carl Moll
130 *In Schönbrunn*, 1911

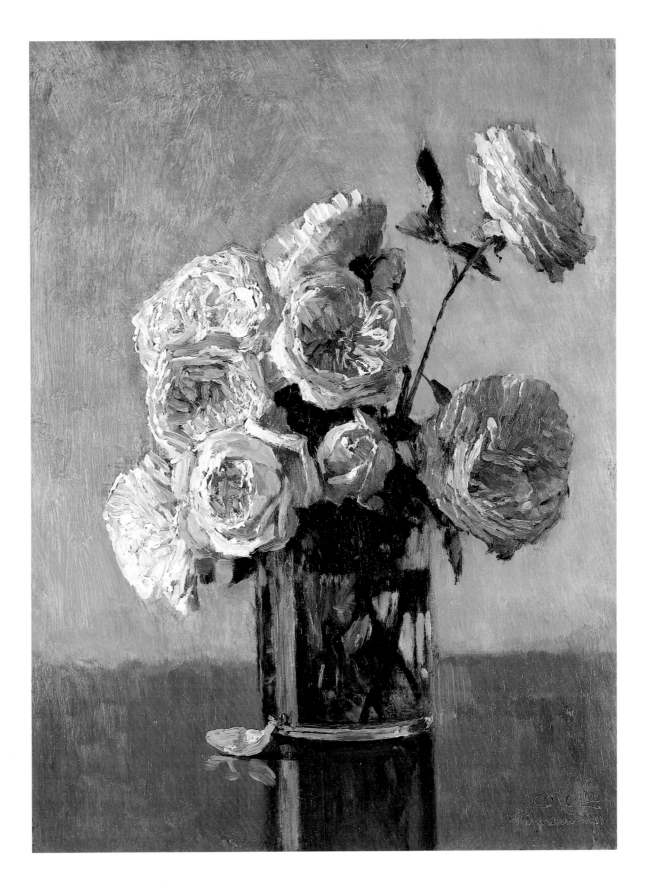

Carl Moll
131 *Roses*, 1911
 Rosen

Koloman (Kolo) Moser
132 *Potted Flowering Plant and Ceramic Jug*, 1912
Blumenstock und Keramikkrug

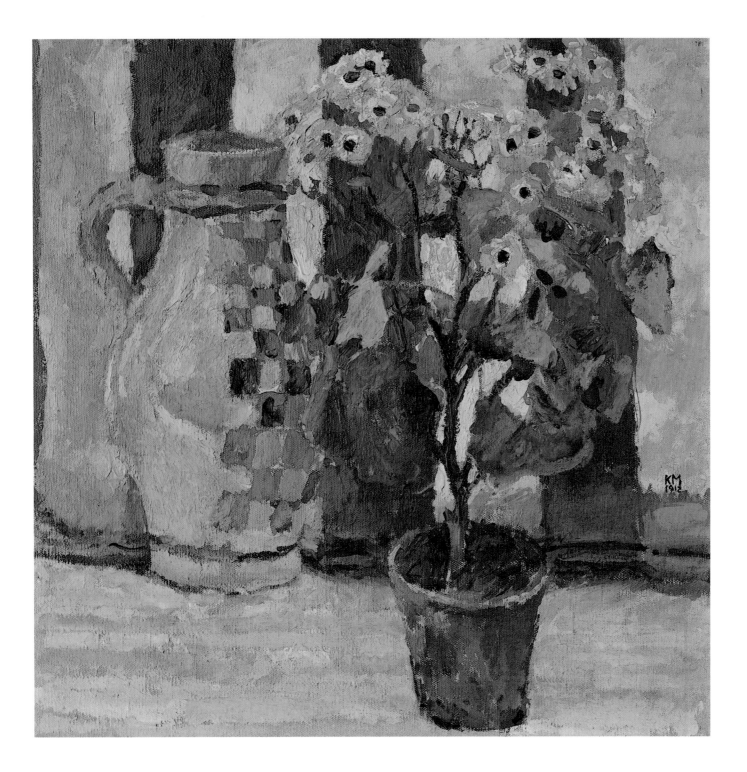

Koloman (Kolo) Moser
133 *Wotan and Brünnhilde, c. 1914*
Wotan und Brünnhilde

Koloman (Kolo) Moser
134 *'The Love-Potion' (Tristan and Isolde), 1913/15*
'Der Liebestrank' (Tristan und Isolde)
(See p. 278)

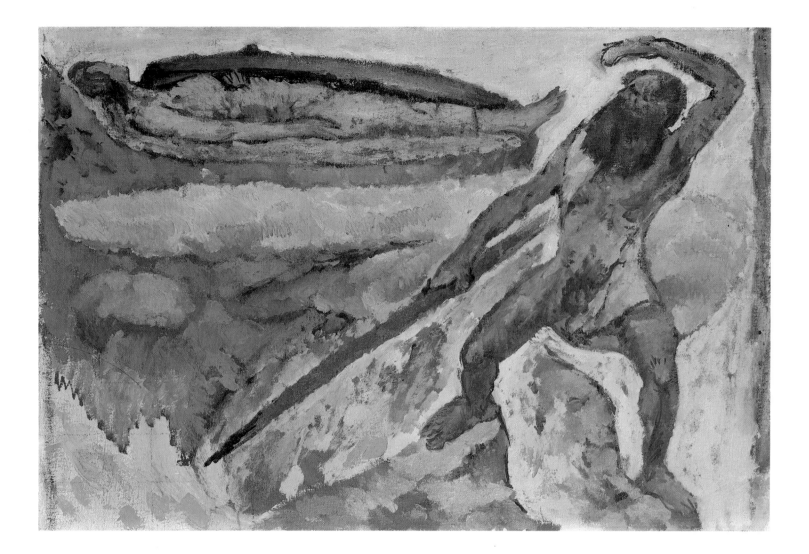

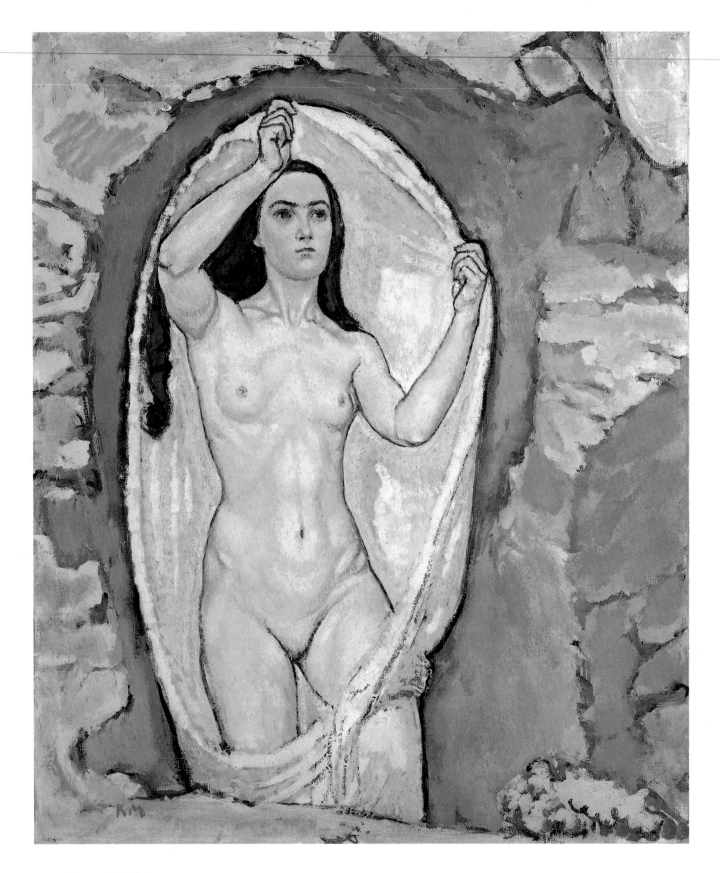

Koloman (Kolo) Moser
135 'Venus in the Grotto', c. 1915
'Venus in der Grotte'

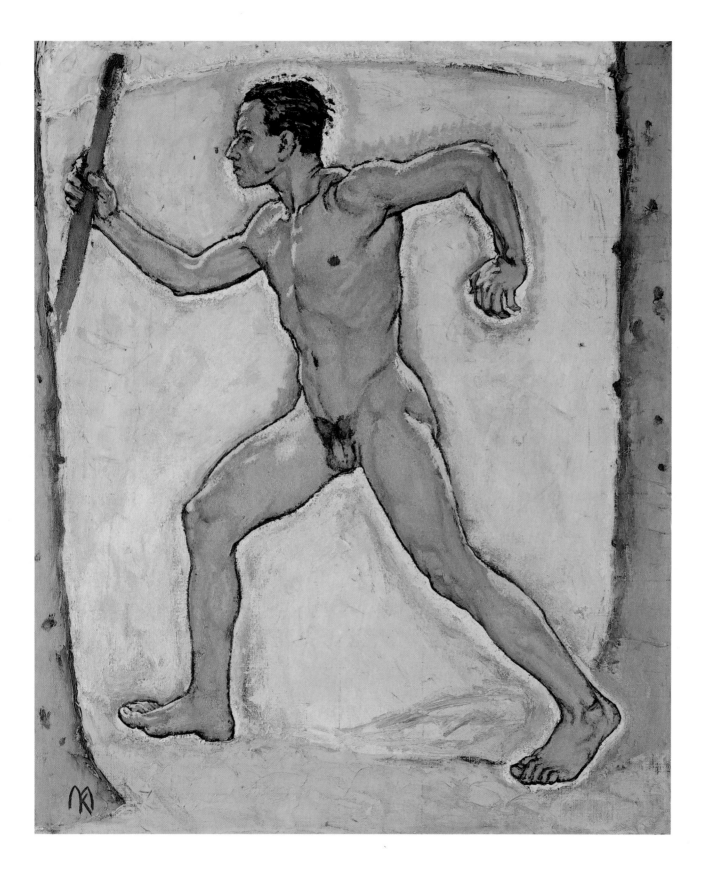

Koloman (Kolo) Moser
136 *'The Wayfarer'*, *c.* 1915
'Der Wanderer'

Koloman (Kolo) Moser
137 *Chestnut Blossoms, c. 1915*
Kastanienblüten

Max Oppenheimer
138 *Portrait of Tilla Durieux, 1913*
Bildnis Tilla Durieux

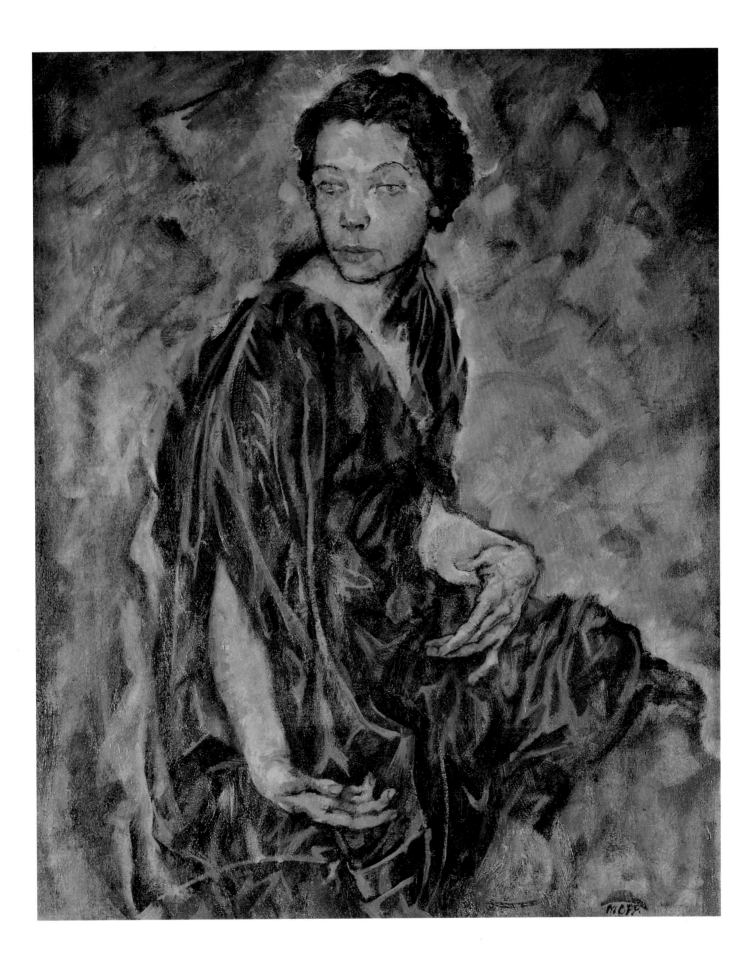

Alfons Walde
141 *Mountains and Clouds, c. 1913*
Berge und Wolken

Rudolf Wacker
139 *Self-Portrait (as Prisoner in Russia), 1917*
Selbstbildnis (als Gefangener in Russland)
(See p. 279)

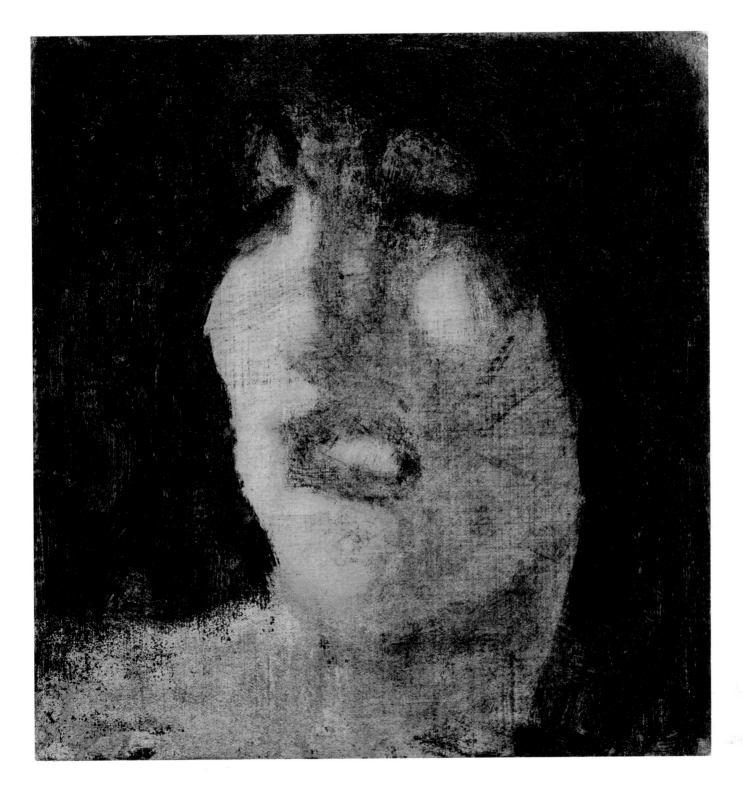

Alfons Walde
140 *Woman's Face, c. 1912*
Frauenantlitz

Alfons Walde
143 'The Short Day', c. 1925/26
 'Der kurze Tag'

Alfons Walde
142 House with Snow-Covered Mountains, c. 1914
 Haus mit beschneiten Bergen
 (See p. 280)

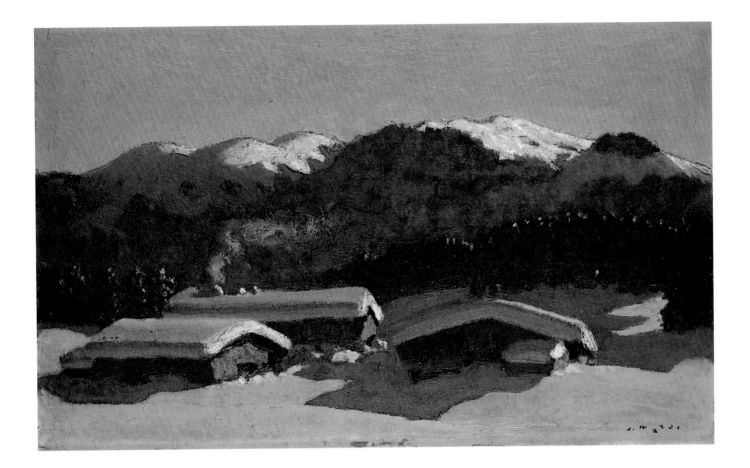

Franz Wiegele
144 *Reclining Nude Girl*, 1920
Liegender Mädchenakt

Franz von Zülow
145 *Millrace, 1907*
Mühlgraben

List of Works

Titles in quotation marks are the artists' own.
The letters and numbers at the foot of an entry refer to the following catalogues raisonnés:
B = Leonore Boeckl, *Werkverzeichnis der Gemälde Herbert Boeckls*, Salzburg, 1976
D = Johannes Dobai, *Gustav Klimt*, ed. Friedrich Welz, 2nd edn, Salzburg, 1975
F = Franz Fuhrmann, *Anton Faistauer*, Salzburg, 1972
H = Heribert Hutter, *Albert Paris Gütersloh*, Vienna, 1977
L = Rudolf Leopold, *Egon Schiele: Gemälde, Aquarelle, Zeichnungen*, Salzburg, 1972
M = Wilfried Kirschl, *Albin Egger-Lienz 1868-1926: Das Gesamtwerk*, Vienna, 1977
S = Alice Strobl, *Gustav Klimt: Die Zeichnungen 1878-1918*, 3 vols, Salzburg, 1980, 1982, 1984
W = Hans M. Wingler, *Oskar Kokoschka: Das Werk des Malers*, Salzburg, 1956

Egon Schiele

1 *Self-Portrait with Palette*
(Selbstbildnis mit Palette), 1905
Body colour, pencil and black chalk on
cardboard
24.9 x 16.4 cm
Inscribed on reverse: Egon Schiele
L 1

2 *Houses against Hillside*
(Häuser vor Bergabhang), 1907
Oil on cardboard on wood
25.6 x 18.1 cm
Inscribed lower right: SCHIELE EGON ... 07.
L 60

3 *Bare Trees, Houses and Wayside Shrine*
(Kahle Bäume, Häuser und Bildstock), 1907
(Klosterneuburg)
Oil and pencil on cardboard
15.5 x 25.5 cm
L 75

4 *Stylized Flowers against Decorative Back-*
ground (Stilisierte Blumen vor dekorativem
Hintergrund), 1908
Oil, and silver and gold bronze-paint on
canvas
65.5 x 65.5 cm
Inscribed lower right: SCHIELE EGON 1908
L 127

5 *Nude Self-Portrait, Kneeling*
(Kniender Selbstakt), 1910
Black chalk, watercolour and body colour
on paper
62.7 x 44.5 cm
Inscribed lower left: S. 10.

6 *Seated Male Nude*
(Sitzender männlicher Akt), 1910
(Based on a self-portrait)
Oil and body colour on canvas
152.5 x 150 cm
L 145

7 *Self-Portrait (Selbstbildnis)*, 1910
Black chalk, watercolour and body colour
on paper
44 x 30.5 cm
Inscribed lower right: S 10.

8 *Crouching Female Nude*
(Hockender weiblicher Akt), 1910
Black chalk, body colour and opaque white
on paper
44.4 x 31 cm
Inscribed centre right: S. 10.

9 *Nude Self-Portrait (Selbstakt)*, 1910
Black chalk, body colour and opaque white
on paper
44.9 x 31.3 cm
Inscribed centre right: S. 10.
(Verso: *Woman with Hair-Net [Frau mit*
Haarmasche], 1909
Pencil and coloured crayon on paper
Inscribed lower right: SCHIELE EGON 09)

10 *Self-Portrait, Pulling a Face*
(Selbstbildnis, eine Grimasse schneidend), 1910
Black chalk and body colour on paper
45.3 x 30.7 cm
Inscribed lower right: Schiele 10.

11 *Self-Portrait, Dressed in Black*
(Selbstbildnis in schwarzem Gewand), 1910
Black chalk and body colour on paper
45.1 x 30.7 cm
Inscribed lower right: S. 10.

12 *Naked Girl with Stockings and Shoes, Seated*
(Sitzendes nacktes Mädchen mit Strümpfen und
Schuhen), 1910
Pencil on paper
55.8 x 36.8 cm
Inscribed lower right: S. 10.

13 *'Dead Mother'* (I) *('Tote Mutter'* [I]*)*, 1910
Oil on panel
32 x 25.7 cm
Inscribed upper right: S. 10.
L 167

14 *Self-Portrait with Cape*
(Selbstdarstellung mit Umhang), 1911
Pencil on paper
54.6 x 36 cm
Stamped on reverse with estate mark

15 *'Poet'*, also *'The Poet'*
('Lyriker', also *'Der Lyriker')*, 1911
Oil on canvas
80.5 x 80 cm
Inscribed upper left: S. 11.
L 172

16 *'Self-Seer'* (II), also *'Death and Man'*
('Selbstseher' [II], also *'Tod und Mann')*, 1911
Oil on canvas
80.5 x 80 cm
Inscribed lower left: S. 11.
L 173

17 *Woman and Man (Frau und Mann)*, 1911
Pencil, body colour and opaque white on
paper
44.9 x 32.2 cm
Inscribed lower right: S. 11.

18 *Wall and House against Hilly Terrain with*
Fence (Mauer und Haus vor hügeligem Gelände
mit Zaun), 1911
Oil on canvas
Inscribed upper left: ES 1911
L 174

19 *Nude Self-Portrait (Akt-Selbstbildnis)*, 1911
Pencil, watercolour, body colour and
opaque white on paper
53 x 29.1 cm
Inscribed lower left: EGON SCHIELE 1911.

20 *Black-Haired Girl with Skirt Turned Up*
(Schwarzhaariges Mädchen mit hochgeschla-
genem Rock), 1911
Pencil, watercolour and body colour on
paper
55.9 x 37.8 cm
Inscribed centre right: E.S. 1911.

21 *'Dead Town'* (III), also *'Town on the*
Blue River' (III) *('Tote Stadt'* [III],
also *'Stadt am Blauen Fluß'* [III]*)*, 1911
Oil on panel
37.3 x 29.8 cm
Inscribed centre right: EGON SCHIELE 1911.
L 182

22 *Moa, the Dancer (Moa, die Tänzerin)*, 1911
Pencil, watercolour and body colour on
paper
47.7 x 31.5 cm
Inscribed centre right: EGON SCHIELE 1911.
Inscribed lower right: MOA

23 *Small Tree in Late Autumn*
(Kleiner Baum im Spätherbst), 1911
Oil on panel, 42 x 33.5 cm
Inscribed lower right: EGON SCHIELE 1911.
L 199

24 *Self-Portrait with Head Inclined*
 (Selbstbildnis mit gesenktem Kopf), 1912
 (Study for 'Hermits')
 Oil on panel, 42.2 x 33.7 cm
 Inscribed lower right: EGON SCHIELE 1912
 (pencil)
 L 202

25 *'Hermits' ('Eremiten')*, 1912
 (Identifiable as Egon Schiele and
 Gustav Klimt)
 Oil on canvas
 181 x 181 cm
 Inscribed lower left three times:
 EGON SCHIELE 1912 (incised)
 L 203

26 *Cardinal and Nun, 'Caress'*
 (Kardinal und Nonne, 'Liebkosung'), 1912
 Oil on canvas
 70 x 80.5 cm
 Inscribed lower right: EGON SCHIELE 1912.
 (incised)
 L 210

27 *Nude Bending Forwards*
 (Nach vorn gebeugter Akt), 1912
 Pencil and watercolour on paper
 37.5 x 28.9 cm
 Inscribed lower left: EGON SCHIELE 1912.

28 *Self-Portrait with Winter Cherry*
 (Selbstbildnis mit Lampionfrüchten), 1912
 Oil and body colour on panel
 32.2 x 39.8 cm
 Inscribed lower right: EGON SCHIELE 1912
 L 211

29 *Portait of Wally (Bildnis Wally)*, 1912
 Oil on panel
 32.7 x 39.8 cm
 Inscribed lower left: EGON SCHIELE 1912.
 L 212

30 *Autumn Tree in a Gust of Wind,*
 'Autumn Tree' (III), also *'Winter Tree'*
 (Herbstbaum in bewegter Luft,
 'Herbstbaum' [III], also *'Winterbaum')*, 1912
 Oil on canvas
 80 x 80.5 cm
 Inscribed centre right: EGON SCHIELE 1912
 L 221

31 *'The Small Town'* (II), also *'Small Town'* (III)
 ('Die Kleine Stadt' [II], also *Kleine Stadt'* [III]),
 1912/13
 Oil on canvas (two sections, sewn together
 by the artist)
 89.5 x 90.5 cm
 Inscribed centre right: EGON SCHIELE 1913
 L 227

32 *'Sinking Sun' ('Versinkende Sonne')*, 1913
 Oil on canvas, 90 x 90.5 cm
 Inscribed centre right: EGON SCHIELE 1913
 Inscribed by the artist on tenter: 'Versin-
 kende Sonne' 1913 (pencil)
 L 235

33 *Old Gable (Alter Giebel)*, 1913
 Pencil and body colour on paper
 32.3 x 49 cm
 Inscribed lower right: EGON SCHIELE 1913.

34 *Mother and Daughter*
 (Mutter und Tochter), 1913
 Pencil, watercolour and body colour on
 paper
 47.9 x 31.9 cm
 Inscribed lower right: EGON SCHIELE 1913.

35 *'Rapt Attention' ('Andacht')*, 1913
 Pencil and body colour on paper
 48.3 x 32 cm
 Inscribed lower right: ANDACHT
 EGON SCHIELE 1913

36 *'The Dancer' ('Der Tänzer')*, 1913
 Pencil, watercolour and body colour on
 paper
 47.8 x 31.9 cm
 Inscribed lower right: DER TÄNZER
 EGON SCHIELE 1913

37 *Krumau on the Moldau, 'The Small Town'* (III),
 also *'Small Town'* (IV), *'Dead Town'* (VII),
 'Town' (I) *(Krumau an der Moldau,*
 'Die kleine Stadt' [III], also *'Kleine Stadt'* [IV],
 'Tote Stadt' [VII], *'Stadt'* [II]); 1913/14
 Oil on canvas
 99.5 x 120.5 cm
 Inscribed lower right: EGON SCHIELE 1914
 L 244

38 *Mother and Child (Mutter und Kind)*, 1914
 Pencil and body colour on paper
 48.2 x 31.9 cm
 Inscribed lower left: EGON SCHIELE 1914

39 *'Blind Mother'*, also *'The Mother'* (I),
 'Mother' (I) *('Blinde Mutter',*
 also *'Die Mutter'* [I], *'Mutter'* [II])*, 1914
 Oil on canvas
 99 x 120 cm
 Inscribed lower centre: EGON SCHIELE 1914
 L 247

40 *Female Nude, Squatting*
 (Kauernder weiblicher Akt), 1914
 Pencil and body colour on paper
 31.4 x 48.3 cm
 Inscribed lower right: EGON SCHIELE 1914

41 *Houses and Coloured Washing, 'Suburb'* (II),
 also *'Two Blocks with Clothes Lines'*
 (Häuser und bunte Wäsche, 'Vorstadt' [II],
 also *'Zwei Häuserblöcke mit Wäscheleinen')*,
 1914
 Oil on canvas
 100.5 x 120.5 cm
 Inscribed lower centre: EGON SCHIELE 1914.
 L 251

42 *Seated Woman with Blue Hairband*
 (Sitzende mit blauem Haarband), 1914
 Pencil and body colour on paper
 48.2 x 32 cm
 Inscribed lower centre: EGON SCHIELE
 19. Sept. 1914.

43 *Lovers (Liebespaar)*, 1914/15
 Pencil and body colour on paper
 47.4 x 30.5 cm
 Stamped lower left with collection mark of
 Heinrich Böhler
 Stamped on reverse with estate mark

44 *Part of Krumau (Krumauer Stadtviertel)*, 1914
 (Sketch for *The Row of Houses*, L 258 and
 L 260)
 Pencil on paper
 43.7 x 32.4 cm
 Inscribed lower right: EGON SCHIELE 1914

45 *The Row of Houses, 'Island Town'*
 (Der Häuserbogen, 'Inselstadt'), 1915
 Oil on canvas
 110.5 x 140.5 cm
 Inscribed centre right: EGON SCHIELE 1915
 L 260

46 *Act of Love (Study) (Liebesakt [Studie])*, 1915
 Pencil on paper
 32.9 x 49.6 cm
 Inscribed lower right: EGON SCHIELE 1915

47 *Act of Love (Liebesakt)*, 1915
 Pencil and body colour on paper
 49.8 x 31.6 cm
 Inscribed upper right: EGON SCHIELE 1915

48 *Mother with Two Children, 'Mother'* (II)
 (Mutter mit zwei Kindern, 'Mutter' (II)), 1915
 Oil on canvas
 149.5 x 160 cm
 L 261

49 *One-Year Volunteer Lance-Corporal*
 (Einjährig freiwilliger Gefreiter), 1916
 Pencil and body colour on paper
 48 x 31.3 cm
 Inscribed centre right: EGON SCHIELE 1916

50 *'Reclining Woman' ('Liegende Frau')*, 1917
 Oil on canvas
 96 x 171 cm
 Inscribed lower right: EGON SCHIELE 1917
 L 278

51 *Girl Kneeling, Resting on Both Elbows*
 (Kniendes Mädchen, auf beide Ellbogen
 gestützt), 1917
 Black chalk and body colour on paper
 28.7 x 44.3 cm
 Inscribed lower right: EGON SCHIELE 1917

52 *Pair of Women Squatting, 'Crouching Pair'*
 (Hockendes Frauenpaar, 'Kauerndes Paar'),
 1918
 (Unfinished)
 Oil and body colour on canvas
 110 x 140.5 cm
 L 296

Ferdinand Andri ▷

53 *Mountain Landscape (Gebirgslandschaft),*
 c. 1905
 Pen and ink on paper
 Sheet: 23 x 25.5 cm
 Image: 12.9 x 14.4 cm
 Inscribed lower right: F.A.

Leopold Blauensteiner

54 *Landscape with Sheaves of Corn*
 (Landschaft mit Ährengarben), 1902/3
 Oil on canvas
 36.1 x 36.5 cm
 Stamped on reverse with estate mark

55 *Landscape with Sheaves of Corn*
 (Landschaft mit Ährengarben), 1902/3
 Oil on canvas
 36.9 x 50 cm
 Stamped on reverse with estate mark

56 *Landscape with Sheaves of Corn*
 (Landschaft mit Ährengarben), 1902/3
 Oil on canvas
 53.4 x 50.9 cm
 Stamped on reverse with estate mark

53

Herbert Boeckl

57 *Reclining Woman (Liegende Frau), 1919*
 Oil on canvas
 108 x 155.5 cm
 Inscribed upper right: HB 19
 B 17

58 *Berlin Factory (Berliner Fabrik), 1921*
 Oil on canvas
 36 x 27 cm
 Inscribed lower right: Böckl
 B 29

59 *Still-Life with Dead Pigeon*
 (Stilleben mit toter Taube), 1922
 Oil on canvas
 44.5 x 72.4 cm
 Inscribed lower left: Böckl 22.
 B 32

60 *Bathers at Klopein Lake*
 (Badende am Klopeiner See), 1922
 Oil on canvas
 67 x 53.3 cm
 (Reverse: unfinished still-life with apples)
 B 39

61 *Large Sicilian Landscape*
 (Grosse Sizilianische Landschaft), 1924
 Oil on canvas
 77 x 108 cm
 Inscribed lower left: H. Böckl. 1924
 B 55

Hans Böhler

62 *Negro Boy in Blue Jacket*
 (Negerjunge mit blauer Jacke), c. 1925
 Oil on canvas
 70.5 x 58.5 cm
 Inscribed lower right: HB
 Inscribed on stretcher: HANS BÖHLER
 (black ink)

63 *Baden Landscape (Badener Landschaft), 1925*
 Oil on canvas
 78.2 x 62.7 cm
 Inscribed lower left: HB, lower right: 25

64 *Seated Woman with Bunch of Flowers*
 (Sitzende mit Blumenstrauss), 1928
 Oil on canvas
 71.5 x 92 cm

Arnold Clementschitsch

65 *Street Scene (Strassenszene), 1920*
 Oil on canvas
 86.9 x 116.2 cm
 Inscribed lower right: Clementschitsch
 1920

Josef Dobrowsky

66 *Children and Women in Landscape*
 with Farmhouse
 (Kinder und Frauen in Landschaft mit
 Bauernhaus), 1924

Oil on panel
65.4 x 81.6 cm
Inscribed lower left: JD 1924

67 *Painter at the Easel (Maler an der Staffelei),*
 c. 1925
 Oil on cardboard
 41.8 x 32.1 cm

68 *By the Torrent (Am Wildbach), 1926*
 Oil on panel
 53.4 x 44 cm
 Inscribed lower left: J. DOBROWSKY 26.,
 lower right: JD 26.

Albin Egger-Lienz

69 *Alpine Pastures in the Ötz Valley*
 (Almlandschaft im Ötztal), 1911
 Oil on canvas
 32.5 x 52.5 cm
 M 297

70 *'Finale', 1918*
 Oil on canvas
 140 x 228 cm
 Inscribed lower centre: Egger-Lienz
 M 412

71 *'The Reapers', also 'The Mountain Reapers in*
 Gathering Storm' ('Die Schnitter', also
 'Die Bergmäher bei aufsteigendem Gewitter'),
 c. 1922
 Oil on canvas, 82 x 138 cm
 Inscribed lower right: Egger-Lienz
 M 453

56 Leopold Blauensteiner, *Landscape with Sheaves of Corn*, 1902/3

72 *'The Spring' ('Die Quelle')*, 1923
Oil on canvas
85 x 126 cm
Inscribed lower left: Egger-Lienz
M 591

Anton Faistauer

73 *Old Mill near Maishofen
(Alte Mühle bei Maishofen)*, 1911
Oil on cardboard
41 x 46 cm
Inscribed lower left: Af 1911
F 41

74 *Larkspur Still-Life (Rittersporn-Stilleben)*,
c. 1913
Oil on canvas
68 x 42 cm
Inscribed upper centre: A, upper right: F 13

75 *Still-Life (Set Table)
(Stilleben [Gedeckter Tisch])*, 1916
65.5 x 95.2 cm
Inscribed upper right: A faistauer 16
F 128

76 *Lady with Dark Hat
(Dame mit dunklem Hut)*, 1917
Oil on canvas
66.2 x 50.3 cm
Inscribed centre left: A faistauer 1917
F 145

Gerhart Frankl

77 *Roofs with Chimneys, in the Background
Mountains (Dächer mit Rauchfängen,
im Hintergrund Berge)*, c. 1924
Oil on canvas
57 x 71 cm

78 *Still-Life with Lobster
(Stilleben mit Hummer)*, 1928
Oil on canvas
45.7 x 68 cm
Inscribed lower left: Gerh Frankl 1928

79 *Rheims Cathedral
(Die Kathedrale von Reims)*, 1929
Oil on canvas, 61.2 x 87.2 cm
Inscribed lower right: Gerhart Frankl Reims
1929

Richard Gerstl

80 *Self-Portrait, Semi-nude, against Blue
Background (Selbstdarstellung als Halbakt
vor blauem Hintergrund)*, 1901
Oil on canvas
160 x 110 cm

81 *View of the Park (Blick in den Park)*,
c. 1908
Oil on canvas
35.3 x 49.7 cm
Stamped on reverse with estate mark

82 *Meadow with Houses in the Background
(Wiese mit Häusern im Hintergrund)*, c. 1908
Oil on canvas
33.8 x 18.3 cm
Estate confirmation by the Neue Galerie,
Vienna, on reverse

83 *By the Danube Canal (Am Donaukanal)*,
c. 1908
Oil on canvas
63 x 47 cm
Stamped on reverse with estate mark

84 *Lake Traun with the 'Schlafende Griechin'
(Traunsee mit 'Schlafender Griechin')*, 1908
(The mountain is so named owing to its
resemblance to a sleeping Greek woman)
Oil on canvas
37.5 x 39 cm

85 *Lakeshore Road near Gmunden,
in the Background the 'Schlafende Griechin'
(Uferstrasse bei Gmunden, im Hintergrund
die 'Schlafende Griechin')*, 1908
Oil on canvas
32 x 33 cm
Stamped on reverse with estate mark

86 *Sunlit Meadow with Fruit-Trees
(Sonnige Wiese mit Obstbäumen)*, 1908
Oil on canvas
43.9 x 34.5 cm
Stamped on reverse with estate mark

87 *Nude Self-Portrait (Selbstakt)*, 1908
Oil on canvas
141 x 109 cm
Inscribed lower right:
12. September 1908

Albert Paris Gütersloh

88 *Still-Life with Armchair
(Stilleben mit Sessel)*, 1912
Oil on canvas
60.5 x 60 cm
Inscribed upper left: PG 12

89 *Woman and Child (Frau mit Kind)*, 1913
Oil on canvas
68.2 x 55.6 cm
Inscribed on reverse by the artist:
GÜTERSLOH
H 1913/5

90 *Portrait of a Woman (Frauenbildnis)*, 1914
Oil on canvas
54 x 38 cm
Inscribed on reverse by the artist: A.P.
Gütersloh
H 1914/2 (Hutter incorrectly gives the
inscription on the reverse as 'Mdme
Thibeault')

Anton Hanak

91 *Reclining Female Nude with Legs Drawn Up
(Liegender Frauenakt mit aufgestützten Beinen)*,
c. 1915
Ink diluted with water on paper
18.3 x 27.3 cm
Certification of authenticity by the artist's
son on verso

92 *Crouching Female Nude
(Hockender Frauenakt), c.* 1915
Ink diluted with water on paper
24.5 x 19.9 cm
Certification of authenticity by the artist's
son on verso

93 *Male Nude with Raised Arms
(Männerakt mit erhobenen Armen)*, 1915
(First idea for 'Man on Fire')
Ink diluted with water on paper
27.3 x 20.9 cm
Inscribed lower right: ANTON HANAK 1915

94 *Figure in Ecstatic Motion
(Figur in ekstatischer Bewegung), c.* 1921
Pen and ink on paper
28.9 x 21.8 cm
Certification of authenticity by the artist's
son on verso

95 Ludwig Heinrich Jungnickel, *Girl in Front of a Farm, c.* 1903

Ludwig Heinrich Jungnickel

95 *Girl in Front of a Farmhouse
(Mädchen vor einem Bauernhof), c.* 1903
Pencil, coloured crayon, and pen and ink on
paper
21.4 x 21.5 cm
Inscribed lower right: L. JUNGNICKEL

96 *Meadow with Trees (Wiese mit Bäumen)*,
1905/6
Spray technique on paper
31.8 x 58.5 cm

97 *Sun in the Forest (Sonne im Wald)*, 1905/6
Spray technique on dark paper
57.7 x 32.5 cm
Inscribed lower right: L.H. JUNGNICKEL

Gustav Klimt

98 *Girl with Hat and Cape in Profile
(Mädchen mit Hut und Cape im Profil)*,
1897/98
Charcoal and black chalk on paper
42.3 x 22.4 cm

Inscribed lower right: Gustav Klimt
(blue crayon)
S 390

99 *Still Pond in Schloss Kammer Grounds (Stiller
Weiher im Schlosspark von Kammer), c.* 1899
Oil on canvas
74 x 74 cm
Inscribed lower left: GUSTAV KLIMT
D 108

100 *The Embrace (Die Umarmung)*, 1902
(Study for the composition 'This Our Kiss
for All the World' in the Beethoven Frieze)
Black chalk on paper
46.7 x 31.6 cm
Stamped lower right with estate mark
S 854

101 *The Large Poplar* (II), *also 'Gathering Storm'
(Die grosse Pappel* (II), *also 'Aufsteigendes
Gewitter')*, 1903
Oil on canvas, 100 x 100 cm
Inscribed lower right on reverse: Eigentum
der Frau Therese Flöge-Paulick (black ink)
D 135

102 *Portrait of a Girl (Mädchenbildnis)*, 1904/5
(The same young English woman posed for
the drawing S 1519, Cat. 103)
Pencil and red and blue crayon, heightened
with white, on paper
55.1 x 35 cm
Inscribed lower left: GUSTAV KLIMT
S 1200

103 *Reclining Female Nude, Head on the Right,
with Ruff
(Liegender Frauenakt nach rechts mit
Halskrause)*,
1905/6
Pencil and red crayon on paper
37 x 56 cm
Inscribed centre left: GUSTAV KLIMT
S 1519

104 *Naked Girl Standing, Right Hand on Breast
(Stehendes nacktes Mädchen, die rechte Hand
an der Brust)*, 1906/7
Red crayon on paper
55.1 x 35 cm
Stamped on reverse with estate mark
S 1573

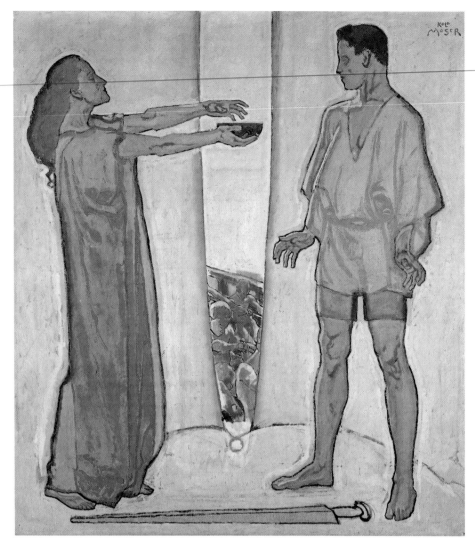

134 Koloman (Kolo) Moser, 'The Love-Potion' (Tristan and Isolde), 1913/15

105 Dancer (Tänzerin), c. 1908
Pencil, black chalk and body colour
(Smaller version lower left, in black chalk)
55 x 34.9 cm
Stamped lower right with estate mark
S 1694

106 Seated Semi-Nude, Leaning on Right Knee
(Sitzender Halbakt, sich auf dem rechten Knie
aufstützend), 1909/10
Pencil and red and blue crayon on paper
56.1 x 37.1 cm
Stamped lower left with estate mark
S 1947

107 Two Studies for a Nike
(Zwei Entwürfe einer Nike), 1911
(For 'Otto Wagner Testimonial')
Pencil, body colour and metal colour on
paper
56 x 37 cm
Inscribed lower centre: für Cajetan
S 2029

108 Head of an Old Woman
(Kopf einer alten Frau), 1908-11
(Study for the mother in 'Death and Life')
Pencil on paper
56.6 x 37.3 cm
Stamped lower right with estate mark
S 1879

109 Death and Life (Tod und Leben), before 1911,
reworked 1915
Oil on canvas
178 x 198 cm
Inscribed lower right: GUSTAV KLIMT
D 183

110 Reclining Semi-Nude, Head on the Right,
with Eyes Closed (Masturbating)
(Liegender Halbakt nach rechts mit geschlos-
senen Augen [masturbierend]), 1912/13
Red crayon on paper
37 x 56.1 cm
Stamped lower right with estate mark
S 2324

111 Kneeling Semi-Nude with Eyes Closed, Bending
Forwards (Kauernder Halbakt mit geschlos-
senen Augen, nach vorn gebeugt), 1913/14
(The pose closely anticipates that in 'Leda')
Pencil on paper
56 x 36.9 cm
Stamped lower right with estate mark
S 2359

112 Woman Dancing in Wrap
(Tanzende mit Umhang), 1917/18
Pencil on paper
57 x 35.1 cm
Stamped lower left with estate mark
S 2997

113 Semi-Nude with Eyes Closed
(Halbakt mit geschlossenen Augen), 1917/18
Pencil, heightened with white, on paper
56.7 x 37.1 cm
Stamped lower left with estate mark
S 3069

Oskar Kokoschka

114 Girl Leaning (Mädchen, sich aufstützend),
1908/9
Pencil on paper
45 x 31 cm
Inscribed centre left: OK

115 The Savoyard Boy (Der Savoyardenknabe),
1912
Black chalk and body colour on paper
39.8 x 30.2 cm

116 Self-Portrait with Lover (Alma Mahler)
(Selbstbildnis mit Geliebter [Alma Mahler]),
1913
Charcoal and black chalk on paper
43.8 x 31.3 cm
Later inscribed by the artist lower right:
Kohlezeichnung Oskar Kokoschka 1913

117 Landscape in the Dolomites
(with the Cima Tre Croci) (Dolomitenlandschaft
[mit der Cima Tre Croci]), 1913
Oil on canvas
79.5 x 120.3 cm
Inscribed lower left: OK
W 81

118 The Couple by Candlelight
(Das Paar im Kerzenlicht), 1913
(Oskar Kokoschka and Alma Mahler)
Black chalk on paper
46.9 x 29.7 cm
Inscribed lower right: OK

119 Parting of the Ways (Am Scheideweg), 1913
Black chalk on paper, 42.5 x 29.6 cm
Inscribed lower right: OK

120 Self-Portrait, Hand Touching Face
(Selbstbildnis, die Hand ans Gesicht gelegt),
1918/19
Oil on canvas, 83.6 x 62.8 cm
Inscribed upper left: OK
W 125

121 *Seated Girl, with Hands in Lap (Sitzendes
 Mädchen, die Hände in den Schoss gelegt),*
 1921
 Body colour on paper
 69 x 50.3 cm
 Inscribed lower right: Oskar Kokoschka

Anton Kolig

122 *Seated Nude (Kauernder Akt),* 1912
 Body colour and opaque white on paper
 31.8 x 43.7 cm
 Inscribed lower right: AK 12

123 *Still-Life with Apples and Grapes
 (Stilleben mit Äpfeln und Weintrauben),* 1912
 Oil on canvas
 49 x 63.5 cm
 Inscribed lower right: A. Kolig 1912

124 *Captain Boleslavski
 (Hauptmann Boleslavski),* 1916
 Oil on canvas
 56 x 44 cm
 Inscribed lower right: Kolig 1916

125 *Nude Youths, Reclining and Leaning (Liegender
 und sich aufstützender Jünglingsakt),* c. 1916
 Pencil on paper
 36.4 x 51.1 cm
 Inscribed lower centre: A.K.

126 *Seated Nude Youth
 (Sitzender Jünglingsakt),* 1919
 Oil on canvas
 151 x 91 cm
 Inscribed lower right: AK 19

127 *Standing Male Nude
 (Stehender Männerakt),* 1924
 Black chalk on paper
 60.4 x 44.8 cm
 Inscribed lower right: AK 24

128 *Self-Portrait in Blue Jacket
 (Selbstbildnis in blauer Jacke),* 1926
 Oil on canvas
 128 x 79 cm
 Inscribed by the artist on label on reverse
 with subject and date

Carl Moll

129 *Heiligenstadt Park in Winter
 (Heiligenstädter-Park im Winter),* 1904
 Oil on canvas
 73.5 x 78.5 cm
 Inscribed lower left: CM

130 *In Schönbrunn,* 1911
 Oil on panel, 31.6 x 22.6 cm
 Inscribed lower left: C. MOLL

131 *Roses (Rosen),* 1911
 Oil on panel, 34.7 x 25.9 cm
 Inscribed lower right: C. MOLL WEIHNACHT
 1911

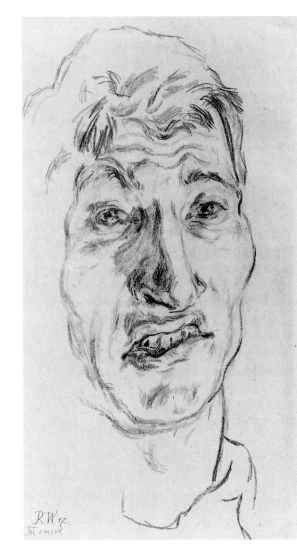

139 Rudolf Wacker
*Self-Portrait
(as Prisoner in Russia)*
1917

Koloman (Kolo) Moser

132 *Potted Flowering Plant and Ceramic Jug
 (Blumenstock und Keramikkrug),* 1912
 Oil on canvas, 50 x 50 cm
 Inscribed lower right: KM 1912

133 *Wotan and Brünnhilde (Wotan und
 Brünnhilde),* c. 1914
 Oil on canvas (with partially visible enlarge-
 ment grid in pencil)
 50.2 x 75.3 cm
 Stamped on reverse with estate mark
 Inscribed on stretcher with estate
 number 171

134 *'The Love-Potion' (Tristan and Isolde)
 ('Der Liebestrank' [Tristan und Isolde]),* 1913/15
 Oil on canvas
 215.2 x 195 cm
 Inscribed upper right: KOLO MOSER

135 *'Venus in the Grotto' ('Venus in der Grotte'),*
 c. 1915
 Oil on canvas, 75.5 x 62.5 cm
 Inscribed lower right: KM

136 *'The Wayfarer' ('Der Wanderer'),* c. 1915
 Oil on canvas, 75.5 x 62.5 cm
 Inscribed lower left: KM

137 *Chestnut Blossoms (Kastanienblüten),* c. 1915
 Oil on canvas, 75.3 x 75.3 cm
 Stamped on reverse with estate mark
 Inscribed on stretcher with estate
 number 134

Max (MOPP) Oppenheimer

138 *Portrait of Tilla Durieux (Bildnis
 Tilla Durieux),* 1913
 Oil on canvas, 95.5 x 78.7 cm
 Inscribed lower right: MOPP

Rudolf Wacker

139 *Self-Portrait (as Prisoner in Russia)
 (Selbstbildnis [als Gefangener in Russland]),*
 1917
 Pencil on paper, 29 x 16 cm
 Inscribed lower left: RW 17 TOMSK

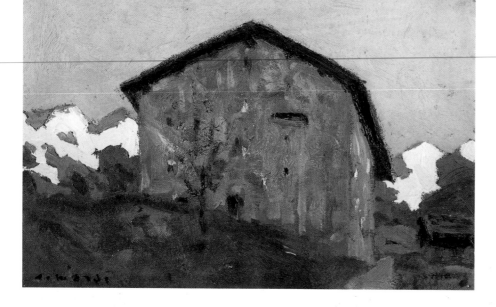

142 Alfons Walde
House with Snow-Covered Mountains,
c. 1914

Alfons Walde

140 *Woman's Face (Frauenantlitz),*
c. 1912
Oil on canvasboard
16.4 x 25.2 cm
Stamped on reverse with estate mark

141 *Mountains and Clouds (Berge und Wolken),*
c. 1913
Oil on paper
17.9 x 25.1 cm
Stamped on reverse with estate mark

142 *House with Snow-Covered Mountains*
(Haus mit beschneiten Bergen), c. 1914
Oil on paper
16.4 x 25.2 cm
Inscribed lower left: A. Walde
Stamped on reverse with estate mark

143 *'The Short Day' ('Der kurze Tag'),* 1925/26
Oil on cardboard
43.3 x 70 cm
Inscribed lower right: A. WALDE

Franz Wiegele

144 *Reclining Nude Girl*
(Liegender Mädchenakt), 1920
Pencil on paper
24.7 x 40.7 cm
Inscribed lower right: Wiegele 1920

Franz von Zülow

145 *Millrace (Mühlgraben),* 1907
Ink and body colour on paper
28 x 20.3 cm
Inscribed lower right: 1907 FZ

Biographies of the Artists

by Rudolf Leopold (Schiele) and Antonia Hoerschelmann (others)

Egon Schiele

1890

Schiele is born on 12 June in Tulln, a small town on the Danube in Lower Austria. He is the third child of Adolf Eugen Schiele, a senior railway official, and his wife, Marie (née Soucup). He has two elder sisters: Elvira, born in 1883, who dies at the age of ten, and Melanie, born in 1886. A younger sister, Gertrude, is born in 1896; she will often be his model in the early years of his career; in 1914 she marries the painter Anton Peschka.

1896-1905

Schiele goes to the Volksschule (junior school) in Tulln. He does drawings of Tulln station, where his father has an apartment that goes with the job.

At the age of ten he enrols at the Gymnasium (grammar school) in Krems. His school reports are no better than before, and in the autumn of 1902 his father transfers him to the Landes-Real-und Obergymnasium (state high school) in Klosterneuburg. Here, his schoolwork continues to be unsatisfactory; the teachers complain that he is a disruptive element because he draws in class. This early interest in art is documented in a letter to his friend Max Karpfen, in which he says he is busy with the 'works' for their joint 'Union-Kunstausstellung' (Union Art Exhibition).

In the early hours of 1 January 1905 Schiele's father dies of progressive paralysis. (Strictly speaking, therefore, he was not mentally ill, as some authors have asserted with recourse to the old cliché that links genius with madness.) This is a heavy blow for the fourteen-year-old Egon, as we learn from a letter written many years later to Anton Peschka.

His uncle and godfather, the engineer Leopold Czihaczek, is appointed Egon's guardian; he hopes the boy will get a place at technical college.

1906

In view of his poor progress at the high school, Egon's mother asks her sister, Olga Angerer, whether her husband could give the youngster a job as a draughtsman in his photo-engraving business; the Angerers, however, are unwilling to help.

Two members of the high school staff — Ludwig Karl Strauch, art teacher, and Dr Wolfgang

Fig. 1 Egon Schiele in 1914. Photograph by Anton Trčka

Pauker, art historian and Augustinian monk — recommend that Schiele embark on an artistic career, a view endorsed by the Klosterneuburg painter Max Kahrer. Schiele submits some drawings to the Kunstgewerbeschule (School of Arts and Crafts) in Vienna; these are highly praised, and Schiele is advised to apply to the Akademie für bildende Künste (Academy of Visual Arts). He passes the entrance examination for this institution in October, and enrols in Christian Griepenkerl's painting class. Schiele addresses himself to his new task with great enthusiasm, but his relationship with his reactionary teacher soon becomes strained.

1907

Schiele makes the acquaintance of Gustav Klimt. With his younger sister, Gertrude, he travels to Trieste, where he does several studies of harbour motifs. He rents a studio for himself at No. 6 Kurzbauergasse in Vienna's 2nd district.

1908

Schiele's first public exposure comes when he contributes ten works to an exhibition staged in the Imperial Hall of Klosterneuburg Abbey from 16 May to the end of June.

1909

Schiele and Griepenkerl disagree more and more on fundamental issues; Schiele and many of his fellow students leave the Academy in April. With a number of like-minded friends he founds the *Neukunstgruppe* (New-Art Group).

He has four pictures accepted for the 1909 'Internationale Kunstschau Wien' (International Art Show Vienna), whose exhibition committee is chaired by Klimt. A meeting with Josef Hoffmann introduces him to the Wiener Werkstätte (Vienna Workshop).

In December the *Neukunstgruppe* stages its first exhibition at the Schwarzenbergplatz salon of the art dealer Pisko. Anton Faistauer designs a poster for this event; Schiele produces a manifesto. In the course of the exhibition Schiele makes the acquaintance of Arthur Roessler, writer on art and critic of the *Arbeiter Zeitung* newspaper, the collectors Carl Reininghaus and Dr Oskar Reichel, and the publisher Eduard Kosmack.

1910

The Wiener Werkstätte publishes three art postcards designed by Schiele. Josef Hoffmann also arranges for a Schiele picture (L 143 a, now lost) to be shown with those of the 'Klimt Group' at the 'Internationale Jagdausstellung' (International Hunting Exhibition) in Vienna. 1909/10 sees the composition of a number of prose poems. Schiele writes them in block letters and arranges the words in intricate graphic patterns.

Taking up a suggestion of the architect Otto Wagner, Schiele paints lifesize portraits of well-known personalities; the plan is to produce a series. Roessler and Kosmack are among those painted. Wagner himself sits for a portrait, but he soon loses patience and suggests someone else should sit for him, the head being finished anyway. Schiele, disillusioned, abandons the plan.

In the autumn he again has works exhibited in Klosterneuburg Abbey. The railway official Heinrich Benesch is so taken with the picture *Sunflower* (*Sonnenblume*, L 139) that he decides to call on Schiele personally. He will later be the keenest collector of Schiele's drawings and watercolours.

1911

The first published work dealing with the artist is Albert Paris Gütersloh's *Egon Schiele: Versuch einer Vorrede* (Egon Schiele: An Attempt at an

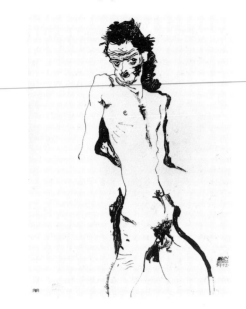

Fig. 2 Egon Schiele, *Self-Portrait as Nude*, 1912; lithograph from the Sema Album (Delphin-Verlag, Munich)

Introduction). Arthur Roessler writes an essay on Schiele for issue No. 3 of the art monthly *Bildende Künstler*.

Schiele's first one-man show, albeit on a fairly small scale, is mounted by the prestigious Galerie Miethke in Vienna in April/May.

Five attractive designs for postcards are rejected by the Wiener Werkstätte. Schiele moves to Krumau (Český Krumlov) on the Moldau (Vltava), home town of his mother: a period of great artistic productivity commences. The works of this phase include fantastic, visionary townscapes, painted on small wooden panels. Soon, however, the petit-bourgeois morals of the people of Krumau are offended when Schiele hires young local girls to pose for nude studies – not to mention the scandal of 'living in sin' with his model Wally Neuzil from Vienna. Schiele is forced to leave the town. After a short stay with his mother he takes up residence in Neulengbach, a small town near Vienna.

In September Roessler puts him in touch with the Munich art dealer Hans Goltz. From a total of seven oil paintings and seventy-two watercolours that Schiele sends him in October, Goltz presents a selection in his exhibition 'Buch und Bild' (Book and Picture). In November Schiele is accepted as a member of Sema, the Munich artists' association to which Kubin and Klee belong.

1912

Early in the year, Schiele and the *Neukunstgruppe* organize an exhibition at the Artists' House in Budapest – no sales result, however. In February/March Goltz in Munich exhibits canvases and work on paper by Schiele together with works by artists of the *Blauer Reiter* (Blue Rider) group. He then sends samples of Schiele's work (along with prints by Emile Zoire) to the Museum Folkwang in Hagen (Ruhr District), where Karl Ernst Osthaus mounts a representative exhibition in April/May. In March/April Schiele takes part in an exhibition of the Munich Secession.

His first print, the lithograph *Self-Portrait as Nude* (*Selbstdarstellung als Akt*; Fig. 2), is published in the *Sema Mappe* (Sema Album).

This promising phase in Schiele's career is rudely interrupted on 13 April, when he is arrested in Neulengbach and remanded in custody to appear before the county court in St Pölten on 30 April. The main charge, corruption of a minor, is obviously unfounded and is soon dropped, but he is found guilty of 'publishing indecent drawings', on the grounds that the nude studies in his studio were occasionally seen by children. The judge (who, ironically enough, himself collects pornographic pictures by a Biedermeier painter) sentences Schiele to three days' detention. At the end of the trial he orders a watercolour drawing of a naked girl, found pinned to the wall of Schiele's studio, to be publicly burned. All this is a severe shock for the artist. (In 1922, four years after Schiele's death, Arthur Roessler will publish Schiele's 'jail diary', in reality an invention of Roessler's.) So ends the Neulengbach period, one of the most productive in Schiele's life.

Schiele travels to Carinthia and Trieste. On his return to Vienna he temporarily rents a studio ('the cheapest one going at the time', he says) from Erwin Osen, a painter acquaintance who is spending the summer in Krumau.

In July Schiele is represented at an exhibition of the *Hagenbund* (Hagen Group) by seven oil paintings, including the major large-scale work *Hermits* (*Eremiten*; Cat. 25). This exhibition introduces Franz Hauer, a restauranteur and art-lover, to Schiele's work, which he begins to collect.

Three works by Schiele are shown at the major international *Sonderbund* exhibition in Cologne from 25 May to 30 September.

In August Schiele travels to Munich, Lindau and Bregenz. It is several weeks before he returns to Vienna; in November he finds a studio that

Fig. 3 Egon Schiele, *Edith Standing in Striped Skirt*; sketch for painting L 267

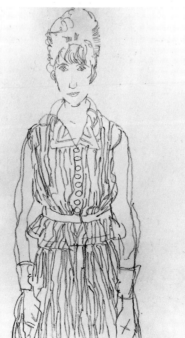

suits him at No. 101 Hietzinger Hauptstrasse – a studio he will keep until his death.

Schiele is one of the very few artists Klimt really respects, and he introduces his young friend to one of his wealthiest collectors, the industrialist August Lederer. The magnate invites Schiele to spend Christmas and New Year at his villa in Győr on the Rába river (Hungary); Erich Lederer has his portrait painted by Schiele and becomes his pupil.

1913

On 17 January the *Bund Österreichischer Künstler* (League of Austrian Artists) decides to admit Schiele as a member; Klimt, the League's president, sends Schiele the official invitation. Twenty of Schiele's works on paper are shown at a League exhibition in March.

Schiele again takes part in the spring exhibition of the Munich Secession. From 26 June to 15 July the Galerie Goltz shows a major retrospective of his works. Pictures by Schiele are also seen in Berlin and in the Düsseldorf 'Grosse deutsche Kunstausstellung' (Large German Art Exhibition). In Vienna he participates in the 'Internationale Schwarzweissausstellung' (International Black-and-White Exhibition) and in the 43rd exhibition of the Vienna Secession. Schiele continues to travel a lot: several times to the Wachau region, which inspires the pictures of Stein on the Danube (L 232/233 and L 239/240), and also to Krumau, Munich, Villach and Tarvis. He spends the summer months in the Lake Traun area and in Carinthia.

Schiele joins the staff of the Berlin journal *Die Aktion*. From now on this 'weekly magazine for politics, literature and art', edited by Franz Pfemfert, will feature drawings and prose poems by Schiele. In 1916 *Die Aktion* publishes a Schiele issue (No. 35/36): alongside numerous reproductions of drawings, it contains the woodcut *Men Bathing* (*Badende Männer*) and the poem 'Abendland' (Western World). The woodcut *Male Head* (*Männlicher Kopf*) appears in issue No. 39/40.

1914

Works by Schiele are exhibited by two Dresden dealers, the Hamburg Art Association and the Munich Secession, and are also seen at the Cologne exhibition of the *Werkbund* (an association for the furtherance of creative design in craft and industry). Schiele contributes for the first time to exhibitions outside the Austro-Hungarian Empire and Germany: in Rome (International Secession), Brussels and Paris. Abroad, however, his art achieves no more than a *succès d'estime*.

Nor does the decisive breakthrough come in Vienna. In the competition organized by Carl Reininghaus in January/February, only Faistauer and Gütersloh win prizes, the latter for his picture *Woman and Child* (*Frau mit Kind*; Cat. 89).

In March and April Schiele takes lessons from Robert Philippi in the arts of woodcut and etching; by the summer he has produced six etchings. Together with the photographer Anton Josef Trčka, Schiele experiments with portrait photography, producing a number of highly idiosyncratic compositions (Fig. 1). Heinrich

Böhler, cousin of the painter Hans Böhler, is a new, well-heeled collector of Schiele who also becomes his pupil for about a year.

1915

From 31 December 1914 to 31 January 1915 the Galerie Guido Arnot in Vienna mounts an important Schiele retrospective with sixteen canvases alongside watercolours and drawings. Watercolours and drawings are also shown at the Kunsthaus gallery in Zurich.

On 16 February Schiele informs Roessler that he plans to marry, but only later does he reveal the identity of his fiancée: it is Edith Harms, and the wedding takes place on 17 June, four days before Schiele is called up. He had met Edith and her sister Adele at the beginning of 1914 – they lived with their parents in the house opposite his studio.

On 21 June Schiele is posted to Prague. A few days later his wife travels to Prague and takes a room at the Hotel Paris, shortly thereafter accompanying her husband to Neuhaus (Jindři-chův Hradec) in Bohemia, where his unit has been transferred. But by 20 July Schiele has been posted back to Vienna. In his free time he sketches and paints the large-scale *Portrait of Edith Schiele in Striped Skirt (Bildnis Edith Schiele in gestreiftem Rock*, L 267; see Fig. 3). One of his duties as a soldier is to escort Russian prisoners of war: he makes the most of the opportunity and does sketches of them.

Towards the end of the year Schiele is invited by the Berlin Secession to participate in the 'Wiener Kunstschau' (Viennese Art Show).

1916

To this major exhibition, which takes place at the Berlin Secession in January/February, Schiele contributes a number of works on paper and the canvases *Floating Away (Entschwebung*, L 265), *Death and Maiden (Tod und Mädchen*, L 266) and *Mother with Two Children (Mutter mit zwei Kindern*, L 273; Cat. 48). *Floating Away*, Schiele relates in a letter, is hung in the entrance hall of the Secession opposite Klimt's *Death and Life (Tod und Leben*, D 183; Cat. 109). Schiele is also represented in exhibitions at the Munich Secession and the Galerie Goltz, and at the print show of the Dresden Artists' Association.

Fig. 4 Egon Schiele, *Head of Klimt, Post Mortem*, '7. II. 1918'; black chalk

From 8 March to 30 September he keeps a war diary. On 1 May he is transferred to a POW camp for Russian officers in Mühling, near Wieselburg; from this period date a number of drawings of Russian and Austrian officers. The only surviving paintings of the time are *Disused Mill (Zerfallende Mühle*, L 271) and a work commissioned by a superior who is a keen hunter, *The Vision of St Hubert (Die Vision des heiligen Hubertus*, L 272).

In issue No. 3 of the journal of graphic art *Die Graphischen Künste*, Leopold Liegler publishes a perceptive and appreciative article on Schiele's art.

1917

In January Schiele is able to return to Vienna: he is posted to the Konsumanstalt, a sort of NAAFI or PX for serving members of the forces. His commanding officer, Lieutenant Dr Hans Rosé, commissions him to do drawings of the Konsumanstalt headquarters in Vienna and of its various branches throughout the empire for a souvenir brochure (whose publication is pre-

vented by the end of the war). Thus, in late spring and summer, Schiele gets the chance to travel; among the fruits of this period are some Tyrolean sketches.

There is an abortive project to create an action group christened *Kunsthalle*, in which figures from the world of art, literature and music were to lay the foundations for a rebirth of cultural life after the war. Schiele is, however, invited to take part in the 'Kriegsausstellung' (War Exhibition) held in the Kaisergarten hall in the Prater Park; together with Gütersloh, he is entrusted with the selection of works for Room III.

He also sends eight canvases and ten drawings to the Munich Secession exhibition, this time held in the Crystal Palace. Towards the end of the year exhibitions of Austrian art in Amsterdam, Stockholm and Copenhagen feature his work. In October the Richard Lanyi bookshop publishes a first album with original-size reproductions of drawings and watercolours by Schiele.

1918

On 15 December 1917 *Der Anbruch: Flugblätter aus der Zeit* (The New Dawn: Topical Pamphlets) had been launched with a Schiele drawing on the front cover. The issue dated 15 January again features a cover graphic by Schiele, with two more drawings in the body of the magazine. No. 3 of the *Flugblätter* prints Schiele's obituary of Klimt, who had died on 6 February. On 7 February Schiele does three drawings of the dead Klimt (his beard had been shaved off) in the General Hospital (Fig. 4).

For their 49th exhibition in March, the Vienna Secession offer their premises to Schiele and his group; Schiele himself is assigned the great hall, which allows him to display nineteen large paintings and twenty-nine drawings, some with watercolour. This is Schiele's first real success, artistically and financially. Also in March, the *Gesellschaft für vervielfältigende Kunst* (Society for Art Reproductions) invites Schiele to submit a study for a nude or a landscape for inclusion as a coloured lithograph in their yearly album. However, both his contributions – *Naked Girl (Nacktes Mädchen*; Fig. 5) and *Portrait of Albert Paris Gütersloh (Bildnis Albert Paris Gütersloh*; Fig. 6) – are rejected.

Fig. 5 Egon Schiele, *Naked Girl*, 1918; lithograph

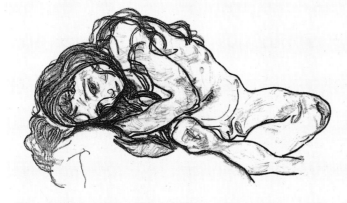

Fig. 6 Egon Schiele, *Portrait of Albert Paris Gütersloh*, 1918; lithograph

Not until April does Schiele manage to get himself transferred to the Imperial Army Museum, where his duties leave him a good deal more time for artistic activity. The exhibition 'Ein Jahrhundert Wiener Malerei' (A Century of Viennese Painting), which runs from 12 May to 16 June at the Kunsthaus gallery in Zurich, features four canvases and a large number of works on paper by Schiele. In May the Art Association of Bohemia in Prague invites him to mount an exhibition of some 200 prints and drawings by his 'artistic group'; these are shown at the Künstlerhaus Rudolphinum gallery in Prague, and then travel to the Galerie Arnold in Dresden.

On 5 July Schiele moves into a new studio at No. 6 Wattmanngasse in the suburb of Hietzing, but he keeps his old one in Hietzinger Hauptstrasse.

One of Schiele's letters indicates that his wife Edith has been ill with 'Spanish flu' since 19 October – she is six months pregnant. She dies at 8 a.m. on 28 October. The evening before, Schiele does two drawings of her (Fig. 7). Schiele catches the same disease, and is cared for by his wife's family. He dies at 1 a.m. on 31 October. Martha Fein photographs him on his deathbed, and Anton Sandig makes the deathmask. On 3 November Schiele is buried in Ober St Veit cemetery.

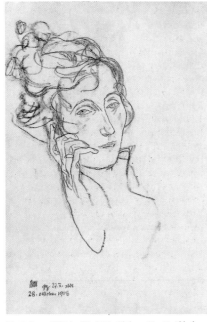

Fig. 7 Egon Schiele, *His Wife Edith on Her Deathbed*, '27. X. 1918'; black chalk

In 1943 Arthur Roessler makes known Schiele's last words. He claims to have them on good authority, but one must suspect that his own imagination played a part, judging by the various other details of the artist's life that he has falsified (for example, the 'jail diary'). Schiele's sister-in-law, Adele Harms, was in the next room when he died; through the open door she heard him say to her mother: 'The war is over, and I must go. My pictures shall be shown in all the world's museums!'

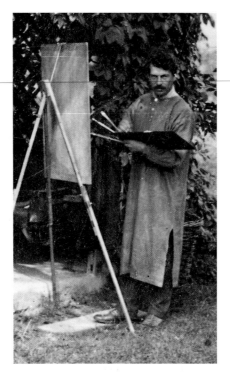

Ferdinand Andri

1871 Waidhofen/Ybbs – 1956 Vienna

The painter, sculptor and lithographer Ferdinand Andri was apprenticed to a carver of altarpieces in a village near Linz before going to the Staatsgewerbeschule (State College of Crafts) in Innsbruck to study sculpture and painting; he continued his studies at the academies in Vienna and Karlsruhe. From 1899 to 1909 he was a member – and in 1905 president – of the Vienna Secession. In the years up to 1924 he made frequent trips to the Alps and Dolomites of South Tyrol. The First World War saw him working as a war artist in Montenegro, Albania, Galicia (Poland) and Russia, and on the Alpine front. From 1919 he was professor of painting at the Vienna Academy, and from 1939 to 1945 principal of the Meisterschule für Wandmalerei (College of Mural Painting) in Vienna.

Influenced by the style of the Secession, Andri became an exponent of the Hodler school of *Jugendstil*, producing many paintings of a highly decorative and monumental character. He took his subjects mainly from peasant life, his keen eye capturing characteristic features of this milieu. With his decorative sculptures for contemporary building projects he sought to underline the unity of architecture and sculpture.

Literature: *Abbild und Emotion: Österreichischer Realismus 1914-1944*, exhibition catalogue, Vienna, Österreichisches Museum für angewandte Kunst, 1984

Leopold Blauensteiner

1880 Vienna – 1947 Vienna

From 1898 to 1902 Leopold Blauensteiner studied at the Akademie der bildenden Künste (Academy of Visual Arts) in Vienna. In 1920 he became a member of the Vienna Künstlerhaus, and from 1938 to 1941 was president of this 'cooperative of visual artists of Austria'. Founded in 1861, the Künstlerhaus was the first influential artists' association to be established in Vienna, and the only one still active during the Second World War – the Secession and the *Hagenbund* (Hagen Group) were banned by the Nazis in 1938. After his presidential term at the Künstlerhaus, Blauensteiner was appointed director of the Reichskunstkammer, the watchdog organization set up by the Fascists to regulate all aspects of art in the state.

Blauensteiner's art, both in formative years and in maturity, owes much to the Neo-Impressionists. Pointillism, a technique he was introduced to by his teacher Christian Griepenkerl and by Giovanni Segantini, helps to create a rich texture of predominantly light colours. After the Great War, Blauensteiner turned away from the landscape genre he had hitherto favoured and made a speciality of classically organized compositions evoking the grief of mothers who had lost their sons in the conflict. In these works from the 1920s the artist interprets death for the fatherland as a glorious and heroic gesture, clearly foreshadowing the artistic ideals of Hitler's Germany.

Literature: *Abbild und Emotion: Österreichischer Realismus 1914-1944*, exhibition catalogue, Vienna, Österreichisches Museum für angewandte Kunst, 1984

Herbert Boeckl

1894 Klagenfurt – 1966 Vienna

The son of an engineer, Herbert Boeckl failed to gain a place at the Vienna Akademie der bildenden Künste (Academy of Visual Arts). From 1912 he studied architecture for two years at the Vienna Technische Hochschule (Polytechnic), taking private lessons from Adolf Loos on the side. He began to paint while on active service, and after the war decided to take up painting as a career. Thanks to a patron, the Vienna art dealer Gustav Nebehay, he was able to study in Berlin in 1921/22. In 1923 he travelled to Paris, and in 1924 to Palermo; thereafter he resided mainly in Carinthia and Vienna, where he was professor at the Academy from 1935 to 1939. In 1951/52 he travelled extensively in Spain. Boeckl is an important figure in twentieth-century Austrian art, and was invited to participate in the Venice Biennale in 1950 and in 1956.

Schiele and Kokoschka were early influences on Boeckl. He soon became fascinated by the manifold possibilities of using colour as a compositional element, an interest stimulated by his study of the late works of Lovis Corinth. The months in France were also valuable primarily for the encounters with the works of painters who had given colour a new expressive role: Cézanne, Van Gogh and, above all, the Fauves.

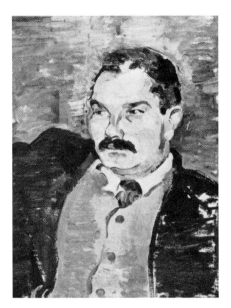

Among earlier French painters, such colourists as Delacroix, Géricault, Millet and Courbet had much to offer the young visitor from Austria. Thus, in the years of study and travel after the First World War, Boeckl's art was characterized by powerful effects of colour; favourite themes were landscapes, still-lifes, figure compositions and portraits. From the Thirties on, religious subjects also featured in Boeckl's oeuvre: in 1951/52 he was commissioned to paint the walls of the Chapel of the Angels in Seckau Abbey: these frescos depicting the apocalypse are in many ways stylistically reminiscent of the Romanesque frescos Boeckl had seen on his travels in Spain, but they also reveal how the artist was beginning to veer towards abstraction. However, it is the expressive use of colour that dominates Boeckl's work and directly engages the eye of the viewer.

Literature: Gerbert Frodl, *Herbert Boeckl*, Salzburg, 1976

Hans Böhler

1884 Vienna – 1961 Vienna

Born into a wealthy Viennese industrialist family, Hans Böhler decided at the age of seventeen that he wanted to be a painter. After studying at the Vienna Academy and other institutions, he soon began to enjoy recognition as an artist, participating, for example, in the spring exhibition of the Vienna Secession in 1908. Thereafter he travelled extensively in Asia (1910/11) and South America (1913/14), also visiting New York. In Vienna again, he became friends with Schiele and Klimt. His works were shown in Stockholm and Copenhagen in 1915, and Böhler exhibitions were also mounted in Vienna, Hamburg and Munich. After the war he took up residence in Switzerland, and in 1936 he emigrated to the United States, where he lived in New York. However, he maintained his ties with Austria, and never gave up his membership of the Vienna Secession, which he had joined in 1934. It was on a visit to his native city that he suffered the accident which led to his death.

Böhler's work is somewhat untypical for the Austrian art scene of his time. In the first quarter of the century, the use of colour was one of the most characteristic features of Austrian painting – colour as the key structural element of the picture and as a means of imbuing subject-matter with expressive power, as can be seen in the work of Gerstl and Kokoschka. Some of Böhler's paintings do manifest this dynamic surge of expression in colour and brushstroke, but more

frequently they are characterized by an arrangement of well-defined areas, in which, notwithstanding a lively use of colour, a more subdued mood is felt. In this, Böhler has often been compared with Gauguin, and he did in fact own several works by the French master, sharing with him a penchant for the exotic and the female form in his choice of subjects. Böhler's oeuvre can stand in its own right as a successful synthesis of the Austrian tradition of painting and French influences.

Literature: Otto Breicha, *Hans Böhler*, Salzburg, 1981

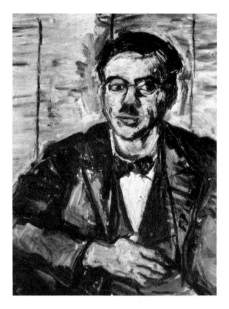

Arnold Clementschitsch

1887 Villach – 1970 Villach

Arnold Clementschitsch studied in Vienna at the Graphische Lehr- und Versuchsanstalt (Printing Trades College and Research Institute), at the Academy and at the Kunstgewerbeschule (School of Arts and Crafts). From 1911 to 1915 he continued his studies in Munich, and various short trips introduced him to the art scene in Germany, Italy and France. His first opportunity to show his pictures came at the autumn exhibition of the Vienna Secession in 1920, and he regularly took part in Secession exhibitions up to 1925. From 1924 he was a close friend of Boeckl's, and later of Felix Esterl's, artists affiliated with the Nötsch Circle. In 1928 he represented Austria at the World Fair in Barcelona and in 1932 at the Venice Biennale. From 1945 onwards he taught at the Kärntner Landesinstitut für Bildende Kunst (Carinthian State Institute for Visual Art), which he himself had founded.

Clementschitsch's artistic goal was the depiction of motion, and thus his favourite subjects were equine studies and street scenes. He greatly admired Manet and Monet, whom he had been able to study in France and in exhibitions at the Galerie Miethke in Vienna. He began by using Impressionist techniques, and later developed a way of applying the paint to the canvas in broad areas, giving an effect of movement frozen in a split second of perception; the organization of areas through colour is clearly a primary concern. From 1925 onwards Clementschitsch addressed himself more and more to portrait and landscape painting. Here, under the influence of his friends Boeckl and Esterl, he used colour to increasingly expressive effect.

Literature: Leopoldine Springschitz, *Arnold Clementschitsch*, Buchreihe des Landesmuseums für Kärnten, vol. 3, Klagenfurt, 1957

Josef Dobrowsky

1889 Karlsbad (Karlovy Vary) – 1964 Vienna

Josef Dobrowsky, whose family moved from Karlsbad to Vienna in 1900, studied at the Vienna Academy. He was a soldier in the First World War. In 1929 he became a member of the Vienna Secession and in 1934 of the Prague Secession. His work was seen in exhibitions at home and abroad, and he was represented at the Venice Biennale in 1934, 1936 and 1952. From 1946 to his death he was a professor at the Vienna Academy.

The basic elements of Dobrowsky's style had taken shape soon after the Great War, and the most characteristic feature is a very personal, earthy spectrum of colours. We do not find the glowing, expressive colouration of Boeckl, the painters of the Nötsch Circle (Esterl, Kolig, Wiegele), Kokoschka or Walde; subdued, earthy shades dominate Dobrowsky's pictures, the interplay of greys and browns providing the main chromatic contrast. Thus, many of his works have a reflective, melancholic, even depressive character. The use of colour is reminiscent of the work of Pieter Brueghel the Elder, whose paintings Dobrowsky studied in the Kunsthistorisches Museum. Towards the end of his career, brighter, often luminescent colours found their way into Dobrowsky's palette. The influence of *Neue Sachlichkeit* (New Objectivity) can be traced in his work from the mid-Twenties onwards, and objects are depicted in a realistic manner; yet there is something in the unconventional use of colour that conjurs up unseen, symbolic elements. Thus, an emotional dimension that transcends reality subtly makes itself felt.

Literature: *Josef Dobrowsky*, exhibition catalogue, Vienna, Galerie Würthle, 1979

Albin Egger-Lienz

1868 Striebach, near Lienz, East Tyrol – 1926 Rautsch, near Bolzano

After taking painting lessons from his father, who was a church decorator, Albin Egger-Lienz studied at the Academy in Munich from 1884 to 1893. He had his own studio in Munich until he moved to Vienna in 1899. In 1911/12 he taught at the Weimar Hochschule für bildende Kunst (College of Visual Art). For the rest of his life he lived in South Tyrol.

In his early period, Egger-Lienz's pictures were naturalistic; they set out to tell a story, to make it come to life before the viewer's eye, to embellish it with a variety of motifs. Later, he began to concentrate more on the central aspect of a narrative. Peasant life provided his main inspiration from an early date; around the turn of the century he began to depict it in an increasingly monumental manner. His encounter with the work of Ferdinand Hodler resulted in a transition to a more simplified and two-dimensional technique of symbolic representation. The First World War, which he experienced first as a soldier and, from 1916, as a war artist, marked a

turning-point in Egger-Lienz's life and artistic development: the pictures of this period are timeless documents of the madness of war, and to this day they stand as monumental accusations and warnings. Turned fifty, the artist continued with undiminished zeal to seek new directions in art, turning down a professorship at the Vienna Academy for that reason. He abandoned the linear style of his mature works and returned to the naturalism of his early period, without, however, sacrificing the insights he had gained in his monumental phase. Thus, the pictures of the Twenties enshrine a new synthesis. The smaller-scale works combine the flowing strokes of earlier times with a new, more vivid colouration; the colours now melt into one another, are no longer rigorously delimited. Where the early works showed the hardness, the exertions, of the farmer's life, a more passive, contemplative atmosphere is present in those of the late period. Egger-Lienz left behind an oeuvre of great diversity, unique in expressive power and monumentality, and timeless in its political message.

Literature: Wilfried Kirschl, *Albin Egger-Lienz 1868-1926: Das Gesamtwerk*, Vienna, 1977

Anton Faistauer

1887 St Martin/Lofer, Salzburg – 1930 Vienna

Anton Faistauer originally wanted to become a writer; his interest in painting was awakened by Gütersloh, with whom he became friends in Bolzano, where they both went to school. One of his first formative experiences was a visit to the Impressionist exhibition in Vienna in 1903: he had already discovered Cézanne, and now he was able to view the painter's work at first hand. Not long after enrolling at the Vienna Academy he joined his classmates Schiele, Wiegele and Robin Christian Andersen in walking out in protest against the conservative teaching system. The four ex-students founded the *Neukunstgruppe* (New-Art Group), which on the occasion of an

exhibition in 1911 won new adherents in the shape of Kokoschka, Hofer, Sebastian Isepp and others. Up to the outbreak of war Faistauer travelled a lot, visiting northern Italy, Switzerland and, in 1914, Berlin. After war service he was a founding member of the Salzburg artists' association *Der Wassermann* (The Water-Sprite, Aquarius), of which F. A. Harta was appointed president. In the years that followed, Faistauer worked extensively in Vienna and Paris. With his fame growing, he was commissioned to do frescos in public buildings, such as the porch of the church in Morzg, Salzburg, rooms in St Peter's Abbey in Salzburg and the foyer of the Salzburg Festival Theatre (1927). His book *Neue Malerei in Österreich* (New Painting in Austria), published in 1923, is an important document for the understanding of contemporary attitudes towards Austrian art.

Faistauer was intensely interested in colour as a vehicle of artistic expression, as is evidenced by his enthusiasm as a young man for the early work of Cézanne. The next important influence was the art of Schiele. Around 1911, however, Faistauer again turned his attention to Cézanne: his painting now began to manifest a new intensity of colour and a concentrated attempt to depict material reality. Broad, uncramped brushstrokes predominate in the paintings of the

second decade of the century. In the Twenties his palette becomes somewhat lighter, forms are more clearly defined, the objects in the pictures have distinctly traced outlines, formal structure tends to be emphasized. This process became more and more evident in the years up to Faistauer's death.

Literature: Albin Rohrmoser, *Anton Faistauer 1887-1930*, Salzburg, 1987

Gerhart Frankl

1901 Vienna – 1965 Vienna

After a short time studying chemistry, Gerhart Frankl decided to become a painter. Instead of taking the traditional course and enrolling at the Vienna Academy, he went to Kolig, the leading light in the Nötsch Circle, and took lessons from him in the summer months of 1920 and 1921. At the same time he embarked on a study of the Old Masters – especially Rubens, Brueghel and Beyeren – in the Kunsthistorisches Museum in Vienna. He travelled to North Africa, France, Italy and Holland. In 1938 he emigrated to London, where he lived for the rest of his life. He only returned to his native land for short visits, dying in Vienna in 1965.

Frankl's choice of teachers, Kolig and the Old Masters, is significant for his career as an artist. In an essay written in 1951 and entitled 'How Cézanne Saw and Used Colour', he investigated the problems surrounding the use of colour from Titian onwards. He saw himself as a part of the tradition he described: from the start he wanted his pictures to be *'malerische Malerei'* (painterly painting). In his early years he grappled with the opposition between closed form and disruptive dynamism. His landscapes of the Twenties exemplify his search for a synthesis of Austrian Expressionism, Baroque painting and Cézanne's form-through-colour. In his early work he managed to combine these seemingly incompatible approaches in cogent, densely atmospheric compositions.

From 1926 onwards the influence of Cézanne gained the upper hand and endowed Frankl's paintings with a new structural stability. The paint is applied thickly, creating dense, solid forms. The painterly element is still marked in the works of the Thirties, but is joined by forms that are hard and taut, and by incisive lines. During the war years a bleak, melancholy mood pervades his pictures – the brooding of the exile. After the war, a stay in France led him to experiment with abstract compositions. Special mention must be made of Frankl's last cycle of pictures, painted shortly before his death: the eighteen paintings comprising *In Memoriam* were inspired by newspaper photos of concentration camps and constitute a documentation of, in the words of the artist, 'what we can only describe in our inadequate language as "unspeakable".'

Literature: *Der Maler Gerhart Frankl (1901-1965)*, exhibition catalogue, Vienna, Historisches Museum der Stadt Wien, 1987

Richard Gerstl

1883 Vienna – 1908 Vienna

Richard Gerstl studied under Christian Griepenkerl at the Vienna Academy, but was unable to establish a rapport with his teacher, who was something of a traditionalist. He therefore transferred to the school of the more progressive Heinrich Lefler, co-founder of the *Hagenbund* (Hagen Group). A passionate music-lover who publicly declared his support for Gustav Mahler, Gerstl made the acquaintance of Arnold Schoenberg and Alexander von Zemlinsky, whose portraits he painted along with those of many other personalities of Viennese musical life. He spent the summers of 1907 and 1908 with the Schoenberg family on the shores of Lake Traun, and gave the composer drawing lessons. An affair with Mathilde Schoenberg, who left her husband temporarily on his account, led to a rupture between the two men. Gerstl drifted into total isolation and committed suicide towards the end of 1908. His pictures were stored with a removal firm. It was not until 1931 that the art dealer Kallir-Nirenstein mounted a big Gerstl exhibition at his Neue Galerie in Vienna, bringing the artist to the attention of a wider public. Almost all his works on paper have been lost.

Along with Klimt, Schiele and Kokoschka, Gerstl was one of the great innovators in turn-of-the-century Austrian art. Otto Breicha writes: 'Gerstl is a nebulous figure not so much because he only left a few examples of his work, but

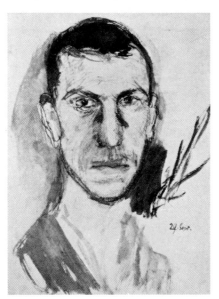

because it is difficult to place him in a specific category. He was in at the beginning of Expressionism, yet he never ceased to paint things as they appeared to human perception, as advocated by contemporary exponents of the Impressionistic painting of light. Only a short time remained for him to take a stance as regards *Jugendstil* and the *fin de siècle* mood all around him. He was an innovator and an epigone at the same time, an artist who was in certain circumstances susceptible to influence, and who in his own way exerted influence on others.'

Gerstl's early works are of Neo-Impressionist inspiration, owing much to Pointillism; however, he galvanizes the individual dabs and strokes of colour to create rich textures and freely flowing contours, so that the subject represented seems to waver on the verge of abstraction. Alongside a fair number of landscapes, which reveal the artist's personal touch with great clarity, figure paintings constitute the main body of his work. Significant milestones in his development are *Self-Portrait, Semi-nude, against Blue Background* (Selbstdarstellung als Halbakt auf blauem Hintergrund; Cat. 80), painted when he was nineteen, and *Nude Self-Portrait* (Selbstakt; Cat. 87), dated 1908, shortly before his suicide. In the former, the areas of colour are clearly set off from one another; the realistic portrayal of the face contrasts with the more abstract depiction of the body; the use of colour to create rich, clear textures reflects Gerstl's admiration of Velázquez's mastery in this field, and the symmetrical composition of the picture reflects the interest of turn-of-the-century artists in planar organization – though here an almost transcendental dimension seems to be present. In contrast, the late self-portrait is characterized by a concentration on the individual stroke of colour rather than by clear distinctions between the various motifs in terms of colour; the transcendental component begins to dissolve the very subject of the picture, which emerges nebulously from the complex of colours. Thus, the painting testifies to the change from description to expression that was beginning to take place in the use of colour. It is significant that, shortly before his death, Gerstl sought to get in touch with Kokoschka, who made his debut at the 'Kunstschau' (Art Show) in 1908 and who was already well on the way towards incorporating the expressive power of colour in his works. But Gerstl's early death prevented him from playing an active part in the evolution of twentieth-century Austrian art.

Literature: *Richard Gerstl (1883-1908)*, exhibition catalogue, Vienna, Historisches Museum der Stadt Wien, 1983/84

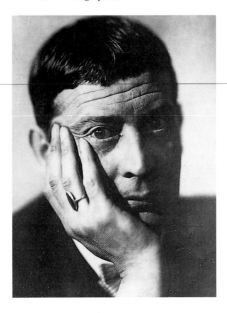

Albert Paris Gütersloh

1887 Vienna – 1973 Baden, near Vienna

After training as an actor, Albert Paris Gütersloh embarked on a stage career; his engagements were mainly in Germany, one of them being at Max Reinhardt's Deutsches Theater in Berlin. In 1909 he gave up acting because of poor health, and had his public debut as a painter at an exhibition of the *Neukunstgruppe* (New-Art Group). Up to the outbreak of war he took part in many more exhibitions. He also worked as a writer, and was in contact with Robert Musil, Franz Blei, Hugo von Hofmannsthal and Hermann Bahr. Between 1919 and 1921 he travelled to Munich, Berlin and Paris. From 1928 to 1930 he lived in Cagnes-sur-Mer. He returned to Vienna, and was a professor at the Kunstgewerbeschule (School of Arts and Crafts) from 1929 to 1938, when he was dismissed by the Nazis. In 1940 he was classified as a 'degenerate' artist and forbidden to work. He resumed his activities in the Austrian art scene after the war, and in 1947 founded the Art Club, whose president he was for many years. The Art Club brought together many Austrian artists who were to make important contributions to the cultural life of the Second Republic. In addition, he was a forerunner of the Viennese school of Fantastic Realism. Gütersloh was one of the most versatile personalities of the Viennese art world, making a name for himself as a painter in oils, a watercolourist, illustrator, writer, teacher, organizer and pioneer and critical observer of the art of his time.

In his early years Gütersloh was associated with Klimt and his circle. However, he soon developed a graphic style of crystalline forms that pointed in the direction of Surrealism. During an extended stay in Paris, from 1911 to 1913, he became a pupil of Maurice Denis, one of the French school of painters who regarded colour as a fundamental factor in the organization of the picture surface. Gütersloh's work up to the First World War reveals a rich variety of modes of artistic expression. After the war the artist started on a course which, by the mid-Twenties, led to a structural simplification and standardization of the various components of his pictures. In his increasing concentration on the representation of the real world he seems to have come under the influence of *Neue Sachlichkeit* (New Objectivity) and Magic Realism, yet the surreal element never entirely disappeared from his work.

Literature: *Albert Paris Gütersloh: Retrospektive*, exhibition catalogue, Vienna, Akademie der bildenden Künste, 1987

Anton Hanak

1875 Brünn (Brno) – 1934 Vienna

At the age of fourteen Anton Hanak was articled to a wood-carver and cabinet-maker in his native Moravia; on completion of his apprenticeship he travelled extensively for five years throughout the Austro-Hungarian Empire. In 1898 he commenced his studies at the Vienna Akademie der bildenden Künste (Academy of Visual Arts). In 1902 he exhibited his first work with the *Hagenbund* (Hagen Group). He spent six months in Rome in 1904/5, and on returning to Vienna set up a studio. He had his first showing at the Vienna Secession in 1905, and was a member of this association from 1906 to 1910. In 1907 he moved to Langenzersdorf in Lower Austria. From 1911 onwards he collaborated frequently with Josef Hoffmann, working with him on the Primavesi country mansion and other projects. In 1913 he began teaching the Monumental Sculpture class at the Vienna Kunstgewerbeschule (School of Arts and Crafts). Notwithstanding the onset of a severe illness in 1918, he continued to work until his death.

Starting from academic concepts of the representation of the human figure, Hanak soon began to endow these principles with a monumental dimension and – a novelty at that time – often left his works in a fragmentary state. From 1910 onwards he began to take an interest in groups of figures, no doubt as a consequence of his activities in the field of architectural sculpture.

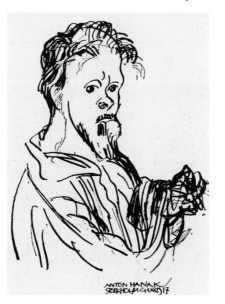

For Hanak, the treatment of the surface was a key factor in the creation of a sculpture, the various finishing techniques allowing a finer characterization of the figure; in this, as in his general attitude to art, Rodin and Michelangelo were his exemplars. Hanak is an important figure in twentieth-century Austrian sculpture: as a teacher at the Kunstgewerbeschule from 1913 to 1932 and at the Akademie der bildenden Künste from 1932 to 1934, he had a significant influence on the future development of many artists, Fritz Wotruba amongst them. He is also notable for his drawings.

Literature: Wilhelm Mrazek, *Anton Hanak 1875-1934*, Vienna and Munich, 1969

Ludwig Heinrich Jungnickel

1881 Wunsiedel, Upper Franconia – 1965 Vienna

The painter and draughtsman Ludwig Heinrich Jungnickel grew up in Munich from 1885 onwards. In his teens he travelled to Rome and Naples, earning a living by making copies of famous pictures and by drawing portraits. He arrived in Vienna in 1899 and enrolled at the Academy, which he soon left; brief attendances at other art schools confirmed that the academic routine was not for him, so he may be described as self-taught. He associated and, in some cases, became friends with Klimt and his circle, Josef Hoffmann, Moser, Kokoschka and Schiele. Unable to settle down, Jungnickel returned to Munich in 1905, only to go back to Vienna the following year. In 1908 he visited Rome a second time; the same year, he showed his work at the 'Kunstschau' (Art Show) in Vienna and contributed designs for the animal frieze of the Palais Stoclet in Brussels, the major project of the Wiener Werkstätte (Vienna Workshop) at the time. In the years that followed he did more work for the Wiener Werkstätte and became well known for the coloured woodcuts and pen and brush drawings that he showed at various exhibi-

tions. After the war, during which he served in the army, he resumed his European travels, principally in Italy and Yugoslavia. Yugoslavia was also his home in exile after he was denounced as a 'degenerate' artist in 1939. In 1952 he returned from Abbazzia (Opatija) to Austria, and spent the rest of his life in Villach and Vienna.

Landscapes and animal studies were Jungnickel's favourite themes, as became evident early in his career. *Jugendstil* influenced his early work, which is characterized by a decorative spatial anchoring of the motif. Between the wars he developed his distinctive style: curving lines and flourishes of colour bring out the essence of the subject. Jungnickel also produced a substantial oeuvre of prints, which well exemplify his love and understanding of nature, particularly the animal world.

Literature: *Kunst in Österreich 1918-1938 aus der Österreichischen Galerie*, exhibition catalogue, Schloss Halbturn, 1984, p. 108 ff.
L. H. Jungnickel, exhibition catalogue, Vienna, Giese & Schweiger, 1984

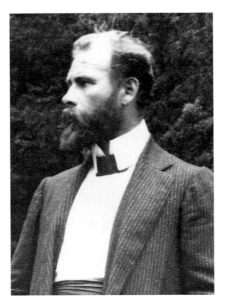

Gustav Klimt

1862 Vienna – 1918 Vienna

Gustav Klimt, son of an engraver from Bohemia, was a pupil of Ferdinand Laufberger and others at the Vienna Kunstgewerbeschule (School of Arts and Crafts) from 1876 to 1883. Thereafter he set up a studio-collective with his brother Ernst and the painter Franz Matsch. The three artists created decorative compositions for the walls and ceiling of the Burgtheater, the Hermes Villa and the Kunsthistorisches Museum in Vienna, and for a number of theatres throughout the empire – for example, in Reichenberg (Liberec), Fiume (Rijeka) and Karlsbad (Karlovy Vary). After the death of his brother in 1892, Klimt gave up painting for six years. In 1897 he was a founding member and first president of the Vienna Secession, where a first major exhibition of eighty of his works was held in 1903. Differences of opinion within the Secession led in 1905 to the resignation of Klimt and the 'Klimt Group', which included Hoelzl, Hoffmann, Moll, Moser, Orlik, Roller and Wagner. In 1908, the group mounted the '1. Internationale Kunstschau' (1st International Art Show) in Vienna as a shop-window for their work: the exhibition constituted a triumph for Klimt over his critics. In 1902 they had poured scorn on his *Beethoven Frieze* (*Beethovenfries*) for the Klinger exhibition in the Secession, and when, in 1903, he presented his allegorical pictures for the ceiling of the Great Hall of the university, conservative critics greeted them with such a hail of abuse that he asked to be released from the commission. An objection by Archduke Franz Ferdinand also blocked Klimt's nomination as professor at the Academy. Thus, in 1917, he could only be made an honorary member of the Academy. Abroad, however, Klimt was a celebrated figure: in 1900 he exhibited his picture *Philosophie* at the World Fair in Paris, and in 1910 he was acclaimed at the Venice Biennale. Between 1908 and 1911 he often spent several weeks at a time in Paris, and also travelled to England and Belgium. The year 1918, in which Klimt, Schiele, Moser and several other artists died, marks the end of a unique era of Austrian art, one in which Klimt played a vital part.

When Klimt began to paint, the artistic life of Vienna reflected the mood of the *Gründerzeit*, a period of rapid industrialization and prosperity; Historicism and a decorative aesthetic were keynotes of contemporary art, with Hans Makart as its foremost exponent. When the Klimt brothers and Franz Matsch were commissioned to paint the ceilings of the side staircases of the Burgtheater, from 1886 to 1888, they had to come to terms with the problems of monumental painting: a traditional solution was chosen, in the spirit of Makart, as taught at the Academy. The decisive step in Klimt's artistic evolution did not come until the 1890s, when, through exhibitions and journals, he began to discover the French Impressionists, Neo-Impressionists and Symbolists, the English Pre-Raphaelites, the Belgian Fer-

Members of the Vienna Secession in 1902. From left to right: Anton Stark, Gustav Klimt (in chair), Koloman Moser (in front of Klimt, wearing hat), Adolf Böhm, Maximilian Lenz (reclining), Ernst Stöhr (wearing hat), Wilhelm List, Emil Orlik (seated), Maximilian Kurzweil (wearing cap), Leopold Stolba, Carl Moll (reclining) and Rudolf Bacher

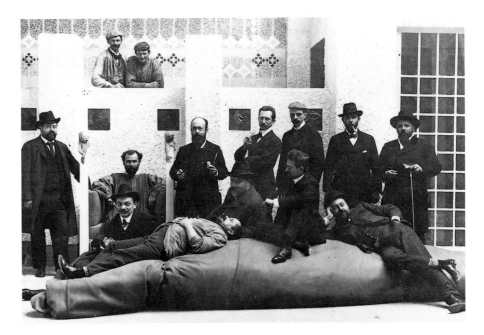

nand Khnopff, the Dutchman Jan Toorop and German *Jugendstil*. Absorbing all these influences, he evolved a specifically Austrian and highly personal form of Art Nouveau. The first flowerings of this new style can be seen in Klimt's contributions to the magazine *Ver Sacrum*, which are characterized by flowing curves and a rhythmic juxtaposition of light areas and dark, often creating a shimmering pattern. He sought to incorporate these new artistic ideas in his designs for the ceiling at the university of Vienna (he had been awarded the commission in 1894), but his submissions were rejected – some of the pictures were later sold to private collectors, many were destroyed in the two world wars. About the same time, in 1902, he painted the monumental *Beethoven Frieze*, which represents his free interpretation of the Ninth Symphony: composed in a strictly linear style, the various scenes are arranged rhythmically along the frieze. Evident here are influences from Toorop's painting and from the delicately sculpted figures of George Minne, who had had an exhibition at the Secession the year before. During the first decade of the century Klimt developed an increasingly geometrical and ornamental pictorial language: a prime example is the mosaic frieze for the banqueting hall of the Palais Stoclet in Brussels, built by Josef Hoffmann and the Wiener Werkstätte (Vienna Workshop). Ornamental features and flowers appear again and again in Klimt's work, not merely for decorative effect, but also as symbolic elements; this is true of both figure compositions and landscape or floral studies, of both paintings and drawings.

From 1908 onwards Klimt produced a number of highly expressive drawings, which often have human suffering as their theme. The oil paintings of the period are characterized by their dark, sombre colours. No longer do we find ornaments, or the use of gold and silver; the structural element of the paintings is less rigorously emphasized, a feature also significant in the final phase of Klimt's career. He now stood on the threshold of Expressionism, and it was the works of this period that most impressed Schiele. Klimt's final phase begins around 1912 and is remarkable for the use of intense colours, which must surely owe something to contemporary French painting. The vibrant surface colour of the figures contrasts with the ornamental, strongly two-dimensional treatment of the background. In the graphic output of the final years the female nude – a genre that had always featured prominently in his oeuvre – is subjected to a process of sublimation which transposes the erotic element to a higher plane. Contours, which in the middle period had been suggested by hasty brushstrokes, are now firmer and more pronounced.

Literature: Alice Strobl, *Gustav Klimt: Zeichnungen und Gemälde*, Salzburg, 1962

Werner Hofmann, *Gustav Klimt und die Wiener Jahrhundertwende*, Salzburg, 1977

Alice Strobl, *Gustav Klimt: Die Zeichnungen 1878-1918*, Salzburg, 1980-4

Oskar Kokoschka

1886 Pöchlarn, Lower Austria – 1980 Montreux

Oskar Kokoschka, who started painting and drawing at the age of fourteen, won a scholarship to the Vienna Kunstgewerbeschule (School of Arts and Crafts), where he studied under Berthold Löffler from 1905 to 1909. From 1907 onwards, at the invitation of Josef Hoffmann, he assisted at the Wiener Werkstätte (Vienna Workshop), which had considerable influence on the Kunstgewerbeschule. In 1908 he took part in the '1. Internationale Kunstschau' (1st International Art Show) organized by the Klimt Group, exhibiting a self-portrait, designs for tapestries and various studies; he also met Adolf Loos, who introduced him to the writers Karl Kraus and Peter Altenberg. In 1909 he made his literary debut with the premiere of his play *Mörder, Hoffnung der Frauen* (Murderer, Hope of Women). Between 1910 and 1914 he often visited Berlin: Herwarth Walden acquired his services as a contributor to his magazine *Der Sturm*, and he also worked for the art dealer Paul Cassirer. In 1911 he first participated in a *Hagenbund* (Hagen Group) exhibition in Vienna. His passionate affair with Alma Mahler began about this time, a relationship that was to end unhappily for him in 1914. An officer in the Austrian cavalry during the war, he was severely wounded and took up residence in Dresden, where he enjoyed great popularity as a teacher at the Academy from 1915 to 1924. There followed restless years of travel in France, England, Italy, North Africa and the Near East; these travels inspired a number of landscapes and townscapes. In 1931 he returned to Vienna, moving to Prague in 1934. In 1937, when in Germany his works were being confiscated (some were shown at the 'Degenerate Art' exhibition), he had his first major one-man show in the Museum für Kunst und Industrie in Vienna. In 1938 he fled to London, where he lived until 1953, before moving to the shores of Lake Geneva. From 1953 to 1963 he was a revered teacher at the Internationale Sommeraka-

demie für bildende Kunst (International Summer Academy for Visual Art), which he founded in Salzburg. During these years he also travelled extensively, visiting England, the United States, Italy and Greece.

Turn-of-the-century Vienna, with the influences of the Wiener Werkstätte and of Klimt, was the cradle of Kokoschka's artistic career. These student years culminated in the illustrations to the book *Träumende Knaben* (Dreaming Boys) of 1908. A decisive moment in his career as a painter came when he saw a Van Gogh exhibition in Vienna: the expressivity of colour took on a new meaning for him. Kokoschka's early pictures of 1907/8 already reveal an interest in the psychological interpretation of the subject, at first mainly people, later also landscapes. In the years that followed he developed a subtle personal style in which broad, expressive brushwork created the accents. In this early Expressionist phase he successively eliminated the graphic elements, the contours faded, and colour, in the form of individual, vehemently applied strokes of paint, became more and more the prime factor in pictorial construction. This development can be clearly traced in the series of portraits painted between 1908 and 1914. A masterpiece of this period is the 1914 oil painting *The Whirlwind* (*Die Windsbraut*), in which Kokoschka employs all his painterly skills to bring out the underlying psychological aspects with startling effectiveness.

During his Dresden period Kokoschka took a keen interest in the work of the *Brücke* painters, Emil Nolde and the French Fauves. These studies bore fruit with the evolution of a novel, expressive approach to pictorial composition on the basis of pure colour, with a preference for very strong, brilliant colours. In the mid-Twenties he adopted a style that he continued to use, with many variations, up to his late period: the brushstrokes are applied with a fine sense of balance between graphic and colouristic effect to create compositions in which the chromatic structure and its expressive power interrelate dynamically with the object depicted. The finest works from this period are pictures of the towns and landscapes that the artist saw on his travels between 1924 and 1931: in spite of the highly personal style, the individual character of the places depicted asserts itself on the canvas. The political allegories of the Thirties are composed along the same lines.

Kokoschka's late style is diffuse but full of atmosphere. He returned to the graphic medium, in which he had experimented in his early years, and produced important cycles of prints, stage designs, and so on. Modernist art in Austria has received significant impulses from Kokoschka's oeuvre, which also constitutes a major contribution to international art of the twentieth century.

Literature: Josef Paul Hodin, *Oskar Kokoschka: Sein Leben, seine Zeit*, Mainz, 1968

Oskar Kokoschka zum 85. Geburtstag, exhibition catalogue, Vienna, Österreichische Galerie, 1971

Hans M. Wingler and Friedrich Welz, *Oskar Kokoschka: Das druckgraphische Werk*, 2 vols, Salzburg, 1975, 1981

Anton Kolig

1886 Neutitschein (Nový Jičín), North Moravia
– 1950 Nötsch im Gailtal, Carinthia

Anton Kolig, son of a painter and decorator, grew up in Vienna. From 1904 to 1906 he studied at the Kunstgewerbeschule (School of Arts and Crafts), and from 1907 to 1912 at the Academy. He first made his mark on the art world at the *Sonderbund* exhibition, organized by the *Hagenbund* (Hagen Group), at which Kokoschka, Faistauer, Gütersloh, Wiegele and Isepp were also represented. From 1912 to 1914 he studied in Paris. After experiencing the Great War as a war artist, he went to live in Nötsch. In 1928 he was appointed professor at the Württembergische Kunstakademie (Württemberg Academy of Art) in Stuttgart, a post he held until 1943. After returning to Nötsch, he and his wife were severely injured in an air raid in which his brother-in-law, the painter Franz Wiegele, was killed. Though now permanently disabled, he continued painting until his death.

Kolig's name is closely associated with the Nötsch Circle, a group of painters that included Isepp, Wiegele, Esterl, Boeckl and Frankl; though never a formally constituted association, the name soon came to be applied to these artists, who cultivated a lively interchange of ideas.

Kolig's early, pre-First World War works reflect his interest in recent trends in French and Austrian painting; still-life is a favourite theme, with the organization of colour a major compositional principle. The war years, and especially the early Twenties, brought an increasing concentration on the human figure, which he depicted in oils and in a large number of interesting nude drawings; his admiration for Michelangelo is reflected in the strong, vigorous execution of his male nudes. The sculptural qualities of Kolig's painting before the late phase are monumentally demonstrated in his fresco designs, such as those for the Vienna crematorium, or in the (unexecuted) mosaic for the foyer of the Salzburg Festival Theatre (1927). Throughout his career, Kolig experimented in various fields: in painting he looked for new artistic directions, and also took an active interest in paint technology, especially the problem of developing new binders to produce more glowing colours.

Literature: *Kunst in Österreich 1918-1938 aus der Österreichischen Galerie*, exhibition catalogue, Schloss Halbturn, 1984, p. 114 ff.

Carl Moll

1861 Vienna – 1945 Vienna

Carl Moll studied under Christian Griepenkerl and Emil Jacob Schindler at the Vienna Academy. He was one of the founding members of the Vienna Secession in 1897. In later years the art scene benefitted from Moll's talent for organization. Thus, for some years he was manager of the Galerie Miethke, which was a Secession outlet; his efforts led to the staging of several exhibitions of artists of international repute whose work had not been seen in Austria, such as Van Gogh and Gauguin. From 1912 onwards, thanks to these achievements, he was in demand among private collectors as an art consultant. With considerable idealism he furthered the careers of promising young artists, and continued to organize exhibitions of modern art after the First World War. He committed suicide at the age of 84.

Moll's early years as an artist were influenced by the 'mood painting' of Austrian Impressionism, as exemplified in the work of his teacher Schindler. The close contact with Klimt in the Vienna Secession is reflected in his pictures from the early years of the century. Between 1913 and 1925 he produced a large number of large-scale coloured lithographs and woodcuts.

Typical of his paintings are a radiant intensity of colour, with the palette knife employed with decorative virtuosity to create lyrical and harmonious chromatic compositions. Favourite themes are landscape and still-life, which offer full scope for a free use of colour.

Literature: Kristian Sotriffer, *Malerei und Plastik in Österreich: Von Makart bis Wotruba*, Vienna, 1963

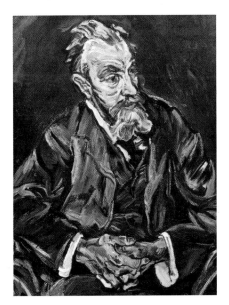

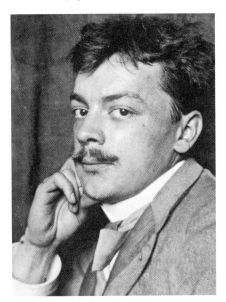

Koloman (Kolo) Moser

1868 Vienna – 1918 Vienna

Kolo Moser studied first at the Vienna Academy, and then at the Kunstgewerbeschule (School of Arts and Crafts). After graduating in 1895, he soon became a prominent figure in the Austrian art world. He was a founding member of the Vienna Secession in the spring of 1897, together with Klimt, Moll and others. The visual appearance of the magazine *Ver Sacrum* owed much to Moser's experience in graphic art. For Olbrich's Secession building Moser designed the decoration of the lateral façade with stylized owls, the frieze of wreath-bearing maidens at the rear and a circular glass window in the entrance wall. From 1899 he taught at the Kunstgewerbeschule, together with Josef Hoffmann, Alfred Roller and Berthold Löffler. In 1903, with Hoffmann, he founded the Wiener Werkstätte (Vienna Workshop), which became a centre of artistic creativity and innovatory craftsmanship in the field of design. Moser died in Vienna after a long illness.

Primary influences on Moser in his early years as a painter were Impressionism and the art of Ferdinand Hodler. As a wood-carver he was particularly fascinated by Japanese art, which of course inspired the Art Nouveau movement as a whole in a variety of ways. Through his interest in graphics he rose to become one of the foremost exponents of book and poster art, with a reputation not confined to Austria. Moser also designed a large number of stage sets. In his designs for utility objects he sought to enhance artistic quality, thus improving aesthetic standards in everyday life. His work for the Wiener Werkstätte has been admired throughout the world, never more so than today.

Literature: Kristian Sotriffer, *Malerei und Plastik in Österreich: Von Makart bis Wotruba*, Vienna, 1963
Werner Fenz, *Koloman Moser*, Salzburg, 1984

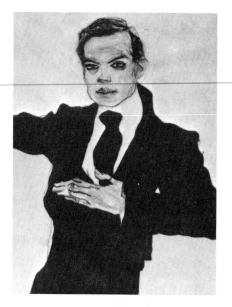

Max Oppenheimer (MOPP)

1885 Vienna – 1954 New York

Max Oppenheimer was the son of the writer Ludwig Oppenheimer. At the age of fifteen, by special dispensation, he was already attending classes at the Vienna Academy. From 1903 to 1906 he studied at the Academy in Prague. In 1908 he contributed several pictures to the 'Kunstschau' (Art Show) in Vienna, and shortly afterwards returned to the Austrian capital, where he became one of the group that gathered around Schiele and Gütersloh. During this Viennese period he created a number of paintings of famous musicians and men of letters. Under the patronage of the art dealer Paul Cassirer he lived in Berlin from 1911 until 1915, when he made his home in Switzerland. The years 1924/25 saw him back in Vienna, with a one-man show featuring 200 works and sponsored by the *Hagenbund* (Hagen Group) in the autumn of 1924. From 1926 to 1938 he again resided in Berlin. Fleeing Nazi Germany in 1938, he published the autobiographical book *Menschen finden ihren Maler* (People Find Their Painter) in Zurich. In 1939 he emigrated to New York, where he spent the rest of his life.

In 1940 the Kallir-Nirenstein Gallery in New York (whose proprietor had formerly run the Neue Galerie in Vienna) mounted an exhibition that featured, among other works, Oppenheimer's *Portrait of Tilla Durieux* (Bildnis Tilla Durieux; Cat. 138), *Flagellation* (Geisselung) and *The World War* (Der Weltkrieg). These early works exemplify a style that, deriving from the *Jugendstil* of the Austrian capital, is typical of Viennese Expressionism, with its exaggerated representation of the subject, dynamic use of colour and extreme perspectives. These features soon underwent a transformation in Oppenheimer's paintings and graphic work to create a balanced synthesis of linear and painterly components. From 1912 onwards 'MOPP' began to incorporate Cubist elements as part of his characteristic expressive vocabulary. Along with musical themes,

which figured in his oeuvre from the start – Oppenheimer was himself no mean violinist – it was the portrait that held a particular attraction for him: before the First World War his sitters included Thomas and Heinrich Mann, Peter Altenberg, Arthur Schnitzler and Arnold Schoenberg. In his late period he turned more to the still-life: his depictions of the little things of everyday life sometimes verge on the abstract.

Literature: *Kunst in Österreich 1918-1938 aus der Österreichischen Galerie*, exhibition catalogue, Schloss Halbturn, 1984, p. 122 ff.
M. A. von Puttkammer, *Max Oppenheimer: Leben und Werk*, Bonn, 1984

Rudolf Wacker

1893 Bregenz – 1939 Bregenz

Rudolf Wacker went to the college of commercial drawing in Bregenz in 1909/10 and continued his studies at the Bauer school of painting in Vienna in 1910/11. Here he met Egger-Lienz, whose master-class at the college of art in Weimar he attended from 1911 to 1914. He joined the army on the outbreak of war, was taken prisoner in 1915 and spent the next six years in Russia. On his return, he lived for a time in Berlin, where he was in contact with Erich Heckel and his artistic circle. In 1924 he moved back to Bregenz and founded *Der Kreis* (The Circle), an association of artists from the Lake Constance area. He was represented at the Venice Biennale in 1934.

After concentrating mainly on drawing in his early years, Wacker began to paint around 1922. Making use of Expressionist techniques in his first works, he adopted a more objective style in the mid-Twenties. Through his magical interpretations he imbued his landscapes, and above all his still-lifes, with a 'more profound reality'.

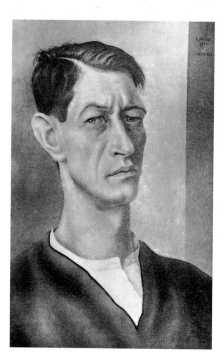

Otto Demus comments: 'Rudolf Wacker's painting is an important phenomenon in the history of twentieth-century Austrian art inasmuch as it represents virtually the only, and certainly the most significant, example of *Neue Sachlichkeit* [New Objectivity], and more precisely, of so-called Magic Realism.'

Literature: Otto Demus, 'Zur Stellung Rudolf Wackers', *Mitteilungen der Österreichischen Galerie*, no. 2, 1958
Kunst in Österreich 1918-1938 aus der Österreichischen Galerie, exhibition catalogue, Schloss Halbturn, 1984

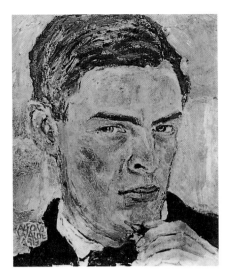

Alfons Walde

1891 Oberndorf, Tyrol – 1958 Kitzbühel

Alfons Walde, whose father was headmaster of
the local school, began studying architecture in
1910 at the Vienna Technische Hochschule (Poly-
technic), where Boeckl was his classmate from
1912 to 1914. Walde took painting lessons at the
same time. He spent the war years in a Tyrolean
regiment of riflemen. In 1925 his work was exhi-
bited at the Biennale in Rome. In 1926 he joined
the Künstlerhaus association in Vienna. He took
part in numerous exhibitions both at home and
abroad.

Initially, Walde was influenced by Egger-
Lienz, whose formal language he took over
without, however, adopting the sombre and
tragic overtones. Further impulses came from the
decorative and ornamental pictures of Klimt and
from the works of Schiele. Decorative still-lifes
and sophisticated female portraits are prominent
subjects in this early period. In later years he
began to concentrate on the traditions and way
of life of his native Tyrol; his paintings of local
farmers and their milieu convey an affirmative
attitude to life that stands in stark contrast to the
depressive, pessimistic mood created by Egger-
Lienz. The Tyrolean landscape, in particular, is
portrayed by Walde as a celebration of beauty,
with intense, generously applied colours.
Between 1920 and 1938 he became known
internationally through his posters showing
snow-covered landscapes and promoting
winter sports.

Franz Wiegele

1887 Nötsch im Gailtal, Carinthia – 1944 Nötsch

After learning the blacksmith's trade from his
father, Franz Wiegele studied at the Vienna Aka-
demie der bildenden Künste (Academy of Visual
Arts) from 1907 to 1911. His first exhibition, in
1911, together with Kolig and Faistauer, brought
him to the notice of Carl Moll, who arranged for
him to go on a study trip to Paris. Further travels
took him to Holland and Africa, where he was
interned on the outbreak of war; he was not
released until 1917, when he was sent to Switzer-
land in an exchange of prisoners. He lived in
Zurich from 1917 to 1925, and in 1918 organized
a big exhibition of contemporary Austrian
painting. In 1925 he returned to Nötsch and
converted his father's smithy into a studio. In
1936 he declined a professorship at the Vienna
Academy. He was killed in an air raid on his
home town in 1944.

As with many Austrian painters of the first
quarter of the century – and especially those of
the Nötsch Circle – colour is the principal factor
in Wiegele's approach to painting. In his case
violent, and sometimes complementary, con-
trasts predominate; often, an impression of frag-
mentariness is created, particularly in the late
works. Many impulses were undoubtedly pro-
vided by his stay in Paris, where he took a special

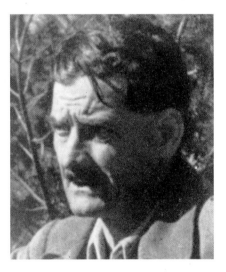

interest in the illusion of space generated by the
radiant colours of Dunoyer de Segonzac and in
Cézanne's pictures of the middle period; it was
here that he learned to create dynamic pictorial
compositions from patches of colour. Some of
Wiegele's paintings of the Swiss period are remi-
niscent of Gauguin, especially as regards similari-
ties of pose and gesture. In the course of the
Twenties he managed to achieve a synthesis be-
tween traditional notions of the picture and mod-
ern renditions of the object. Wiegele's roots in
artistic tradition can be seen most clearly in his
extensive output of prints.

Literature: *Franz Wiegele: Gemälde*, exhibition catalogue,
Klagenfurt and Vienna, 1987

Franz von Zülow

1883 Vienna – 1963 Vienna

Franz von Zülow began his artistic studies in
1901 at the Graphische Lehr- und Versuchsanstalt
(Printing Trades College and Research Institute)
in Vienna. From 1903 to 1907 he attended the
Kunstgewerbeschule (School of Arts and Crafts).
It was not long before he was creating his first
decorative designs for the Wiener Werkstätte
(Vienna Workshop). In 1908 he became a member
of the Vienna Secession. In the Twenties he pro-
duced a wealth of designs for the decoration of
furniture, china and textiles. In 1925 he won the
gold medal at the international exhibition of arts
and crafts in Paris. In 1939 he painted the safety-
curtain of the Akademietheater in Vienna. His
work in the field of applied art did not prevent
him from producing a large number of paintings
and prints. Zülow, who received many prizes and
honours during his long life, was forbidden to
work by the Nazis in 1943.

The many facets of Zülow's oeuvre are char-
acterized by a personal Expressionism that ex-
ploits the vast resources of colour. He started
working in oils in 1925, and from the late Twen-
ties also created frescos. Landscapes are the domi-
nant theme in his paintings: they are deliberately
simple, almost naive in their narrative character
and expressive colouration. Zülow experimented
a great deal with graphic techniques, and in 1907
he invented and patented the cut-paper stencil
process.

Literature: Peter Baum, *Franz von Zülow, 1883-1963*, Vienna,
Munich and Zurich, 1980

Selected Bibliography

Books and Articles

Bahr, Hermann, *Secession*, Vienna, 1900.

Baum, Peter, *Franz von Zülow, 1883-1963*, Vienna, Munich and Zurich, 1980.

Bei, Neda, Wolfgang Förster, Hanna Hacker and Manfred Lang, *Das Lila Wien um 1900: Zur Ästhetik der Homosexualitäten*, Vienna, 1986.

Benesch, Otto, 'Franz Wiegele als Zeichner', *Die graphischen Künste*, 1927, pp. 69-80.

Benesch, Otto, *Egon Schiele als Zeichner*, Vienna, n.d. [1951].

Benesch, Otto, *Mein Weg mit Egon Schiele*, New York, 1965.

Bisanz, Hans, *Alfred Kubin: Zeichner, Schriftsteller und Philosoph*, Salzburg and Munich, 1977.

Boeckl, Leonore, *Werkverzeichnis der Gemälde Herbert Boeckls*, Salzburg, 1976.

Breicha, Otto, 'Gerstl, der Zeichner', *Albertina Studien*, vol. 3, no. 2, 1965, pp. 92-101.

Breicha, Otto (ed.), *Oskar Kokoschka: Vom Erlebnis im Leben*, Salzburg, 1976.

Breicha, Otto, *Hans Böhler*, Salzburg, 1981.

Breicha, Otto (ed.), *Gustav Klimt. Die Goldene Pforte. Werk–Wesen–Wirkung. Bilder und Schriften zu Leben und Werk*, Salzburg, 1985.

Comini, Alessandra, *Egon Schiele*, New York, 1976.

Doderer, Heimito von, *Der Fall Gütersloh: Ein Schicksal und seine Deutung*, Vienna, 1930.

Fenz, Werner, *Koloman Moser: Graphik, Kunstgewerbe, Malerei*, Salzburg, 1984.

Frodl, Gerbert, *Herbert Boeckl*, Salzburg, 1976.

Fuchs, Albert, *Geistige Strömungen in Österreich 1867-1918*, Vienna, 1984 (1st edn, 1949).

Fuchs, Heinrich, *Die österreichischen Maler der Geburtsjahrgänge 1881-1900*, 2 vols, Vienna 1976-7.

Fuhrmann, Franz, *Anton Faistauer*, Salzburg, 1972.

Heřmanský, Bohdan, 'Wiegeles drei Familienbilder', *Mitteilungen der Österreichischen Galerie*, vol. 14, no. 58, 1970, pp. 158-81.

Heřmanský, Bohdan, 'Die Männerakte Koligs und die österreichische Handzeichnung seiner Zeit', *Alte und moderne Kunst*, vol. 17, no. 120, 1972, pp. 27-34.

Hodin, Josef Paul, *Oskar Kokoschka: Sein Leben, seine Zeit*, Mainz, 1968.

Hofmann, Werner, 'Der Wiener Maler Richard Gerstl', *Kunstwerk*, vol. 10, no. 1/2, 1956/57, pp. 99-101.

Hofmann, Werner, *Moderne Malerei in Österreich*, Vienna, 1965.

Hofmann, Werner, *Gustav Klimt und die Wiener Jahrhundertwende*, Salzburg, 1977.

Hutter, Heribert (ed.), *Albert Paris Gütersloh: Beispiele*, Vienna, 1977.

Janik, Albert, and Stephen Toulmin, *Wittgensteins Wien*, Munich and Vienna, 1984.

Johnston, William M., *Österreichische Kultur- und Geistesgeschichte: Gesellschaft und Ideen im Donauraum 1848 bis 1938*, Vienna, 1974.

Kallir, Otto, *Egon Schiele: Œuvre Katalog der Gemälde*, Vienna, 1966.

Kallir, Otto, *Egon Schiele: Das druckgraphische Werk*, Vienna, 1970.

Kallir, Otto, 'Richard Gerstl (1883-1908): Beiträge zur Dokumentation seines Lebens und Werkes', *Mitteilungen der österreichischen Galerie*, vol. 18, 1974, pp. 125-93.

Kirschl, Wilfried, *Albin Egger-Lienz 1868-1926: Das Gesamtwerk*, Vienna, 1977.

Kiss, Endre, *Der Tod der K. und K. Weltordnung in Wien*, Vienna, Cologne and Graz, 1986.

Kokoschka, Oskar, *Mein Leben*, Munich, 1971.

Krapf-Weiler, Almut, 'Max Oppenheimer', in *Wien um 1900: Kunst und Kultur*, Vienna, 1985, p. 536 ff.

Leopold, Rudolf, *Egon Schiele: Gemälde, Aquarelle, Zeichnungen*, Salzburg, 1972.

Michel, Wilhelm, *Max Oppenheimer*, Munich, 1911.

Mitsch, Erwin, *Egon Schiele*, Salzburg, 1974.

Mrazek, Wilhelm, *Anton Hanak, 1875-1934*, Vienna and Munich, 1969.

Nebehay, Christian M., *Gustav Klimt: Dokumentation*, Vienna, 1969.

Nebehay, Christian M., *Egon Schiele 1890-1918: Leben, Briefe, Gedichte*, Veröffentlichung der Albertina no. 13, Salzburg and Vienna, 1979.

Nebehay, Christian M., *Egon Schiele: Leben und Werk*, Salzburg and Vienna, 1980.

Novotny, Fritz, *Franz von Zülow*, Vienna, 1958.

Novotny, Fritz, *Gerhart Frankl*, Salzburg, 1973.

Novotny, Fritz, and Johannes Dobai, *Gustav Klimt: Œuvre-Katalog*, Salzburg, 1967.

Puttkammer, M.A. von, *Max Oppenheimer: Leben und Werk*, Bonn, 1984.

Rathenau, Ernest, *Oskar Kokoschka Handzeichnungen*, Berlin, 1935.

Rathenau, Ernest (ed.), *Der Zeichner Kokoschka*, foreword by Paul Westheim, New York and Hamburg, 1961.

Rathenau, Ernest, *Oskar Kokoschka Handzeichnungen, 1906-1965*, New York, 1966.

Rathenau, Ernest, *Oskar Kokoschka Handzeichnungen, 1906-1969*, Hamburg, 1971.

Roessler, Arthur, *Briefe und Prosa von Egon Schiele*, Vienna, 1921.

Roessler, Arthur, *Erinnerungen an Egon Schiele*, Vienna, 1922; enlarged edn, Vienna, 1948.

Rohrmoser, Albin, *Anton Faistauer 1887-1930*, Salzburg, 1987.

Schiele, Egon, *Schriften und Zeichnungen*, Innsbruck, 1968.

Schmied, Wieland, and Alfred Marks, *Der Zeichner Alfred Kubin*, Salzburg, 1967.

Schorske, Carl Emil, *Wien: Geist und Gesellschaft im Fin de Siècle*, Frankfurt am Main, 1982.

Schweiger, Werner J., *Der junge Kokoschka*, Vienna, 1983.

Sotriffer, Kristian, *Malerei und Plastik in Österreich: Von Makart bis Wotruba*, Vienna, 1963.

Sotriffer, Kristian, *Albin Egger-Lienz, 1868-1926*, Rosenheim, 1983.

Spiel, Hilde, *Glanz und Untergang: Wien 1866 bis 1938*, Munich, 1987.

Springschitz, Leopoldine, *Arnold Clementschitsch*, Buchreihe des Landesmuseums für Kärnten, vol. 13, Klagenfurt, 1957.

Strobl, Alice, *Gustav Klimt: Zeichnungen und Gemälde*, Salzburg, 1962.

Strobl, Alice, *Gustav Klimt: Die Zeichnungen 1878-1918*, 3 vols, Salzburg, 1980-4.

Tietze, Hans, 'Egon Schiele', *Wiener Monatshefte*, no. 2, 1919, pp. 99-110.

Wagner, Nike, *Geist und Geschlecht: Karl Kraus und die Erotik der Wiener Moderne*, Frankfurt am Main, 1982.

Waissenberger, Robert (ed.), *Wien 1870-1930: Traum und Wirklichkeit*, Salzburg and Vienna, 1984.

Werkner, Patrick, 'Kokoschkas frühe Gebärdensprache und ihre Verwurzelung im Tanz', in *Oskar-Kokoschka-Symposion der Hochschule für angewandte Kunst in Wien*, Salzburg and Vienna, 1986.

Werkner, Patrick, *Physis und Psyche: Der österreichische Frühexpressionismus*, Vienna and Munich, 1986.

Wingler, Hans M., *Oskar Kokoschka: Das Werk des Malers*, Salzburg, 1956.

Wingler, Hans M., and Friedrich Welz, *Oskar Kokoschka: Das druckgraphische Werk*, 2 vols, Salzburg, 1975, 1981.

Exhibition Catalogues

Basel, Kunsthalle, *Oskar Kokoschka*, 1974.

Hamburg, Kunsthalle, *Experiment Weltuntergang: Wien um 1900*, ed. Werner Hofmann, 1981.

Innsbruck, Wiener Secession, *Richard Gerstl*, 1966.

Klagenfurt, Kärntner Landesgalerie, and Vienna, Österreichische Galerie, *Franz Wiegele: Gemälde*, 1987.

London, Tate Gallery, *Kokoschka: A Retrospective Exhibition*, 1962.

New York, Galerie St. Etienne, *Austrian Expressionism*, 1981.

Salzburg, Residenzgalerie, and Vienna, Österreichische Galerie, *Anton Faistauer*, 1972.

Schloss Halbturn, *Kunst in Österreich 1918-1938 aus der Österreichischen Galerie*, 1984.

Stuttgart, Staatsgalerie, Graphische Sammlung, *Oskar Kokoschka: Aquarelle und Zeichnungen – Ausstellung zum 80. Geburtstag*, 1966.

Venice, Palazzo Grassi, *Le arti a Vienna dalla Secessione alla caduta dell'imperio asburgico*, 1984.

Vienna, Akademie der bildenden Künste, *Albert Paris Gütersloh: Retrospektive*, 1987.

Vienna, Galerie Pabst, *Max Oppenheimer: Ein österreichisches Schicksal? Ölbilder und Graphiken*, 1974.

Vienna, Galerie Würthle, *Josef Dobrowsky*, 1979.

Vienna, Giese & Schweiger, *Ludwig Heinrich Jungnickel*, 1984.

Vienna, Graphische Sammlung Albertina, *Gustav Klimt, Egon Schiele: Zum Gedächtnis ihres Todes vor 50 Jahren*, 1968.

Vienna, Graphische Sammlung Albertina, *Albert Paris Gütersloh: Aquarelle und Zeichnungen*, 1970.

Vienna, Graphische Sammlung Albertina, *Laske – Jungnickel – Zülow*, 1978-9.

Vienna, Hermesvilla, *Die neue Körpersprache: Grete-Wiesenthal und ihr Tanz*, 1985-6.

Vienna, Historisches Museum der Stadt Wien, *Egon Schiele: Leben und Werk – Ausstellung zur 50. Wiederkehr seines Todestages*, 1968.

Vienna, Historisches Museum der Stadt Wien, and elsewhere, *Oskar Kokoschka: Die frühen Jahre – Zeichnungen und Aquarelle*, 1982-3.

Vienna, Historisches Museum der Stadt Wien, *Richard Gerstl, 1883-1908*, 1983-4.

Vienna, Historisches Museum der Stadt Wien, Wiener Secession and Künstlerhaus, *Wien um 1900*, 1985.

Vienna, Historisches Museum der Stadt Wien, *Der Maler Gerhart Frankl (1901-1965)*, 1987.

Vienna, Kunstforum, *Alfred Kubin: Leben – ein Abgrund*, ed. Klaus Albrecht Schröder, 1985-6.

Vienna, Künstlerhaus, *Oskar Kokoschka*, 1958.

Vienna, Museum für angewandte Kunst, *Abbild und Emotion: Österreichischer Realismus 1914-1944*, 1984.

Vienna, Österreichische Galerie, *Oskar Kokoschka zum 85. Geburtstag*, 1971.

Vienna, Wiener Secession, *Josef Engelhart*, 1909.

Zurich, Kunsthaus, *Der Hang zum Gesamtkunstwerk*, ed. Harald Szeemann, 1983.

Photographic Acknowledgments

Plates

Fotoatelier B. + M. Dermond, Zurich 5-10, 15, 19, 20, 26, 40, 41, 45, 48, 50, 52, 55-57, 63-65, 70, 77-79, 90, 99, 101, 109, 121-123, 129, 133-135, 137, 140, 143

Foto Degonda & Siegenthaler, Zurich 4, 60, 66

Rudolf Leopold, Vienna 1, 11, 12, 14, 16, 22, 32, 36, 39, 44, 46, 49, 51, 53, 58, 94, 98, 100, 108, 111-114, 116-119, 124-128, 130, 131, 139, 144

Fotostudio Otto, Vienna 2, 3, 13, 18, 21, 24, 25, 31, 33, 34, 35, 37, 38, 42, 43, 47, 54, 59, 61, 62, 67, 68, 71-74, 76, 81, 82, 87, 91-93, 95-97, 102-107, 110, 115, 145

H. & A. Pfeifer, Vienna 17, 23, 27-30, 69, 75, 80, 83-86, 88, 89, 120, 132, 136, 138, 141, 142

Text Illustrations

Albertina, Vienna pp. 31/16, 29/15

Albertina, Vienna, exhibition catalogue *Laske, Jungnickel, Zülow*, 1979 p. 293/right

Archiv Boeckl p. 42/5

Bregenz, exhibition catalogue *Rudolf Wacker*, n.d. p. 293/left

Brussels, exhibition catalogue *Fernand Khnopff et la Secession Viennoise*, 1987 p. 25/10

Cosmopress, Geneva pp. 20/3, 290/centre

Direktion der Museen der Stadt Wien, Vienna p. 22/8

Hamburger Kunsthalle, Hamburg p. 20/2

Willi Hartl, Klagenfurt p. 285/left

Historisches Museum der Stadt Wien, Vienna pp. 20/4, 42/4

Foto Kirschl, Innsbruck p. 292/centre

V. Klotz, *Die erzählte Stadt*, Hamburg, 1987 pp. 26/11, 27/12 and 13

Rudolf Leopold, Vienna pp. 11/1 and 2, 18/1, 281-4/1-7

Archiv Christian M. Nebehay, Vienna pp. 28/14, 291/right

F. Novotny and J. Dobai, *Gustav Klimt*, Salzburg, 1967 p. 37/1

Österreichische Galerie, Vienna pp. 39/2, 285/right

Österreichische Nationalbibliothek, Vienna, Bildarchiv pp. 284/centre, 285/centre, 286/centre and right, 288/left and right, 289/top and bottom

Fotostudio Otto, Vienna p. 291/centre

Schroll-Verlag, Vienna, Archiv p. 288/centre

H. Sotriffer, *Malerei und Plastik in Österreich von Makart bis Wotruba*, Vienna, 1963 p. 287/centre

P. Werkner, *Physis und Psyche*, Vienna and Munich, 1986 pp. 22/7, 23/9, 41/3

Galerie Würthle, Vienna, exhibition catalogue *Der Nötscher Kreis*, 1984 pp. 287/left, 291/left, 293/centre